Artistic License

Artistic License

The Philosophical Problems
of Copyright and Appropriation

DARREN HUDSON HICK

The University of Chicago Press
Chicago and London

The University of Chicago Press, Chicago 60637
The University of Chicago Press, Ltd., London
© 2017 by The University of Chicago

Published 2017
Printed and bound by CPI Group (UK) Ltd, Croydon, CR0 4YY

26 25 24 23 22 21 20 19 18 17 1 2 3 4 5

ISBN-13: 978-0-226-46010-9 (cloth)
ISBN-13: 978-0-226-46024-6 (paper)
ISBN-13: 978-0-226-46038-3 (e-book)
DOI: 10.7208/chicago/9780226460383.001.0001

Chapter 5: "Toward an Ontology of Authored Works" reprinted with minor
alterations from Darren Hudson Hick, "Toward an Ontology of Authored
Works," *British Journal of Aesthetics*, 2011, 51, issue 2, 185–99, by permission
of the British Society of Aesthetics.

Chapter 8: "Appropriation and Transformation" reprinted with minor alter-
ations from Darren Hudson Hick, "Appropriation and Transformation," *Ford-
ham Intellectual Property, Media & Entertainment Law Journal*, 2013, 23, issue 4,
1155–95, copyright © 2012 *Fordham Intellectual Property, Media & Entertainment
Law Journal* and Darren Hudson Hick.

Library of Congress Cataloging-in-Publication Data

Names: Hick, Darren Hudson, author.
Title: Artistic license : the philosophical problems of copyright and
appropriation / Darren Hudson Hick.
Description: Chicago ; London : The University of Chicago Press, 2017. |
Includes bibliographical references and index.
Identifiers: LCCN 2016040299 | ISBN 9780226460109 (cloth : alk. paper) |
ISBN 9780226460246 (pbk. : alk. paper) | ISBN 9780226460383 (e-book)
Subjects: LCSH: Copyright—Philosophy. | Intellectual property—Philosophy. |
Intellectual property infringement. | Authorship—Philosophy. | Originality. |
Ontology. | Art—Philosophy.
Classification: LCC K1420.5 .H53 2017 | DDC 346.04/82—dc23 LC record
available at https://lccn.loc.gov/2016040299

♾ This paper meets the requirements of ANSI/NISO Z39.48-1992
(Permanence of Paper).

CONTENTS

ACKNOWLEDGMENTS

The research project that eventually became this book began ten years ago in a bar, where my friend Billy Sunday was doing his very best to justify his rampant illegal downloading of movies, music, and video games from the Internet. I vowed then and there that I would prove him wrong. It's taken some time, and I couldn't have predicted how that vow would take over my life. Over the next decade, I would engage a great many people on the topics of copyright and appropriation, and I owe all of them a debt. I have benefited tremendously from years of discussion with Maria Balcells, Craig Derksen, Pete Groff, Ben Jones, Dustyn Martincich, Joe Scapellato, and Megan Sunday (yes, Billy's wife). Several philosophers of art have played direct roles in personally invigorating, shaping, or challenging my views on their way to this book, especially Jerrold Levinson, Karen Gover, Sherri Irvin, James O. Young, Reinold Schmücker, Eberhard Ortland, and Roger A. Shiner. I owe thanks to the team at the University of Chicago Press, including my editor Elizabeth Branch Dyson, who championed the project; editorial associate Rachel Kelly, who shepherded the book from manuscript to marketing; copyeditor Lisa Wehrle who beautifully polished my writing; and designer Adeetje Bouma. The book has also benefited from several reviews, one by Lawrence A. Husick and three by anonymous scholars—I owe each of these reviewers a great deal, and the book is much better than it would have been without their help. I owe a debt I can never repay to my wife, Delaina Pearson, who has probably been forced to learn more about Richard Prince, fair use, and the Amen Break than she would have ever wanted to know, but always untiringly, always cheerfully, always encouragingly. And most of all, I have to thank Billy, without whom this would have been a book on art and math. Thanks, Billy.

Introduction

Mondrian Mickey

On the cover of this book is a painting by Mick Haggerty—*Mondrian Mickey*—from 1976. Haggerty is best known as a commercial artist, particularly of now-classic album covers. Jimi Hendrix's *Kiss the Sky*, David Bowie's *Let's Dance*, and *Ghost in the Machine* by the Police all feature Haggerty's cover art. Haggerty's illustrations have appeared on the cover of *Time* and *Vanity Fair*. So most of Haggerty's more familiar work has been for others, but *Mondrian Mickey* was just for him. *Mondrian Mickey*, Haggerty tells me, is something of a self-portrait: it illustrates the two often-conflicting worlds that a commercial artist finds himself serving. As a self-portrait, Haggerty says, "I'm somewhere halfway down that wall."[1]

Mickey Mouse and Piet Mondrian's grid paintings are probably two of the most recognizable—and most borrowed—visuals in the Western world. However, both Mickey Mouse (not shockingly) and Mondrian's works (perhaps more surprisingly) are still protected by copyright.

Mickey, Mondrian, and Copyright

The first Mickey Mouse cartoon, *Steamboat Willie*, was created in 1928 and was due to enter the public domain in 2003. Since a character's copyright is tied to the copyrighted work in which that character first appears, that meant Mickey's copyright was also due to expire in 2003. Unsurprisingly, the Walt Disney Company was unhappy about the seemingly inevitable loss of ownership of its flagship character (Goofy, Donald, and the rest would follow within just a few years). And so, between 1997 and 1998, Disney spent (by one estimate) $6.3 million to ensure that didn't happen, lobbying Congress in the form of campaign contributions.[2] It succeeded in the form of the

Sonny Bono Copyright Term Extension Act of 1998—playfully known as the Mickey Mouse Protection Act—which extended US copyright by twenty years (effectively across the board), protecting Mickey until 2023. Perhaps Disney's $6.3 million in campaign contributions sounds like a lot of money. Consider, though, that Disney's *Hercules*, released in 1998, made more than three times that amount *in its opening weekend*. An additional twenty years' protection for all of its properties was a *steal* at $6.3 million.

This was not the first time that Mickey came within reach of being a free-range mouse. In 1928, when *Steamboat Willie* was created, US federal copyright lasted for twenty-eight years from the year of publication, with the option of extension for a further twenty-eight years.[3] Disney filed the appropriate paperwork on both occasions, and so the film's copyright was originally due to expire in 1984.[4] But in 1976—coincidentally, the same year that Mick Haggerty painted *Mondrian Mickey*—Congress passed its first major revision to the US Copyright Act since 1909. The 1976 Act extended the copyright of *Steamboat Willie* (and other works already published and protected by copyright) to a total of seventy-five years from the initial year of publication.[5] The 1976 Act got rid of renewal terms for works created after January 1, 1978, which were now protected for the life of the author plus fifty years.[6] When the Sonny Bono Copyright Term Extension Act added twenty years to Mickey's protection, it also extended the copyright protection of newly created works to life plus seventy years.[7]

Mondrian is an even more complicated story. Mondrian died in February 1944, with most of his now-famous grid works created in Paris between 1919 and 1938. European copyright protects works for the life of the author plus seventy years, so it would seem that Mondrian's copyrights expired on January 1, 2015. However, in the United States, copyright for works by foreign artists first published outside the United States between January 1, 1923, and January 1, 1978 (and not published in the United States within thirty days of their foreign publication, and not in the public domain as of January 1, 1996, in their source countries) is protected for ninety-five years from the date of first publication.[8] Got all that? Good. Now, any of Mondrian's works created prior to 1923 (say, his *Tableau I* from 1921) are in the public domain in both Europe and the United States. Most of his works created between 1923 and 1940 are in the public domain in Europe but still protected in the United States. His *Composition C (No. III)* from 1935, for example, was first shown in London in 1936, so its copyright will be protected in the United States until the end of 2031. In 1940, however, Mondrian moved to New York, which changes things. One of Mondrian's most famous paintings, *Broadway Boogie Woogie*, was completed and exhibited in New York in 1943.

At the time, US federal copyright protection required a copyright notice and registration with the Copyright Office. As the Catalog of Copyright Entries shows no listings for Mondrian anytime in the 1940s, it seems safe to say that the artist did not register any of his New York paintings, meaning *Broadway Boogie Woogie* has *always* been in the public domain in the United States due to failure to comply with formalities required at the time.

Mickey, Mondrian, and Appropriation

Despite his protection, Mickey has been a regular subject of appropriation. Roy Lichtenstein began the most famous phase of his career by repainting an illustration of Mickey Mouse and Donald Duck from a 1960 Golden Book in his *Look Mickey* (1961). For a handful of years, Lichtenstein regularly appropriated from comic books, yellow pages advertisements, and other mundane sources—some 140 works in all. Yet, the Roy Lichtenstein Foundation notes, the artist was never sued for copyright infringement (not by Disney, not by anyone else).[9] Mickey shows up in several of Keith Haring's works, too, apparently without permission.[10] But when Andy Warhol (perhaps the artist best known for appropriating from commercial pop culture sources) was creating his 1981 Myths series—depicting Mickey along with Superman, Santa Claus, Uncle Sam, and others in a series of silkscreen prints—he reached out to Disney for permission and entered into an agreement to share copyright on the work.[11] Curiously, Haring's screen print series Andy Mouse (1986) depicts Warhol *as* Mickey, carried aloft by the masses, up to his knees in money, emblazoned on the money itself (all, again, apparently without permission).

Lichtenstein also appropriated Mondrian's style in his *Non-Objective I* (1964) and *Non-Objective II* (1964), though neither exactly matches the design of any known painting by Mondrian, and each incorporates Lichtenstein's own signature use of Ben-Day dots. Mondrian has turned out to be a particularly fun subject for other artists. Nelson Leirner's Homage to Mondrian series (2010) at first appear to be large, square Mondrianesque works with a number of brushed metal knobs sticking out of their surfaces. On closer examination, the works are sliding puzzles, allowing viewers to slide squares of colors around the surface to create a never-ending series of "Mondrians." In 2002, a Canadian artist group—Price Budget for Boys—created the seemingly inevitable *Pac-Mondrian*, a playable mash-up of the Pac-Man videogame and Mondrian's *Broadway Boogie Woogie*. The game's instructions suggest: "Pac-Mondrian disciplines the syncopated rhythms of Mondrian's spatial arrangements into a regular grid, then frees the gaze to follow the

viewer's whimsical perambulations of the painting: a player's thorough study of the painting clears the level."[12]

To mark the fiftieth anniversary of Mondrian's death, the Netherlands declared 1994 to be "the Mondrian Year," marked with exhibitions and other cultural events celebrating the artist and his work. That year, Mondrian's estate licensed a sea of "Mondriania"—from carpets to shoes to cosmetics—all officially bearing the artist's style and name, and the estate made the wise move of registering with the US Trademark Office. The US trademark on "Piet Mondrian" has since been abandoned, however. In other words, today anyone can put Mondrian's name on a product without worry of legal reprisal. And they do. A quick Google search tells me I can buy "Mondrian" tumblers from the Museum of Modern Art, a "Mondrian" case for my iPhone from Zazzle.com, or a set of "Mondrian" DJ headphones made by Arie17. Bloomingdale's sells a variety of "Mondrian Hipster Bikini Bottoms" for $61 a pair, and Caitlin Freeman's 2013 cookbook, *Modern Arts Desserts*, features the "Mondrian Cake" on its cover, a confection previously available only at the café in the San Francisco Museum of Modern Art.

Mickey and Mondrian are ubiquitous. Mickey Mouse is consistently one of the most recognizable characters in the world. In a 2013 survey, Mickey was familiar to 95 percent of respondents (1 percent more than Santa Claus) and had a "Q Score" (a measure of recognition and favorability) of 50 (the Easter Bunny earns a 42, Morgan Freeman a 47; Batman has a 25).[13] Dead painters don't usually get Q Scores, and the name "Mondrian" is probably (at best) only vaguely familiar to most people. But with the unfettered spread of Mondriania (both official and otherwise), his signature style (if not his name) is likely instantly recognizable to most.

Mondrian Mickey, Again

Haggerty describes *Mondrian Mickey* as a self-portrait. Certainly, then, it's at least curious that Haggerty would choose to use the work of others to represent himself. However, Haggerty has no apparent recognizable visual style of his own. A visit to mickhaggerty.com presents the viewer with a never-ending slideshow of Haggerty's work—both commercial and otherwise—with nothing but the URL to tell you these were all created by the same artist. Haggerty is a chameleon, using what he needs for the project at hand. In this case, it seems, Mickey and Mondrian were those tools.

Just as Mickey has become something of an all-purpose symbol of pop culture (and the incorporation thereof), so has Mondrian's style become a sort of catchall symbol for modern art. Mickey is an empty cipher—devoid

of anything like a personality of his own—so his use as a generic symbol for the Walt Disney Company, and for commercial pop culture in general, makes some sense. On the other hand, while Mondrian's work embodies a fascinating Neoplatonist theory,[14] this is largely unknown by (and would probably be inaccessible to) much of the general public. And so his grid style, devoid of figurative representation, has instead become emblematic of modern art in general. Mickey and Mondrian are *symbols*—instantly recognizable, already rich with meaning and associations—and so, given the subject of his painting, it makes perfect sense for Haggerty to use them.

Now, we might ask, has Haggerty done anything *wrong*? "Surely it's fair use!" somebody yells from the back. First, that's a legal claim, and I was looking for a moral one. But since you bring it up, the "fair use doctrine"—a staple in US copyright law—is a notoriously unpredictable part of the law.[15] Whether a use is "fair" is decided by courts on a case-by-case basis, and what's worse, fair use effectively sets no precedent. What this means is, no matter how much you know about the law, you can't know whether a use is fair without a lawsuit. This should worry you. This should worry *everyone*. Meanwhile, "fair dealing," an alternative system used in other countries, has problems of its own.

Whether he has done anything wrong, Haggerty has certainly done nothing *unusual*. Artistic appropriation is everywhere—just have a look around. Here, where I am writing in Lubbock, Texas, one local business—Boardwalk After School & Summer Camp—emblazons its vans with the image of Rich Uncle Pennybags from the Monopoly game. A local bar's walls are painted with enormous, nostalgic images from 1980s arcade games, including *Space Invaders*, *Donkey Kong*, and *Street Fighter*. Of course, you'll still see the occasional pickup carrying the now twenty-year-old image of Calvin peeing on a Chevy logo . . . or a Ford logo . . . or a Toyota logo . . . And a stroll through the monthly downtown Art Trail will reveal any number of scattered artistic borrowings. None of these, I am certain, is authorized. (Never mind the widespread illegal downloading of music and movies from the Internet.)

"Wait a second!" my interlocutor from the back of the room shouts. "I thought you were talking about ethics, not the law! Which is it?" Actually, I'm talking about both. I'm also talking about artistic practice. Each of these domains plays a role here.

Outline

This book is about copyright and appropriation, with my central aim being to reconcile growing practices of artistic appropriation and related attitudes

about ownership and artistic "taking" with views about authors' rights, both legal and moral. This means coming to an understanding of what these rights are and what grounds them.[16]

First, we need some context. In chapter 1, I look at the sorts of culture clashes at the heart of our more interesting issues of authorship, ownership, and infringement, examining the role that copying and copyright have played in artistic practice, the psychology of ownership, and what seems to be an increasingly accelerating ideological shift, fueled in part by technological advances, bringing about a widening of the gray area between artistic making and artistic taking.

Chapter 2 focuses on the interrelation between art ontology, artistic practice, and the law—three domains, I argue, that can truly only be separated in the abstract. While copying is an artistic practice and an ontological topic, copyright is both a legal and moral one; and though the role of copying in artistic practice has evolved, many argue, copyright has failed to keep step, producing an imbalance that puts the law at odds with the domain it is meant to protect.

Chapters 3 and 4 deal with two notions fundamental to copyright—the nature of originality and the nature of authorship—each of which has been the subject of prolonged skepticism in a number of arenas. In chapter 3, I focus on and work to dissolve claims of what we might call "originality deniers"—those who contend that the notion of originality in art (and as required for copyright law) is an unfounded myth.

In chapter 4, I outline my theory of authorship, that the author of a work is one who has and exercises the power of selecting and arranging elements as constitutive of that work—what we might broadly call the creative or authorial act. Along the way, I work to dispel arguments suggesting that there are no authors, or, alternatively, that effectively anyone having anything to do with a work is thereby an author of that work (two positions with surprisingly robust pedigrees).

In chapter 5, I show how the creative act determines the nature of the authored work—the object protected by copyright—building on the central metaphysical assumptions built into copyright law. In so doing, I offer an ontological model for authored works, establishing conditions of copyrightability and infringement, and drawing a principled distinction between "art works" and "authored works."

In chapter 6, I argue that the author's creative act and the nature of the work created give rise to the author's ownership of the work—a natural right to determine the conditions under which that work may be copied.

Chapter 7 shifts from the rights of authors to the rights of others, beginning with a dissection of two legal doctrines limiting an author's copyright: fair use and fair dealing. Where the former is notoriously loose, I argue, the latter is unwieldy (and ultimately drifts into the looseness of the former anyway). Taking up recently revived discussion of "users' rights," and given our understanding of copyright as a natural right, I draw an important in-principle line between justified and unjustified copying of another's protected work. Although copyright is a natural right, I contend, it is not thus an absolute right.

Chapter 8 focuses on the particular case of appropriation art, a movement defined by usually unauthorized artistic borrowing in the creation of new works. In this chapter, I trace the embattled legal history of appropriation art and the suggested strategies for accommodating it within copyright law, culminating in the recent case of *Cariou v. Prince*. I offer a proposal that we treat appropriation art as presumptively fair in those cases where the new work expresses some idea distinct from that expressed in the work appropriated.

Finally, in my afterword, I look at some of the theoretical and practical implications of my view.

Culture Clashes

HowardCantour.com

Can we talk for a minute about Shia LaBeouf? You may know LaBeouf as a child actor from the early 2000s or as the star of Michael Bay's unfortunate series of *Transformers* movies. In 2012, LaBeouf screened his twelve-minute short film, *HowardCantour.com*, at the Cannes Film Festival, and the following year released the film online. LaBeouf was shortly thereafter called out by *BuzzFeed*'s Jordan Zakarin for having lifted the work from Daniel Clowes's 2007 comic-book story, "Justin M. Damiano."[1] The title character's narration in LaBeouf's film copies that of Clowes's story almost verbatim, changing only the names of characters. His opening monologue is a word-for-word duplicate.

LaBeouf responded to mounting criticisms in late 2013 and early 2014 in a series of online apologies through his Twitter account, and even a skywriting apology to Clowes over the city of Los Angeles (an odd choice, given that Clowes lives in San Francisco).[2] In one tweet, LaBeouf stated, "In my excitement and naiveté as an amateur filmmaker, I got lost in the creative process and neglected to follow proper accreditation."[3] In pleading naiveté, LaBeouf finds himself in the company of any number of student plagiarists who profess ignorance about the proper citation of sources. Although it would not alleviate a charge of copyright infringement, had LaBeouf initially acknowledged Clowes's work as his source, he would have at least been freed from the charge of plagiarism. However, in an interview following his skywriting stunt, LaBeouf points to a view that belies his earlier admission:

> The word law is against my principles.
> The problem begins with the legal fact that authorship is inextricably
> bound up in the idea of ownership and the idea of language as

Intellectual property. Language and ideas flow freely between people
Despite the law. It's not plagiarism in the digital age—it's repurposing.[4]

Appropriately enough, the first sentence here—"The word law is against my principles"—is taken from Marcel Duchamp.[5] The second and third sentences come from poet Gregory Betts.[6] The last sentence is the title of an article by Kenneth Goldsmith.[7]

In January 2014, LaBeouf tweeted a photograph of a storyboard for his "next short 'Daniel Boring.'"[8] The partially obscured script accompanying the storyboard images gives a snippet of conversation:

SAMANTHA: SO WHY [DID YOU] STOP MAKING MOVIES[?]
DANIEL: BECAUSE EVERY STORY HAS ALREADY BEEN TOLD A MILLION TIMES.

The drawings and script in the storyboard replicate panels from Clowes's 2000 graphic novel, *David Boring*. The text accompanying LaBeouf's tweeted image—"Its [*sic*] like Fassbinder meets half-baked Nabokov on Gilligan's Island"—copies Clowes's description of his own story.[9] LaBeouf, it seems, is not naïve, nor is he merely guilty of neglect. Rather, it seems, LaBeouf is playing a little ideological game—one with significant potential consequences. After tweeting the photograph, LaBeouf promptly received a cease-and-desist letter from Clowes's attorney and removed the storyboard images from his Twitter feed.

Although Clowes would have up to three years to file suit for copyright infringement, LaBeouf has yet to face any legal ramifications for any illicit copying as of this writing. By the time this book sees print, LaBeouf's antics may be a distant memory, and his ever-stranger activities may simply have labeled him an eccentric kook. But the story goes deeper than this.

At the same time it was calling out LaBeouf for his appropriations, *BuzzFeed* was running such articles as "'Super Mario Busters' Is the Mario/Ghostbusters Mash-Up You've Been Waiting For"[10] and "7 Classical Masterpieces Surreally Infused with Pop Culture,"[11] articles celebrating acts of what we might call artistic borrowing—the unlicensed revision and adaptation of copyrighted materials. Now, it may just be that *BuzzFeed* is a business and is more worried about revenue-generating click-throughs than anything like a consistent editorial stance on artistic appropriation. Two years earlier, *BuzzFeed* had been called out by *Slate*'s Farhad Manjoo for ongoing practices of rampant online cribbing—what is commonly, neutrally referred to as "aggregating" content. Manjoo writes: "BuzzFeed's staff finds stuff elsewhere on the Web, most often at Reddit. They polish and repackage what they find.

And often—and, from what I can tell, deliberately—their posts are hard to trace back to the original source material."[12] The repackaged posts are typically populated with images culled from the same web sources, a practice that *BuzzFeed* founder Joseph Peretti defends as falling under copyright law's "fair use" doctrine (a contentious claim, as we'll see in a later chapter).[13] But just a few months after it broke the LaBeouf story, the website fired staff writer Benny Johnson, issuing "An Apology to Our Readers":

> After carefully reviewing more than 500 of Benny's posts, we have found 41 instances of sentences or phrases copied word for word from other sites. Benny is a friend, colleague, and, at his best, a creative force, but we had no choice other than letting him go. . . . Plagiarism, much less copying unchecked facts from Wikipedia or other sources, is an act of disrespect to the reader.[14]

As *Gawker*'s Adrian Chen notes, Manjoo's article "set off some chin-scratching over whether what BuzzFeed is doing is actually bad, or whether repackaging funny things found on Reddit is just how the internet works these days."[15]

LaBeouf's attitude is (perhaps appropriately enough) not unique to him, however, and it is an attitude that any theory about copyright in the twenty-first century must grapple with. The same year that LaBeouf screened *HowardCantour.com* at Cannes, Sweden recognized Kopimism as an official religion, after two previous failed petitions by the Missionary Church of Kopimism to be recognized.[16] Founded by philosophy student Isak Gerson, Kopimism (pronounced *copy-me-ism*) rests on the principle that copying is a sacred act. Says Gerson, "For the Church of Kopimism, information is holy and copying is a sacrament. Information holds a value, in itself and in what it contains and the value multiplies through copying."[17]

Lawrence Lessig has suggested that the early twenty-first century is something of a convergence point for a clash between the "Read/Only" culture that typified the twentieth century and the emerging "Read/Write" or "remix" culture emerging into prominence in the twenty-first. A "remix" or "Read/Write" (RW) culture, he suggests, is one composed of members who encourage "creating and re-creating the culture around them," while a "Read/Only" (RO) culture professionalizes creativity and encourages the passive consumption of fixed works (reading books, watching movies, listening to music).[18] RO culture, on this view, divides us into producers and consumers (creators and couch potatoes)—the paradigm of the past century—while the next century "could be both read and write."[19] In defending his "repurposing," LaBeouf would seem to situate himself squarely in the RW camp, and

those who oppose him in RO culture. It would be simple and convenient to characterize the clash here as one between the ideologies of the young, on the one hand, and the old, on the other. However, matters are more nuanced than this. Social networking sites like Facebook, Twitter, and Tumblr are replete with repurposed, reposted, presumably copyrighted materials—and most of us don't bat an eye at this. Indeed, most of us have probably done some reposting ourselves. So why should some, like LaBeouf, be on the receiving end of such vitriol?

To get a little perspective, let's back up to another culture clash, about 100 years ago.

Copyright Blues

Born to sharecropper parents outside Wortham, Texas, at most a generation removed from slavery, Blind Lemon Jefferson may be the most famous musician in the history of blues recording. By 1912, when Hart Wand published the sheet music for "Dallas Blues"—with its twelve-bar structure, widely recognized as the first published blues song[20]—Jefferson could be found most days with his guitar and tin cup on the corner of Elm Street and Central Track in the Deep Ellum area of Dallas, or traveling by rail—"hoboing"—with fellow musician Huddie "Leadbelly" Ledbetter to nearby towns.[21] Vaudeville touring companies had by this time brought ragtime music from the red-light districts of New Orleans and St. Louis to African American communities around the country, and the hundreds of blues songs published in the years following 1912 entered the repertoires of bands performing in both small southern towns and cities across the South and North. In 1920, Mamie Smith became the first black blues singer to be commercially recorded, with her rendition of Perry Bradford's "Crazy Blues." Within a month of its release, Smith's recording sold 75,000 copies (and more than a million in the first six months), and the "race records" industry was effectively born.[22] By the mid-1920s, as record sales began to overtake sales of sheet music, a number of record companies had begun race series, with music in blues, jazz, and gospel recorded by and—almost exclusively—for African Americans.

Not far from his corner of Elm and Central, Jefferson frequented a shine parlor and record shop owned by R. T. Ashford, where patrons could listen to the latest releases by Ethel Waters, Bessie Smith, and other jazz and blues race records pouring out of the Harlem Renaissance. In 1925—possibly at the suggestion of pianist Sammy Price, possibly not—Ashford contacted J. Mayo Williams, the manager of Paramount's Race Artist series, about Jeffer-

son.[23] On Ashford's recommendation, Williams invited Jefferson to Chicago for a recording session. Although these initial recordings were gospel tracks and would ultimately be released under the pseudonym Deacon L. J. Bates, Jefferson was invited back for a second session with Paramount the following year, where he would make his first blues recordings. One of the releases from this session—"Got the Blues" and "Long Lonesome Blues"—garnered six-figure sales, and Jefferson quickly became Paramount's paramount blues artist.[24] All told, Jefferson recorded and released seventy-five blues songs between 1926 and 1929 before dying that year in a Chicago snowstorm.

Although Jefferson's recording career was both extraordinarily prolific and tragically brief, we can see something extremely interesting happening in his music in just these four years. Jefferson was—like many scouted by record companies in the 1920s and 1930s—a true folk blues musician. Unlike the "popular" blues growing out of vaudeville, the folk blues of Texas and the Mississippi Delta remained firmly rooted in the oral traditions of African American communities in the Deep South. Appropriately, folk blues—like other folk traditions—were of and for the "folk," performed within the community and occasionally transmitted to other, similar communities. Being traditional, folk blues presented its listeners with something familiar—but, being orally transmitted, was also subject to constant mutation as a result of both unconscious and deliberate acts of performers. Indeed, unlike some folk music traditions, the blues encouraged this tendency.[25]

Although historically related to spiritual songs, the traditional blues were (and are) distinctly secular, usually focused on the singer's troubled life—and more often than not, his or her troubled love life. Ethnomusicologist David Evans notes that,

> while in their first person delivery [folk blues] purport to express the sentiments and feelings of the singer, many of the verses are, in fact, traditional and known to thousands of blues singers and members of their audiences. If these verses were ever original and unique, they did not remain so for long. They entered the oral tradition and spread throughout black communities across the country.[26]

The folk blues told the folk what they already knew. This was the nature of folk blues. The patchwork essence of these songs further helps to explain their typical lack of thematic development. Of Jefferson's sixteen blues recorded in 1926, Evans notes that all but three were entirely composed of traditional verses, and none of entirely original material. Eleven had no running themes, three had some thematic development, and none developed a

single theme throughout.[27] By 1928, however, this pattern had almost completely reversed itself. Of the twenty blues recorded by Jefferson that year, only one was entirely composed of traditional verses, four partly so, and fifteen made up of wholly original material. Similarly, fifteen were entirely thematic, five partly thematic, and zero nonthematic. So what happened in the two-year interim to bring about such an inversion? In a word: copyright.

In mining the folk blues, record companies were at the same time beholden to the strictures of copyright law, which required that a work be "original" to merit federal protection. Although the meaning of "originality" was still being worked out in the law, record companies operated under the understanding that an original work was one that did not copy from any work previously published or recorded.[28] This would prove a serious challenge for a musical tradition built on borrowing from a common store of lyrics, melodies, and musical tropes. Granted, these same musicians were also adding to the store but, in doing so, were often taking from many of the popular blues songs being released on phonographs.[29] And so there was something of a race among record companies to record "original" folk blues before one's competitors could release a song using any of the same material. According to H. C. Speir, who acted as a freelance talent scout in the late 1920s and 1930s, record companies wanted singers who could produce at least four original compositions for recording. "Many of them," Speir recalled, "could sing plenty of songs, but they were not original. In other words, they were either traditional and had already been recorded in variant form, or they were interpretations of the hit records."[30] Evans estimates that the average folk blues singer would have to sing about twenty blues before meeting the requirement of four "original" compositions.[31] Of course, the more blues that were recorded, the more depleted the common stock became.

A second condition of copyrightability likewise challenged folk blues. Today, US federal copyright law requires of a copyrightable work that it be "fixed in a tangible medium of expression."[32] The Copyright Act of 1976 defines the term:

A work is "fixed" in a tangible medium of expression when its embodiment in a copy or phonorecord, by or under the authority of the author, is sufficiently permanent or stable to permit it to be perceived, reproduced, or otherwise communicated for a period of more than transitory duration.[33]

For the duration of the race records industry, it was an earlier iteration of the Act that held sway—the Copyright Act of 1909—which was less clear in its

terms. However, the 1909 Act built in part on a 1908 case that distinguished "copies" of musical works from "phonorecords." A "copy" of a musical composition was a "written or printed record of it in intelligible notation"—something readable by an intelligent human—while a "phonorecord" (like a player piano roll, a phonograph record, or—today—an MP3 file) was only readable by a machine.[34] Although the 1909 Act did not yet have the language, the implication was that a copyrighted work was something structurally fixed—it was not something mutable. The reasoning here seems straightforward: if a copyrighted work is not structurally fixed, then it would be difficult or impossible to determine when such a copyright had been infringed. The clause in the US Constitution that grounds both copyright and patent law—what is known at the intellectual property clause—specifies that what are protected are the "Writings" of authors (the subject of copyright) and the "Discoveries" of inventors (the subject of patent).[35] By the time of the 1909 Act, "Writings" had come to be interpreted rather loosely, to include "all forms of writing, printing, engraving, etching, &c., by which the ideas in the mind of the author are given visible expression."[36] The "&c." in this passage only continues to get beefier, with copyright protection now extending to photographs, audiovisual works, computer programs, and essentially all other artifacts meeting the dual bar of originality and fixation.[37] The fixation condition was no less an awkward fit for folk blues than the originality requirement.

Lester Melrose, who recorded blues singers for record companies in the 1920s, recalls:

> Some of the artists who could not read or write made it very difficult to record them. Every time they would record a number they could never repeat the same verses. The result would be to record the number about four times and select the one with the best verses. I have rehearsed some of them at least six times on four selections and when we reached the studios, they would sing two or three different verses for each song.[38]

This variability in performance may have been baffling to Melrose and others in the record industry, but this was the nature of the blues. Just as folk blues involved drawing on a common store of lyrics and musical phrases, so too did it encourage a high degree of improvisation. Music critic Max Jones notes:

> Every singer has his own version of a tune and a personal style of improvising, so that no two singers sing one tune alike. Blues is part-created *in the*

performance from scraps of verse and melody known to the community as a whole. For that reason the music has special appeal for the community. But it is usually respected by them as the momentary invention of the song-maker whose job it is (at that particular time, anyway) to give back to the people their own songs in acceptable form and with new, and often topical, flavouring.[39]

In this way, a blues performance and a blues composition are not easily separated. A blues performer will draw, as often as not, on a repertoire of musical elements—lyrics and melodies—and not on a body of set songs. The performance of a folk blues was meant to reflect back to the audience something that was already theirs, and in a way that cemented the performer's own expression as a voice *within* that community. Part of this meant adding and shedding traditional verses on the fly, ad libbing and elaborating as the performance went along. Even if the words—borrowed and reborrowed—were not literally true, they expressed a true sentiment felt by the singer and audience alike. The point was not to create an *original, repeatable* song, but to create an *authentic* performance.

Legal scholar Olufunmilayo Arewa suggests that "the folklorists and record industry scouts who mined blues music from the Mississippi Delta were focused on finding 'authentic' forms of musical production."[40] The problem is that the authentic folk blues they found did not neatly fit into the mold of copyrightable works. In the few short years of his recording career, Blind Lemon Jefferson had to create blues that did.

Now, let's fast-forward about a half century.

The Amen Break

In 1969, the Winstons—a short-lived Washington, DC, funk band—released "Color Him Father," a briefly popular sentimental song set in the home front during the Vietnam War. Released at the height of the war, "Color Him Father" would go on to reach number two on the R&B charts and to win its composer—front man and saxophonist, Richard Lewis Spencer—a Grammy for best R&B song.[41] Now, unless you're a fan of vintage R&B, you probably haven't heard "Color Him Father," which was the Winstons' only hit. Indeed, by the time Spencer accepted his Grammy in 1970, the band had already broken up. However, you're probably heard *something* recorded by the Winstons: you've almost certainly heard the "Amen Break."[42]

On the B-side to the "Color Him Father" album was an instrumental track called "Amen Brother," a lively little number recorded quickly by the

band to fill out the EP.[43] Although catchy, the track quickly passed into obscurity, where it remained for nearly twenty years, until it reappeared on the first volume of *Ultimate Breaks and Beats*, a 1986 bootleg collection of songs compiled by producers Louis "Breakbeat Lou" Flores and Lenny "Breakbeat Lenny" Roberts. Also featuring the Monkees' "Mary Mary," Rufus Thomas's "Do the Funky Penguin," and a number of other tracks with memorable drum segments, the album (like the two dozen that would follow it in the series) was compiled for the convenience of DJs and hip-hop producers, who were already making extensive use of funk and soul recordings in live DJing and as samples for mixing into new material.[44]

One minute and twenty-seven seconds into "Amen Brother," the organ, bass, and saxophone drop out, leaving the drummer performing a six-second, four-bar break before the rest of the band picks up again. The break—now famously known as the Amen Break—quickly became a hip-hop staple, mixed into 2 Live Crew's "Feel Alright Y'all" (1987), N. W. A.'s hit, "Straight Outta Compton" (1988), and Public Enemy's "Bring the Noise" (1988). And while the Amen Break was spreading throughout the New York hip-hop community, forming a sort of recurring genetic string throughout the early evolution of the genre, the musical snippet began appearing across the Atlantic as well. But where the break was sampled and looped—but remained largely unaltered—in American hip-hop, in Britain it started to mutate. Technological advances allowed producers to chop up, layer, and transform the sample as it spread throughout the UK rave scene. By the early 1990s, the rave scene gave birth to "jungle," a genre of fast-paced Jamaican-inspired electronica today better known today as "drum and bass" (DnB), and the Amen Break became ubiquitous. At times—given how it is chopped up and distorted—the sample is difficult to recognize, but once you start listening for it, you hear it everywhere. It may be that you aren't a fan of early hip-hop or British electronica, but you're still unlikely to have avoided the Amen Break. You will hear it in the theme songs for *Futurama* and several other cartoons, in David Bowie's "Little Wonder" (1997), Oasis's "D'You Know What I Mean" (1997), and Amy Winehouse's "You Know I'm No Good" (2007). It shows up in commercial advertisements for Jeep and Levi's.[45] It has been suggested that the Amen Break has appeared in hundreds—or, more probably, thousands—of musical works in the last four decades, making it arguably the most sampled piece of music in history. (Its strongest competitor in this regard is probably Clyde Stubblefield's drum break from James Brown's 1970 piece, "Funky Drummer.")

Sociologist Andrew Whelan suggests that the popularity of the Amen Break is due in part to its distinctive sonic qualities, the "vintage" grain of

the sound resulting from the use of analogue recording technology, and the ease with which each percussive "hit" can be isolated and reordered by mixers. These qualities not only give the break a much sought-after classic sound that cannot be easily recreated using contemporary digital technology, but also a relative ease of use for producers looking to chop up and mix the sounds.[46] The Amen Break has been cited by a number of advocacy groups as evidencing how the unrestricted use of sampling has helped give rise to a multibillion dollar industry.[47] Further, Whelan suggests, the break has become such a standard in hip-hop mixing culture that it stands as a challenge to producers to "assert that they have a contribution to make with it, that they are sufficiently skilled and literate to do something 'original' with it, and thus further contribute to the cult."[48]

All of this was news, however, to Richard Spencer, the sole surviving member of the Winstons and holder of the band's copyrights. Tracked down in 2011 by the BBC, Spencer declared:

> I felt as if I'd been touched somewhere that no one was supposed to touch. . . . Your art is like your children; it's like a part of you. . . . I felt invaded upon. I felt like my privacy had been taken for granted. . . . There's no need of me being angry about it. There's nothing really that I can do about it unless people out of the goodness of their hearts learn, y'know, that this black gentleman, we've taken his music and used it and made money off of it and never paid him.[49]

Neither Spencer nor anyone else has ever received any form of compensation for the unmitigated sampling from "Amen Brother." According to Spencer, Gregory C. Coleman—the drummer who actually performed the Amen Break—died destitute and homeless.[50]

It is perhaps difficult not to see the parallels with the now-infamous case of Henrietta Lacks, the unwitting donor of the "HeLa" cells that would also make her the godmother of modern biotechnology.[51] Lacks's cells, taken during a biopsy of a cervical tumor in 1951, were the first human cells discovered that could be kept alive and reproduced indefinitely. Mass-produced in the first-ever cell-production factory—the HeLa Distribution Center at the Tuskegee Institute—Lacks's cells would shortly prove pivotal to Jonas Salk's revolutionary polio vaccine.[52] In the years following, HeLa cells would be the subject of some 74,000 scientific studies, and are today used in research into AIDS, HPV, Parkinson's disease, cosmetics, and nearly every other corner of the biomedical industry. One scientist estimates that, if collected, the

cells reproduced from Lacks's culture would weigh in at over fifty million tons—that's 137 times the mass of the Empire State Building.[53] What makes Lacks's case *infamous*, however, is that her "contribution" to medicine was made without her consent or knowledge. Lacks herself died in poverty, and while her cells were building the foundation for today's multibillion dollar medical industry, her descendants were left unable to afford medical insurance.

The obvious points aside, there are two important differences between the Lacks case and the case of the Amen Break. First—surprisingly, perhaps—there was nothing illegal about the unconsented harvesting, unfettered reproduction, and sale of Lacks's biological material. In a 1990 case paralleling Lacks's own, the Supreme Court of California found that patients have no property rights to their discarded cells, nor to any profit made from them.[54] Conversely, in the 2005 case of *Bridgeport Music v. Dimension Films*, the US Court of Appeals for the Sixth Circuit established that there is no de minimus amount of sampling from a copyright-protected sound recording that would fall short of prima facie infringement.[55] Simply put, *any* unauthorized reproduction from a copyrighted sound recording—even as little as a few bars of a drum break, indeed as little as a single note—is presumptively illegal.

The second difference is that Lacks and her family are widely considered to be the subjects of a series of moral wrongs. Documented in Rebecca Skloot's bestselling 2010 book, *The Immortal Life of Henrietta Lacks*, the case has received widespread publicity and acknowledgment as an unconscionable violation of medical ethics.[56] Despite this, in 2013 a group of scientists at the European Molecular Biology Laboratory (EMBL) in Heidelberg, Germany, published the DNA sequence of a population of HeLa cells without the knowledge or consent of the Lacks family.[57] The ensuing outcry forced the EMBL to withhold access to the data until the National Institutes of Health (NIH) reached an agreement with Lacks's surviving family, and today two family members serve on an NIH committee regulating access to the genetic code in HeLa cells.[58] Conversely, practically no one seems to think that either Coleman or Spencer has been wronged. As one composer puts it, "I've always had a hard time about beats being something that you should necessarily have to pay for."[59] Michael "Mike D" Diamond of the Beastie Boys suggests, "If you're using little pieces and little 'ah-hehs' from James Brown, and whatever, I think these should be, like . . . giveaways."[60] Diamond is suggesting that little musical flourishes are simply too insignificant to be owned. Others offer a broader claim. DJ Kool Akiem argues:

Once a piece of music is out there, it's in the air. How can you really say you own this vibration that's moving through the air in this configuration? You not around to see what's happenin.' How do you own that? I mean, that's like saying you own a certain wavelength of color . . . it's ridiculous.[61]

Journalist Simon Reynolds contends that, while Spencer and Coleman have been denied any financial remuneration, they—like Henrietta Lacks—have obtained a certain kind of immortality: "It's a bit like the man who goes to the sperm bank and unknowingly sires hundreds of children."[62] However, unlike our hypothetical sperm donor—and like Lacks—neither Spencer nor Coleman willingly donated *anything*.

Makers and Takers

Artists have copied artists for about as long as there have been artists. Indeed, copying is standard training practice across the arts. And when copying is standard practice within an art form, trouble doesn't usually arise. Within the folk blues community, musicians who borrowed from others had no problems. This was, after all, the standard, and those borrowed from worked within the same traditions as those doing the borrowing. Trouble only arose when the record publishers—and copyright—entered the picture. In looking to capture authentic folk blues, record companies were trying to fit a square peg into a round hole. Smoothing the corners off didn't change folk blues—which still continues unabated—but it did change the game for Blind Lemon Jefferson and his fellow blues-recording pioneers.

Where hip-hop producers ran into trouble was in borrowing from musicians and record companies outside their community—those who did not share their sentiments, and who (as luck would have it) happened to own the material being borrowed. In the wake of the *Bridgeport* case—and as it became clear that hip-hop was gaining commercial viability—no longer could sampling expect to be overlooked. Judge Ralph Guy's instruction in the *Bridgeport* decision—"Get a license or do not sample"—drew a clear line in the sand.[63] With potential punitive damages reaching into the millions for acts of illicit sampling, the sampling game changed effectively overnight. In the wake of the *Bridgeport* case and a number of conflicts settled out of court, producers had to become savvier about permissioning samples, and unpermissioned sampling has largely gone back underground.

Lessig suggests: "Remix is an essential act of RW creativity. It is the expression of a freedom to take 'the songs of the day or the old songs' and create with them."[64] On this analysis, the folk blues and hip-hop commu-

nities would both be RW cultures, where the record companies and other copyright holders promote RO culture. Within the folk blues community, members are free to take from and add to the common store of musical material in any performance—this is central to folk blues—but the privilege does not extend to nonmembers. The borrowing and reborrowing of stock material by folk musicians is in service of creating an authentic performance, of speaking as a member of the community with the words of that community. Critic Ralph J. Gleason suggests, however, that "the blues is black man's music, and whites diminish it at best or steal it at worst. In any case they have no moral right to use it."[65] Paul C. Taylor contends that this is centrally because the blues audience would reject any white singer as having the appropriate experiential access to what is at the heart of the blues: being black.[66] Joel Rudinow seeks to undercut this claim by suggesting that community membership in this case is not, in principle, a racial or ethnic issue, and that there is always the possibility of a white musician being indoctrinated into the folk blues community or a black musician falling outside the group.[67] Whatever it is that determines membership, however, outsiders to the folk blues community—*being* outsiders—are incapable of creating such an authentic performance. At best, such an outsider might create a simulacrum of authenticity.

As regards taking, the matter is essentially reversed in hip-hop culture. Interestingly, while there is no general ethical issue within this community of unpermissioned sampling from vintage records, there is a norm against sampling from other hip-hop records—a practice known within the community as "biting."[68] The suggestion here is that where the original mixer had to dig through acres of vinyl to find just the right break or beat to sample, "it doesn't take any work to sample from a rap record."[69] Vintage recordings, in other words, are something discovered—and one does not simply take another's discovery. Richard L. Schur suggests, "While record companies, copyright holders, and legal discourse tend to view sampling as theft, hip-hop producers understand the process as being much more like research and development."[70] So long as one doesn't take from *within* the community, there is no issue.

Of those who illicitly copy—either in whole or in part—from the works of others, there is a distinction to be made between those who act as *mere* takers and those who are at the same time both makers *and* takers of works. Our folk blues musicians and our hip-hop composers are both makers *and* takers—borrowing from others to create new works. Comparatively, the person who downloads a copy of "Amen Brother" through a file-sharing network—either because he can't afford to purchase it legally, would prefer

not to spend the money, or because the song isn't available otherwise—is acting as a *mere* taker. Of course, this is only a schematic distinction: those who are maker-takers may sometimes act as mere takers, and those who are typically mere takers may on occasion act as maker-takers.

I have, throughout this chapter, used the term "borrowing" to refer to the taking of material from some work for use in another. "Borrowing" is perhaps the term most often used by maker-takers and their supporters because it does not carry the same semantic baggage as "stealing," or perhaps even as much as "taking." I use it for the same reason—that it does not imply wrongdoing—but not because I believe that such borrowings are never wrongs. Indeed, as we will see, I think many such borrowings are *grievous* wrongs. But *that* an act is one of artistic borrowing should not by itself be taken to imply such a wrong. As Thomas Mallon notes in *Stolen Words*, there are "two entirely different kinds of appropriation: one that re-invents and rearranges and indeed often depends upon an audience's recognition of the earlier material that's being transmuted; and another that hopes, beyond all else, for the original material to remain unrecognized as such."[71]

Perhaps the most common complaint against the maker-taker is that he is a *plagiarist*. However, "plagiarism" is itself a loaded term that can be cashed out in a number of different ways. The word "plagiarist" derives from the Latin root for "kidnapper," *plagiarius*, implying an unjust taking, though etymology only gets us so far and is rarely helpful in conceptual analysis. In *The Little Book of Plagiarism*, Judge Richard A. Posner suggests:

> A judgment of plagiarism requires that the copying, besides being deceitful in the sense of misleading the intended readers, induce *reliance* by them. . . . The reader has to *care* about being deceived about authorial identity in order for the deceit to cross the line to fraud and thus constitute plagiarism. More precisely, he has to care enough that had he known he would have acted differently. There are innumerable intellectual deceits that do little or no harm because they engender little or no reliance. They arouse not even tepid moral indignation, and so they escape the plagiarism label.[72]

In short, Posner suggests that (1) a true act of plagiarism is one that causes the reader/viewer/listener to act in some way he or she would not have acted otherwise, and so causes some substantial amount of harm; and (2) where an act causes no moral indignation, it is not plagiarism. Each of these points is suspect. Regarding the first point, suppose a student turns in an essay in which he has copied liberally from *Wikipedia* without citation. Further suppose that the course instructor, hardened by years of teaching, simply can-

not be bothered jumping through the administrative hoops in cases of academic dishonesty, and only gives a failing grade on assignments in such cases. As it happens, our student's paper is—*Wikipedia*-pilfering notwithstanding—a largely incomprehensible essay only tangentially related to the assigned topic. In other words, our instructor would have given the essay a failing grade regardless of whether it was plagiarized. According to Posner's analysis, because the student was getting an F on the assignment with or without the plagiarism, and would receive no additional repercussions in cases of plagiarism, this student is not a plagiarist. This just seems false. Regarding the second point, Posner's suggested relationship between moral indignation and plagiarism seems unwarranted. Our instructor could, of course, recognize an act as one of plagiarism and feel neither here nor there about it. On Posner's view, one who held this position would be in a state of conceptual confusion. This, too, seems false.

Only a handful of pages later, Posner defines plagiarism more simply as "nonconsensual fraudulent copying," inserting "nonconsensual" to exclude from the category of plagiarists the student who submits under his own name a paper purchased from an online essay mill.[73] Since the student does not harm the actual author of the essay, Posner does not want to count him among plagiarists. Since, I suspect, a sizeable percentage of academics would call this not only a clear case of plagiarism, but indeed a *paradigm* case, I think we have reason to reject this analysis of Posner's as well. Indeed, I suspect that any attempt to define plagiarism in terms of harm is due to fail. This is not to say that plagiarism *isn't* often harmful—I suspect it often is: to the audience, to the source, and to the plagiarist himself—but I think a workable definition is more readily had without reference to harm. I would suggest the following:

> An act of plagiarism is one in which an author (broadly speaking) uses another's ideas or expression (words, images, sounds) in such a way that the audience is not expected by the author to be aware that she is doing so, and such that the author is to be taken to be responsible for such ideas or expression. In short, the plagiarist presents another's work as her own.

As Posner rightly notes, neither allusion nor parody normally fall under the heading of plagiarism.[74] In such cases, I may use some of another's words, images, or musical notes without citing my source and still not be a plagiarist if I might reasonably expect that you, my reader/viewer/listener, would recognize that I am doing so. In opening an essay with "It was the best of times, it was the worst of times," I am alluding—paying homage—to Charles

Dickens's *A Tale of Two Cities*. Citation, we can assume, is not necessary here *because* I might reasonably expect that you already get the reference. Similarly, parody typically *depends* on the audience getting the underhanded reference. There is something more to plagiarism than failing to cite one's sources. Plagiarism is an act of *concealing* one's sources.

The norms of plagiarism are, however, largely institutional in nature. In academia (whether as a student or professional academic), to present another's ideas—or to use another's words—as your own is ordinarily a blameworthy act. The same would generally be true for journalism and the writing of popular fiction and nonfiction, though the use of ghostwriters is a generally accepted norm in trade publishing. We would not, for instance, call President John F. Kennedy a plagiarist on the basis that his *Profiles in Courage* was largely ghostwritten by his speechwriter Ted Sorensen. The matter may be even less blameworthy—or perhaps not blameworthy at all—in ordinary conversation, though one might not be surprised to be called out for presenting another's ideas as one's own even in this context. At the very least, it would seem a bit strange for such a person to be called a "plagiarist."

That Blind Lemon Jefferson takes from the common stock of blues lyrics without citing his sources does not make him a plagiarist. His borrowing is standard practice in folk blues, and his audience was well aware of what he was doing. He is not claiming to have written those words, and is attempting no deception. Similarly, the hip-hop producer who samples the Amen Break is not thus a plagiarist; his cohorts in the hip-hop community would be well aware that he did not actually drum that break. That same producer, however, is almost certainly a prima facie copyright infringer, where Blind Lemon Jefferson was not.

In the media, "plagiarism" tends to be treated interchangeably with—or as a shorthand for—"copyright infringement." The equivocation becomes even thicker when copyright infringers are referred to as plagiarists in the legal domain. Although any given plagiarist may be a copyright infringer, and vice versa, there are conceptual distinctions between these categories. While both plagiarism and copyright infringement may be treated as moral infractions, "copyright infringement" is a legal term and "plagiarism" is not. And so, one may plagiarize where there is no copyright to be infringed—either because one is only copying ideas (which are not subject to copyright protection) or because the work being copied is in the public domain—and one may infringe copyright while at the same time giving the appropriate credit, and so not be a plagiarist. Nevertheless, despite these distinctions, infringement and plagiarism are not only conceptually—but also culturally—entangled, and attitudes toward them tend to overlap.

Copycats

E. B. White—author of *Charlotte's Web* and coauthor of the classic *Elements of Style*—distinguishes two sorts of plagiarists: "the thief, who, either because he is emotionally unstable or in desperate need, just goes out and swipes something [and] the dope, who is a little vague about the printed word and regards anything in the way of printed matter as mildly miraculous and common property."[75] Where the thief realizes what he is doing is wrong, the dope simply does not understand the ethics involved.

Psychologists Alex Shaw, Vivian Li, and Kristina R. Olson suggest that children as young as six years old recognize ownership of intellectual property, here understood broadly to include solutions to mathematical problems, stories, jokes, and songs, where ownership amounts to control of use, and where such ownership cannot be transferred through theft.[76] And, in another study, Olson and Shaw suggest that children as young as five make negative moral judgments about those who copy others' artistic works: "copycats."[77]

Curiously, then, while such studies indicate acceptance of basic notions of intellectual property and aversion to plagiarism at a young age, other studies suggest that this aversion begins dwindling within just a few years. A 1986 study by Barbara Brandes, for instance, shows that 41 percent of sixth-grade students self-reported plagiarizing,[78] a percentage holding steady in junior-high students in a 1999 study by Donald L. McCabe.[79] In a 1993–1994 study by McCabe and Linda K. Treviño, 26 percent of college student respondents self-reported having "plagiarized from public material on papers." Perhaps this number is higher than we would hope—believing that the education system would either teach students something about original research or else weed out those who fail to learn—but not altogether surprisingly high. However, when we look at the percentage of students in the same survey responding in the affirmative to "copying a few sentences of material without footnoting in a paper," that number jumps to 54 percent. In a 1990 survey of students at Miami University of Ohio, 72.1 percent reported having plagiarized in their college classes. Asked whether they had ever used outside information in a paper without citing it, 91.2 percent responded in the affirmative. One of the surveyors, Jerold Hale, noted, "There is a significant problem because many students believe that what they are doing is not plagiarism."[80]

By 2002–2010, the numbers appear to be dropping, with only 36 percent of college students reporting "copying a few sentences of material without footnoting in a paper." Perhaps this seems encouraging. However, 36 percent

also report cutting and pasting or paraphrasing from Internet sources without citation, and this is not exactly the *same* 36 percent. Combining the overlapping self-reporting rates for both of these behaviors gives us a return of 43 percent. What is particularly unusual, however, is that in 2002–2010 only 6 percent of the same students report having "plagiarized from public material on papers."[81] In other words, what we are seeing is not some upward trend in the relative number of plagiarists in our midst, but rather an upward trend in the number of those plagiarists who don't think they are plagiarists. McCabe and his colleagues suggest, in fact, that the numbers may still underrepresent the facts:

> Not only has the Internet become the cut-and-paste mechanism of choice, but it seems to have helped blur students' views about whether cut-and-paste plagiarism is actually cheating. Although we cannot accurately quantify this point, we are convinced that a large number of students respond "no" to questions about engaging in cut-and-paste plagiarism for this reason. While we try to suggest to students that they should report actual engagement in this behavior regardless of whether they think it is cheating or not, students often appear not to understand, or they ignore, this request. Many students today simply do not consider cut-and-paste plagiarism from the Internet or written sources to be cheating, so when asked in a survey on "cheating" whether they have engaged in this behavior, many simply say no—even if they have. . . . [I]n their open-ended comments, many explain that they answered this way because, when *they* engaged in one of these behaviors, it simply wasn't cheating.[82]

Jeffrey R. Young suggests that today's students "have become so accustomed to downloading music and reading articles free on the Internet that they see it as acceptable to incorporate passages into their papers without attribution as well."[83] Similarly, Trudy Lieberman suggests that, within the field of journalism, plagiarism "may be part of an evolving journalistic culture that has come to rely heavily on borrowing and quoting from other publications as a substitute for original research."[84]

It seems the privilege of each generation to disparage the norms of the one that comes after it (and vice versa), and educators have characterized the recent cohort of students as "generation 'why not?'"[85] and the "no fear generation."[86] Anthropologist Susan D. Blum suggests that the practice of quoting—cutting and pasting—without citation is simply being transferred into students' academic work from their ordinary lives.[87] The sort of student

who habitually engages in this practice is what Blum calls a "performance self"—one willing to say or write whatever is required as a matter of practicality. Where an "authentic self" will only say what she genuinely believes, performance selves "don't feel a tight connection between their words and their inner being, so they don't sweat it if others use their words or if they use the words of others."[88] While not everyone—and not every student—is what Blum would call a performance self, for those who are, plagiarism just makes sense as a means to the desired end: "For a performance self, intellectual property is a quaint yet meaningless notion. . . . For students it does not matter much whose words go into a paper, because in their experience it is impossible and unnecessary to trace anything to a singular point of origin."[89]

Undoubtedly, at least some of this activity is the result of laziness and opportunism. Just as the unrepentant downloader—the mere taker—simply wants his music for free, so too, I am certain, do many students simply want the grade without having to do the work. Others are motivated by outside pressures and expectations to excel. If a student's peers seem to be getting ahead through plagiarism, nonplagiarists may be motivated to do likewise.[90] Blum and others, however, suggest that at the center of the current wave of plagiarism is not merely an undercurrent of practicality, but rather an ideological shift. Darsie Bowden traces the rise in plagiarism to a postmodern turn toward social conceptions of language and self, and away from notions of authorship and ownership.[91] Mark Fritz of the *Los Angeles Times* writes, "Many students seem to almost reflexively embrace a philosophy rooted in the subculture of computer hackers: that all information is, or should be, free for the taking."[92]

Configurable Culture

Aram Sinnreich, Mark Latonero, and Marissa Gluck suggest that changing practices have brought about an erosion of the line between production and consumption, accompanied by a complex, evolving framework of attitudes toward such practices.[93] Where Lessig discusses "remix culture," and others talk of "copy culture"[94] or "participatory culture,"[95] Sinnreich et al. prefer the term "configurable culture." The suggestion here is that production and consumption occur on a continuum, with "pure" production and "pure" consumption at opposing ends, and innumerable gray areas existing in between. Close to—but not at—the consumption end, we will find "consumption-adjacent" activities: a user's creation of a music playlist, for

instance, or a player's creation of a video-game avatar. And toward—but not at—the other end, we find "production-adjacent" practices: the creation of mash-ups and remixes, for example.[96] Although this is not an altogether new continuum (a century ago, Blind Lemon Jefferson found himself forced to shift closer to the pure production end after participating for years in activities nearer to center), the emergence and spread of digital media technologies have allowed for an unprecedented widening of the gray area.

Sinnreich et al. refer to the sorts of reconfiguration found especially in "production-adjacent" activities as forms of "second-order expression,"[97] and suggest that "each of us, in our own way, contributes to the ongoing reconfiguration of culture, whether through a calibrated cultural intervention (e.g., art, rhetoric, resource investment) or simply through the quotidian, and largely unconscious, rituals and interactions of daily life."[98] As their empirical research shows, however, not all such second-order expression meets with universal approval. An act—or product—of artistic appropriation may meet with approval if it is seen as *original, aesthetically valuable,* or the result of *hard work*. Alternatively, it may garner disapproval if is seen as *lacking meaning,* if it is created *for profit,* or if it fails to *acknowledge* its source.

While it seems to be the case that the younger generation is more likely to both engage in, and approve of, activities of configurable culture than older ones, the matter cannot be neatly summarized as a clash between traditional, conservative values and emerging, progressive ones. Within this context, however, we can perhaps begin to make some sense of the vitriol leveled against Shia LaBeouf. *HowardCantour.com* is thoroughly unoriginal, lifted nearly word-for-word and shot-for-shot from "Justin M. Damiano" without acknowledgment. Although he is not a *mere* taker (*HowardCantour .com* is, despite its unoriginality, a distinct work from "Justin M. Damiano"), any meaning in LaBeouf's film would appear to be stolen meaning. LaBeouf is not paying homage to Clowes. Although his later declarations would seem to suggest an ideological move, there is no playful wink or nod to Daniel Clowes in *HowardCantour.com*; at the time LaBeouf's film was released, Clowes's story had only appeared in *The Book of Other People,* a 2007 Penguin collection of original short stories edited by Zadie Smith—a volume likely unfamiliar to most of LaBeouf's audience.

For her anthology, Smith's instruction to contributors was simple: *"make somebody up."*[99] Clowes did that. LaBeouf did not: for all intents and purposes, Howard Cantour *is* Justin M. Damiano. Howard Cantour is a copy and LaBeouf is a copycat—a plagiarist (although it isn't altogether clear whether he would qualify as a *thief* or a *dope* on E. B. White's analysis). As noted at the

beginning of this chapter, had he attributed his source, LaBeouf would have been cleared of the charge of plagiarism, but the charge of copyright infringement would remain. In his apologia, while disregarding the very notion of plagiarism in the digital age, LaBeouf notes (via Gregory Betts) that "authorship is inextricably bound up in the idea of ownership." He (well, Betts) is right about this much: the very notion of authorship is not so easily extracted from copyright. And, while copyright *is* a legal matter, it is more than this: in being bound up with authorship, it is also a matter of artistic practice. (It is a moral matter, too, but first things first.)

Ontology, Copyright, and Artistic Practice

Two Little Academic Disagreements

Back in September 2008, I was asked by the editors of the *American Society for Aesthetics Newsletter* if I would contribute a paper on copyright and art. As the ink on my doctoral diploma was still drying, I happily said yes. The editors' idea was that I would contribute one paper, while German philosopher Eberhard Ortland would write another. As I imagined it, the central thrust of my short article would be that the tools of aesthetics are uniquely suited to solving the problems of copyright law, of which there are many. I wrote to Ortland (who, at that point, I had not yet met) and floated my idea. He replied, suggesting instead that I consider the inverse notion: that "it is important for philosophers of art to study copyright law because the arguments, concepts and distinctions developed in copyright law and litigation give us an opportunity to understand the difficulties of the ontology of artworks more profoundly and more adequately." However, Ortland suggested:

> The problem with such an approach would be, of course, that you would have to argue that the philosophy of art, as it has been developed by philosophers so far, mostly without taking much notice of copyright law, falls short of providing an adequate understanding of its central object—not a pleasant thing to tell the philosophers. . . .[1]

My view was that the law should look to aesthetics; Ortland's was that aesthetics should look to the law. As far as I was concerned, we had hit dialectical pay dirt.

In my ensuing little article, "Aesthetics and Copyright," I argue that "copyright law has focused primarily on issues of the rights of copyright, and not on the nature of its objects, or else has tried to estimate the latter in its

attempts to explicate the former, and it is from here that many of the problems of copyright arise."[2] Copyright law, I argue, is replete with metaphysical assumptions (many of which we shall be discussing later in this book), but which are not actually spelled out in the law, leaving judges to their own devices to sort these matters out. As a result, the conceptual framework of copyright tends to lead to results that are alternatively arbitrary, counterintuitive, and—taken as a whole—often self-contradictory. Although copyright is rife with quandaries seemingly custom-designed for philosophers of art, aestheticians have to date largely ignored this fertile area. So, in the end, I presented a challenge to aestheticians to investigate some of these problems: "Granted, you might have to learn a little bit of law along the way, but what other domain of application offers such opportunity for aestheticians to make such a substantial impact in the way the world treats artworks?"[3]

My article for the *Newsletter* would not appear until 2010. In the meantime, I wrote a longer essay—"Making Sense of the Copyrightability of Plots"—as something of a test case for the view. In this essay, I take up one of the conceptual problems I introduced in the *Newsletter* article, to argue that the copyrightability of plots depends as much on ontology as it does on the concepts of the law. Part of the ontological issue at hand involves sorting out the nature of plots themselves. However, of more general significance, I argue, is the central distinction in copyright law between "ideas" and "expressions." While expressions are in principle copyrightable and ideas are not, neither of these terms, I note, is actually defined in the law (neither in legislation nor case law).[4] As such, after outlining how copyright's lack of definitions of these terms has led to the rather odd, counterintuitive result that the only difference between an idea and an expression is the amount of detail in each, I provide definitions that I think clarify the distinction while reflecting the motivations of copyright law generally:

> *Idea* (df): the content of a thought, feeling, emotion, desire, and/or other cognitive state or event.

> *Expression* (df): the manifestation or embodiment of an idea or ideas in a perceptible form.[5]

On this understanding, then, "expression" will always be an ellipsis for "expression of an idea" or "expression of ideas," and so while one can have an idea without expression, one cannot have expression without idea. Although thus tied together, ideas and expressions are nevertheless distinct sorts of entities, both conceptually and ontologically: one a class internal to

the mind, and the other external. With these definitions provisionally put forward, I then work in the essay to determine into which category plots belong. I won't rehash the whole of my argument here, but it was a fun exercise (and this distinction between ideas and expressions will serve us later in this book).

The following year, Roger A. Shiner (who, like Ortland, I had not yet met) penned a response to my essay, calling me to task essentially for calling the law to task. Shiner suggests that I am mistaken to assume "that the *legal* terms 'idea' and 'expression' are about those entities in the real world that we can plausibly identify as ideas and expressions."[6] These are terms of law, Shiner suggests, and *merely* terms of law. The law, he argues, is not beholden to—or perhaps even concerned with—the concepts of the real world—and certainly not those of art or philosophy. Operating on a constructivist view of the law, he writes:

> Legal concepts are practical concepts: they are not abstract concepts that exist prior to litigation and whose use may in litigation take this or that form. Appellate courts—especially supreme courts—may speak as though they are describing the contents of an eternal "jurists' heaven." But they are not, and I do not think that if asked, they would themselves say otherwise. They are simply enacting moments in the ongoing enterprise of governing human conduct through laws.[7]

In short, Shiner writes, "It misunderstands the nature of legal discourse to suppose it has exposure to the results of philosophical inquiry."[8] Put simply, Shiner argues that philosophy is one domain, the law another, and never the twain shall meet. Where ontology is an idle but harmless theoretical game, legal matters are essentially practical.

In my response, I note that the law itself does not make the distinction in domains that Shiner suggests it does. The law is not disconnected from the real world: indeed, it is—at least in principle—supposed to be *about* the real world, both in terms of reflecting it and of impacting it. Reiterating the central point from my *Newsletter* article, I write:

> Copyright law is rife with metaphysical assumptions about its objects—beginning with the principle that authored works [the things that copyright protects] are abstract rather than material objects. The law goes further in suggesting that ideas are things themselves *embodied* in authored works. These are ontological distinctions, and in opening the door to ontology, the law invites in the philosopher. Introducing into copyright law a central distinction

between ideas and expressions is like embossing the invitation in gold. And when the law is conceptually confused, whether about its own technical concepts or those of ordinary usage, I would argue not only that the door is open, but also that it is the philosopher's *duty* to step through it.[9]

Although Ortland's paper for the *ASA Newsletter* was never written, he *did* present a paper to the 2008 World Congress of Philosophy, providing some insight into his view. In "The Aesthetics of Copyright," he suggests:

> Copyright law is a crucial part of the normative framework of the artistic and art-related practices in the modern world. It facilitates the production and public accessibility of certain works of art and literature, music, moving image, etc. At the same time, it prevents the production and public accessibility of others which might have been just as interesting as those we got to know. Intellectual property norms imprint our ideas of authorship as well as the ontological constitution of artworks.[10]

Where I suggest that copyright law is, for the aesthetician, a field of philosophical fruit ripe for the picking, Ortland suggests something stronger: that, to properly understand their central object of inquiry, philosophers of art *need* to learn about copyright because the law is part of what determines its nature. Ortland is right. I'm right, too. It's okay: we can both be right. But Shiner is wrong.

The implication of Shiner's view is that philosophy is one domain, the law another, and art perhaps a third, and that we make a mistake when we seek to overlap them. However, art, ontology, and copyright law can really only be separated in the abstract.

Ontology and Copyright

A view steadily gaining ground in analytic aesthetics is that the nature—the ontology—of art depends centrally on artistic practice. Amie Thomasson and David Davies have each advanced compelling arguments for the position. Simply put, while determining the nature of a natural kind—like an element or, perhaps, a species—is best accomplished by studying the thing itself, the same approach will not work for uncovering the nature of artifact-kinds like artworks. The reason is that things like artworks are simply not open to empirical investigation in the same way that a chemical element is. I might learn all manner of things about the nature of a chemical element

by seeing how it reacts with other chemicals, by subjecting it to atomic spectroscopy, or simply by lighting it on fire.[11] However, we're unlikely to learn much about the nature of a novel like *To Kill a Mockingbird* by dunking my copy in acid, exciting its electrons, or setting it aflame. Granted, I might learn some things about the nature of the paper and ink making up my copy, but this isn't of much help if *To Kill a Mockingbird* is not essentially that hunk of paper and ink—and whether it *is* or *isn't* was the very question we wanted to answer. Rather, Thomasson suggests:

> [T]he only way to find out the truth about the ontology of the work of art is by way of conceptual analysis that teases out from our practices and things we say the tacit underlying ontological conception of those who ground the reference of the term, perhaps making it more explicit, smoothing out any apparent inconsistencies, and showing its place in an overall ontological picture.[12]

That is, if we want to learn about the nature of artworks, rather than performing empirical investigation, we should be performing conceptual analysis. And the best way to do this, Thomasson suggests, is by studying the practices of those "competent grounders"—artists, audiences, critics—who hold the relevant concepts and perform the relevant practices.[13]

Certainly, copyright is a relevant part of artistic practice. Last chapter, we looked at the case of musical sampling, and at Judge Ralph Guy's instruction in the 2005 *Bridgeport* decision: "Get a license or do not sample." Many within the music industry, however, point to an earlier case as the turning point for musical sampling: *Grand Upright v. Warner*.[14] In this 1991 case, hip-hop artist Biz Markie attempted to obtain clearance to use a sample from a Gilbert O'Sullivan recording in his song "Alone Again." However, Markie released the song while permission for the license was still pending, and O'Sullivan filed suit. Citing the Book of Exodus, District Judge Kevin Thomas Duffy opened his decision:

> "Thou shall not steal" has been an admonition followed since the dawn of civilization. Unfortunately, in the modern world of business this admonition is not always followed. Indeed, the defendants in this action for copyright infringement would have this court believe that stealing is rampant in the music business and, for that reason, their conduct here should be excused. The conduct of the defendants herein, however, violates not only the Seventh Commandment, but also the copyright laws of this country.[15]

Judge Duffy thus dismisses the contention that Markie's action might be excused as a matter of artistic practice, instead arguing that the law trumps practice: theft is theft, and the law is the law.[16] However, Judge Duffy's decision did more than *ignore* artistic practice: it *changed* artistic practice. Prior to the *Grand Upright* decision, by one industry reckoning, some 80 percent of samples were used without licensing; two years later, 80 percent of samples used were cleared in advance.[17]

This may sound like a mere change in *business* practice rather than *artistic* practice, but samples are expensive to license, and this may substantially alter what goes into a work. There is no straightforward algorithm for calculating the cost of a sample—cost will vary based on the length of the sample, the popularity of the originating song or artist, and the whims of the copyright owner. We can, however, consider an example: Public Enemy's album, *Fear of a Black Planet*—released in 1990—employs upwards of 100 samples from the likes of James Brown, Diana Ross, Michael Jackson, and even Eddie Murphy. (And yes, one track—ironically titled, "Who Stole the Soul?"—samples the Amen Break.) According to music journalist Harry Allen, had the group had to pay for all of the samples on the album, it would have had to charge $159 per CD simply to recoup its costs.[18] Public Enemy's Chuck D suggests that the *Grand Upright* decision changed everything: "That's when the sound of hip hop music shifted and people started to only sample one hook, because it was cheaper than paying for 20 or 30 clips in each song—like how we did it."[19] In other words, Judge Duffy's ruling did not simply change the *business* of hip-hop music—it changed the *content*; it changed the *sound*.

It isn't just musicians whose artistic practices are affected by copyright. Sherrie Levine—who we will be discussing in greater detail in later chapters—is perhaps the best known of contemporary appropriation artists. And among the best known of Levine's works are her unaltered "rephotographs" of works by Edward Weston and Walker Evans. Reportedly, when Weston's estate threatened a copyright infringement suit, Levine moved on to rephotographing works free of "copyright snags."[20] More generally, according to a 2014 study commissioned by the College Art Association, one-third of visual artists and visual art professionals have either avoided or abandoned projects because of copyright concerns.[21] This includes artists who avoid collage and multimedia works, curators who avoid staging exhibitions, and academics and editors who abandon projects that cannot support the cost of copyright permissions, or else because of fear of legal reprisals. One curator notes, "We just avoid certain artists."[22] By affecting how artists act and the artistic choices they make, copyright in many ways

determines what is and isn't made, and what form it takes—and all of this is certainly a matter of artistic practice.[23] But, in digging a little deeper, we can see that copyright does more than this.

Let's consider again the case of Blind Lemon Jefferson from last chapter. As copyright would change the game for musical sampling a little more than half a century later, we saw how it changed the game for folk blues in the 1920s when the recording industry got involved. We saw how Jefferson's recordings quickly evolved from captured performances drawing on a wealth of traditional lyrics and melodies (as was the standard for folk blues) to songs created from the ground up, better suited to the originality requirement enshrined in copyright law (and beholden to by Paramount Records). Let's have a look at one of the songs recorded by Jefferson: "See That My Grave Is Kept Clean." First recorded by Jefferson in 1927, and then again in 1928 with only minor variation, the song is so associated with Jefferson that the opening lines are carved into his tombstone:

> Lord, it's one kind favor I'll ask of you
> See that my grave is kept clean.

"See That My Grave Is Kept Clean" cobbles together lyrics from a variety of traditional sources, including earlier folk blues, spirituals, and even a sea shanty.[24] The song borrows its melody from another traditional, "Careless Love." Like Jefferson's other early recordings, then, "See That My Grave Is Kept Clean" is emblematic of the folk blues' tradition of combining and recombining elements in countless ways as the performer saw fit. Now, consider what happened after Paramount released Jefferson's version. Under a variety of titles, the song was covered by Son House (1930, as "See That My Grave Is Kept Clean"), The Two Poor Boys (1931, as "Two White Horses in a Line"), and Smith Casey (1934, "Two White Horses Standin' in a Line"). Several later recorded versions were released under the title "One Kind Favor." B. B. King used *One Kind Favor* as the name for his 2008 album, which included "See That My Grave Is Kept Clean" as its first track. Bob Dylan used it as the last track on his debut 1962 album. In each of these cases, there are some minor variations, but all of Jefferson's verses are included, and songwriting credit is normally given to him[25]—indeed, when Pete Harris recorded the song in 1934, it was titled "Blind Lemon's Song." All of this is curious. Unlike most of Jefferson's later recordings, "See That My Grave Is Kept Clean" comes straight out of the folk blues tradition—his would have been one variant of many, each with its own verses and idiosyncrasies, given the whims of the performer. In ontological terms, prior to Jefferson's

recording, it may not have even made a lot of sense to identify any one thing as *the* song "See That My Grave Is Kept Clean"—at best, there may have been degrees of family resemblance between many performances drawing from the same supply of blues elements. After 1927, *the* song is identifiably the one that Jefferson recorded, and perhaps for a curious reason.

Under current US copyright law, you don't need permission to record a cover version of a copyright-protected song that has already been recorded; you merely have to pay a standard licensing fee (under what's called a "mechanical license"): 9.1¢ per copy per song produced, or 1.75¢ per minute (whichever is higher).[26] Although some of the details have changed, the mechanical license dates back to the 1909 Act, well before Jefferson recorded "See That My Grave Is Kept Clean." As well as introducing the mechanical license, the 1909 Act codified for the first time in US law the author's right against unlicensed translation and adaptation of one's protected works, including the arrangement and adaptation of musical works.[27] In the language of today's Act, the author has the exclusive right to create any "derivative work"—a work based on some preexisting protected work, but that *recasts, transforms,* or *adapts* that work into something itself representing "an original work of authorship."[28] The mechanical license to record a cover version of a song requires that the cover "shall not change the basic melody or fundamental character of the work."[29] In other words, if you deviate too far from the original musical *work*—that thing captured in the original recording—you will be creating a distinct work that borrows without permission from the original, and thus risk infringing the original author's copyright. Copyright has, in short, fixed the nature of "See That My Grave Is Kept Clean"—and so, as a part of artistic practice, has (at least in part) determined its ontology.

Copies and Copies

"Copy" is an ambiguous term. Since Nelson Goodman's *Languages of Art,* ontologists of art have become used to making the distinction between two sorts of "copies" of a work. Goodman gets to this distinction first by distinguishing between *autographic* work-kinds and *allographic* work-kinds. A work of art is autographic "if and only if even the most exact duplication of it does not thereby count as genuine," and otherwise allographic.[30] So, there are copies and there are copies: a genuine copy (like my copy of *To Kill a Mockingbird*) is an *instance* of that work in virtue of being an exact duplicate of it; a replica or reproduction (like the copy I have made of Munch's *Scream*) is not, regardless of how much it resembles the original. One way of

looking at this is that genuine copies are *authentic* or *legitimate* copies, while mere replicas are *inauthentic* or *illegitimate* ones (though not necessarily—as in the case of forgeries—*counterfeit* or intentionally deceptive ones). Some art forms are more complicated than others in this regard, however. Take printmaking, which Goodman classes as an autographic kind. He writes:

> The only way of ascertaining whether a print is genuine is by finding out whether it was taken from a certain plate. A print falsely purporting to have been so produced is in the full sense a forgery of the work.[31]

To this, Goodman adds a lengthy footnote:

> To be original a print must be from a certain plate but need not be printed by the artist. Furthermore, in the case of a woodcut, the artist sometimes only draws upon the block, leaving the cutting to someone else—Holbein's blocks, for example, were usually cut by Lützelberger. Authenticity in an autographic art always depends upon the object's having the requisite, sometimes rather complicated, history of production; but that history does not always include ultimate execution by the original artist.[32]

In the case of a lithograph, normally an artist will personally create the negative matrix on a stone or zinc plate, and then supervise the printing of copies from the plate—usually in a numbered edition—after which the plate is defaced or destroyed. Now, if the plate *isn't* destroyed, one could in principle produce new prints of the artist's work, but if done without the artist's permission these will not be authentic prints—they will be, in this sense, *illegitimate* copies. To sell such an inauthentic copy *as if* it were an authentic print would be fraudulent—the inauthentic copy will be a *counterfeit*.[33] It seems that, contra Goodman, determining that a copy was made from the original plate will not be enough to ascertain that it is the genuine article: it will have to be so made *with the artist's authority*. So, at least in this case, authenticity depends on authority, and copyright *codifies* this relationship: copyright ownership ensures the printmaker's exclusive authority to determine what *is* and what *isn't* an authentic copy. When I sneak into the printmaker's studio and surreptitiously produce a new copy of her print, that print will be inauthentic *because* it is illicit. Now, in this case, what we have is only a necessary condition, and not a sufficient one. The printmaker may authorize copies that are not themselves authentic copies—artist's proofs and printer's proofs, for instance. In other arenas, there would seem to be all manner of illicit-but-authentic copies of works. If I purchase a pirated copy

of a DVD that I cannot legally find for sale—say, *Alligator 2: The Mutation*—the copy will be illicit. Nevertheless, I think we want to say that if I go home and watch that DVD, I will be watching the actual 1991 horror classic, the actual work.

Goodman also treats cast sculptures as allographic, but allowing for multiple genuine instances. The authentic copies of a cast sculpture are those cast from the original mold. However, like printmaking, things are more complicated than this. When sculptor Auguste Rodin died in 1917, he transferred his works, some 7,000 plaster casts, and (importantly for our purposes) his copyrights to the nation of France. This included the rights to his most famous sculpture, *The Thinker*. France opened the Musée Rodin in 1919 to administer, exhibit, and produce authentic castings of Rodin's body of works. A 1978 decree would limit the number of "originals"—authentic copies, as opposed to reproductions—that could be produced from any cast to a total of twelve.[34] Aida Edemariam of the *Guardian* notes, "The last 'original' large-form bronze *Thinker* was cast in 1974; any identical *Thinker* after that date is a reproduction. The Musée Rodin still produces originals, from plasters yet to be cast 12 times."[35]

Copyright expired on Rodin's works in 1987, though by this point France had not yet cast all of its allotted Rodins, and here is where things get a little complicated. Shortly before Rodin's copyrights expired, the French government issued a decree requiring that "[a]ll facsimiles, casts of casts, copies, or other reproductions of an original work of art . . . must carry in a visible and indelible manner the notation 'Reproduction.'"[36] In 2001, Toronto's Royal Ontario Museum hosted "From Plaster to Bronze: The Sculpture of Auguste Rodin," an exhibition including more than seventy plasters and bronzes. The casts for the show were provided by the MacLaren Art Centre in Barrie, Ontario, which claims to own a large number of Rodin plaster casts dating from Rodin's lifetime (though the authenticity of the casts has been contested by the Musée Rodin). Eleven of the bronzes for the show were produced by the Italian-based company Gruppo Mondiale in 1999 and 2000.[37] Gruppo Mondiale claims that its own plaster casts were among Rodin's originals that never made it to the Musée Rodin in 1917, but transferred hands a number of times before coming into the company's possession. Over the years, Gruppo Mondiale would reportedly cast and sell more than 1,700 bronzes, some for upwards of $220,000. In 2001, the Musée Rodin accused Gruppo Mondiale of forgery.[38] Under French law, Gruppo Mondiale would be required to clearly label its bronzes as reproductions, which it had not. But Gruppo Mondiale is not in France, and, in 2014, Paris's criminal court found that Gruppo Mondiale had thus violated no French laws.

The Musée Rodin claims that Gruppo Mondiale's bronzes are forgeries—inauthentic copies sold as the real thing. James Adams of Toronto's *Globe and Mail* writes:

> [W]ho knows, maybe the MacLaren Art Centre, home of the 60 plasters, will someday make its own reproduction casts. The centre's director, William Moore, says he has no plans for this, but there's pretty much nothing to stop the MacLaren from doing so. Since Rodin died in 1917, there are no copyright concerns and, despite all the bleatings of the Musée Rodin, no impediments in terms of legal or moral rights. Rodins, rain down on us![39]

The problem comes in calling those copies "Rodins," with the implication that they are *authentic* works of Rodin. While copyright held sway, the matter was generally accepted as fairly straightforward: any authentic *Thinkers* would be those produced under Rodin's own supervision, or those produced by the Musée Rodin. And with the work having since passed into the public domain, it seems unproblematic that those copies once accepted as authentic remain authentic. It also seems a generally accepted matter that the copies produced by Gruppo Mondiale are inauthentic copies: reproductions. But what, we might ask, about post-1987 copies produced by the Musée Rodin itself? What gave the museum the rights to produce authentic Rodins was the sculptor's transfer of his copyrights to the nation of France. With the copyrights since expired, what claim does the Musée Rodin have to any exclusive power to produce authentic Rodin copies? The Musée Rodin argues that Gruppo Mondiale's copies are inauthentic-because-illicit, but if what determines the licit/illicit line fades away, what qualifies as an authentic copy becomes less clear. That is, with copyright removed as setting the authority in the matter, authenticity becomes an open question left to the artworld to sort out.

The institution of art—the *artworld*—is, first and foremost, a set of shared practices and concepts. And, as much as we would like to imagine artists—or ourselves—as living apart from other real-world practical concerns, the artworld is thoroughly invested with copyright. And so, if the ontology of art is determined by artistic practices, it should perhaps come as no great surprise that copyright has a role to play in this. Artistic practice is complicated, however, and copyright is certainly not the be-all, end-all of the artworld, or of artistic ontology. Nevertheless, today, there is effectively no artistic creation—no "authorship"—outside of copyright. If you create something with even a modicum of creativity—a poem, a doodle, a photograph—that thing is probably protected by copyright, and (in most cases) that copyright belongs to you.[40] With extremely rare exceptions, you don't have to register

your copyright, and you don't have to put a copyright notice on what you have created.[41] In most cases, your work simply receives copyright protection at the moment of creation.[42]

Now, while the ontology of art is grounded in artistic practice, which is pervaded by copyright, copyright law is in turn meant to *reflect* artistic practice, which in turn embodies our concepts of art. And artistic practice is changing.

Practice Is Meant to Inform the Law

In 1988, after a century of holding out (for reasons we will discuss in a later chapter), the United States joined the Berne Convention, the oldest international copyright treaty. Part of its rationale for joining is described by Congress in 1986:

> The harmonization of different national intellectual property systems, the principle of national treatment, and minimum rights have enabled the periodic revision of international conventions, which has given the international system the flexibility needed to adapt over time to technological change and changing attitudes about intellectual property protection. However, with the development of many new ways of creating, reproducing, and exploiting intellectual works, the international intellectual property system is currently experiencing a number of new and perhaps more serious stresses.[43]

Copyright law is often described in terms of a balance between the rights and interests of authors and users.[44] The stresses that Congress speaks of are both social and technological in nature, and together challenge this balance. Technology has always played a pivotal role in the advancement of the arts, from the invention of movable-type printing technology, to the development of photography, phonography, and moving pictures, to the advent of digital media. Some of these advances have made the copying of works of art exponentially easier, and artists of all sorts have exploited such ease of copying in creating new works, and new kinds of works. Musical sampling, which actually began in the 1940s, reached an apex in the 1980s, fueling the development of hip-hop and rap music. Where recorded sampling once required extensive technical training and access to expensive equipment, today's digital software allows nearly anyone to copy and transform samples of recorded music, and the Internet further fosters the proliferation and dissemination of such works. If something has been digitized, it is potential fodder for artistic borrowing.

As artists explore and exploit new technologies, new artistic practices evolve. Some of these changes are as a direct result of the proliferation of such technology: it was not until well into the twentieth century that photography came to be accepted as an art form, but today it is a central pillar of the artworld, and art practices that appeared on the periphery of the artworld just a decade ago are now attracting serious attention. Consider the case of Cory Arcangel, best known for his works based on modifying the code in obsolete video-game cartridges. Perhaps the most famous (or notorious) of his "digital hacks" is *Clouds* (2002), a modified version of the *Super Mario Brothers* (1985) video game for Nintendo's NES platform, in which everything has been removed except the fluffy white clouds scrolling slowly along the blue background. Arcangel describes *Clouds* simply as "Super Mario Brothers, . . . but with just the clouds." Arcangel's work has been showcased in New York's Museum of Modern Art, Chicago's Museum of Contemporary Art, and elsewhere, but *Clouds* is available for viewing at any time on YouTube.[45]

In January 2016, the New York Public Library released via its website nearly 200,000 high-resolution items from its digital archives, including photographs, manuscripts, map, letters, and atlases (all in the public domain). At the same time, the library launched its "Remix Residency" program, giving two winning applicants the opportunity to help the library further advance access to its materials. "The whole reason we digitize," says Ben Vershbow, director of the library's NYPL Labs, "is so that [collections] can be reused, remixed, reinterpreted."[46] Technological advances have ignited—or fueled—conceptual shifts in how we think about the arts. And a number of artistic practices, while not centrally exploiting such technologies, nevertheless embody such changes in how we think about art, originality, and creativity—and, as a result, intellectual property. Think, here, about Shia LaBeouf. We spent a good deal of the last chapter looking at how attitudes are changing when it comes to intellectual property. Given continuing shifts in attitudes—by creators, users, and those somewhere in between ends of the spectrum—Congress suggests the law must adapt to keep up. The problem, many argue, is that the law has failed to do so—that the law is, in fact, criminalizing common artistic practice.

Lawrence Lessig suggests that sampling, mash-ups, collage, fan fiction, and other artistic borrowings are exactly the common sorts of reconfigured expression flourishing in today's remix culture. He urges:

> We, as a society, can't kill this new form of creativity. We can only criminalize
> it. We can't stop our kids from using the technologies we give them to remix
> the culture around them. We can only drive that remix underground. We can't

make our kids passive in the way we were toward the culture around us. We can only make them "pirates." So does this criminalization make sense?[47]

In criminalizing this sort of activity, Lessig contends, we are criminalizing ordinary, everyday activities. Rather than turning our children into criminals, he suggests, it would be better to "achieve the same ends that copyright seeks, without making felons of those who naturally do what new technologies encourage them to do."[48]

In addition to authoring several books on copyright reform, Lessig is one of the founders of Creative Commons. Created in 2001, Creative Commons is a nonprofit organization that develops licenses creators can use to communicate which rights they wish to reserve for any given work, and which they wish to relinquish. So, for example, a storywriter, photographer, or computer programmer may wish to make her work available free to copy (among the "baseline rights" of Creative Commons), but require that it always be clearly attributed to her, and not allow for users to create derivative works based on it. A series of simple symbols mirroring the iconic copyright symbol communicate the assortment of rights. In 2009, Creative Commons created the "CC0" or "Creative Commons Zero" mark—a slashed zero in a circle—to communicate an author's waiving of all copyrights and related rights. In 2010, it released the public domain mark—a copyright symbol with a slash through it—to indicate a work *already* in the public domain. Curiously, when Creative Commons submitted the CC0 designation for use by the Open Source Initiative—perhaps the leading organization dedicated to promoting open-source software—it was rejected on the grounds that, in some jurisdictions, it is not legally *possible* to relinquish all such rights.[49] Creative Commons, after all, is not an *alternative* to the system of copyright; quite the opposite, it is meant to work *within* existing copyright laws. Nevertheless, Creative Commons licenses have become wildly popular and are used by both *Wikipedia* and the photography website Flickr. In 2015, Creative Commons estimated some one billion works carried a Creative Commons license.[50] If nothing else, this is testament to the popularity of sharing works in the age of digital media. Creative Commons, and the more general "copyleft" movement, have in part inspired governments to take another look at their existing copyright laws.

Between 2005 and 2012, the Canadian Parliament introduced a series of bills to amend the Canadian Copyright Act. The first of these, Bill C-60, was seen by many Canadians as a move toward strengthening the rights of copyright owners while weakening those of users. Even before the bill was formally introduced, nearly 2,000 Canadians signed a Petition for Users'

Rights, stating that "the Copyright Act is properly recognized as being a careful balance between the rights of creators and the rights of the public (including viewers, readers and listeners)," and calling for greater protections for the latter group.[51] The Appropriation Art Coalition, a group of more than 600 artists and art professionals, issued an open letter to the Canadian government, reading in part:

> Effective copyright laws should offer artists the legal means to enforce their rights in their work, but should not over-reach and stifle or even destroy creativity of others. We do not believe Canada's [existing] copyright laws reflect the reality of contemporary artistic practice.[52]

The point here is that, if copyright law is meant to reflect a balance between the rights and interests of owners and users, then it needs to reflect current artistic practice, and artistic practice will include both the activities of artists and of ordinary users.

In 2012, the Australian government tasked the Australian Law Reform Commission with undertaking a review on "Copyright and the Digital Economy." In the Commission's official report a year later, it echoes Lessig's thinking:

> Many people innocently infringe copyright in going about their everyday activities. Reforms are recommended to legalise common consumer practices which do not harm copyright owners. The same discussions are taking place around the world as respect for copyright law is diminishing.
>
> . . . Some stakeholders expressed concern about the extent to which consumer attitudes and practices may influence law reform. In this context some stakeholders stated that it is preferable for law to shape consumer behaviour, rather than for consumer behaviour to shape the law. . . . Laws that are almost universally ignored are not likely to engender respect for the more serious concerns of copyright owners: "[p]eople don't obey laws they don't believe in."[53]

Quoting a submission by the Law Institute of Victoria, the Commission suggests:

> Copyright law needs to be in step with common, established community practice. This is important to promote public perception of copyright law as a constructive, flexible and sensible framework for governing protection and access to content.[54]

Copyright law, the Commission maintains, needs to reflect artistic practice and maintain the balance between copyright owner and user. In particular, it contends, the law should "provide more room for some artistic practices, including the sampling, mashup and remixing of copyrighted material in musical compositions, new films, art works and fan fiction."[55]

The Commission, above, is quoting legal scholar Jessica Litman, who writes:

> People don't obey laws that they don't believe in. . . . Most people try to comply, at least substantially, with what they believe the law to say. If they don't believe the law says what it in fact does say, though, they won't obey it—not because they are protesting its provisions, but because it doesn't stick in their heads.[56]

Litman compares our current copyright laws with the US 55 mph national maximum speed limit, signed into law in 1974. Although introduced in an effort to increase road safety and to reduce oil consumption in an ongoing oil crisis, the law met with widespread noncompliance. Despite the threat of stiff penalties, the great majority of drivers routinely drove above the posted speed limit. Since, Litman suggests, people don't believe that driving at 70 mph is really against the law, they don't refrain from doing so, and "[g]overnments stop enforcing laws that people don't believe in. Laws that people don't obey and that governments don't enforce get repealed."[57] And, indeed, the national speed limit was repealed in 1995. Now, it would be difficult to accept that the majority of drivers simply did not *believe* that the speed limit on highways was 55 mph—or that it didn't "stick in their heads"—what with signs posted all along the side of the highway. However, it is easier to accept that drivers simply didn't *buy into* the law or believed that they wouldn't be punished for breaking it. What is most likely is that, while aware of the safety risks and costs of gas, as well as the potential for stiff penalties for breaking the law, drivers had other, competing interests. Apparently drivers were happy to take a risk on their well-being if it meant greater convenience, and so it made little sense to continue to enforce a law that most people were not going to follow anyway. Likewise, Litman suggests, since so many fail to believe in copyright laws that infringing practices have become ubiquitous, it makes little sense to continue to criminalize such behaviors.

Now, let's consider this line of argument with another widespread practice. Following the brutal 2012 gang rape and murder of a young woman in New Delhi, India, the extent of rape culture in India gained worldwide attention. One of the four men convicted for the crime, Mukesh Singh, was

the driver of the bus on which the rape took place. When interviewed for a documentary by Leslee Udwin, Udwin reports that Singh's attitude was, "Why are they making a fuss about us, everyone is doing it."[58] Indeed, says sociologist Shiv Visvanathan, "Indian society is such that it thinks rape is normal, that rape is a part of a woman's fate."[59] Although the case resulted in reform to India's laws, rape remains widespread in the country. Ironically, perhaps, Udwin's documentary—*India's Daughter*—received nearly as much backlash in India as the crime on which it reported. Of course, rape is not only endemic to India, but is horrifyingly widespread, despite severe punishments handed down for convictions in most countries. Apparently a great many people—as Litman might phrase it—simply do not *believe* in rape laws, and in far too many countries these laws aren't systematically enforced anyway. Should we thus repeal laws against rape?

Lessig anticipates this question, asking, "Do we respond to high levels of rape by decriminalizing rape? . . . Or put generally: Does the fact of crime justify the repeal of criminal law?"[60] Of course not, Lessig answers:

> Rape is wrong and should be punished severely whether or not people continue to rape. . . . Nothing I'm saying about the copyright war in particular generalizes automatically to every other area of regulation. I'm talking specifically about one unwinnable war, and about alternatives to that war that have the consequence of decriminalizing our kids, and decriminalizing many of us too. . . . We should always be thinking about how to moderate regulation in light of the likelihood that the target of regulation will comply. It does no one any good to regulate in ways that we know people will not obey.[61]

The assumption here seems to be that rape is illegal because it is immoral— thus, even if many will not comply with the law, rape should continue to be illegal. Conversely, it seems, at least some acts currently considered illegal infringements of copyright should be allowed under the law because there is (at least) nothing immoral about them. However, this in itself requires a moral argument. Much later in his book, Lessig writes:

> There is no plausible argument that allowing kids to remix music is going to hurt anyone. Until someone can show that it will, the law should simply get out of the way. We need to decriminalize creativity before we further criminalize a generation of our kids.[62]

So, it would seem for Lessig, the issue is *harm*. To compare again with rape: rape *harms* its victims (and others as well), and so should be illegal; copyright

infringement—at least of some sorts—conversely *harms* no one (or, at least, not very much), and so should not be illegal. Harm was raised as a condition by the Australian Law Reform Commission, above, and last chapter we considered Judge Posner's attempt to define plagiarism in terms of harm. Certainly, we could quibble about whether artistic borrowing materially harms the copyright owner—and, if so, to what degree—but there is a deeper issue here. Presumably, what makes rape immoral is not simply (nor, I would suggest, centrally) a matter of some physical or psychological *harm* to the victim, but rather that rape is a gross violation of the victim's *rights*. The same, I would argue, is true in the case of copyright infringement.

Copyright is embedded in both the practice and ontology of art, and so sorting out the right (and wrongs) of copyright require analyzing a number of entangled strings. *Super Mario Brothers*, produced by Shigeru Miyamota and designed by Miyamota and Takashi Tezuka, is a copyrighted work, and *Clouds* is almost certainly (at least) a prima facie infringement of this copyright. But determining whether Arcangel has done anything *wrong* in creating *Clouds* depends on understanding (1) the nature of the works in question, (2) the relationship of the author to the work, (3) the rights of the author and how they arise from this relationship, (4) the relationship holding between the original work and the potentially infringing work, and (5) the rights of nonauthors—if any—with regard to a given work. These are interdependent metaphysical and ethical issues, and understanding them requires understanding them in the institutional, cultural, and legal framework of intellectual property.

The Myth of Unoriginality

Axolotl Roadkill

In 2010, at age 17, German wunderkind Helene Hegemann published her debut novel, *Axolotl Roadkill*. Within weeks, the coming-of-age story—hailed as "a lightning ball of prose form and language"[1]—was flirting with top position on the German bestseller lists, and was quickly nominated for one of the country's most coveted fiction prizes. Hegemann, already a noted playwright and screenwriter, was thrust fully into the national spotlight. Her work was being compared with *The Catcher in the Rye* and *Bonjour Tristesse*—the celebrated debut novel of fellow prodigy Françoise Sagan.[2] But, thanks to blogger Deef Pirmasens, *Axolotl Roadkill* was being compared with another work as well: *Strobo*, a novel published a year earlier by the pseudonymous blogger Airen.[3] Shortly after the release of *Axolotl Roadkill*, Pirmasens noted that several passages in Hegemann's novel bore more than a passing resemblance to Airen's work. Indeed, several pages' worth of material in the novel were lifted essentially word-for-word from *Strobo* and other sources without citation.[4]

A short way into *Axolotl Roadkill* is a particularly apropos passage of dialogue:

> Berlin is here to mix everything with everything, man . . . I steal from anywhere that resonates with inspiration or fuels my imagination. . . . Film, music, books, paintings, cold-cuts poetry, photos, conversations, dreams . . . Street signs, clouds . . . Light and shadows, that's right, because my work and my theft are authentic as long as something speaks directly to my soul. It's not where I take things from—it's where I take them to.[5]

What, in retrospect, seems to be an apologia from Hegemann herself is spoken by the character of Edmond. The first line, however—"Berlin is here to

mix everything with everything"—is taken directly from Airen's blog.[6] The explanation for stealing that follows is stolen, too—from filmmaker Jim Jarmusch.[7] The last line, Jarmusch attributes to Jean-Luc Godard.[8] Hegemann drops the attribution, along with any other hints that her material is appropriated.

With the evidence flooding in, Hegemann's publisher, Ullstein, quickly went into damage-control mode. Ullstein reached a settlement with Airen's publisher, Sukultur,[9] and future printings of the book would include an appendix with six pages of citations. Under pressure, one imagines, Hegemann publicly apologized for her unattributed borrowing—for "not having mentioned accordingly from the outset all of the people whose thoughts and texts have helped me"[10]—but her apology is tempered: "I've said it again and it's still my best defence: there's no such thing as originality, just authenticity."[11] She cribbed that line from Jim Jarmusch, too.[12]

Originality and Unoriginality

Hegemann's claim that "there's no such thing as originality" is, today, an all-too-familiar refrain. Most of us, I am sure, have heard it claimed that there is some limited supply of plots and scenes available to storytellers. This much goes back at least as far as Samuel Johnson, who is reported to have "projected, but at what part of his life is not known, a work to show how small a quantity of REAL FICTION there is in the world; and that the same images, with very little variation, have served all the authors who have ever written."[13] Precisely how small a quantity is a matter of some debate. Georges Polti suggested in 1912 that there were precisely thirty-six "dramatic situations" in literature, aligning with mankind's thirty-six emotions.[14] Meanwhile a claim attributed to authors as diverse as Leo Tolstoy and John Gardner is that there are exactly two basic literary storylines: a stranger comes to town, and a man goes on a journey.[15] These, of course, are two sides of the same coin, and so may be collapsed into precisely one essential plot. But what we might call the cult of unoriginality says much more than this. It says that all art—perhaps necessarily—is appropriation art, that nothing is truly original.

In his 1967 essay, "The Death of the Author," Roland Barthes famously put the point: "[T]he writer can only imitate a gesture that is always anterior, never original. His only power is to mix writings, to counter the ones with the others, in such a way as never to rest on any of them."[16] And although the direct influence of Barthes's essay is inestimable, his polemic was itself hardly novel. Just a few years before Barthes made his point, Canadian writer Hubert Aquin suggested:

[T]he originality of a piece of work is directly proportional to the ignorance of its readers. There is no originality: works of literature are reproductions (which serve a purpose of course in a society with large amounts of spare time to kill and blessed, moreover, with pulp) run off from worn out plates made from other "originals" reproduced from reproductions that are true copies of earlier forgeries that one does not need to have known to understand that they were not archetypes but simply variants. A cruel invariability governs the mass production of those variants that go by the name of original works. History, too, copies itself. Originality is as impossible there as in literature. Originality does not exist; it is a delusion.[17]

Stanley Fish has recently noted that, across the varied fields of academia, assaults against the notion of originality have been so successful that the word "originality" now often appears in scare quotes.[18]

What we might call the Standard Position is that our contemporary view of authorship—resting on this notion of originality—itself arose in the romantic period of the late eighteenth century. This is the period picked out by Michel Foucault, for example, who suggests, "Texts, books, and discourses really began to have authors (other than mythical, 'sacralized' and 'sacralizing' figures) to the extent that authors became subject to punishment, that is, to the extent that discourses could be transgressive."[19] Among other things, the eighteenth century gave birth to modern copyright law—presumably the source of authorial transgression of which Foucault speaks. Great Britain introduced the first true copyright law—the Statute of Anne—in 1710. Louis XVI recognized authorial rights by royal decree in 1777, and the French National Assembly retained such rights in 1793 after Louis lost his head. The US Constitution, adopted in 1787, recognizes the power of Congress to secure the rights of authors, and the first federal US Copyright Act passed three years later.[20] While I would question Foucault's suggestion (echoed by many) that the very notion of an author is a product of the eighteenth century, it seems reasonable to say that the romantic period is responsible for the birth of the author as a *legal* entity. And at the core of this notion of authorship is originality.

Different countries cash out originality in copyright in slightly different ways. Copyrighted works in the United States are officially recognized as "original works of authorship,"[21] with originality being a necessary condition for a work's protection, though the term itself isn't defined in the law. Canada recognizes copyright in "original literary, dramatic, musical and artistic" works, but similarly fails to define "original."[22] Under EU copyright harmonization, a work is considered "original"—and so copyrightable—only if it

is "the author's own intellectual creation."[23] Although the term—or its linguistic equivalent—is not always encoded in any given country's statutory copyright law, the principle of originality is almost always central, and begins to work its way out in court cases. Indeed, it has been suggested that originality is "the most important notion of copyright law because it is the sieve that determines which 'products of the human spirit' are protected by copyright and acquire the status of 'work.'"[24] So it would seem to follow that, if originality is a fiction, then our copyright laws are built on a foundation of sinking sand: if there is no originality, there is no legal authorship, and no ownership. Without ownership, there is nothing truly to be infringed.

Martha Woodmansee and Peter Jaszi, following Foucault, suggest:

> [T]he modern regime of authorship, far from being timeless and universal, is a relatively recent formation—the result of a quite radical reconceptualization of the creative process that culminated less than 200 years ago in the heroic self-presentation of Romantic poets. As they saw it, *genuine* authorship is *originary* in the sense that it results not in a variation, an imitation, or an adaptation, and certainly not in a mere re-production . . . but in an utterly new, unique—in a word, "original"—work which, accordingly, may be said to be the property of its creator and to merit the law's protection as such.[25]

A true author—a *genius*—created something from nothing. This notion of creation ex nihilo has come to be called "Romantic Originality," and many trace the concept to poet Edward Young's 1759 tract, *Conjectures on Original Composition.*[26] Robert MacFarlane, for example, suggests Young's notion of originality is "now familiar: the original work of literature is unbidden, native to an individual, and comes into being out of nothing."[27]

The Original Genius

The artistic genius was a tragic hero: imbued with superhuman talent and, because of that, placed forever outside ordinary society. His existence was one of noble isolation, and his tortures were of a kind unknown and unknowable to ordinary men. Artists themselves were, of course, only too willing to perpetuate the notion. Originally, the term "genius" referred to an external spirit (it being the root of "genie"), but by the eighteenth century, the genius had moved *into* the artist—indeed, had become a *property* of his. The Hellenistic Greeks did not have the term "genius" (the closest analogue would seem to be "daemon"), but Plato's description of Ion as the possessor of a divine, irrational power—a gift of the gods—stands as a fair precursor to the romantic ge-

nius. At least as seen from the outside, the artistic genius walked the thin line of insanity, occasionally crossing over into madness. Genius allows the author to step outside the rules of composition, producing a sort of evolutionary leap—a work that does not simply follow logically from what came before. This is the "Original" for Young—that which "can arise from Genius only."[28]

Young writes:

> *Imitators* only give us a sort of Duplicates of what we had, possibly much better, before; increasing the mere Drug of books, while all that makes them valuable, *Knowledge* and *Genius*, are at a stand. The pen of an *Original* Writer, like *Armida*'s wand, out of a barren waste calls a blooming spring: Out of that blooming spring an *Imitator* is a transplanter of Laurels, which sometimes die on removal, always languish in a foreign soil.[29]

Genius brings forth new life from barren ground—but barren in the sense of sterility, not in the sense of emptiness. For when the rules of composition have produced all the offspring they can, genius still allows for new life: *originals* that do not, in this sense, depend on what came before. Where Young describes genius and originality in organic terms, imitation is always mechanical:

> An *Original* may be said to be of a *vegetable* nature; it rises spontaneously from the vital root of Genius; it *grows*, it is not *made*: *Imitations* are often a sort of *Manufacture* wrought up by those *Mechanics*, *Art*, and *Labour*, out of preexistent materials not their own.[30]

It is passages like this one that, quoted time and again, have given Young his dubious honor as the father of Romantic Originality.

However, while he describes originals as like vegetables, rising "spontaneously from the vital root of Genius," Young seems to recognize that even the spontaneous acts of genius must draw from their soil:

> Knowledge physical, mathematical, moral, and divine, increases; all arts and sciences are making considerable advance; with them, all the accommodations, ornaments, delights, and glories of human life; and these are new food to the Genius of the polite writer; these are as the root, and composition, as the flower; and as the root spreads, and thrives, shall the flower fail?[31]

Though genius imbues its possessor with a certain power to perform such miracles, the new life that he produces hardly comes from nothing.

For Young, the modern writer holds a tenuous relationship with past works—particularly those of the ancients. He writes:

> Let us be as far from neglecting, as from copying, their admirable Composi-
> tions: Sacred be their Rights, and inviolable their Fame. Let our Understand-
> ing feed on theirs; they afford the noblest nourishment: But let them nourish,
> not annihilate, our own.[32]

Young's advice is to do *as* past geniuses had done, but not *what* they had done—"imitate not the *Composition*, but the *Man*."[33]

However, with Shakespeare, Young seems to have backed himself into a logical corner. At the time of Young's writing, Shakespeare was considered the pinnacle of genius, on par with or surpassing that of the ancients. Young suggests, "*Shakespeare* mingled no water in his wine, lower'd his Genius by no vapid Imitation. *Shakespeare* gave us a *Shakespeare*, nor could the first in antient fame have given us more. *Shakespeare* is not their Son, but Brother; their Equal, and that, in spite of all his faults."[34] But it was hardly unknown that the bard had borrowed many of his stories from other sources. More than half a century before Young's *Conjectures*, Gerard Langbaine's *An Account of the English Dramatick Poets* (1691) identified for the first time many of Shakespeare's more obscure sources. And, just a scant few years before Young published his tract, Charlotte Lennox published *Shakespear Illustrated* (1753–54), a critical three-volume work analyzing Shakespeare's plays and their sources. Indeed, at least some of Shakespeare's sources—including translations of Plutarch's *Lives of the Noble Greeks and Romans* and Raphael Holinshed's *Chronicles*—were in wide circulation in the eighteenth century. So how is it that Shakespeare could so exemplify genius, when genius was in apparent opposition to such borrowing? We could perhaps suppose that Young was simply ignorant of Shakespeare's sources—whether willfully or not—but there seems a more likely correct, if more nuanced, answer.

On Young's view, too *little* learning robs the writer of the nutrients required to "grow" original works; too *much* learning fetters such efforts, leaving no room for genius to bloom. Young writes:

> It is by a sort of noble Contagion, from a general familiarity with their Writ-
> ings, and not by any particular sordid Theft, that we can be the better for those
> who went before us. Hope we, from Plagiarism, any Dominion in Literature;
> as that of *Rome* arose from a nest of Thieves?[35]

In Shakespeare, we have the ideal mix, though this conclusion seems to rest on a bit of inverted logic: since Shakespeare's works are of the highest genius, and since overeducation tempers or eradicates genius, Shakespeare must have had rather limited learning—all evidence to the contrary. "Who knows," asks Young, "if *Shakespeare* might not have thought less, if he had read more."[36]

Young tells us that "[l]earning is borrowed knowledge; Genius is knowledge innate, and quite our own."[37] So, while genius may be knowledge *nurtured* by what has come before, it is not knowledge that can be simply *derived* from the common store. Young suggests, "Genius can set us right in Composition, without the Rules of the Learned; as Conscience sets us right in Life, without the Laws of the Land."[38] So it is not that Shakespeare pulled the stories of Julius Caesar, Macbeth, and Hamlet from thin air: rather, he did things with these stories that none had—or, perhaps, could—before. Shakespeare took familiar stories from the "barren waste" of common knowledge and made them into extraordinary works.

According to Tilar J. Mazzeo, Young distinguished between imitations from the "universal" and imitations from the "particular," where the former included "the natural, the true, or the common cultural elements of another writer's text" and the latter the "style and tone as well as a broader range of localized eccentricities and opinions."[39] Borrowings of the universal sort were appropriate, while those of the particular sort were not.[40] Although Mazzeo's evidence for this interpretation is exceedingly light and dubious at best, it remains apparent that originality for Young is not creation ex nihilo. Indeed, at least part of the challenge for Young and his romantic contemporaries was how to hold on to the notion of artistic genius *while* allowing that artistic creation was not creation from nothing.

The cult of genius spread quickly, and Young was, as they say, very big in Germany. When the first German translation of his *Conjectures* appeared in 1760, the Germans were already primed to embrace it. Young's poem, "Night Thoughts," had been translated a few years prior to great renown, and the *Conjectures* has been called "epoch-making" for German thinking on genius and originality.[41] Among those German thinkers most heavily influenced by Young's *Conjectures*—whether directly or more indirectly— are Johann Gottfried Herder and Immanuel Kant, each drawing on Young's view in building their respective larger (and ultimately clashing) aesthetic theories.

In his lengthy 1800 commentary on Kant's *Critique of Judgment*, Herder quotes Kant's view that

[g]enius is a *talent* for producing something for which no determinate rule can be given, not a predisposition consisting of a skill for something that can be learned by following some rule or other; hence the foremost property of genius must be *originality*.[42]

In response, Herder writes:

At all events, genius works according to rules, arises according to rules, and is a rule unto itself, even granted that not every third person could point it out. The "originality" (a very much abused word) of genius can only mean that the genius produces a work of his own powers, not imitated, nowhere borrowed.[43]

So stated, however, Herder's position is ambiguous. On its face, it may seem that he is advocating for a sort of creation ex nihilo—Romantic Originality—in suggesting that a genius produces a *work* that is "not imitated, nowhere borrowed." However, the more compelling reading—given that Herder is modeling this aspect of his view on Kant's—is that it is in the *powers of the author*, the genius, that originality resides. It is this genius that is not borrowed.[44] Herder and Kant disagree on a number of points, but this is a position on which they overlap, and so it may be helpful to examine Kant's more detailed explanation:

[G]enius is the exemplary originality of a subject's natural endowment in the *free* use of his cognitive powers. . . . The other genius, who follows the example, is aroused by it to a feeling of his own originality, which allows him to exercise in art his freedom from the constraint of rules.[45]

As becomes clearer from this passage, the originality Kant speaks of is not originality in the work, but rather originality in opposition to rule following: the genius is not a mechanical follower of rules of composition, but brings about a work that is itself rule determining. The successful work of art sets such a rule in the sense that it brings about the same free play of the imagination and understanding—and so pleasure—in all its viewers.[46]

Although artists and philosophers of the romantic era—in Britain, Germany, and elsewhere—were obsessed with genius and preoccupied with originality, the prevalent romantic notion of originality was not, as is often touted, a notion of creation without drawing on, alluding to, or borrowing from what has come before: creation from nothing. Indeed, the most generally accepted use of originality was primarily applied to the author—or to

his genius—as the power to create outside of accepted rules of composition, and was only secondarily applied to the work, which was "original" in the sense that it was the product of original genius. So where did we ever get the idea that the romantic notion of originality was creation ex nihilo? Robert MacFarlane argues that we can blame the Victorians for that.

MacFarlane suggests that the notion of Romantic Originality was not a view generally held during the height of the romantic era at all, but was retroactively applied in the late 1820s and 1830s as the views of Young and his ilk were "simplified and mythified." The early Victorians had conjured up a nemesis for themselves—the proponent of artistic creation ex nihilo—who was until then effectively unknown.[47] Ignoring this, in Britain, a new class of journalists—"plagiarism hunters"—worked to undermine Romantic Originality by ferreting out sources drawn on by the most celebrated "original" of authors. In his 1887 article, "Literary Plagiarism," Andrew Lang writes: "If you merely use old ideas (and there are no new ideas), and so produce a fresh combination, a fresh whole, you are not a plagiarist at all."[48] Lang predicts postmodernist originality denial: since no author can claim originality to her work, none harms her by borrowing from her. Without originality, there is no ownership; and without ownership, there is no theft. In Germany, the backlash against the specter of Romantic Originality seems to have appeared even earlier. Johann Wolfgang von Goethe, speaking with Johann Peter Eckermann in 1825, asks:

> People are always talking about originality, but what do they mean? As soon as we are born, the world begins to work upon us, and this goes on to the end. And, after all, what can we call our own except energy, strength, and will? If I could give an account of all that I owe to great predecessors and contemporaries, there would be but a small balance in my favor.[49]

A clear favorite among nineteenth-century plagiarism hunters was Samuel Taylor Coleridge, a poet whose name is effectively synonymous with the romantic period of English literature. In the same paper in which essayist Thomas De Quincey calls Coleridge "a man of most original genius,"[50] he also calls the poet out for, among other things, lifting an entire essay in the *Biographia Literaria* from Friedrich Schelling: "from the first word to the last, [the essay] is a *verbatim* translation from Schelling, with no attempt in a single instance to appropriate the paper by developing the arguments or by diversifying the illustrations."[51] Coleridge himself attempts to forestall any labeling as a plagiarist by suggesting that "many of the most striking resemblances, indeed all the main and fundamental ideas, were born and

matured in my mind before I had ever seen a single page of the German Phi-
losopher."[52] Coleridge calls any overlap in their views "[not] a coincidence at
all to be wondered at," given similarities in their respective educations and
studies.[53] Although this defense perhaps outstretches credulity, Coleridge's
view on originality and genius suggests that artistic borrowing—even out-
right plundering—and originality are not at odds. Coleridge contends that
genius lies centrally in the ability "[t]o find no contradiction in the union
of old and new; to contemplate the ancient of days and all his works with
feeling as fresh, as if they had then sprang forth at the first creative *fiat*."[54] As
Paul Guyer puts it, for Coleridge, "Genius is not a gift for discovery or in-
vention so much as for rediscovery of what, in some sense, has been felt all
along."[55]

Coleridge will forever be linked in history with fellow romantic poet
William Wordsworth, with whom he jointly released *Lyrical Ballads* in 1798.
MacFarlane points to "Coleridge's accolade for Wordsworth's poetry, 'per-
fectly unborrowed and [the poet's] own.'"[56] However, in so paraphrasing
Coleridge, MacFarlane falls victim to the same trap that he suggests the Vic-
torians set for themselves. If we turn to the source, we see that Coleridge is
not, in fact, describing Wordsworth's *poetry*, but rather his poetic *imagination*:
"In imaginative power, he stands nearest of all modern writers to Shakespeare
and Milton; and yet in a kind perfectly unborrowed and his own."[57] This way
of speaking should be familiar to us now. The influence of Kant's thinking
on beauty and art can be found throughout Coleridge, and the poet was fa-
miliar with Herder's work as well, so it should come as no surprise that the
poet's view on originality is in line with the philosophers.' Indeed, given his
penchant for the unapologetic pilfering of German philosophers, it seems
likely that this is not mere influence at play—though Coleridge would likely
still call it original.

Disambiguating "Originality"

The Myth of Unoriginality sets up as a foil the persistent belief that au-
thors—writers, artists, composers—create their works ex nihilo. As we have
seen, the first problem with the Myth is that essentially no one held this
belief. The Victorians and their German cohorts were battling, perhaps unbe-
known to them, a boogeyman that did not exist. The Myth, however, would
be passed down from generation to generation, from the late and post-
romantics through the postmodernists, and ultimately to Helene Hegemann
and her contemporaries. The Myth originally seems to have arisen from
a misreading of the theories of Young, Kant, and others, centrally owing to

an oversimplification of dominant romantic views. Analogies of poets as godlike in their acts of creation (analogies ancient even at that time[58]) gave critics an easy model on which to base the caricature of Romantic Originality—certainly an easier task than attempting to explain Kant's aesthetic philosophy to a layman. In some cases, this misreading seems probably intentional, giving plagiarism hunters and others a straw man that, on its surface, superficially resembled the views of the romantics, but was much easier to knock down. At least part of this misreading, however, is likely owing to the fact that the romantics themselves were not always clear about what they meant by originality, and all too frequently oscillated freely between describing the originality of authors and the originality of their works, in the process melding together several conceptually distinct qualities.

This leads to the second problem with the Myth of Unoriginality. The central outcome of unoriginality, we are told, is that it undermines institutions of intellectual property—particularly copyright—and related notions of plagiarism: since modern copyright depends on originality for its central tenet of authorship, if there is no originality, there is no property, and so there can be no infringement. R. G. Collingwood writes:

> We try to secure a livelihood for our artists (and God knows they need it) by copyright laws protecting them against plagiarism; but the reason why our artists are in such a poor way is because of that very individualism which these laws enforce. If an artist may say nothing except what he has invented by his own sole efforts, it stands to reason he will be poor in ideas. If he could take what he wants wherever he finds it . . . his larder would always be full, and his cookery might be worth tasting.[59]

That no one actually believes in Romantic Originality, the purveyors of the Myth might say, only seems to heighten the urgency of this outcome. But we have already seen that several notions of originality are being bandied about, and so assessing this claim depends first on disambiguating these notions.

To say that a work is original in the sense that Young centrally employs is to say that the work is the product of original genius—a work arising from "knowledge innate." The originality of genius, Kant similarly suggests, lies in the *free* use of one's cognitive powers:

> Hence genius actually consists in the happy relation—one that no science can teach and that cannot be learned by any diligence—allowing us, first, to discover ideas for a given concept, and, second, to hit upon a way of *expressing*

these ideas that enables us to communicate to others, as accompanying a concept, the mental attunement that those ideas produce.[60]

The original work should *appear* to have been created according to some rule, but will at the same time seem fresh and appealing. Young writes, "*Originals* shine, like comets; have no peer in their path; are rival'd by none, and the gaze of all."[61] Originality, both of persons and works, tends to be treated meritoriously. Kant suggests, however, that simply departing from rules of composition—hitting on some underived ideas—is as likely to produce "original nonsense."[62] It is only *exemplary* originality that will successfully serve as inspiration to the genius of others.[63]

As might be expected, the sense of originality as the independent exercise of artistic genius (or the products thereof) tends to overlap with notions of originality-as-novelty. At one point, for instance, Young describes an original work as "a perfect stranger" bringing news from a foreign land.[64] There is, of course, nothing strictly conceptual tying these two notions of originality together. Although two artists working from the same rules may be more likely to produce similar outcomes, there seems nothing to prevent two geniuses, each working outside the rules, from doing the same. This notion of originality-as-novelty is likely the most common use of the term today. A recent review of the Netflix series *Orange Is the New Black*, illustrates:

> The series, based on Piper Kerman's memoir of her incarceration and developed by Jenji Kohan, the creator of *Weeds*, was instead bought by streaming service Netflix as part of its nascent original-content business. . . . Netflix has, with Orange is the New Black, a great series that is truly original.[65]

Although based on Kerman's memoir, we are told, the series is nevertheless "truly original": an unusual premise and unique storytelling make for a novel show. As well as being the most common usage, this is also—almost certainly—the notion of originality that most who declare "there is nothing truly original" have in mind. Everything is just a rehashing of what we already had, or as the biblical aphorism goes,

> What has been will be again,
> what has been done will be done again;
> there is nothing new under the sun.[66]

If there *is* originality in the sense of novelty, however, it certainly comes in degrees. Herbert Read suggests that, to the extent that a new work is "slightly

different" from what came before, "it is to that extent original,"[67] defining originality as "a capacity to invent formal variations in the technique of communication."[68] Young, too, allows that "some Compositions are more [original] than others," but he does not expound on this.[69] Young does, however, suggest that one work that borrows even heavily from others may nevertheless be an "accidental Original," if the works from which it borrows are lost.[70] Luckily, we do not have to go in search of true novelty to rebuff originality deniers, since the sort of originality they deny—novelty—is neither the sort of originality at issue in Romantic Originality nor, as it happens, the sort of originality generally at issue in copyright.

Since copyright is largely a matter of each nation's laws, it can at times be difficult to discuss copyright in general terms, though international treaties have largely served to standardize certain aspects of intellectual property law. Jurisdictions within the European Union are still grappling with the 2001 harmonization of EU copyright and how it impacts each nation's copyright laws. However, in a 2011 case, the Court of Justice of the European Union determined that a photograph merited copyright protection if it reflected "the author's personality," that is, "if the author was able to express his creative abilities in the production of the work by making free and creative choices."[71] By choosing such elements as the subject's background, pose, and lighting, a portrait photographer can "stamp" the work with his "personal touch" and so merit copyright protection.[72] The language here reflects a preharmonization tradition in some jurisdictions requiring that a work carry the "stamp of the author's personality," an opaque bit of phrasing. By suggesting that the free and creative choices were sufficient for such a stamp of personality, the CJEU opinion effectively simplified EU conditions of originality.[73]

The CJEU's reasoning mirrors that of an 1884 US Supreme Court case that largely set the initial standard for originality in American copyright law. Here, the court found that a photograph of Oscar Wilde met the minimum requisite bar for originality. By "posing the said Oscar Wilde in front of the camera, selecting and arranging the costume, draperies, and other various accessories in said photograph," the photographer had created "an original work of art."[74] In general, the court suggested, "An author . . . is he to whom anything owes its origin; originator; maker; one who completes a work of science or literature," extending that definition to include "all forms of writing, printing, engraving, etching &c., by which the ideas in the mind of the author are given visible expression."[75]

This notion of originality would continue to be clarified through case law. In a 1936 case, Justice Learned Hand effectively distinguished the legal concept of originality from a principle of novelty, noting:

Borrowed the work must indeed not be, for a plagiarist is not himself pro tanto an "author"; but if by some magic a man who had never known it were to compose anew Keats's Ode on a Grecian Urn, he would be an "author," and, if he copyrighted it, others might not copy that poem, though they might of course copy Keats's.[76]

Decades of court decisions would establish the ground for the Copyright Act of 1976—still holding sway today—which recognizes protected works as "original works of authorship." The 1976 House Report, which forms the legislative history of the Act, notes:

The phrase "original works of authorship," which is purposely left undefined, is intended to incorporate without change the standard of originality established by the courts under the [previous 1909 Copyright Act]. This standard does not include requirements of novelty, ingenuity, or esthetic merit, and there is no intention to enlarge the standard of copyright protection to require them.[77]

This is to say, under US copyright, for a work to quality as original and so protectable, it need not be novel: it need not (a) express unique ideas, nor (b) express ideas in a unique manner. Moreover, it need not possess any discernible aesthetic merit.[78]

Perhaps one of the most-quoted lines about unoriginality comes from English clergyman William Ralph Inge: "What is originality? Undetected plagiarism." As is so often the case with epigrams, the quote is typically accompanied by Inge's name, but not the source. This is telling. In the context of Inge's essay, appropriately titled "Stolen Epigrams," we see a little more:

What is originality? Undetected plagiarism. This is probably itself a plagiarism, but I cannot remember who said it before me. If originality means thinking for oneself, and not thinking differently from other people, a man does not forfeit his claim to it by saying things which have occurred to others.[79]

The first portion of the passage is generally quoted in support of the "myth of originality"—that all purportedly original works simply reproduce what has come before—but the remainder of the passage suggests that novelty is not what is at issue in originality—at least, not the sort of originality we care about in copyright and plagiarism. Rather, what is at issue here is whether the work owes its origin to its author. Indeed, on Hand's interpretation, this is just what authorship *is*.

Arthur Danto suggests in "Artworks and Real Things" that originality in this sense is necessary to being a work: "Being an original means that the work must in a deep sense originate with the artist we believe to have done it."[80] Danto looks to Jorge Luis Borges's "Pierre Menard, Author of the Quixote," the story of an author who looks to write Cervantes's *Don Quixote*—not to *copy* it, but to *write* the novel from his own experience, without reference to the original. By some unexplained mechanism, Menard manages to do precisely this, at least to the amount of two chapters and a fragment of another. Though the completed selection aligns word-for-word with Cervantes' original, we are told, Menard's work is subtler, more ambiguous, and infinitely richer than Cervantes's. This can only be the case, Danto suggests, because Cervantes's work is original *to Cervantes*, and Menard's *to him*. What saves Menard's work from simply *being* Cervantes's is that it was not a *copy*—rather, it was a new original.

Two complications remain, however, with this notion of originality. The first is an issue arising in US law, which I will deal with in a short addendum to follow. The second complication lies in contentiousness regarding the notion that *any* work owes its origin to any single individual—a sort of last-ditch effort by originality deniers—which will be the focus of our next chapter.

American Originality: An Addendum

In 1991, the US Supreme Court decided a case involving telephone books—remember those?[81] Rural Telephone Service was a public utility providing telephone service and (by law) telephone directories to communities in Kansas. Feist Publications produced phone books for larger areas and licensed listings from the producers of regional directories, like Rural. However, Rural refused to license its listings to Feist, and so Feist used the listings without Rural's consent. Rural discovered this when Feist inadvertently reproduced four fictitious listings that Rural had included in its directory, a trap set for exactly this sort of circumstance. There was, as such, no question that Feist had copied from Rural, but the court surprised many by finding that there was no infringement because Rural's directories were not copyrightable in the first place.

Since a telephone directory consists of nothing but facts, which are not copyrightable, if there was copyright to be had, it would have to be found in their collection and arrangement. So far as it goes, this seems to mirror the creation of any other original work. Neither words, nor shapes, nor musical notes are individually copyrightable either, but the original collection and arrangement of such items will be, as literary, visual, and musical works.

The court found, however, that there was a difference between works such as these that merit copyright and the humble telephone book. The court suggested:

> Original, as the term is used in copyright, means only that the work was in-dependently created by the author (as opposed to copied from other works), and that it possesses at least some minimal degree of creativity. . . . To be sure, the requisite level of creativity is extremely low; even a slight amount will suffice. The vast majority of works made the grade quite easily, as they possess some creative spark, "no matter how crude, humble or obvious" it may be.[82]

In the case of telephone books, the court surmised that "there is nothing remotely creative about arranging names alphabetically in a white pages directory. It is an age-old practice, firmly rooted in tradition and so com-monplace that it has come to be expected as a matter of course."[83] Since the selection and arrangement was the only aspect of the publications that could conceivably merit copyright, that left telephone directories in general in the public domain. The court's opinion effectively eliminated American copy-right on the basis of industrious collection—colloquially, the "sweat-of-the-brow" doctrine—which previously protected works consisting in nothing but facts, but where such facts were laboriously collected together by some author or authors. Australia still recognizes such "sweat" copyright—as, until fairly recently, did Canada—but the US Supreme Court changed the game by inter-preting originality as requiring not only independent creation, but also some minimal "creative spark." The problem was that the court offered no explana-tion or conditions for this spark, and in so interpreting originality the court had effectively replaced one ambiguous term with another.[84]

Today, an entire cottage industry attempts to decipher this revised notion of originality, and courts have struggled to pinpoint the precise location of the new minimal bar. (And certainly this isn't the only area in the law where theorists and lower-court judges attempt to "find" some coherent basis left unexplained at a higher-court level.) One popular suggestion is that this creative spark is best interpreted as a matter of "non-trivial" or "material variation." This interpretation begins with the 1992 finding in *Atari Games Corp. v. Oman*, where the court suggested that copyrightability of factual compilations requires "'distinguishable variation in the arrangement and manner of presentation' of public domain elements."[85] However, such an interpretation would seem to violate the preestablished understanding that the notion of originality at play does not include novelty. In a more recent 2003 Seventh Circuit case, Judge Richard Posner (the same Judge Posner

we discussed in chapter 1) suggested that copyright "requires only enough originality to enable a work to be distinguished from similar works that are in the public domain, since without some discernible distinction it would be impossible to determine whether a subsequent work was copying a copyrighted work or a public-domain work."[86] However, it would be incoherent to read this as doing anything but directly contradicting Learned Hand's "Ode on a Grecian Urn" example.

Happily, there seems a more reasonable solution to the problem, one that does not rely on replacing an already difficult term, "originality," with an even more mysterious "creative spark," and which does not require collapsing our notion of originality into originality-as-novelty. Rather, it relies on another basic principle: copyright protects expressions, not ideas. The 1976 Act specifies that

> [i]n no case does copyright protection for an original work of authorship extend to any idea, procedure, process, system, method of operation, concept, principle, or discovery, regardless of the form in which it is described, explained, illustrated, or embodied in such work.[87]

Where some given idea can only be expressed in one or some very limited number of ways, that expression will not merit copyright protection, as protecting the expression would in effect also protect the idea.[88] This principle is known as the "merger doctrine." A utilitarian function qualifies as an idea under the law.[89] And it seems reasonable to suggest that the central function of a telephone directory is to allow users to easily look up the contact information of a person or business in a given area (the area covered by the directory). Further, it seems the only reasonable method for arranging such information is alphabetically by surname or business name. With only one apparent method for "expressing" that "idea," the expression would not be copyrightable under the merger doctrine. Since the organization of the data is the only element of the phone book that a publisher would have claim to (all else being simply facts), and since it has merged with its idea, the phone book as a whole is uncopyrightable.

In short, we do not need to introduce some mysterious "creative spark"— whether or not this would require a principle of novelty—or otherwise overhaul or amend our notion of originality to exclude telephone directories from copyright protection. Indeed, it seems they were not protectable in the first place.

Authorship, Power, and Responsibility

Pride and Prejudice and Zombies

In 2008, Seth Grahame-Smith, nonfiction author of *How to Survive a Horror Movie* and *The Big Book of Porn*, was approached by Quirk Books editor Jason Rekulak with the idea of working a zombie plotline into Jane Austen's beloved classic, *Pride and Prejudice*. Grahame-Smith readily agreed, and in two months churned out *Pride and Prejudice and Zombies*. Published the next year, the work was an instant pop-culture phenomenon, reaching number three on the *New York Times* bestseller list. By 2010, more than 1.5 million copies had been sold, a staggering number given the initial print run of 12,000 copies.[1]

With both Austen and Grahame-Smith credited as authors, the book has been described as "an intriguing literary mashup of Regency romance, B-movie horror and martial arts that attempts to turn a classic novel into a post-modern geek fest."[2] Grahame-Smith began with Austen's novel, then worked to introduce zombies (and a handful of ninjas) into the storyline, adding new material while eliminating or truncating parts of Austen's text. Grahame-Smith notes:

> The point wasn't to rewrite or modernize the original. . . . Rather, it was to preserve as much of it as I could while surgically weaving in (as seamlessly as possible) new words, lines, paragraphs, and occasionally—pages of new battle sequences. Doing that without jarring the reader was the biggest challenge of writing the book. The language and cadence is extremely difficult, and a lot of time was spent reading and re-reading Austen's words in an attempt to mimic them.[3]

The *New Yorker*'s Macy Halford suggests the novel is 85 percent Austen, 15 percent Grahame-Smith, "and one hundred per cent terrible."[4] Vit Wagner of the *Toronto Star* writes:

This week brings good and bad news to those convinced our culture is continuing its uninterrupted march to hell in a hand basket. . . . The good news is that Jane Austen has been restored to the best seller lists. . . . The bad news is that the volume in question is *Pride and Prejudice and Zombies*, a literary mashup co-authored by Seth Grahame-Smith.[5]

I have a problem with these reviews—not with the negative evaluation of the novel (I found it nearly unreadable), but rather with the implication that Austen contributed *anything* to *Pride and Prejudice and Zombies*, that she is (as the cover would suggest) an author of the book. And, I think, mine is not a minority view. Indeed, despite what it says on the novel's cover, most reviewers talk of the novel as being Grahame-Smith's work, discussing Austen only with regard to how Grahame-Smith has alternatively preserved or mangled elements of her original novel.

Multiple Authorship

Some would contend, however, that treating Grahame-Smith as the sole author of *Pride and Prejudice and Zombies* reflects what Jack Stillinger calls the misguided "Myth of Solitary Genius"[6]: the notion that authors work in isolation in their acts of creation.

Peter Jaszi would suggest that Austen and Grahame-Smith are coauthors of a "serial collaboration"—a work "resulting from successive elaborations of an idea or text by a series of creative workers, occurring perhaps over years or decades."[7] Or, in our case, centuries. Jaszi distinguishes this particular form of coauthorship from the more standard categories of "synchronous collaboration," in which two or more authors work in real time as a unit to produce a work, and from "asynchronous collaboration," in which authors work more loosely toward a finished product with no real-time coordination. An example of an asynchronous collaboration would be a *Wikipedia* article, with contributors who may not even be aware of each other's identities, often altering each other's writing in an uncoordinated back-and-forth editing process without any determinable end. An example of a synchronous collaboration would be a more standardly coauthored article, novel, song, or other work that involves some coordination of efforts outside of the work itself in order to produce the seamless finished product. With Jaszi's serial collaboration, there is no coordination between authors, but rather each author in the series takes up what the previous author left behind. It would not matter that, in this case, what Austen left behind was a finished, published novel of her own.

On a similar line of thought, Harold Love treats "authorship" generally as "a set of linked activities (*authemes*) which are sometimes performed by a single person but will often be performed collaboratively or by several persons in succession."[8] As regards *Pride and Prejudice and Zombies*, Austen would fall into Love's category of "precursory authorship," which includes "anyone whose function as a 'source' or 'influence' makes a substantial contribution to the shape and substance of the work."[9] What counts as "substantial" isn't specified by Love, but his examples range from a friend who serves as the model for a character, and snippets of overheard conversation, to cases of more full-blown textual appropriation. In the latter sort of case, if author *B* plagiarizes, appropriates, or otherwise borrows from the work of author *A* in creating her work, then *A* will count as a precursory author of *B*'s work on this account.[10] That author *A* is in no way a willing participant in this process is neither here nor there on Love's account. *A* and *B* are coauthors of what we have been mistakenly calling "*B*'s work."

Stillinger suggests that, although "authors themselves are among the most ardent believers in the myth of single authorship," the view is perpetuated by editors, with their "continual insistence on the supreme importance of the author and the downplaying of their own contributions to the works in which they are, in fact, collaborators."[11] After all, Stillinger notes, an involved editor "is ultimately responsible for the difference between the existence and the nonexistence of a book."[12] Certainly this seems true of Jason Rekulak, who not only edited *Pride and Prejudice and Zombies*, but suggested the original idea. Rekulak, too, would qualify as a precursory author on Love's account. Love argues that "we need to recognize that most novels are much more like films than we are prepared to acknowledge in deserving a long roll-out of credits at the end."[13] Stillinger similarly suggests that a central question remains as to "whether 'pure' authorship is possible under any circumstances—single authorship without any influence, intervention, alteration, or distortion whatsoever by someone other than the nominal author."[14]

In a study finding that 87 percent of professionals surveyed—including psychologists, chemists, engineers, technical writers, and others—engaged in collaborative writing, Andrea Lunsford and Lisa Ede define writing as "any of the activities that lead to a completed written document [including] written and spoken brainstorming, outlining, note-taking, organizational planning, drafting, revising, and editing."[15] The notion of authorship as an individual activity, Lunsford and Ede argue, that "strikes most people as not only commonsensical but also somehow inevitable, is actually a cultural construct, and a recent one at that."[16] It is worth noting that Lunsford and

Ede's finding came only after an earlier one in which 82 percent of respondents reported only writing on their own. Lunsford and Ede note, "The wording of the question [in the original survey] and the commonsense view of writing as the physical act of putting pen or typewriter key to paper probably contributed to this anomalous response."[17] It isn't clear what, exactly, made such a response "anomalous," but if we want to include any act in which one engages with others about a work they are writing, including any act of brainstorming or editing, as "writing," then I am frankly stunned that only 87 percent admitted engaging in such activities. The remaining 13 percent must be self-publishing hermits or else working exclusively on high-level classified government contracts.

Perhaps Stillinger is correct that "pure" authorship of the sort he describes is a myth, but it is a far cry from suggesting that the truly "solitary" author is a fiction to concluding that each and every individual who impacts the creation of a work is thereby an author of it.

Authorship and Responsibility

In *Art and Art Attempts* (2013), Christy Mag Uidhir suggests the following minimal condition of authorship:

> A is an author of w as an F if and only if A is directly responsible, at least in part, for w as an F (i.e., the way in which w falls under sortal F).[18]

Mag Uidhir argues that, at minimum, authorship is a three-place relationship holding between a work (w), an author (A), and a sortal kind (F). So, as an author, one does not create a work *simpliciter*; rather, one creates a work of a particular kind—a novel, an abstract painting, an installation piece, with each sort of work carrying its own satisfaction conditions. I am skeptical about the notion that authorship must be sortal in this way, but we can put that to the side. I am more interested here in Mag Uidhir's notion of *collective* authorship.

Where there are multiple authors, Mag Uidhir distinguishes between *collaborative* and *noncollaborative collective authorship*. In each case, each contributing author is responsible for some aspect or aspects of the work in question. Where collective authorship is collaborative, there is some dependence relation holding between the respective authors' contributions to work w being of kind F: either author B's contribution in this regard depends on the contribution of author A, or vice versa, or they mutually depend on each other. Where collective authorship is noncollaborative, each contribution

is independent: each contributes in her own way to w being of kind F, but neither contribution depends on the other for its success in this regard.

Mag Uidhir suggests his view of collaborative collective authorship can cover problematic cases including "posthumous authoring (e.g., B completing the late A's unfinished novel)."[19] But this seems particularly odd. Take the famous case of Charles Dickens's *The Mystery of Edwin Drood*. Published serially in monthly installments between April and September 1870, Dickens had apparently planned a further six installments, but died before having a chance to complete the work. Starting that very same year and continuing right up until the present, several writers have taken it upon themselves to provide endings to the story. An 1875 ending, for example, was published by Thomas James, who claimed to be channeling Dickens's spirit. Assuming we can happily put aside James's paranormal claim, we can nevertheless ask, *is* Dickens an author (presumably, a coauthor with James) of this "complete" work of *Drood*? According to Mag Uidhir's account, apparently he is. With A and B representing (for our purposes) Dickens and James respectively, P indicating the product of each writer's work, and I standing for each writer's intentions regarding the art-making activities, Mag Uidhir describes collaborative collective authorship:

(1) Only P_A and P_B are constitutive of w as an F.

(2) P_A if *or* only if P_B.

(3) So, I_A substantively figures in P_A being constitutive of w as an F if *or* only if I_B substantively figures in P_B being constitutive of w as an F.

(4) So, A is an author of w as an F if *or* only if B is an author of w as an F.[20]

In short, Dickens and James are coauthors in Mag Uidhir's collaborative sense because (one presumes) James's contributions (P_B) depend on Dickens' contributions (P_A). Perhaps you are okay with this result—perhaps you don't have a horse in this race—but there are two strange outcomes here.

First, as laid out by Mag Uidhir, there is nothing in the view that would disbar a *contemporary* of Dickens—say, a young Mark Twain—from doing exactly what James did, but before Dickens's death: publishing new chapters to *Drood* (say, before Dickens was able to write the next installment), and so becoming a coauthor of the work. I certainly do not think that we want to allow one writer to hijack the work of another in this way, but more on this below.

Second, if we want to allow that Dickens *is* a coauthor of the "James" *Drood*, then it would seem he is *also* a coauthor of the 1980 version with an ending provided by Leon Garfield (as Dickens's "contribution" to each is

the same, and there is presumably no other difference about the cases that would make him the author of one but not the other), as well as the several other "complete" versions published in the interim. One needs to ask, how many works has Dickens been authoring from his grave?

The issue here seems to turn on the w in Mag Uidhir's analysis. Presumably, Dickens, James, and Garfield are not *all* coauthors of one and the same work. For one thing, the "James" *Drood* has a very different ending from the "Garfield" *Drood*; for another, James's and Garfield's products and intentions in no way depend on each other. And so where James had intentions and performed activities directed toward some work, w_1, Garfield presumably directed his intentions and activities toward some distinct work, w_2. Now, we might ask, what was the w toward which Dickens was directing *his* intentions and activities?

Presumably, in writing *Drood*, Dickens was not directing his intentions and activities toward two distinct works (and certainly not the potentially countless "finished" versions possible). So, granting that James's work and Garfield's work *are* distinct works, Dickens (insofar as he was directing his intentions and activities toward a single work) could not have been directing his intentions and activities toward both. And since there is no principled distinction, so far as we know, between the activities of James and Garfield as regards their respective works, there is nothing to suggest that Dickens coauthored the work of one but not the other. And so we are left with the only apparent option: Dickens was not a coauthor of *either* James's work or Garfield's.

Mag Uidhir may now revise his claim about posthumous authoring and suggest that the cases of both James and Garfield fall into his category of appropriation cases, where the intentions of the source author (in our case, Dickens) in no way direct the art-making intentions and activities of the appropriators.[21] And this much seems right. We do *not*, I think, want to hold Dickens responsible for *any* aspect of "completed" versions of *Drood*—not even those that remained unchanged from his writing. And this, I would argue, is because whether the material that Dickens "contributed" remained the same or was changed (as was the case with the first "completion" by Robert Henry Newell, in 1870) was in no way *up to Dickens*. And the same seems true for Jane Austen and *Pride and Prejudice and Zombies*.[22]

Certainly, I think, it would be a failing if Seth Grahame-Smith pretended that he had *not* taken extensively from Jane Austen in creating *Pride and Prejudice and Zombies*. Undoubtedly, he owes a great debt to her. However, to attribute authorship to Austen seems to repay a debt with a burden. Authorship implies responsibility. To attribute *authorship* to Austen is to imply that

she is in some way *responsible* for *Pride and Prejudice and Zombies*. Would it be reasonable to blame Austen in any way for the sheer number of anachronisms in the novel? Alternatively, would it be reasonable to praise Austen for those delightful scenes of haughty aristocrats being devoured by the undead? Perhaps not, one might say, but only because these are elements of the novel contributed by Grahame-Smith, and not Austen. In general, however, it seems unreasonable to attribute praise or blame for the elements of a work over which one had no choice. Austen *had* a choice about whether to have Elizabeth turn down Mr. Collins's marriage proposal in chapter 19 of *Pride and Prejudice*, but *no* choice about the same event in the same chapter of *Pride and Prejudice and Zombies*. One should not confuse one novel with the other.

The *Drood* case is essentially the flip of *Pride and Prejudice and Zombies*: in the former, one writer has tried to make himself an author of the work of another; in the latter, one writer has tried to make another an author of his work. The difficulty is the same in each case, however: although authorship is undoubtedly an intentional matter, intention alone (whether one's own or that of another) will not make one an author of a given work. Just as authorship implies responsibility, responsibility implies power.

Authorship and Power

A work undoubtedly comes about as the result of intentional activities: the selection and arrangement by the author or authors of elements that will constitute the work. If the work is a work of literature, for example, these will ordinarily be words, punctuation, and other formal bits and pieces arranged together into sentences, these into paragraphs, and these into chapters. Authors are not restricted to the standards of a medium, though these certainly *are* standards: painters standardly work with paint, photographers with cameras and photographic paper, and musicians with notes and instruments. But, whatever her medium, and however closely she adheres to the standards of that medium, the author's work comes about as a result of her directing her intentional activities of selection and arrangement toward that work.

Even before she begins, the author is more than likely directing her intentions toward some object not yet in existence—what we would call a *merely intentional object*—in the same way that I may direct my thoughts and energies toward a car I may want to buy some day down the road, but which does not yet exist. The difference between the cases is that the author will go about *creating* the object of her intentions, while I have neither the inclination nor ability to create my car.

However, to be an author of some given artwork, it isn't enough that an agent *directs* her intentional activities toward that object. Consider, again, the case of a young Mark Twain who in the spring of 1870 takes it upon himself to hijack *The Mystery of Edwin Drood*—at the time still being written by a living Charles Dickens—say, by writing and publishing a second install- ment before Dickens himself has an opportunity to do so. Our young Twain has directed his intentional activities—here, by writing—toward Dickens's novel, but I do not think we want to allow that Twain can, simply by his intentional actions toward Dickens's work, contribute to that work. He cer- tainly may have created a work of *his own*, but what seems to keep Twain from hijacking Dickens's work in this way is that he lacks the *power* to do so.

So, what determines this power?

At a first pass, it would appear that what bars agent *B* from determining the nature of the work of agent *A* is that *A* has a form of first-comer *owner- ship* over the work. That is, Twain cannot select elements as constitutive of *The Mystery of Edwin Drood* because the work *belongs* to Dickens. Even before beginning writing the novel, we might say—when the work is still merely an intentional object—Dickens has staked a claim to it, making our young Twain a sort of claim jumper. However initially intuitive, on reflection this avenue appears to be a wrong turn. It is at least in principle *possible* to violate another's ownership rights: I own my car, but it is certainly possible that you might steal it; if I own my home, I still lock my doors and windows to keep others from entering it. Ownership rights are a normative matter— they *can* be violated—and the possibility of violating a right seems con- tained in the very notion of a "right." Whether or not author *B* can become a coauthor of the work of author *A* is not a normative matter in this restric- tive sense. It's not that Twain would be *blameworthy* for making himself an author of Dickens's work; rather, he would not be able to do so at all. For a more promising analogy, we might want to look instead to something like a basketball game. Suppose that I am attending a basketball game, and I am upset that the home team is behind on points. In an effort to save the game, I leap from my seat, charge onto the court, rip the ball from the hands of the visiting team's point guard, and hurl it across the court into his net. My miraculous three-point shot puts the home team ahead just as the buzzer goes, and I am carried off the court on their shoulders. Well, no. Although I *have* undoubtedly violated some norms, the central problem here is that I simply am not able to affect the outcome of the game in this way. I do not have the power to score points in a game to which I am merely a spectator, no matter how good of a ballplayer I might be. And what is true for me here is true for young Twain: although he may violate some norms in attempting

to hijack Dickens's work, this isn't the central problem; his attempt will not be successful, regardless of how good a job he does.

What keeps young Twain (or James, or Garfield) from being an author of Dickens's work is the same as what keeps Austen from being an author of *Pride and Prejudice and Zombies*: in each case, the writer lacks the power of becoming an author of the work in question. Similarly, Grahame-Smith and Rekulak lack the power to *make* Austen an author of Grahame-Smith's work by intentional fiat. Like my failed basketball play, however, what makes it the case that an individual lacks the power to coauthor a given work (or to make another an author of some work) only makes sense in terms of a wider cultural practice.

Last chapter, we considered Michel Foucault's suggestion that the notion of authorship arose in the romantic period as a function of discourse. The "author function," Foucault argues, is a cultural construct—a means of limiting the proliferation of meaning and discourse by tying meaning to an author. Again, Foucault follows Roland Barthes, who contends, "To give a text an Author is to impose a limit on that text, to furnish it with a final signified, to close the writing."[23] Foucault suggests that

> the author is not an indefinite source of significations which fill a work; the author does not precede the works, he is a certain functional principle by which, in our culture, one limits, excludes, and chooses; in short, by which one impedes the free circulation, the free manipulation, the free composition, decomposition, and recomposition of fiction.[24]

Many, inspired by this line of thinking, have suggested that, indeed, the author function is the *key* to literary interpretation: that, rather than looking to some factual author to settle matters of debate, we should look instead to an "author" *constructed* from the work. Alexander Nehamas suggests, "The author is the agent postulated to account for construing a text as an action, as a work."[25] The author and work emerge from the interpretive act, with the author being "whoever can be understood to have produced a particular text as we interpret it."[26] Similarly, Daniel Nathan argues that we should, in our interpretive acts, look to the "intentions" of "an idealized, hypothetical author, an author who can be held responsible for everything in the text, being aware of all the relevant context, conventions, and background assumptions, an author for whom we can imagine everything is there by design, on purpose."[27] Jenefer Robinson argues that a work's style is normally expressive of a work's implied author: "the author as she seems to be from the evidence of the work," the persona adopted by the author to tell a story.[28]

With the possible exception of Nehamas, however, proponents of the "postulated," "hypothetical," or "implied" author would seem to rely, at least conceptually, on the notion of an *actual* flesh-and-blood author, but one who is unavailable, unreliable, or otherwise wanting as a basis for determining meaning. Others, equally inspired by Foucault, have suggested that there is, after all, *no* true author of any work (quite often as a misreading of Foucault).[29] Marjorie Perloff tells this story:

> In the late 1980s, when my university was trying to hire an assistant professor in modern fiction, a candidate who had given a talk on Joyce was criticized by a senior fiction writer in the department, a man who, as it happened, regularly taught courses on *Ulysses* and *Finnegans Wake*. In response to this professor's critique, a young cultural studies star, who was rooting for the candidate, responded scathingly, "Well, what does X know? He's only a writer!" These were the Foucauldian days, when we all knew there was no such thing as an author, only an author function—no individual talent, only writing as a symptom of the culture it represented. Genius theory was deader than dead—a quaint notion left over from Romantic poets such as Percy Bysshe Shelley, who dared to call poets the "unacknowledged legislators of the world."[30]

Quite often, the no-author position is tied to the issue of originality considered last chapter: without ex nihilo originality, there is no authorship.[31] Others have suggested, instead, that authorship is merely "a culturally, politically, economically, and socially constructed category rather than a real or natural one."[32] Following Foucault, Martha Woodmansee contends that the notion of an author, "an individual who is solely responsible—and therefore exclusively deserving of credit—for the production of a unique work" is an "invention" of eighteenth-century writers.[33]

Undoubtedly, authorship *is* a product of artistic and broader cultural practice, but it would be a mistake to jump from this to the all-too-familiar claim that "the author is a fiction." Basketball too is, after all, a social construct, but that man with the ball *really is* a point guard. In general, my view is that authorship of a given work consists in the exercise of one's power to select and arrange elements as constitutive of that work. And just as it is the rules of the game that make an individual a basketball player in a given game, so too do the rules of the art game determine what makes an individual an author of a given work. As Stanley Fish rightly notes, "It is no contradiction to say that something is socially constructed and also real."[34] A full and complete answer to what determines the rules of the art game such that an author retains sole power to create her work will undoubtedly be a

complex historical, sociological, and anthropological one, but the short answer is: *we* do, *society* does. Power in this sense is recognized power. Recognition that the author brings about something we would identify as a work is grounded in artistic practice, as is the power vesting in such authorship, but none of this makes the author a fiction: an unreal thing.

What *gives* the author sole power to create his work is a matter of cultural practice, and certainly could have been otherwise. Foucault, Woodmansee, Mark Rose, and others contend that authorship of this sort arose with (perhaps as a result of) the institution of copyright in the eighteenth century and the by-then-widespread notion of artistic genius.[35] I would suggest that copyright laws were developed to *reflect* the recognition of authorial power. Nevertheless, I think we can agree that there was most likely a time in history when there were no authors in this sense. In preliterate cultures, oral traditions of storytelling would seem to necessarily resist such a power, stories being passed down and modified with each telling. It may simply be that, with such orally transmitted and transmutable stories, there is no work to *have* an author. How far back must we go in Western civilization to find such a culture? I can't say. However, the simple fact that the ancient Greeks recognized some individual, Homer, as the author of the *Iliad*—even if this attribution is erroneous[36]—is evidence that *some* notion of authorship was at play. That there were cultures, or are cultures, that lack our concept of "work" and so our concept of "author" is no argument that we have no works and authors today; these same cultures probably lack basketball players as well, but this doesn't mean there aren't basketball players here in our culture, today.

To say that things *could* have been otherwise is not to suggest that they *should* be otherwise. On this point, Barthes is unclear as to whether his view about the death of the author is a meant as a descriptive view or a prescriptive one—that is, whether the author *is* dead, or whether we should *kill* her. Foucault, for his part, simply predicts an eventual sloughing off of the author function:

> I think that, as our society changes, at the very moment when it is in the process of changing, the author-function will disappear, and in such a manner that fiction and its polysemic texts will once again function according to another mode, but still with a system of constraint—one which will no longer be the author, but which will have to be determined or, perhaps, experienced.[37]

And certainly, a number of theorists and artists have attempted to fulfill the Foucauldian prophecy by accelerating the death of authorship, perhaps most notably Sherrie Levine. Among Levine's early works is a series of silhouettes

of US presidents. However, instead of cutting her silhouettes from matte black paper or cardboard—as in the tradition of August Edouart or Philippe Derome—Levine cut hers from seemingly unrelated magazine pages, and so a runway model is captured in the silhouette of Abraham Lincoln, and a smiling mother hoists a laughing child inside John F. Kennedy's simple profile. Each silhouette became a frame for the image inside—or beyond—it, playing off contrasts hinted at by the juxtaposition. Before long, Levine moved from hanging these works on gallery walls to simply projecting enormous wall-sized images of them. Gerald Marzorati suggests that in these oversized, blurry projections, Levine herself had faded away: "Her hand was gone; but what was *there?*"[38] The audience member, Marzorati suggests, is left in an ambivalent state, untrusting his own response because unsure about where—if anywhere—the artist figures in the work.

Eventually, Levine abandoned altogether the frame and moved toward forms of *reproduction*—rephotographing photographs by Walker Evans and Edward Weston; repainting paintings by Kasimir Malevich and Ilya Chasnik; recasting lawn gnomes and even Duchamp's *Fountain* in bronze. Levine herself, however, only *suggests* her refusal of authorship without stating it outright. In a 1982 artist's statement (itself borrowing heavily and without citation from Barthes and other sources), Levine writes, "Succeeding the painter, the plagiarist no longer bears within him passions, humours, feelings, impressions, but rather this immense encyclopaedia from which he draws."[39] One of Levine's early critical supporters, Craig Owens, asks:

> [W]hen Sherrie Levine appropriates—literally takes—Walker Evans's photographs of the rural poor or, perhaps more pertinently, Edward Weston's photographs of his *son* Neil posed as a classical Greek torso, is she simply dramatizing the diminished possibilities for creativity in an image-saturated culture, as is often repeated? Or is her refusal of authorship not in fact a refusal of the role of creator as "father" of his work, of the paternal rights assigned to the author by law?[40]

Perhaps the foremost authority on Levine's work, Howard Singerman, suggests:

> The question of authorship continues to inform most readings of her work—correctly, I think—but it provides an oddly unstable ground of interpretation: initially understood as working against the "oeuvre"—one of the central figures for the author, for his organization and coherence—Levine now, some thirty years later, has a body of work of her own.[41]

And there's the rub. That Levine's works are interpretable at all, argues Sherri Irvin, is evidence of their being authored: authorship consists in the artist's responsibility for the objectives pursued in the work, and for every aspect of the work chosen to fulfill those objectives.[42] And it is this responsibility, Irvin argues, that makes interpretation a coherent activity. We might reasonably ask of Levine's work, for example, why did she select the image of a high-fashion model to fill the visage of Abraham Lincoln, and the mother-and-child image to fill up Kennedy's negative space? And if these were random choices, why did Levine choose randomly? We can ask why Levine selects only the works of male photographers to rephotograph, and then seemingly only when that photographer is depicting someone so "other" than himself. Certainly, these are reasonable interpretive questions, but they are reasonable only because Levine bears responsibility for her artistic projects—because she *is* the author of her work. Ironically, Levine is attempting to eschew authorship through acts *of authorship*, but she can't have it both ways.

Authorship arises from our cultural practices regarding art, and it is ultimately these practices that give an author—exclusive to all others—the power to select and arrange elements as constitutive of her work. Foucault is certainly correct that works have authors of the sort they do because we treat them that way. In principle, any cultural practice—including any artistic practice—seems open to change. However, changing such practices requires conceptual change, which may prove especially difficult when a concept is as deeply rooted as our concept of authorship. And Sherrie Levine seems to have found that the mantle of authorship is not one easily shed. The central difficulty would seem to be that Levine's attempts are made within the very framework of practices that itself empowers authorship. As things stand, however, in practice, avoiding authorship is a simple thing to do: stop authoring, stop creating works.

Multiple Authorship, Again

Given my view that an author of a given work is one who has and exercises the power of selecting and arranging elements as constitutive of that work, it would appear that authorship is a sort of intentional action, with authored works being the products of such actions. As authorship implies responsibility, and intentional actions are the central sorts of things for which we hold agents responsible, this seems to fit. Further, treating authorship as a form of intentional action would also seem to help explain genuine cases of multiple or coauthorship by looking to views of collective intentionality, and a number of philosophers have attempted precisely this.

C. Paul Sellors argues that authorship is "an *intentional action of an intending agent* that *causes* a text,"[43] and this much certainly seems in line with the view I have put forward. Looking to account for collective authorship, Sellors relies on John Searle's notion of "we-intentions."[44] Where an individual intentional action will rest on the agent's "I-intention" (such as a lone author's intention to express some attitude, or to do so using these words, notes, or colors), collective action rests on something over and above any of the I-intentions had by any of the collective agents. As Searle rejects anything like a group mind—and so a truly shared intention—a we-intention will not be an intention had by a "we," but rather an intention had by a member of the group taking the form, "We intend that we perform act A,"[45] including some presumed collaborative activity on the part of other agents with regard to some given project. So, applied to cases of collective art making, two authors of a cowritten novel, for example, would each ordinarily have the "we-intention" that they work together to create the work, each doing his or her own part. However, Searle and Sellors recognize that any such person could be mistaken about there actually being any true group to which he is a member—that an agent "may be mistaken in taking it that the 'we' in 'we intend' actually refers to a we."[46] So, while the having of the we-intention will be sufficient to make one a coauthor of the work in question, it is not necessary that any of the other coauthors have similar such we-intentions. On Sellors's view, then, it appears our young Mark Twain could reasonably make himself a coauthor of Dickens's *The Mystery of Edwin Drood* by virtue of his we-intention, and there would be simply nothing that Dickens could do about it. That James or Garfield could become coauthors of Dickens's work after his death, or Grahame-Smith make Austen a coauthor of *Pride and Prejudice and Zombies*, seem at least possible on this view, but I would suggest the Twain hijacking case alone establishes grounds for rejecting Sellors's approach.

Another approach is adopted by Paisley Livingston, drawing on Michael Bratman's theory of collective intention underlying shared cooperative activity.[47] Livingston suggests that coauthorship (what he calls "joint authorship") rests on the "meshing sub-plans" of a work's authors. Livingston lays out his view:

> [J]oint authorship requires that two or more contributors A_1, \ldots, A_n intentionally make an utterance or work for which they take shared responsibility or credit, and they do so by acting on the following intentions:
>
> (1) A_1 intends to contribute to the making of utterance U as an expression of A_1's attitudes.

(2) A_1 intends to realize (1) by acting on, and in accordance with subplans that mesh with those of the other contributors, including subplans relative to the manner in which the utterance is to be produced and to the utterance's expressive contents.

(3) A_2 intends to contribute to the making of utterance U as an expression of A_2's attitudes.

(4) A_2 intends to realize (3) by acting on, and in accordance with subplans that mesh with those of the other contributors, including subplans relative to the manner in which the utterance is to be produced and to the utterance's expressive contents (and so on for other contributors).

(5) A_1, \ldots, A_n mutually believe that they have the attitudes 1–4.[48]

On Livingston's view, the central difference between being a coauthor and being a mere contributor, it would seem, is that the coauthor intends the work to which he contributes to be (in part) an expression of *his* attitudes. A mere contributor to the final shape of the project is simply doing his job. On this view, young Mark Twain would not be an author of *The Mystery of Edwin Drood*, and Jane Austen would not be an author of *Pride and Prejudice and Zombies*, and so things are looking good so far.[49] However, the view will run into problems. Take the case of the 2000 film, *Left Behind*. Adapted from the 1995 novel by Tim LaHaye and Jerry B. Jenkins, the film centers on the Christian eschatological theory of pretribulation Rapture, in which believers are taken up to heaven, while the remaining humans are left behind to endure the coming apocalypse. The film is an ambitious attempt to make a populist narrative from a Christian story, interweaving Tom-Clancyesque espionage and disaster movie tropes with the central story of the Book of Revelation. The movie stars Kirk Cameron, who famously left the sitcom *Growing Pains* because his outspoken Christian evangelicalism was at odds—he felt—with the television show, its cast and crew. Says Cameron, "As an actor, I wanted to be a part of projects that are going to point people toward good things. It's not that I wouldn't be involved in a project that would portray wicked and evil things, but I want ultimately the takeaway from the film to be edifying to the Lord"[50]—a fair description of *Left Behind*. Now, we might reasonably imagine that Cameron signed on to the project, at least in part, because he took it to be an expression of his Christian attitudes, and contributed to the making of the work as an actor because of this. So Cameron would fulfill Livingston's first condition. Further, we can imagine that Cameron intended to realize this by acting according to subplans (for instance, how he would flesh out his character) in ways that would mesh with the subplans of the other contributors (the director, the producers, or

the editor, for example). And so Cameron would fulfill Livingston's second condition. It would not seem to matter that any of the other such contributors (the director, producers, or editor) share Cameron's particular Christian attitudes—which, apparently, they did not[51]—so long as his subplans *meshed* with theirs. And so, assuming all parties believe the others are acting on plans and subplans according to which the work is an expression of their respective and compatible intentional attitudes, all are coauthors, including Cameron.

Perhaps this seems an unusual case, but not too unusual to allow.[52] Imagine, however, that Cameron had been an atheist and took the role only to pay his bills, and not because he saw the work as an expression of his own attitudes—indeed, saw the work as antithetical to his views—but nevertheless did his job in precisely the manner of the actual Cameron. Now, it seems, atheist-Cameron would *not* be an author of the work (failing condition 1, and so also 2), with the only apparent difference being a matter of buy-in to the film's Christian message. It seems strange that whether or not Cameron is an author of the film should turn on this. I suspect, however, that the problem lies in a deeper issue. While actual-Cameron signs on to the project because he takes it to be expressive of his Christian attitudes, and atheist-Cameron signs on simply to receive a paycheck, what neither actual-Cameron not atheist-Cameron has is the power *to* determine what the film is ultimately an expression *of*. In each scenario, Cameron is essentially a free-rider on the attitude being expressed, and while we might hold either responsible for what the *New York Times* calls the "high-school-level acting" in the film,[53] neither, I think, can reasonably be held responsible for the work *as a whole*.

Livingston reasonably does not take the contributions of ordinary actors as contributions of authorship, and wants to limit authorship to that individual or individuals whose "contribution and control are decisive and overarching."[54] However, it seems that his conditions of coauthorship fail to decisively make this distinction. What Cameron lacks with regard to *Left Behind*, and what Livingston's conditions of coauthorship centrally fail to capture, is *power*.

A third approach is offered by Sondra Bacharach and Deborah Tollefsen, who draw on the work of Margaret Gilbert.[55] Coauthorship, on this view, depends on authors being members of a mutually recognized artistic group who have made a joint commitment to make some work or works *as a body*. Unlike Sellors's view, Bacharach and Tollefsen's approach requires some actual recognition among members that they are acting as a group, such that members are granted both obligations and entitlements with regard to the

project at hand. Sellors's view seems to allow that one can simply "intend" a group into existence, and Livingston's view seems to allow that one can "intend" his way into a group by having the right sorts of beliefs about the work. Bacharach and Tollefsen, however, contend that members of a group must be mutually *aware* that they are members of such a group and create a work "as far as possible . . . as if there were a single author."[56] In acting as a body, Bacharach and Tollefsen suggest, it makes sense to praise or blame the body as a whole for the resulting work or works.

Now, as there is no such joint commitment between Austen and Grahame-Smith, or Dickens and James, Garfield, or Twain, these will not be cases of coauthorship on this view, and this is as we would hope. But it seems reasonable to suggest that there *is* a joint commitment to create a work of film by the director, producers, editor, and actors in *Left Behind*, seemingly making all such parties members of the group and so coauthors of the work. Having made such a commitment—and here, explicitly by contract—each member of the group is assigned certain obligations and entitlements. Perhaps surprisingly, this outcome is precisely what Bacharach and Tollefsen contend:

> Gilbert's theory of plural subjects allows for the fact that in many social groups there will be a distribution of labor and that decision making may be relegated to certain members of the group. A cast and crew may jointly commit to making a film together but also jointly commit to a specified mechanism for determining the shape of the film, namely the director's say-so.[57]

And so, not only would Kirk Cameron be a coauthor of *Left Behind*, so too would have been his atheistic counterpart. Indeed, according to this view, so too would be almost every member of the cast and crew.[58] Certainly, it makes sense to hold Cameron responsible for his acting, whether good or bad, just as it makes sense to hold the dolly grip responsible for the smooth movement of the camera dolly. But neither of these individuals is ultimately responsible for the acting or shots *as they appear as a part of the film*. Those decisions seem up to others. How a scene is to be shot and whether a scene needs to be *reshot* are typically decisions of the director. Which shots are selected and how they are to be combined are ordinarily the decisions of the editor. We can quibble over which of these individuals has the ultimate say in the shape of the film (though I would expect that in most cases it is a matter of agreement between them), but what is clear is that the shape *of the film* is not a decision to be had by anyone serving in his capacity as an actor or a dolly grip. When the cast and crew "jointly commit to a specified mechanism for determining the shape of the film"—when they hand over

the power to select and arrange elements as constitutive of the work—what they cede control of is *authorship*.

Of course, many works do have more than one author. Where there are multiple authors to a work, there is more than one individual who has and exercises the power to select and arrange elements as constitutive of that work. In cowriting an article with a colleague, he and I share responsibility for the outcome of the work because he and I have exercised our shared power to create the work. In this case, we likely take shared responsibility for the work as a whole. In other cases, a work may have multiple authors, each of whom takes responsibility for only his or her contribution to the work, as when several authors contribute entries for an encyclopedia or, more impressively, the 48,000 individually created three-foot-by-six-foot panels making up the NAMES Project AIDS Memorial Quilt. In either case, where more than one individual can be identified as meeting the condition for authorship of a work, that work has more than one author. Where that work is made up of discrete, identifiable units of authorship, let us call that work *multiply authored*. Where the work is a unified whole without discrete, identifiable units of authorship, let us call that work *coauthored*. In a coauthored work, each author will retain the power of authorship for the work as a whole, and so responsibility for the whole; in a multiply authored work, each author retains power of authorship only for her discrete part of the work, and so responsibility for that part. Certainly, cases of coauthorship will normally involve intentions regarding one's coauthors—and cases of multiple authorship *may* involve such intentions—but I would argue this is not strictly required.[59] Although authorship is undoubtedly an intentional matter, what makes two individuals authors of the same work are not centrally coordinated intentions, but rather each acting on her power to *be* an author of that work.

Authorship Is Messy

As a cultural practice, intentional acts of authorship are restricted by the rules embedded in such practice. Culture is messy, however, and so authorship is bound to be messy as well. In particular, questions are sure to arise as to who has and exercises the power in a given dynamic to select and arrange elements as constitutive of a given work. If, for instance, I bring the manuscript I am currently writing and offer it to a publisher, and that publisher demands changes before accepting it, the publisher is certainly evidencing a certain sort of power. However, this would not be the power of authorship. I can agree to these changes, or I can take my project elsewhere. But what about producers who hire a director for a film? In 1977, Richard Donner

was hired by producers Alexander and Ilya Salkind to direct both *Superman: The Movie* (1978) and *Superman II* (1980), which were to be filmed concurrently.[60] Principal photography for *Superman* wrapped in October of that year, and shooting for the sequel—which was about three-quarters complete—was halted while Donner worked on postproduction for the first film.[61] A year and a half later, shooting recommenced on *Superman II*, and although *Superman* had been a blockbuster, the Salkinds replaced Donner with Richard Lester. Reportedly, Lester offered Donner shared directorial credit for the final film, but Donner refused. Under Directors Guild rules, Lester would then have to shoot 40 percent of the film to obtain sole director's credit, which required filming a great deal of new material.[62]

Although Lester offered Donner shared *credit*, this would not amount to authorship if Donner did not retain power over the final shape of the film. In either being fired from the film or in abandoning it (accounts differ), Donner lost any claim to authorship of it. So, it would seem that Lester retains sole authorship of the film. However, there is reason to hesitate here as there may be reason to think that the film's producers, the Salkinds, are ultimately the film's authors. Certainly, the Salkinds had the power to replace Lester at any stage if they were unhappy with his work. And, unlike the case in which a publisher turns down my manuscript, it seems that contract and copyright keep Donner and Lester from simply taking their work elsewhere. Rather, each director was hired to work on one and the same film—the film being produced by the Salkinds. This is to say that the producers had the power to *determine* who had the power to select and arrange elements as constitutive of that very film. On its face, however, this power of the Salkinds' does not itself amount to authorship, which requires not only *having* the power to determine the shape of the work, but also *exercising* this power. If the Salkinds allowed Lester to determine the shape of the film in the way that he saw fit, Lester alone would appear to be the work's author. If, however, the producers stepped in at postproduction and altered the shape of the film, this would seem to make the Salkinds the work's authors. Similarly, the producers could maintain an authorship position even if they made no hands-on alteration to the film, but rather provided the director with instructions about how they envisioned the work, on the understanding that if the director failed to make the work to their satisfaction, they would bring in another director to do so. In this scenario, the producers would bear a relationship to the director analogous to that which an artist like Ai Weiwei or Rachel Whiteread bears to his or her hired fabricators. Although neither Ai nor Whiteread may step in and get his or her hands dirty on a given project—leaving the actual production to others—I would suggest

that the instruction and direction amount to the selection and arrangement of elements as constitutive of the work at hand. Power dynamics can be complicated relationships, and I expect that many may disagree about who retains what power in any given such relationship. However, even in such cases of disagreement, I would suggest that disagreements *are* ultimately disagreements of fact over who had responsibility for what, who had power over what, and what each party created, if anything.

Livingston suggests that when things get *too* messy, there simply *is* no author. Livingston raises cases of what he calls "traffic jam" films:

> Consider, for example, an extreme case in which a film gets made by a number of professional film makers who are hired and fired in succession by warring producers who themselves have no overarching scheme for the organization of these individuals' disparate contributions . . . the creative activities themselves were not guided by even the most schematic shared plans. The upshot, I contend, is an author-less product, a result of social forces and activities, no doubt, but not of collaborative or joint action.[63]

Like a real traffic jam, Livingston suggests, there is no organization here, no meshing subplans of participants, and it is precisely for this reason that we get movies like *Waterworld* (1995). Certainly, I would grant that there is nothing like coauthorship of the sort Livingston imagines here, but that this leads him to the conclusion that there is thus no author of the work is, I think, all the much stronger evidence against his view. I would suggest that "unauthored work" is a self-contradictory notion. If there is no individual—or individuals—having and exercising the power to select and arrange elements as constitutive of the work, then there is no work. Conversely, to accept, say, *Waterworld* as a work just is to accept it as an authored thing. Perhaps the last director to work on the film is to blame for *Waterworld*—for its incoherence as a story, for it being so mind-numbingly long. Perhaps it's the producers, perhaps it's the editor, or perhaps it's the entire body of directors. But dammit, somebody's to blame for *Waterworld*. Somebody—and possibly many somebodies—selected and arranged those elements as constitutive of that work—somebody with the power to do so.

Toward an Ontology of Authored Works

Untitled (Cowboy)

In 2003, a photograph taken by Richard Prince, *Untitled (Cowboy)* (2000), sold at auction for $332,300. Some might be surprised that a photograph could garner such a sum, but—in this case at least—none more so than Jim Krantz. Krantz might be allowed a certain level of incredulity, for Prince's photograph was a photograph of *another* photograph, this one taken by Krantz himself while on commercial assignment for Marlboro in 1998.[1] Indeed, as Sherrie Levine did with photographs by Walker Evans and Edward Weston, Prince has based entire gallery shows on photographs of Krantz's commercial work. How is this legal? As things stand, it probably isn't.[2] As far as copyright is concerned, Krantz's photograph and Prince's are the same work. One might ask, doesn't it matter that Prince put in labor in his work? Doesn't it matter that Prince was making some sort of statement? As far as copyright is concerned, no, it doesn't. But we are getting ahead of ourselves.

An author's copyright consists in a special claim of ownership in a work in virtue of having created that work. Although the term "copyright" tends to cover a bundle of rights,[3] chief among these is the exclusive right to make or authorize copies of the work, whether in whole or in part (say, as a part of another work). Given this description, it seems imperative to ask, what *is* this work—what is it that one has such rights *over*? Problematically, copyright law doesn't really tell us. But it *does* seem to provide the foundation necessary to build such an understanding.

Toward an Ontology of Authored Works

The volume of literature devoted to copyright is staggering, and I shall not attempt to summarize it here. Rather, I will focus on a handful of points

that I take to be at least generally accepted of copyright, although not always uncontroversially so.

I should note that I am focusing in this chapter specifically on the nature of those items that copyright is meant to protect, and not on the rights themselves. In the next chapter, I will argue that copyright in general does—or should—grow from an understanding of these objects, but the present chapter will focus on forming a basic understanding of the ontology involved. Further, although copyright laws regularly refer to artworks, I shall for the sake of clarity in this article refer to the objects of copyright as "authored works" and their creators as "authors," reflecting standard (although by no means universal) language in US copyright law.[4] I do so not to prioritize American law, but because, as will be discussed toward the end of the chapter, I believe there is an important distinction to be maintained between "authored works" (the objects of copyright) and "artworks" (being something distinct but ontologically overlapping), and I wish to avoid any complicating issues that are sure to arise from equivocating over the two.

Having said this, then, what kind of a thing *is* an authored work? The very notion of copyright provides us with a good starting point. First, authored works are things created, not things discovered. Although ownership claims over things discovered are not entirely uncommon, standardly copyright ownership rests on the notion that an authored work owes its existence to its author or authors. As understood here, then, an authored work is "original" to its author in the sense that it owes its *origin* to its author, the notion of originality set out in chapter 3.

Second, what is protected by copyright is not any physical object, but rather an abstract object that may be *embodied* in physical objects. Ownership of an authored work does not entail ownership of any material object in which the work is embodied, nor vice versa.[5] In principle, authored works, being abstract objects, are multiply instantiable, capable of existing in many copies, each of which qualifies as a full and complete instance of the work. Although many copyright complaints rest on some new work being too *similar* to some preexisting and protected work, these rely fundamentally on more central cases in which some protected item is *exactly* copied.

Third, copyright protection standardly extends only to the *expression* of an idea, and not to the idea *itself*.[6] This is to say that the authored work—the thing protected—is itself an expression. As touched on at the end of chapter 3, exactly what marks the conceptual boundary between idea and expression becomes a tricky matter in the law, however as a basic distinction, illustrative cases are not difficult to come by. The simple idea that love con-

quers all, for example, is variously expressed in the film *Sleepless in Seattle*, in Sarah McLachlan's song "Sweet Surrender," and in countless other works. Although each work expresses the same idea, each does so in original and entirely dissimilar ways.[7] To this end, one authored work is distinguished from another not according to *what* ideas are expressed, but rather according to *how* ideas are expressed.

Beyond these few points, copyright laws vary wildly by country. However, this basic framework should provide us with the necessary foundation for determining what kind of a thing an authored work *is*, and what kind of a thing it *isn't*. In search of a schematic on which to base our understanding, despite the caveat above, it would seem reasonable to begin our search in accounts of the ontology of art. After all, while I seek to maintain a distinction between authored works and artworks per se, the core body of copyrighted works consists of such things as musical compositions, novels, films, and the like.

The ontological structure that I believe best reflects the nature of authored works is that authored works are *types* and their instances *tokens*, a distinction first introduced by Charles Sanders Peirce as an alternative to traditional universal/particular accounts. Certainly, both types and universals are abstract, where tokens and particulars are concrete. Likewise, universals are instantiated in particulars, and types in their tokens. However, universals are typically thought to be predicated of particulars: to say that some particular sheet of paper participates in, or is an instance of, the universal "whiteness" is to say that "white" is a predicate of the sheet of paper. The same sort of talk, however, does not seem to apply as easily to types and tokens, nor to authored works. In counting the number of words on a page, Peirce says, "There will ordinarily be about twenty *the*'s on a page, and of course they count as twenty words. In another sense of the word 'word,' however, there is but one word 'the' in the English language."[8] In the first case, *the*'s are counted as tokens; in the second case, as a type. Unlike whiteness, an instance of "the" on the page cannot comfortably be described as participating in "the-ness," nor does it seem that an instance of "the" has some predicate "is the" as a sheet of paper has the predicate "is white."[9] Whether some given item qualifies as a token of some given type (whether the type is embodied in the token) depends on whether that item has the requisite properties as determined by the type. The question to be asked, though, is *which* properties—and *why*? The matter is difficult enough when dealing with words,[10] and becomes only more complex when dealing with authored works.[11]

Creation and the Atomic Dimension of Authored Works

On a simple view, a work of literature is composed of a series of words, a musical work of a series of notes, a painting of certain colors, lines, and shapes, and so on. Of course, the matter may—and often will—become more complex. A writer may select preexisting characters to use in his work, and a sculptor may work with premanufactured or "found" objects. A composer may select not only a series of notes, but also the means and manner by which they are played.[12] The creator of an art installation may even feel that the setting is integral to the work, in which case this too will be among its composite elements. Certainly, a painter selects not only colors, lines, and shapes, but also the kind of paint to be used and the sort of brushstrokes used to apply it, and while the author of a novel would not ordinarily do so, he certainly *may* select certain font styles and colors requisite for printing the work.[13] Similarly, while it is normal for a sculptor to select a particular material or materials for his work, he seems free to *not* select any particular material, allowing the work to be cast alternatively in bronze, concrete, or even lime Jell-O. What an author may choose as component elements of his work seems entirely up to him, and while he is perhaps *guided* by what is standard for any particular category of art, he seems not at all *restricted* by such standards.[14]

As argued in the last chapter, an author of a given work is one who has and exercises the power of selecting and arranging elements as constitutive of that work. Regardless of whether one is working with words, notes, or stone, whether one's final work is rich or impoverished in detail, and whether the work is standard or nonstandard, the act of composing any authored work essentially involves *selection* and *arrangement*. As such, a composer *creates* a musical work by selecting notes and arranging them in some particular sequence. A writer normally does precisely the same with words, and a painter with lines and fields of color. As soon as an author has created an item from selected elements, I submit, he has done what is necessary to create an authored work. Granted, most works involve innumerable such elements, but as little as a single brushstroke or the selection of a single musical note of some duration may constitute the creation of an authored work. In this way, the author is not a mere *discoverer* of some work as a physicist is a discoverer of some principle of the universe. Rather, the author selects from among the innumerable elements available to him (words, sounds, colors, shapes, materials) and arranges these into something *new*, and so *creates* the work.[15]

Nicholas Wolterstorff suggests in *Works and Worlds of Art* (1980) that artworks are best understood as "norm-kinds"—that the artist selects for a work certain properties as "criteria for correctness," such that a certain set of properties determined by the artist is *normatively* associated with a work. If this approach works for artworks, so too may it apply to authored works. In the case of a musical work, the properties selected will consist in a string of sounds, in the case of literature, a fixed sequence of words, and so on. In each case, the selected properties specify what counts as a correct instance. The author *may* select font style or size as a criterion of correctness for the work, but normally he would not. So, where some item possesses all of the properties normatively associated with the work as determined by the work's creator, it will be a correct instance. Alternatively, where some item comes *"fairly close to exemplifying the properties normative within"* that work, such will only qualify as an *incorrect* instance.[16] Here, we might consider minimally flawed performances of musical or dramatic works, or copies of literary works containing typos. As such, Wolterstorff's approach contains a principled means of establishing which properties are or are not among those that make up the work.

Problematically for Wolterstorff's view, however, if two authors independently select the same norm-kind by selecting the same properties as criteria for correctness, they have picked out the same work. As Gregory Currie notes, on this view, "Once we know how a work is properly to be played, then we know all there is to know about the identity of the work itself."[17] At first blush, this seems fairly reasonable. If I publish sheet music that is note-for-note indistinguishable from Beethoven's Hammerklavier Sonata, or a poem that contains precisely the same words in the same order as Dylan Thomas's "Do not go gentle into that good night," it seems commonsensical to say that all I have published is Beethoven's score or Thomas's poem.

However, I suspect our instincts here are compelled by the sheer unlikelihood that such should happen by sheer coincidence, especially given the complexity of the works involved. Let us then instead consider a more condensed form—the haiku. While the haiku form effectively allows for countless possible poems, it does not seem unthinkable (or, perhaps, even unlikely) that one poet might independently string together the same seventeen syllables in the same order as another poet. Copyright consists in a special claim of ownership as the result of having created a work. And while textually indistinguishable, it seems problematic to say that the author of the first haiku should have any claim over having created the second, or the second over the first: neither is in any way responsible for the other's *creative*

act. Rather, each performed his own creative act with no link between them, and it seems the most we can say is that the second author wrote a haiku that is composed of the same linguistic entities as that produced by the first author, or that each happened to select the same criteria for correctness for the respective poems. While the second haiku is not *novel* or *unique*, it seems to at least possess its own *originality* inasmuch as it has a unique *origin*. Insofar as copyright vests in an object as a result of the creative act, and insofar as each poet independently acted, copyright applies independently to each product of creation.[18] The connection that seems to be missing between the poems, and which is likely assumed to exist in the Beethoven and Thomas cases, is a robust *causal* connection between one item and the other.[19] On Wolterstorff's view, the first poet (composing, say, in the early nineteenth century) might reasonably be described as creating the work; however, the second poet (composing in the early twenty-first century) who independently and coincidentally strings together the same words in the same order has as a result created *nothing* because the work already exists. This seems unsatisfying. I contend that such works are individuated not only by their composite "atomic" elements,[20] but also by their respective *contexts of creation*.

In his account of the ontology of musical works, Jerrold Levinson argues that creation in different musico-historical contexts results in works with different aesthetic properties.[21] For example, Tchaikovsky's Fourth Symphony is decidedly Beethoven-influenced. However, had the Fourth Symphony been composed by Mozart in 1778 rather than by Tchaikovsky a century later, it could not sensibly be so described. And where the Fourth Symphony represents a natural progression in Tchaikovsky's oeuvre, being an understandable sequel to the Third Symphony, as written by Mozart it would be jarring, not to mention decidedly bizarre, given that the fourth movement of the symphony incorporates a famous Russian folk song as one of its themes.

While I wish to remain agnostic here as regards aesthetic properties,[22] Levinson employs divergence in aesthetic properties of formally identical works as evidence of their individuation, though seemingly not as antecedent to it. That is, were two composers to independently create compositions with identical formal structures *and* identical aesthetic properties, Levinson would probably say they would nevertheless *not* thereby be creating the same work, but each their own, albeit formally and aesthetically identical, works.[23]

As a variation on Levinson's theory, I take it that, for any authored work, there is a particular context of creation, determined by the author or authors

and the time and place of creation. That is, for any given work, W, I believe that we can point to certain *causal-historical properties* of such works: a (the property of having been created by a particular author), t (that of having been created at some particular time), and p (that of having been created at some particular place).[24] Picking out some particular created atomic structure, along with its <a, t, p> properties, picks out some unique work. And where any of these properties differ, a different work has been created. So, if some item, W_1, has the properties <a_1, t_1, p_1>, and another item, W_2, has some different property, a_2, t_2, or p_2, then W_1 and W_2 are different works in virtue of having different *causal-historical* properties, even if they are *formally* or *perceptually* identical.[25]

Just as we might distinguish the creation of a work from the creation of its preexisting composite elements, such as words, notes, and found objects, so too can we distinguish the creation of a work from its instantiation. The act of instantiating some work will result in something new—a new *instance* of the work—but it does not result in a new *work*. As such, we may distinguish a work's unique context of creation from any particular copy's unique context of instantiation, determined by the instantiator (who may or may not be the same person as the author of the work) and the time and place of the instantiation (which, if it is the first instance of the work, may be the same as the time and place of the work's creation). That being said, we have yet to determine what it is that *makes* some item an instance of some given work. Certainly, it must instantiate the atomic properties selected and arranged by the work's author. However, as established above, mere atomic similarity does not seem sufficient to ground the work-instance relationship when it comes to authored works. Rather, something further is needed.

The Causal Dimension of Authored Works

What seems critical for some item, x, to qualify as an instance of some authored work, Y, is that x not only be atomically identical to Y, but that it also be *causally* related in the right way to Y.[26] Let us take as a recent illustrative case the iconic "Hope" poster depicting the visage of Barack Obama as painted by Shepard Fairey. "Hope" bears special relationships to two sorts of preexisting works. First, Fairey's work is clearly influenced by the simplified style of silk screening, widely popularized in the 1960s, of reducing a realistic representation of a subject to its simplest basis using solid blocks of color. For influential examples of this style, we might look to Jim Fitzpatrick's famous 1968 silkscreen of Che Guevara or Andy Warhol's various prints depicting Marilyn Monroe and Jackie Onassis. "Hope" bears a special sort

of relationship to these works, but it bears another sort of relationship to a photograph of Obama taken in 2006 by Associated Press photographer Mannie Garcia, the direct source for Fairey's depiction of the future president. I will call the relationship between "Hope" and such works as Fitzpatrick's and Warhol's *weak* historical links and that between "Hope" and Garcia's photograph a *strong* historical link.

Both weak and strong historical links connect a given work to some preexisting work or works. Where there is a strong historical link, some property or properties of a new work depend on some property or properties of some *particular* preexisting work. Where there is a weak historical link, some property or properties of a new work depend on some property or properties held in common by a *body* of preexisting works.

Certainly, weak historical links holding between distinct works are much more common than are strong ones. A weak historical link can perhaps best be characterized as an influence relation, a weak sort of asymmetric dependency relation holding between works. Where there is a weak historical link, a given work is the way it is—has the properties it has—in part because of some body of preexisting works. This will be most evident in a work's apparent *style*. In the example of "Hope," given the dominant stylistic influence of the iconic silkscreen movement, had these works not preceded the creation of "Hope," the work itself would not exist, or at least would look very different—that is, "Hope" *draws* on these works. However, the new work's properties will not likely depend on the properties of any *single* preexisting work from this body. Rather, the multiple influences have a cumulative effect, such that the alteration or removal of any one such influencing work is unlikely to have a noticeable effect on the new work.[27]

Notably, a historical link (whether weak or strong) is not a *direct* link between works, but necessarily operates via the author creating the new work. As such, in the case of a weak historical link, we can talk about an author being classically influenced or alternatively about a given work being classically influenced. Certainly, for some authored work to possess a weak historical link to some preexisting body of works, the author must have at very least been exposed to the works making up that body (though the author himself might not be consciously *aware* of this relation), so "Hope" will not likely have a weak historical link to *all* preexisting silk-screened works created in a similar style. Moreover, it is worth noting that historical links between works (whether weak or strong) may not result in the new work being *similar* to the preexisting one(s). Rather, a new work may have been created in *response* or *reaction* to some work or body of works, and those

properties in the new work linked to properties in the earlier work(s) may not be very similar at all.[28]

Where a weak historical link holds between some given work and some preexisting *body* of works, a strong historical link operates between some given work and some *particular* preexisting work. We might thus characterize this sort of link as a strong asymmetric dependency relation holding between particular properties in particular works. The strong historical link may be most perspicuously expressed as a counterfactual relationship between the properties of the works involved. Roughly, for works X and W, there is a strong historical link between them if it is the case that, *had* some particular property of the earlier work W been different, this difference would have resulted in a corresponding difference in some particular property of the new work X. This is to say, X is the way it is in part because W is the way *it* is. In the case of "Hope," we might reasonably say, for example, that had Garcia's photograph depicted Obama from a slightly different angle, so too would Fairey's work.[29] As with the weaker variety, strong historical links are necessarily author-dependent, but need not come about as the result of conscious and deliberate intention on the author's part. Unlike weak historical links, however, it would appear that strong historical links can be maintained along a chain of works.[30] Where some new work X has a strong historical link to some preexisting work, W, operating respectively over the properties *a*, *b*, and *c* in W, and *d*, *e*, and *f* in X, and another still newer work, Y, has a strong historical link operating over properties *g*, *h*, and *i* in Y, and properties *d*, *e*, and *f* in X, then, it seems, Y will have a strong historical link to W.[31] However, the strong historical link will only operate over unbroken chains in properties. As an example, we might think of the mass-produced prints of Fairey's original painting, which bear strong historical links to the painting itself, and this to Garcia's photograph.

In cases of both weak historical links and strong historical links, there is a causal connection between some given work and some preexisting work or works. However, where some work has a weak historical link to some body of preexisting works, its properties do not depend on any *one* particular work from that body. As such, no author whose work is among that body can reasonably claim that, had it not been for his particular work, the new work would be in any way different. However, where a strong historical link connects two particular works, it seems, the author of the preexisting work *can* make such a claim.

To connect the issue of strong and weak historical links to the earlier discussion of the context of creation, I believe we can say that where some

given item is connected to some preexisting work by a strong historical link operating over *all* of the properties of both items (that is, over all of the properties selected and arranged as essential to both), and where the properties so connected are the same in each respective item, the new item is a *duplicate* or *instance* of the preexisting work, and *not* a new authored work at all—that is to say, it is a token of the same type. Where there is anything less than such a universal strong historical link, we will have two distinct works, however similar. In the latter case, each work will have its own context of creation; in the former case, the two works will share their context of creation, but have distinct contexts of instantiation.

Conditions of Copyrightability and Infringement

As tokens are tokens-of-a-type only insofar as they instantiate the properties of the type, the context of creation adheres primarily to the type, and secondarily to the token. When a type is instantiated in tokens, these tokens carry (or have associated with them) the same context of creation as the type itself. That is, as a token is a token only inasmuch as it is a token-of-a-type, it does not represent a new creation (that is, a new selection and arrangement of composite elements), but rather a mere instantiation of the created type. The instantiation of the token therefore does not supplant the original work's context of creation, but rather adds a context of instantiation, being a property of the token, and not of the type. The instantiator cannot claim responsibility for having created some new authored work (and so claim a copyright in the work), for what he has instantiated is some particular selection-and-arrangement *as created by* some other author.

Today, in most nations, copyright protection adheres to a work roughly from the moment of its creation.[32] As such, on the type/token account here outlined, to qualify as a new authored work, some item must constitute a new type. To qualify as a new type, it is *sufficient* that the work (1) possess some essential properties that differ from those of any preexisting work, or (2) fail to possess strong historical links to any preexisting work. Although atomic *similarity* to some preexisting work is insufficient to establish that two items are tokens of the same type, atomic *dissimilarity* is sufficient to establish that two items are *not* tokens of the same type.[33] And where a work possesses no strong historical link to any earlier work, regardless of how similar the two might be in their composite properties, the new work will qualify as a new type, for it will be the product of *its* author's creativity, and not that of any other. That is, where a work does not owe its origin to any earlier work or author, insofar as it is an authored work, it is original to *its* author.

Infringement can come in many degrees. At the top end, an individual might illicitly reproduce some copyrighted work wholesale, say, by copying a CD or DVD, by photocopying or retyping a book, or by making a new print from a photographic negative. One might also illicitly reproduce only *part* of some authored work, or do so as an aspect of some *new* work, as in musical sampling. One might also modify without permission some copyrighted work into a new form, say, as a translation or as an adaptation to another medium. However, while different in degree, each of these cases of infringement operates in essentially the same fashion.

To have infringed a copyright is for some new work, or parts thereof, to depend in a special way on some preexisting copyrighted work (and this without permission of the original copyright holder). Put another way, if work B infringes the copyright of work A, then the author of A has some claim over B, or some part or parts thereof. Where establishing copyrightability depends necessarily on establishing that a work is of a new type and sufficiently on establishing atomic dissimilarity or an absence of strong historical links to preexisting works, establishing prima facie copyright infringement[34] is a matter of a necessary *and* sufficient condition in two parts, each being necessary, and together being sufficient. Establishing prima facie infringement requires (1) atomic similarity between the new and old items, and (2) a strong historical link operating over the property or properties held in common between the two works. As outlined above, atomic similarity alone cannot reasonably ground a complaint of infringement, for two works might conceivably have been created entirely independently and yet be to a great extent atomically similar. Here, the author of the original work would seem to have no claim over the new work.[35]

Conversely, a strong historical link between some new work, B, and some preexisting work, A, seems a reasonable basis for the author of A to claim that, had it not been for her creating A, B would be different. What she cannot reasonably claim on this basis alone, however, is that she created any part of the new work, and *this* is what is required for a claim of infringement to hold water. To illustrate, let us imagine a relatively straightforward case. Taking a simple musical composition, say, Mozart's *Andante in C*, I assign each note a color value. Then, in a simple grid of squares, I fill in each square in sequence with the color corresponding to each note in the sequence of Mozart's composition. What we will be left with is a sort of visual representation of *Andante in C*, such that, had Mozart used a different note in any particular place, the corresponding square in my painting would be a different color. While my work will depend in a very strong way on Mozart's, as the basic entities that make up each work are of fundamentally different

kinds, there seems no reasonable claim that Mozart himself created any aspect of my painting. To ground a claim of infringement requires *both* a strong historical link *and* atomic similarity between those properties over which the link holds.

There are two points worth noting here. First, where less than an entire work has been infringed—that is, where the new item is not simply a token of the preexisting type—the author of the infringing work may nevertheless hold a copyright in those elements of the work that he did not infringe, being those elements that he independently selected and arranged, and so some work can be both infringing and meriting of copyright. Second, because strong historical links operate in chains, if some work, *X*, infringes on elements of some preexisting work, *W*, and some later work, *Y*, copies these same elements from *X*, then *Y* infringes *W*, but does not infringe *X*, because the author of *X* has no claim to having created that part of his work, but the author of *W* does.

It should be noted that establishing infringement may not always be a simple matter. Here, we might consider a case such as Mendrick Maertensz Sorgh's *Lute Player* (1661) and Joan Miró's *Dutch Interior I* (1928). Certainly, there is *something* similar going on here as Miró appropriates from Sorgh's painting, but does the similarity operate over any of the elements selected and arranged by the authors? Are there strong historical links holding between those elements? I cannot pretend to have all of the answers here, but rather only to offer a first step in understanding how to reach those answers.

The Authored Work Is Not the Artwork

Although there is a great deal of overlap between the class of artworks and the class of authored works, there are many objects protected by copyright that we do not normally want to call artworks, including boat hull designs, mundane works of architecture, and any number of pieces of nonliterary writing. This seems enough to say that the class of authored works is not coextensive with the class of artworks.[36] What, though, of those authored works that we *would* wish to call artworks? Here, let us return to the case invoked at the beginning of this chapter—that of Richard Prince's 2000 photograph, *Untitled (Cowboy)*.

Prince's photograph is a prima facie case of copyright infringement as we have come to understand it. First, Prince's photograph is by all reports perceptually indistinguishable from Jim Krantz's original. Krantz stated on seeing Prince's photograph, "there's not a pixel, there's not a grain that's different."[37] Second, every pixel and grain in Prince's photograph is the way

it is *because* Krantz's original is the way it is. Prince did not set out to re-produce and photograph the same *scene* that Krantz photographed, but rather simply photographed Krantz's *photograph*. This is to say that every element of Prince's photograph is connected to its corresponding element in Krantz's photograph by a strong historical link. According to the conditions set out above, considered as an authored work, Prince's photograph simply *is* Krantz's work—it is a token of the type.[38] Indeed, it seems, the very *point* of Prince's photograph is that it exactly reproduce Krantz's. In apparent irony, then, the auction catalog listing for Prince's photograph contends "This work is unique."[39] However, considered another way, this statement might be entirely correct.

As described above, an authored work is defined atomically and causally. That is, what makes some item an instance of some given authored work is that it has the correct composite elements and that it has them for the correct causal reasons, and what distinguishes one such work from another is that it has different composite elements or that its composite elements have distinct causal bases.

This, however, does not seem to fully identify or describe an *artwork*. As discussed, copyright does not protect its author's ideas, but only his original expression. One authored work is not distinguished from another insofar as they are taken to express different ideas. Most artworks, however, are very much connected with their respective ideas, to the point where we might reasonably say that the *idea*—what the work means, or what the artist is saying in or through the work—is a *part* of the artwork. As G. W. F. Hegel put the matter:

> This is the way in which a work of art should have its meaning, and not ap-pear as exhausted in these mere particular lines, curves, surfaces, borings, re-liefs in the stone, in these colours, tones, sounds, of words, or whatever other medium is employed; but it should reveal life, feeling, soul, import and mind, which is just what we mean by the significance of a work of art.[40]

It is a cornerstone of Arthur Danto's concept of art that "works of art are always about something, and hence have a content or meaning."[41] And here, Danto means, they have such content or meaning *essentially*. In principle, perhaps, an authored work could be bereft of meaningful content, but—at least on Danto's view—not so an artwork. Precisely what idea Prince's pho-tograph is about, if anything, would be a matter of some debate. Perhaps not every artwork has as a part of its content some determinate idea. But in such cases as it does, it seems reasonable to conclude that the authored work

is not the artwork, insofar as the artwork has some essential element that the authored work lacks. One might suggest that Prince is using appropriation to comment on the reality or unreality of the cowboys depicted in the photographs. He might even be commenting *on* artistic appropriation. Or he might simply be saying that an inherently singular work *can* be created by copying a multiply instantiable one. In any event, by investing the work with a new idea, it might be argued that qua artwork, the photograph is something new, even though qua authored work it is not. Although their methods of creation seem largely synonymous—indeed, in most cases, in creating an artwork, one will also be at the same time creating an authored work—"same authored work" does not entail "same artwork." And while an artist might have reasonable grounds for arguing that in appropriating another's work, he has made something new, such a claim—even if true—may hold little weight in the legal realm of copyright.

Where the artist *may* have some room for argument, however, is in a claim that his prima facie infringing work qualifies as a "fair use" of the pre-existing work. Before we get to *that* discussion, however, first we need to connect the dots between the ontology of authored works and the authors' rights to those works.

The Rights of Authors

The View So Far

One of the first attempts to provide a moral argument for the right of copyright is found in Johann Gottlieb Fichte's 1793 tract, "Proof of the Illegality of Reprinting: A Rationale and a Parable." Fichte's central argument is terrible, and there's really no reason to go into it, but the terrible argument is grounded in an important observation: there is a distinction to be had between (1) a material book, (2) the ideas contained in that book, and (3) the *form* in which these ideas are presented in the book—the author's particular phrasing and wording. A right to one of these does not imply a right to either of the others, and one's claim to ownership depends on the nature of the thing, and one's relationship to it.[1] The claim to copyright is a claim to the *form of expression*, not to the ideas being expressed, and not to the material thing in which that expression is embodied.

As we have discussed so far, the thing protected by copyright—the authored work—is not per se a material object (though it may be embodied in one), and it is not an idea (though it will almost certainly express one). Rather, it is an abstract object—a type—brought into existence by (and partly individuated according to) the authorial act. Insofar as one owns copyright in a thing, *this* is what one owns. Our central questions for this chapter, then, are, *why* does the author own her work, and in what does this ownership consist?

The Rights of Copyright: Two Models

Traditionally, copyright is treated either as an "economic right" or as a "moral right," depending on which country one happens to be in. In common law jurisdictions (where the law depends primarily on precedents set in case law,

as in Britain, the United States, and Canada), copyright tends to be treated as an economic right; in civil law jurisdictions (where the law is formally codified in legislated statutes, as in most of continental Europe, and South and Central America), it is most often treated as a moral right (*droit d'auteur* in France, *Urheberrecht* in Germany).[2] Roughly, an author's "economic rights" protect the economic value of a protected work; an author's "moral rights" centrally protect the moral interests of the author.

As an economic right, copyright is largely defined in terms of an exclusive right to copy (or authorize copying of) a thing—whether outright, in performance or broadcast, or in adaptation into a derivative work. Moral rights go beyond these to include the right of attribution, the right to publish a work anonymously or pseudonymously, and the right to the integrity of the work. Where an author's economic right can be transferred through sale or contract, her moral rights traditionally cannot (though in some jurisdictions, as in Germany, they can be transferred by heritage).

In large part, as a matter of practice, international treaties have served to merge these two models. Treaties like the Berne Convention for the Protection of Literary and Artistic Works require signatories to recognize the copyrights of authors from other member countries, and set basic minimum standards required for membership. Among a great many other things, the Berne Convention requires signatories to guarantee both the economic and moral rights of authors.[3] Although the Berne Convention was created in Switzerland in 1886—and includes as signatories most member states of the United Nations—as noted in chapter 2, the United States did not become a member until 1988. One of its central reasons for holding out was the Berne Convention's requirement that signatories recognize and enforce the moral rights of authors.[4] Eventually, the United States gave in, and with the Berne Convention Implementation Act of 1988 recognized moral rights—but only in a restricted category of visual art, spelled out in the Visual Artists Rights Act (VARA) of 1990.

For the sake of this chapter, I am centrally interested in grounding the right at the core of contemporary copyright: the right to copy. (Justification for additional "moral rights" of the author may emerge naturally from this, or may require independent argument.[5]) There is certainly enough here to keep us busy.

Copyright as an Instrumental Right: The Constitutional View

Instrumental rights models to copyright suggest that recognition of copyright is in service of some greater common good. The most common such model

consists in the claim that copyright is a necessary incentive for authors to create. Since we value the work and ideas of authors, and since such authors would not go through the pains of creating such works without some appropriate form of remuneration, copyright provides the necessary incentive. This is the model embodied in the US Constitution, and which forms the recognized legislative basis to copyright in the United States.

Article I, § 8, clause 8 of the US Constitution states:

> Congress shall have power . . . [t]o Promote the Progress of Science and useful Arts, by securing for limited Times to Authors and Inventors the exclusive Right to their respective Writings and Discoveries.[6]

Written in 1787, the "intellectual property clause" or "copyright clause" thus empowers Congress to create laws giving authors the exclusive right to their "Writings" (copyright) and inventors the exclusive right to their "Discoveries" (patent). Just three years later, Congress acted on its newfound powers to create the Copyright Act of 1790 and the Patent Act of 1790. Although the two Acts have evolved separately, each is officially, ideologically grounded in the value of promoting the progress of mankind's available pool of knowledge and technology. Thomas Jefferson reflects:

> Stable ownership is the gift of social law, and is given late in the progress of society. . . . Society may give an exclusive right to the profits arising from [inventions], as an encouragement to men to pursue ideas which may produce utility, but this may or may not be done, according to the will and convenience of the society, without claim or complaint from any body.[7]

Jefferson was writing here about patents, but his view reflects traditional thinking about US copyright law as well: ownership is a gift of the government to incentivize authors. Ideas are themselves valuable (either instrumentally or inherently), but (at least most) authors will not pursue such ideas—and thus add to mankind's available pool of knowledge—without the secure ability to profit from their work. A promise of ownership thus contributes to the marketplace of ideas available to all.[8] Insofar as we all have an interest in access to ideas, a necessary incentive to those whose expressions provide such access would seem warranted on instrumental grounds.

This model, then, is in service of achieving the balance between the rights and interests of authors and users, discussed in chapter 2. The Patent Act of 1790 (dubbed "An Act to promote the progress of useful Arts") offered protection for inventions for up to fourteen years. The Copyright Act of 1790

("An Act for the encouragement of learning") granted protection for fourteen years with the possibility of renewal for a further fourteen-year term (if the author was still alive). The Patent Act required inventors to submit to the Secretary of State a description of the invention, along with a draft or model, "to enable a workman or other person skilled in the art or manufacture . . . to make, construct, or use the same, to the end that the public may have the full benefit thereof, after the expiration of the patent term."[9] The Copyright Act similarly required authors to deposit a copy of the book, map, or chart (being all that the original Act protected) with the clerk of their local district court.[10] After patent or copyright protection expired, the work fell into the public domain, and the requirement of submission meant that the work in each case—and, more importantly, the ideas it embodied—became freely available to the public.[11]

Granted, a great many authors whose works are protected by copyright probably contribute little if anything to the marketplace of ideas. As discussed in chapter 3, the originality requirement of copyright is not a requirement of *novelty*, and original-but-stale works will gain copyright protection just as much as groundbreaking, insightful ones. And even where a work is entirely novel in its content, most ideas, it must be said, are not valuable ideas. However, granting copyright ownership only to those authors who will, in fact, contribute to the pool of valuable or novel ideas would require impossible predictive power—who is to say, after all, whether the new expression of some tired or simply bad idea won't spark some new insight somewhere down the road? In protecting the sort of product—authored works—that *tend* to contribute to the desired end of expanding mankind's available pool of knowledge, copyright arguably serves society's best interests. Even if we have to give ownership to a score of authors for every one who actually serves this desired end, copyright will have paid for itself.[12] At least, that's the official view.

The central problem with the official view is that copyright seems neither necessary nor sufficient to achieving the desired end of maximizing the marketplace of ideas. We might ask, if we eliminated copyright tomorrow, would the proliferation of ideas slow down and eventually dry up? Certainly, some authors would find more secure work. But copyright itself has only been around a little over three centuries, and many of the most renowned works of art, literature, and music predate the 1710 Statute of Anne. The works of Homer, Chaucer, Shakespeare, and Cervantes have never been protected by copyright. Neither Plato's *Republic*, nor Machiavelli's *The Prince*, nor Immanuel Kant's three Critiques have known copyright protection.[13] None of the Renaissance painters or sculptors, and neither Bach nor Mozart, would have

owned copyright in their works.[14] And yet, somehow, despite no promise that their works would not be copied and recopied (as indeed they have been), these authors, artists, and composers created some of the most enduring works in the Western world. Indeed, it might be argued that these creators in part owe their popularity—and so their legacy—to the unrestricted copying of their works, and that by *not* offering copyright, less talented creators—those with little to contribute to the marketplace of ideas—were weeded out.[15]

Now, granting that incentive plays *some* role in promoting the creation of knowledge-expanding works, it is worth asking, why is *ownership* the appropriate carrot to dangle? Could something less than ownership have the desired effect, or indeed do a better job? One option, suggested by Joost Smiers and Marieke van Schijndel, is the replacement of our system of copyright *ownership* with a temporarily protected *usufruct*. A usufruct is an exclusive entitlement to use the item in question or to enjoy the profits derived from it, but falling short of ownership. One might have usufruct of a house, for instance, and so be exclusively entitled to live in it or rent it out, but without *owning* it. The house is *owned* by the community at large. Similarly, one who writes and so has usufruct of a novel will have exclusive entitlement to profits in sales of copies of the book, but not, say, exclusive entitlement to adapt the book into a play or film. The work itself is in the public domain.[16] Smiers, van Schijndel, and a number of others have further suggested that government-provided subsidies for the creation of new works (with those works themselves immediately falling into the public domain) would have the desired effect of incentivizing creation without the exclusionary nature of either ownership or usufruct.[17] Certainly, any alternative to copyright ownership would face as much scrutiny as copyright, but with such alternatives on the table, it remains at least an open question whether copyright is necessary to achieving the desired end of maximizing the marketplace of ideas. Of course, there is also a question of whether copyright is even *sufficient* to achieving that end.

In chapter 3 we discussed Shakespeare's rampant appropriation, and there is considerable evidence that Chaucer's *Canterbury Tales* borrows liberally from a number of sources, principally Boccaccio's *Decameron*.[18] Cervantes, too, has been accused of plagiarizing two of the twelve short stories in his *Novales Ejemplares*.[19] Mozart, meanwhile, seems to have borrowed many of the dramatic and musical elements in *The Magic Flute* from another opera, *The Beneficent Dervish*.[20] (The sport of plagiarism hunting has, if anything, only become more popular since the nineteenth century.) If copyright had applied in these cases—and, importantly, been enforced—each of these

works could have been quashed. There is an intuitive argument to be had, at least, that by restricting the materials that creators can use to express themselves, copyright actually has the effect of squelching expression. In chapter 2 we noted how a sizeable percentage of contemporary artists and authors have avoided or abandoned projects specifically because of copyright concerns.

Edwin Hettinger calls the instrumentalist approach paradoxical: "It establishes a right to restrict the current availability and use of intellectual products for the purpose of increasing the production and thus future availability and use of new intellectual products."[21] Several legal scholars have argued that while *limited* copyright (and patent) can result in increased innovation, strong protection (either in terms of what activities are protected against, or in terms of an extended period of protection) can have the opposite effect.[22] At the very least, the claim that copyright—whether in its current, past, or some imaginable future form—serves to maximize the marketplace of ideas is an empirical claim that remains to be tested, and that has a number of prima facie strikes against it. At this point, the long-standing pedigree of instrumentalism in Anglo-American copyright is unpersuasive: that a system of law has been built on sinking sand is not an argument for putting a fresh coat of paint on our statutes; it is an argument for moving to firmer ground.

Copyright as a Natural Right: The Personality Right View

Where the instrumentalist approach is the official foundation for copyright in the United States, those countries (in continental Europe, especially) that traditionally ground copyright in the moral rights of the author tend to take another approach: that copyright is a natural right grounded in the author's personality. And, here, it is G. W. F. Hegel's personality rights model outlined in his *Philosophy of Right* that is most often appealed to.[23] On Hegel's view, property plays a central role in the construction of personality, and one gains ownership in an item where that item represents a manifestation of one's personality or self.

One's personality, according to Hegel, "is that which struggles to lift itself above this restriction [of being only subjective] and to give itself reality, or in other words to claim that external world as its own."[24] Personality represents the will's struggle to actualize itself. By physically seizing some part of the world, imposing a form on it, or otherwise marking it, the will *occupies* that object. In putting one's will into a thing, one gives that thing *purpose* as "the first embodiment of [one's] freedom"—itself a substantive end.[25] As one's body *is* one's body only insofar as one's will occupies it, so too with those items one has appropriated as personal possessions. In effect, the object

becomes a *part* of one's personality (albeit an external part), and one's ownership will be maintained so long as her will manifests itself in the object. Some object is yours, in this sense, because your sense of self is tied up in it, and I can't come to own what you already own unless you first give it up.[26]

Intellectual property is a special case for Hegel. By investing a work with his personality, the creator "comes into possession of the universal methods of so expressing himself and producing numerous other things of the same sort"—in other words, of producing tokens of that type.[27] Like Fichte before him, Hegel points at a distinction between ownership of the form of expression, ownership of the ideas expressed, and ownership of the material thing in which the expression is embodied. Another can come to own, say, a copy of the book I have written without interfering with the investment of my personality in the *type*. Indeed, Hegel notes, in coming to own a copy of a book, another may invest that thing with *her* personality—making its thoughts her own. And, in this way, another can also lay claim to ideas gleaned from another's work, and so go on to produce works of her own. And, again, none of this interferes with the original author's ownership of the work, provided she does not copy the original author's form of expression.

Certainly, Hegel's notion is an interesting one, but it isn't at all clear that it will serve as a justification for copyright generally, or as a workable standard in the law. Certainly, not every change you make to the world results in, or from, a change to your personality—so how are we to distinguish the objects you thus own from those you do not? Imagine that someone writes a poem in an attempt to express herself. On Hegel's view, if she succeeds, she will thus own that work—that form of expression—for so long as it continues to embody her personality. Our first question, though, is how we might determine whether she *did* so succeed. On Hegel's view, it seems, the only sure way to determine this will be to ask the author. Our second question is how we might determine whether, after some period of time has passed, the work *still* embodies her personality. Again, it seems, we must defer to the author. However, insofar as one does not have perfect introspective awareness of one's own psychology or nature, even the author herself may not be able to say whether the work embodies her personality. At the very least, we have a practical difficulty.

A second complication comes from Hegel himself, who writes:

> In the case of works of art, the form—the portrayal of thought in an external medium—is, regarded as a thing, so peculiarly the property of the individual artist that a copy of a work of art is essentially a product of the copyist's own mental and technical ability.[28]

The implication here is that insofar as the copyist of an artwork (a painting or sculpture, distinguished from a literary or other work reproduced *mechanically*) uses his mental and technical ability in that reproduction, he has thus portrayed his *own* thought, and so imbued it with *his* personality. The first problem is that the original artist and the copyist have apparently come to own the very same form. As a practical matter, this would not seem to be an issue for Hegel, as anyone who copies either the original *or* the reproduction would *also* own the form, so there shall be no reason to bicker over whose ownership claims have been infringed. As a theoretical matter, however, this would seem to violate Hegel's contention that one cannot come to own another's property unless the original owner first gives it up.

It may be that Hegel was simply trying to preserve the permissibility of the age-old tradition of painters copying the works of other painters. But, we might ask, is there any good *in-principle* reason for the distinction between mechanical and manual reproductions? Hegel's only suggestion is that mechanical reproductions are "commonplace accomplishments,"[29] which seems little justification.[30] Nothing else in Hegel's view suggests that one must accomplish something novel to gain ownership. If we are dealing with slavish reproduction, then it is simply not clear that a retyping of a literary work is importantly different in kind from a repainting of a painting. Indeed, it isn't clear why there should be any difference in kind between a slavish *mechanical* reproduction and a slavish *manual* reproduction except for the inadvertent introduction of errors by the copyist (and such errors, presumably, are not embodiments of the copyist's personality).

A second problem lies with Hegel's suggestion in this passage that the use of one's mental and technical ability is sufficiently an expression of one's personality. There are all manner of things I might create with mental and technical ability that I do not want to say express my personality. If I am hired to design a company's website, I am certainly drawing on mental and technical abilities, but I am making the website to suit my *clients*, not myself—if anyone's personality is going to shine through, it will (or, at least, should) be theirs, not mine. Perhaps we can suggest that the special case for visual art is an error on Hegel's part, but it has brought out a question that cannot similarly be dismissed: what does it mean for something to express one's personality?

Personality is central to copyright ownership in French law, where the minimum bar of originality is understood as consisting in some mark of the author's personality. And, as we noted in chapter 3, the Court of Justice of the European Union has more generally accepted this notion as foundational. However, the courts have struggled with the question of what, exactly,

it means for some creation to be an expression of the author's personality. In France, whether some work is copyrightable (whether it embodies the author's personality) is left to the courts to determine on a case-by-case basis, and French courts have recently recognized such an embodiment (and so ownership) in shoe designs, the interiors of restaurants, and fish bait, but not in the rules of a game.[31] In determining whether some work carries the mark of the author's personality, French courts ask whether the author was "obliged to make personal and arbitrary artistic choices on the basis of his personal interpretation."[32] In terms of utilitarian objects—shoe designs and fish bait, for instance—French and other European courts ask whether the author's creative choices fall outside ordinary standards for that sort of object and considerations of optimal functionality and efficiency. André Lucas calls this "l'arbitraire de l'auteur"—the arbitrariness of the author.[33] This test seems like a reasonable move for determining originality, and it seems to offer a solution to our earlier problem of subjectivity and imperfect introspection. However, it isn't altogether clear that the arbitrariness of an author's choices are a sufficient indicator of an author's personality.

Take Jean (Hans) Arp's 1933 collage, *According to the Laws of Chance*, composed of a series of torn scraps of black paper glued onto a white card. There is no discernible pattern. This, it seems, is not simply an *appearance* of random chance. Arp explains:

> In 1915, Sophie Täuber and I painted, embroidered, and did collages; all these works were drawn from the simplest forms. . . . These works are Realities, pure and independent, with no meaning or cerebral intention. We rejected all mimesis and description, giving free rein to the Elementary and the Spontaneous. Since the arrangement of planes and their proportions and colors seems to hinge solely on chance, I declared that these works were arranged "according to the law of chance," as in the order of nature, chance being for me simply a part of an inexplicable reason, of an inaccessible order.[34]

In the case of *According to the Laws of Chance*, the Tate Gallery suggests, "Arp may have let the pieces fall onto an already glued surface."[35] Given Arp's method, there should be nothing in the arrangement of scraps that should indicate anything about his personality.[36] Now, perhaps we might argue that it is the *choice* of arbitrariness itself that tells us about Arp's personality, but this will not obviously be found in any "mark" on the work. However, even if we were to accept that the arbitrary choices of an author *are* a sufficient indicator of personality, that the selection and arrangement of elements by an author is arbitrary gives us no reason to believe that the work, years after

the act of creation, *still* reflects the author's personality. As Hegel would suggest, one's personality may be mercurial, and, on his view, the author only maintains ownership in a work so long as it continues to embody her personality. (At the very least, I would like to think that the angsty poetry I wrote as a teenager no longer reflects my personality.) In the end, if the "creative choices" test is the best test we have for determining whether some work embodies its author's personality, then it seems we can jettison talk of personality altogether and simply ask about those choices. We'll come back to this shortly.

Copyright as a Natural Right: Locke's Acquisition View

Perhaps the most commonly discussed view in terms of justifying the rights of copyright is grounded in John Locke's theory of acquisition, a natural rights argument for private property arising from one's labor.[37] Locke outlines his approach in his *Second Treatise on Government* (1698):

> Though the Earth, and all inferior Creatures be common to all Men, yet every Man has a *Property* in his own *Person*. This no Body has any Right to but himself. The *Labour* of his Body, and the *Work* of his Hands, we may say, are properly his. Whatsoever then he removes out of the State that Nature hath provided, and left it in, he hath mixed his *Labour* with, and joined to it something that is his own, and thereby makes it his *Property*. It being by him removed from the common state Nature placed it in, it hath by this *labour* something annexed to it, that excludes the common right of other Men. For this *Labour* being the unquestionable Property of the Labourer, no Man but he can have a right to what that is one joined to, at least where there is enough, and as good left in common for others.[38]

On Locke's view, then, one has a sole right to—and property in—one's own person and, by extension, to one's labor. The natural world, meanwhile, is "common to all Men." By altering some element of the "common" through labor—by *mixing* one's labor with it—one lays claim to it, and so gains a right in it. That is, because one owns oneself, and thus one's labor, one owns the products of one's labor. The resulting property is thus removed from the common and placed outside others' liberty just as the man himself is outside the reach of others. All of this is provided that our man has not, in so laboring, made the situation worse for others by exhausting the common—a limitation known as the "scarcity proviso."[39] And so, some contend, where

physical labor brings about ownership of physical property, intellectual labor brings about the ownership of intellectual property. At least, this is the *standard* interpretation of Locke's account.

Seana Valentine Shiffrin, however, questions the standard interpretation, primarily on the basis that it ignores (and, she argues, is incompatible with) Locke's account of common ownership. Here, Shiffrin argues, we must look to the Grant of God, outlined a little earlier in Locke's *Second Treatise*:

> God, who hath given the World to men in common, hath also given them reason to make use of it to the best advantage of Life, and convenience. The Earth, and all that is therein, is given to Men for the Support and Comfort of their being. And though all the Fruits it naturally produces, and Beasts it feeds, belong to Mankind in common, as they are produced by the spontaneous hand of Nature; and no body has original a private Dominion, exclusive of the rest of Mankind, in any of them, as they are thus in their natural state: yet being given for the use of Men, there must of necessity be a means *to appropriate* them some way or other before they can be of any use, or at all beneficial to any particular Man.[40]

So, God gave the world to mankind in common for its benefit. But, Shiffrin argues, to *be* of benefit, some articles of the common must be appropriated by an individual for that individual's exclusive use. Insofar as one enjoys a natural right for her subsistence to be met, one has a right to appropriate from the common for such purposes so long as it does not infringe on others' rights to do likewise. As a simple case, imagine an apple growing on a tree in the common: the tree is owned by everyone, but no one can gain benefit from the apple without exclusive possession of that apple. Shiffrin writes:

> So, for those items that have a use that requires exclusive possession, the institution of private property would be justified and consistent with the purposes of God's grant. An institution of private appropriation in *some parts* of the common stock is justified on two grounds: because it comports with the underlying motivation of the common grant and because it is necessary to fulfill the natural right of self-preservation.[41]

On this interpretation, one who has labored has a stronger claim than one who has not.[42] One's ownership claim is *supported* by God's Grant.

The move in the standard interpretation that Shiffrin questions is the move from owning one's labor to owning the *products* of one's labor. Insofar

as the standard interpretation leaves out mention of God's Grant, Shiffrin suggests, the standard interpretation cannot justify this move. That is, if the exclusive appropriation is not in necessary support of the God-granted right to self-preservation, then why does one gain ownership in the products of one's labor rather than losing that labor back to the common owned by all? On Shiffrin's interpretation, one gains exclusive ownership in *some* products of one's labor because without that possession being exclusive, one could not benefit from it. It is only because one has the God-granted right to self-preservation (being the very reason for nature being given in common ownership to all men) that one's claim to the products of one's labor outweighs the competing (common) ownership claims of others.

Now, none of this, Shiffrin submits, causes any real problems for ownership of material goods, but it *does* cause problems with a Lockean justification of *intellectual* property. The problem is essentially this: on what basis can one claim that, without taking exclusive possession of some authored work, one will be unable to benefit from what was granted by God to all? I *can't* reasonably enjoy the benefits of an apple without exclusively eating that apple—my ability to do so *requires* the exclusion of others. Things are different for the products of intellectual labor:

> The fully effective use of an idea, proposition, concept, expression, method, invention, melody, picture, or sculpture generally does not require, by its nature, prolonged exclusive use or control. Generally, one's use or consumption of an idea, proposition, concept, expression, method, and so forth, is fully compatible with others' use, even their simultaneous use. Moreover, intellectual products often require at least some fairly concurrent, shared (though not necessarily coordinated) use for their full value to be achieved and appreciated.[43]

That is, if the intellectual common includes such things as ideas, concepts, expressions, and so on, and if the justification for ownership on the Lockean account rests, first, on our God-given common right to benefit from this common, and second, on the necessity of private possession to enjoy such benefits, then since such private possession is *not* required for enjoyment of the benefit of ideas and the like, private ownership of any elements of the intellectual commons will be unjustified.

At least as regards the historical Locke, Shiffrin makes an interesting—and perhaps compelling—argument. Locke himself was not attempting to justify a natural right in intellectual property, after all—indeed, he elsewhere argued against such a notion.[44] At the very least, Locke's view would need some tweaks to be made applicable to intellectual property.

Copyright as a Creative Right

There is something of an ambiguity in Locke's notion of the common. What Locke says is that God "hath given the World to men in common," and that the fruits and beasts of the Earth "belong to Mankind in common." There are a couple of ways to read this: that the common is owned collectively by all men, and alternatively that it is owned by no one. Scholars disagree here: Peter Singer,[45] Stephen Kershner,[46] and Richard A. Epstein[47] (to name three) take Locke's common to be *commonly* owned, while Robert Nozick,[48] Jan Narveson,[49] and Adam D. Moore[50] (among others) interpret the common as altogether *unowned*.[51] It may very well be that Locke saw no important distinction here, though his wording suggests a view of common ownership. On Shiffrin's view, this is a critical distinction for Locke's acquisition theory. Happily, I am not beholden to the historical Locke for my own view.

Let's suppose that, when it comes to intellectual property—and copyright in particular—the common that one draws on consists in such elements as *ideas, shapes, colors, notes, individual words*, and the like. And now, rather than thinking of such an intellectual common as *commonly owned* (so, putting aside any Grant of God), let's think of it as altogether *unowned*. (This is, at least, what copyright law suggests.) Now, if the products of one's labor are composed of materials to which others have a legitimate claim (as would be the case if, say, one builds a house from trees that are commonly owned), then one's ownership claim would require some further move to suggest that the rights gained through labor outstrip others' competing claims. (This is the move that Shiffrin makes on Locke's behalf, using God's Grant to do the outstripping for the laborer.) However, if no one has any such competing ownership claim (because the raw materials were not *commonly* owned, but *unowned*), then the further justificatory move is unneeded. However, we are now left with another problem: saying that no one *else* has a claim to your creation is not the same as saying that *you do*. So, we must ask, what justifies *your* ownership claim? As regards the standard interpretation of Locke's acquisition theory, this is where Shiffrin finds a gaping hole: how do we get from the ownership of one's labor to the ownership of the *products* of one's labor without the underlying justification motivating God's Grant of collective ownership of the common?

In *Anarchy, State, and Utopia*, Robert Nozick asks, "If I own a can of tomato juice and spill it in the sea so that its molecules (made radioactive, so I can check this) mingle evenly throughout the sea, do I thereby come to own the sea, or have I foolishly dissipated my tomato juice?"[52] Simply put, when you mix your labor with the common, why do you come to own the product,

and not lose your labor? Stephan Kinsella expands on this concern, asking, why is it that, if a baker bakes a loaf of bread, he thereby owns the bread? Kinsella suggests that labor—or creation more generally—is a red herring: the baker owns the bread because the baker owned the dough. The act of creation—the transformation of the dough into bread—does not generate any new property rights, Kinsella argues. If the baker was an employee of the bakery and did not own the raw materials, he would not own the product he made by transforming these materials. Rather, whoever owned the dough would. If the raw materials were *commonly* owned, then, it is not clear that any transformation would thus transfer ownership exclusively to the baker. And if the raw materials were *unowned*, it isn't clear why such transformative labor would play any new role in conferring ownership. "So creation," Kinsella contends, "is not sufficient for ownership."[53]

The beginning of an answer, I think, involves moving one further step *back* in Locke's argument, to the premise that one owns one's labor. Shiffrin doesn't raise any problems with this suggestion, nor do I think many would question the move.[54] But, we might ask, *why* does one own one's labor? In her sketch of the standard interpretation, Shiffrin states, "One's labor is a part of one's self and so one owns one's labor."[55] There are two immediate problems with this statement: first, Locke makes no such claim; and second, the claim is surely false. In what sense is one's labor a part of oneself? Is it a part of one's body? Of one's psychology? Of one's soul? Rather, the relationship almost certainly goes in the reverse: *one is a part of one's labor.* Labor (in this context) is an action, and an action is an event. The metaphysics of events is a fairly broad arena, but perhaps the most compelling theory of event ontology is primarily associated with Jaegwon Kim, who suggests that events consist in the exemplification of some attribute (some property or relation) by some object or objects at some time or during some period of time: say, x's having property P at time t. One event, then, is individuated from others according to its constituent elements: $[x, P, t]$.[56] Insofar as one exerts effort at some time (i.e., one labors), the laborer is the x, the exertion of effort, P, and t the time during which x exerts that effort.[57] This formulation should seem familiar. Last chapter, I suggested individuation conditions for authored works, such that, as well has having its particular atomic structure, any given work has causal-historical properties: a (having been created by its particular author), t (having been created at some particular time), and p (having been created at some particular place). The author, on this analysis, is not a *part* of the work (nor is the work a part of the author), but serves as an individuation condition *for* that work: where two works differ in their author (or in its t or p properties), they are different works. We might suggest, as a starting point,

that you own your labor not because your labor is a part of you, but because *that labor owes its existence to you.* Put another way, if we grant your sole, exclusive ownership in yourself, then your ownership of your labor seems justified only in that it owes its existence solely to you—that is, as its free cause. And, if this is the case for owning one's labor, then the same would seem to hold for the *product* of one's labor, that it owes its existence solely to that labor (which, in turn, owes its existence solely to the laborer).[58]

Now, labor is still something of a problem for justifications of copyright. Certainly, many have suggested that, as physical labor brings about one's ownership of material goods, *intellectual* labor plays the equivalent role for intellectual property. In his dissent in the 1834 case of *Wheaton v. Peters*, for example, Justice Thompson states:

> The great principle on which the author's right rests, is, that it is the fruit or production of his own labour, and which may, by the labour of the faculties of the mind, establish a right of property . . . and it is difficult to perceive any well founded objection to such a claim of right. It is founded upon the soundest principles of justice, equity and public policy.[59]

Our first problem is that a labor-based theory of property may extend *greater* protection to the copyist than to the original author. Consider Alfredo Martinez, who was jailed in 2002 for three years for forging drawings by Jean-Michel Basquiat. Says Martinez:

> When I first saw his stuff, like [Keith] Haring's work too, I just knew instinctively it was something I could forge. I could make perfect copies as well as make originals in their style, passing them off as if they were authentic. It was such an easy way to make a quick 20 grand.[60]

Both Basquiat and Haring began their art careers as graffiti artists in the late 1970s, Basquiat spray painting New York buildings under the name SAMO (the name tagged with a copyright symbol). As he transitioned into the art world, Basquiat developed a raw visual style—often manic, sketchy, and spontaneous. Haring began by defacing black panels of paper used in New York subway stations as placeholders for advertisements. He filled them with dashed-off chalk drawings of babies, dogs, flying saucers, and other figures, all in a simple, whimsical, cartoonish, and iconic style. This style stayed with Haring as he moved from chalk to paint and from graffiti artist to commercial juggernaut. Perhaps because of their beginnings in illegal graffiti, both Basquiat and Haring worked quickly, their drawings sketched energetically. It

would be quite easy for Haring to pick up an indelible marker and draw his recognizable "atomic dog" or "radiant baby" on a scrap of paper, or for Basquiat to produce one of his childlike drawings in graphite or colored pencils. Producing an *exact likeness* of even the simplest Basquiat or Haring, though, would take a great deal more work. Such forgery would require much greater attention to detail than the original artist employed—in short, more labor, more time, more effort. If (as Justice Thompson suggests) the right of ownership comes as a result of labor, then it seems Alfredo Martinez has a *greater* claim to the works of Basquiat and Haring than do the original artists themselves. If labor were the sole justification for ownership, then there would seem no reason to say that a second-comer could not wrest ownership away from the original owner by outlaboring him. At the very least, this is at odds with the very notion of copyright.

The problem goes deeper than this, however. The labor-based justification of copyright seems at odds with what we centrally value in authored works and why we tend to think they deserve protection. Jerrold Levinson notes, "When all is said and done, in art we primarily appreciate the *product*, viewed in its context of production; we don't primarily appreciate the *activity of production*, as readable from the product."[61] Even if we might be impressed with the amount of labor—physical or mental—that went into creating a work, in the end it is the *work* that we value, and we may be as impressed with (and value as much or more) a Basquiat or Haring drawing created spontaneously and quickly as we would a work that took months or years of mental wresting and physical exertion to create. More than labor, we tend to value ingenuity, sensitivity, and vision; we appreciate good form, whether complex or simple—not merely the idea, but *how that idea is brought to life*. In short, we value the *creativity* embodied in authored works: the author's choices. A theory that grounds the value of works—and our reason for protecting them—in labor seems to miss the point.[62]

Let's begin pulling this together. As Locke suggests, one owns oneself. However, the common that concerns us in copyright consists in those pre-existing, unowned elements which an author selects and arranges as constituent of her work. These will include ideas, facts, shapes, colors, sounds, individual words, and the like. These elements are free for anyone to use—to select and arrange in the creative act of authorship. By selecting and arranging these unownable elements as an authored work, one creates something that owes its existence solely to the author's creative act, and so lays a claim to it (a claim against all others). Where, on the standard Lockean view, the laborer who builds a house from previously unowned (or commonly owned) trees lays claim to those trees, the author does *not* lay claim to those elements

culled from the common in the creative act. Rather, one lays claim to what one has created—a type: the structured *arrangement* of elements. This—and not the letters, colors, or sounds—is what owes its existence to the author, and to which the author can lay claim. And so, what makes one an author of a work is precisely what gives one ownership of that work. (And so, as I mentioned in chapter 4, it should come as no surprise that copyright laws were developed to reflect our recognition of authorship.) Where some element of your work owes its existence to someone else (say, where one appropriates some expression from another's work), or to no one at all (as in the case of materials drawn from the intellectual common), you do not own that element. (And so, contra-Shiffrin, the common does *not* thus include expressions—copyrightable works of authorship—which owe their existence to their authors.[63])

Now, in what, we might ask, does this ownership *consist?* Ownership, broadly speaking, is the exclusive right to exploit (or authorize exploitation of) one's property. And how one exploits one's property depends on the sort of thing that it is. If one owns a house, one exploits it by occupying it, or perhaps by developing it. If you trespass in my house, then, you are infringing on my exclusive right to occupy that house (and similarly if you give it a new paint job while I am on vacation, however much that might be appreciated). But an authored work is not a material object (though it will likely be embodied in one), and one does not exploit an abstract object like a type by occupying it.[64] Rather, one exploits a type by instantiating it: by making token copies (whether in whole or in part). In his seminal essay, "Ownership," Tony Honoré points in this direction, suggesting that the right to possess consists centrally in having "exclusive physical control of a thing, or to have such control *as the nature of thing admits.*"[65] What control a thing admits of depends very much on the kind of thing that it is. Honoré suggests, "We are left, not with an inclination to adopt a terminology which confines ownership to material objects, but with an understanding of a certain shift of meaning as ownership is applied to different classes of things owned."[66] Ownership, I suggest, is actually a largely *stable* concept and generally consists in the exclusive right to exploit (or authorize exploitation of) one's property; what shifts is what it means *to* exploit that kind of thing.

Where the right of copyright consists in the exclusive right to copy (or to authorize copying of) one's work, prima facie infringement of that right will then consist in copying (from) the protected work without permission. Such an infringement may take the form of a mere taking—an outright copying of the work (regardless of the method of doing so), such as by retyping or photocopying a literary work, the printing of a photograph, or the electronic

duplication of a film or musical work; it may take the form of a performance or broadcast of a dramatic or musical work; or it may consist in the creation of a derivative work which copies in part from another's original work but which adds new material in a new act of authorship. As discussed last chapter, infringement may come in degrees.

A Libertarian Worry

Jeremy Waldron argues that intellectual property operates by "prohibiting anyone from using or enjoying the work except on terms agreed with the author."[67] Tom G. Palmer contends:

> If the foundation to the natural right of copyright is ownership in one's self, however, then claims to own ideas or other ideal objects conflict with this right to self-ownership, for such a claim is no less than a claim to the right to control how another uses his or her body. When one claims to own a dance step, for example, one claims that no one else can so move his or her body so as to perform this dance, and therefore that one has a right of dominion over the bodies of everyone else. Similarly, a copyright over a musical composition means that others cannot use their mouths to blow air in certain sequences and in certain ways into musical instruments they own without obtaining the permission of the copyright holder.[68]

Both Waldron and Palmer are suggesting that copyright restricts our liberty. Taken as a universal claim, Waldron's statement is, of course, false. If I borrow a novel from my local library, the book's author has no power to restrict my ability to read and enjoy the book. If I buy a copy of the latest blockbuster on Blu-ray, I am free to watch and enjoy (or not enjoy) the movie at my leisure. I am likewise free to gaze on, ponder, and enjoy Robert Bruno's behemoth of a sculpture on Texas Tech University's campus. And when my wife calls it "The Headless Polar Bear," neither Bruno's ghost, nor his heirs, have any power to censor her. Now, it's true that the authors of each of these works *had* the power to make (or refrain from making) their works available to the public, but having done so, copyright does not provide the author any general powers to restrict the use or enjoyment of the work.

Palmer's claim is more interesting, suggesting that any argument for copyright based on man's exclusive ownership of himself is self-defeating. If (on this basis) one owns some "ideal object" (the authored work), and this ownership gives the author the power to restrict the copying of that work, then, Palmer suggests, the copyright owner has the power to restrict what another

can do with her own body: dancing the dance or singing the song that the author owns.[69] Copyright, Palmer contends, thus both relies on and negates our ownership of ourselves. If, as I have suggested, ownership amounts to the exclusive right to exploit (or authorize exploitation of) the thing owned, then ownership of oneself presumably includes the exclusive right to exploit one's body. However, first, ownership—the exclusive right to exploit a thing—is not without its limits. Owning my car does not thereby provide me the power to exploit it by painting it up like a police cruiser, or driving it at 100 miles per hour through city streets. Owning my house does not give me the liberty to convert it into a nuclear power facility. And so it should come as no surprise that ownership of one's body is similarly limited in its scope. My exclusive right to exploit my body does not thereby give me the right to use it to trespass on your land, for instance, or to assault your body. Second, and perhaps more importantly for our purposes, the creative act of authorship, which provides the author copyright ownership in her work, does not take away a single freedom already enjoyed by others. In particular, such ownership does not restrict another's independent powers of authorship—not even to select and arrange the very same elements from the intellectual common as constitutive of a new (if formally indistinguishable) work. All that one is restricted from doing is *copying* the protected work—which one could not have done before the work existed. Anything that one was able to do before the authorship of that work, one remains free to do.[70]

Now, all this being said, while I argue that copyright is a natural right, I do not thus hold that it is an absolute, inviolate right.

The Rights of Others

Let's Go Crazy

In February 2007, Stephanie Lenz uploaded a twenty-nine-second home video to YouTube of her year-old son Holden dancing (well, bouncing happily, supported by his Fisher-Price baby walker) to the background music of Prince's 1984 hit, "Let's Go Crazy." Four months later, Universal Music—which administers Prince's copyrights—sent a "takedown notice" for the video to YouTube, and YouTube complied the same day, removing the video and sending Lenz a notification. Codified into law in 1998, the Digital Millennium Copyright Act (DMCA) establishes a number of provisions, including "anti-circumvention" provisions—which make it illegal to circumvent access-control technology on digital information—and, importantly for the purposes of this case, "safe harbor" protections for online service providers, which immunize OSPs (like YouTube) against liability in copyright-infringement claims if, on receiving notification that they are hosting infringing material, remove or block access to that material. Universal had informed YouTube that Lenz's video was infringing, and so YouTube removed the video. However, the DMCA also includes provisions allowing parties to submit counter-notices to OSPs if the parties believe their removed or blocked materials are *not* infringing. Lenz submitted such a counter-notice to YouTube, and six weeks after the video was taken down, it was restored. Lenz filed suit against Universal, and, after some back and forth, both parties moved for summary judgment, asking the court to make a legal decision without a full trial.

In oral arguments, Lenz contended that Universal's takedown notice was in bad faith—that it had not considered the possibility that her use of twenty-nine seconds of Prince's song in her video was a noninfringing "fair use." Incorporated into § 107 of the Copyright Act, the fair use doctrine permits certain uses of copyrighted materials without requiring permission of the copyright

owner. As paradigm cases of fair use, we might think of a clip of a film used in a movie review or a copy of a book chapter used for research purposes. In her arguments, Lenz contended that her video was "self-evident" fair use. The district court judge, however, pointed out that there is effectively no such thing— that a fair use decision is not a mechanical matter of simple assessment, of applying a general rule to a particular case, but rather involves a "considered legal judgment." So, in 2013, although the court agreed that Universal had issued its takedown notice without considering the possibility of fair use, it rejected both sides' motions for summary judgment. Both parties cross-appealed.[1]

Fair Use and Fair Dealing

Jeremy Fogel, the US district judge in the Lenz case, is absolutely correct: there are no "self-evident" cases of fair use, and there is no straightforward rule for determining such. Arising from the 1841 case of *Folsom v. Marsh*, and integrated into the 1976 Act, the fair use doctrine has been called both "one of the most important and well-established limitations on the exclusive right of copyright owners"[2] and "the most troublesome [doctrine] in the whole of copyright."[3] The trouble centrally arises from the doctrine's notorious looseness. Section 107 of the US Copyright Act outlines the doctrine:

> Notwithstanding the provisions of sections 106 and 106A [which outline the rights included under copyright ownership], the fair use of a copyrighted work, including such use by reproduction in copies or phonorecords or by any other means specified in that section, for purposes such as criticism, comment, news reporting, teaching (including multiple copies for classroom use), scholarship, or research, is not an infringement of copyright. In determining whether the use made of a work in a particular case is a fair use the factors to be considered shall include—
>
> (1) the purpose and character of the use, including whether such use is of a commercial nature or is for nonprofit educational purposes;
> (2) the nature of the copyrighted work;
> (3) the amount and substantiality of the portion used in relation to the copyrighted work as a whole; and
> (4) the effect of the use upon the potential market for or value of the copyrighted work.
> The fact that a work is unpublished shall not itself bar a finding of fair use if such finding is made upon consideration of all the above factors.[4]

Although detailing such "purposes as criticism, comment, news reporting," and so on, these categories of use do not fully specify the boundaries of what may be considered fair, nor does any use falling within these categories thus necessarily qualify as fair. Rather, the fairness of a use can only be determined by considering the factors outlined above, and this must be done on a case-by-case basis. We have to ask, for instance, *why* the original work is being used (first factor), whether the work being copied is primarily a fact-based work or a fictional work (second factor), and how *much*—and what *part*—of the original work has been copied (third factor). Problematically, nothing in the doctrine specifies whether the four factors carry equal weight, nor whether they are conceptually exclusive or should be considered holistically. Simply put, nothing in the doctrine as written would tell Stephanie Lenz that her use was fair, and nothing in the doctrine would tell Universal that it was not. Amazingly, this seems to have been precisely Congress's *intent*, as reflected in legislative history:

> Although the courts have considered and ruled upon the fair use doctrine over and over again, no real definition of the concept has ever emerged. Indeed, since the doctrine is an equitable rule of reason, no generally applicable definition is possible, and each case raising the question must be decided on its own facts.[5]

The doctrine was specifically *designed* by Congress to be treated on a case-by-case basis and, being so designed, puts the onus on courts to decide whether any given use is fair.

Matthew Sag appropriately refers to fair use as "the god in the copyright machine," invoking the image from Greek tragedy of a deity floating down from on high to solve an otherwise insoluble problem.[6] Courts are required to play this role because the law as such offers us no means to do so ourselves. As it stands in the Copyright Act, the fair use doctrine offers effectively no predictive value, and (perhaps worse) sets no reliable precedents. What this means is that, despite all that I know about copyright law, I simply cannot tell you whether some use is fair. Nor can anyone else. In effect, the only way to find out if a use is fair is to get sued and go to court.

Not that matters are much easier for those who actually have to *make* the fair use decisions. US District Court Judge Pierre N. Leval notes:

> Our statute and our judge-made law talk around the subject [of fair use]. They mention factors, but give no standard. And those factors are stated in an opaque

and uninformative way. We are told for example to look at the purpose and character of the secondary use and at the nature of the copyrighted work. "What about them?," you may ask. We are not told. We are told to look at the amount of the taking and the effect on the market. "How much is too much?" We are not told.[7]

Indeed, as the doctrine only states that, in a fair use decision, "the factors to be considered shall *include*" those listed, judges are not restricted to just those four enumerated in the Copyright Act, and any number of additional considerations have been noted as playing the role of a "fifth factor" in judicial decisions. William Wallace cites several factors that have played this decisive role, including a "Public Interest Factor" (whether the use contributes to the constitutionally specified goal of copyright to expand the marketplace of ideas), a "Good Faith Factor" (whether the use represents an attempt to displace the original, for instance), and an "Intrinsic Purpose Factor" (whether the use is in harmony with the original work's designed function).[8] All of this may explain why, even in those relatively rare cases in which all four factors point in favor of either the plaintiff or the defendant, the judicial decision ultimately only goes in the same direction some 54 percent of the time.[9]

As an example, consider first the case of *MCA, Inc. v. Wilson*.[10] In this 1981 case, the defendants had produced an off-Broadway musical, *Let My People Come*, which included the song, "Cunnilingus Champion of Company C," sung to the tune of "Boogie Woogie Bugle Boy of Company B." The latter's composer filed suit. Weighing the four factors, the court found that all four weighed against fair use: (1) the parody was commercial, (2) the original was highly expressive, (3) the copying was substantial, and (4) the two works were "competitors in the entertainment field."[11] *Wilson* was a landslide decision. Now consider the 1994 case of *Campbell v. Acuff-Rose Music*.[12] In this case, rap group 2 Live Crew was sued for allegedly infringing Roy Orbison's classic song, "Oh, Pretty Woman." The 2 Live Crew song, "Pretty Woman," copied the famous first line of lyrics and recognizable bass line from Orbison's work, thereafter deviating further and further from the original. Given the outcome in the *Wilson* case, the rap parody would seem to fail all four factors of fair use, and for the same reasons. However, the court in this case found that *because* the work was a parody, it *required* substantial copying from the original, thus neutralizing the third factor. And, in interpreting the fourth factor, the court argued that parody that *suppresses* the market for the original is allowable, while those that *usurp* the original are not, thus swinging the fourth factor in favor of 2 Live Crew. The first factor was essentially a

draw: although the parody was commercial, it was also "transformative" of the original—a new work rather than a mere replication (a good deal more about this next chapter). In the end, the court found 2 Live Crew's parody "fair" regardless of its material equivalence to the *Wilson* case. Julie Van Camp argues that there was a "fifth factor" at work here—what we might call an "Aesthetic Value Factor"—that weighed in favor of the "Pretty Woman" parody,[13] and that was left unconsidered in *Wilson*. As David Nimmer suggests, "had Congress legislated a dartboard rather than the particular four fair use factors embodied in the Copyright Act, it appears that the upshot would be the same."[14]

The central reason for the open-endedness of the fair-use doctrine was to allow copyright to adapt to ongoing social and technological change without requiring the law to be rewritten every few years, and without having to exclusively specify the innumerable cases where it would be reasonable to call a use "fair." In effect, as Sag notes, in setting up ambiguous factors rather than setting a "bright-line rule," Congress passed the buck to the courts and "has relieved itself of the burden of difficult decisions and left the judiciary to apply a vague and open-ended standard."[15] Congress's other option, of course, would have been to provide a list of all of those uses that *are* fair, restricting flexibility for the sake of predictive value. This tends to be the reasoning behind "fair dealing" doctrines used in other jurisdictions.

Guyana's Copyright Act of 1956 is a paradigm "fair dealing" case, specifying that copying of artistic, literary, dramatic, or musical works for the purposes of research, criticism, or review is fair and uninfringing.[16] India's Copyright Act of 1957 is similar, but offers more specifics for exceptions in cases of computer programs.[17] The similarity should not be surprising, as both of these acts are based on Britain's Copyright Act of 1956, which spends a great many pages detailing exceptions under fair dealing. Section 6 of the Act deals with literary, dramatic, and musical works. In part:

> (1) No fair dealing with a literary, dramatic or musical work for purposes of research or private study shall constitute an infringement of the copyright in the work.
> (2) No fair dealing with a literary, dramatic or musical work shall constitute an infringement of the copyright in the work if it is for purposes of criticism or review, whether of that work or of another work, and is accompanied by a sufficient acknowledgment.
> (3) No fair dealing with a literary, dramatic or musical work shall constitute an infringement of the copyright in the work if it is for the purpose of reporting current events—

(a) in a newspaper, magazine or similar periodical, or

(b) by means of broadcasting, or in a cinematograph film, and, in a case falling within paragraph (a) of this subsection, is accompanied by a sufficient acknowledgment.

(4) The copyright in a literary, dramatic or musical work is not infringed by reproducing it for the purposes of a judicial proceeding, or for the purposes of a report of a judicial proceeding.

(5) The reading or recitation in public by one person of any reasonable extract from a published literary or dramatic work, if accompanied by a sufficient acknowledgment, shall not constitute an infringement of the copyright in the work:

Provided that this subsection shall not apply to anything done for the purposes of broadcasting.[18]

This section continues with specific rules about the use of such works in collections for schools and for broadcast in jurisdictions outside of England. Other, parallel rules are laid out for recorded musical works, visual artworks and film, and works of industrial design. In all, the fair-dealing section of the 1956 Act goes on for some 5,000 words. British law was revised with the Copyright, Designs and Patents Act of 1988, which adds fair-dealing rules for computer programs as a matter of research or private study, but otherwise pares down the rules of fair dealing to the essentials.

Notably, the new Act includes provisions for the "incidental inclusion" of a copyrighted work in an artistic work, sound recording, or film. However—as would be important for Stephanie Lenz, were her case to be tried in Britain— "[a] musical work, words spoken or sung with music, or so much of a sound recording or broadcast as includes a musical work of such words, shall not be regarded as incidentally included in another work if it is deliberately included."[19] Intuitively, if a filmmaker adds background music to the scene of a film in postproduction, this would most certainly be deliberate and so not fair dealing. By contrast, if a documentary filmmaker is recording a street scene, and a car happens to drive by with music playing from its open windows, this will not be deliberate, and would seem to be straightforwardly incidental and so fair. But what of Lenz? The use of "Let's Go Crazy" in her twenty-nine-second film is not "deliberate" in the same way that the filmmaker's inclusion of a song in postproduction is deliberate. Nor, however, is her case quite the same as the documentary maker's incidental inclusion of background music: Lenz's film is very much *about* her baby bopping along to "Let's Go Crazy." Indeed, the title of her short film is "Let's Go Crazy #1." In this sense, the

song is not *incidental* to the video; it is *material* to it. In a 2003 case, *Football Association Premier League Ltd. v. Panini UK*, the FAPL filed suit against Panini for its photographic stickers, which depicted famous footballers with their respective club emblems visible in the photographs. Panini argued that the uses of these copyrighted emblems were incidental. The court disagreed. While declining to define "incidental" (and thus giving anything like a useful rule), the court stated that the term is "sufficiently clear to enable the courts to apply it to the ascertainable objective context of the particular infringing act in question."[20] As Lionel Bently and Brad Sherman note, "The question of whether the uses were incidental did not have to be determined at the time that the photograph was taken, but rather when the sticker was created."[21] In other words, perhaps the emblems were incidental in the photographing of the footballers, but not in the creation of the stickers. Might we, on similar grounds, distinguish between Lenz's recording of her son and her subsequent creation of a work or broadcast of the same? There is no clear answer in the law.[22] As such, we might expect, a case like this would have to be decided in court after all. Although the most common complaint against fair-dealing doctrines is that they are overly rigid and do not allow for the flexibility of a fair use doctrine, specific rules, like those of fair-dealing doctrines, cannot provide all of the necessary details and so must often revert to case-by-case analysis, inheriting many of the same problems as the US fair use doctrine.

In fact, most jurisdictions employ a combination of the paradigmatic fair use and fair-dealings systems. Although, for example, Antigua and Barbuda's Copyright Act of 2003 refers to "fair dealing," its system for determining fair dealing references the same four factors as the US fair use doctrine and follows the same case-by-case system, while specifying that copying made for the purposes of reporting current events, or as is necessary for criticism or review, is fair.[23] Similarly, while using the terminology of "fair dealing," Canada, Australia, and New Zealand each employ systems similar to the US fair-use doctrine, though including more factors. However, each also sets out specifics for cases of presumptive fair dealing, variously including cases of criticism and review, parody or satire, and news reporting.[24] A recent fair-dealing case in the Canadian Supreme Court, however, introduced a new element: "users' rights."

Users' Rights

In the 2004 case of *CCH Canadian Ltd. v. Law Society of Upper Canada*, the Supreme Court argued:

Reviewing the scope of the fair dealing exception under the *Copyright Act*, it is important to clarify some general considerations about exceptions to copyright infringement. Procedurally, a defendant is required to prove that his or her dealing with a work has been fair; however, the fair dealing exception is perhaps more properly understood as an integral part of the *Copyright Act* than simply a defence. Any act falling within the fair dealing exception will not be an infringement of copyright. The fair dealing exception, like other exceptions in the *Copyright Act*, is a *user's right*. In order to maintain the proper balance between the rights of a copyright owner and users' interests, it must not be interpreted restrictively.[25]

Although talk of "users' rights" had been around in academic and legal circles for years, introduction of the notion into a Supreme Court decision (in Canada or elsewhere) was unprecedented. The US Copyright Act contains one buried mention, in § 108 (which deals with special exceptions to copyright for libraries and archives), specifying that nothing in the section "in any way affects *the right of fair use* as provided by section 107, or any contractual obligations assumed at any time by the library or archives when it obtained a copy or phonorecord of a work in its collections."[26] Curiously, nothing in § 107 itself—which, recall, lays out the details of the fair use doctrine—makes any mention of a "right" of users. Indeed, while mention of "users' rights" may occasionally escape the lips of American judges, the same year that the Canadian Supreme Court affirmed them, at least one US court explicitly disavowed the existence of any constitutionally protected fair use rights.[27]

A number of Canadian industries pushed back on the Supreme Court's introduction of users' rights. Access Copyright, which collects and distributes revenues for Canadian copyright holders, argued:

> In *CCH* this Court raised expectations when it held that fair dealing is a "user's right." Those raised expectations have led users like the appellants to ask that the right be clarified and made more predictable. However, this should not come at the expense of upsetting the balance between users' and creators' rights under the *Act*.[28]

Rather than providing any such clarification, however, in 2012, the Supreme Court doubled-down:

> *CCH* confirmed that users' rights are an essential part of furthering the public interest objectives of the *Copyright Act*. One of the tools employed to achieve the proper balance between protection and access in the *Act* is the concept

of fair dealing, which allows users to engage in some activities that might otherwise amount to copyright infringement. In order to maintain the proper balance between these interests, the fair dealing provision "must not be interpreted restrictively."[29]

While American law recognizes an explicit right for authors and (one strange mention aside) none for users, the constitutional foundation for copyright law—that it exists "[t]o Promote the Progress of Science and useful Arts"—is framed solely in terms of public interest, and not at all in terms of some natural right for authors. Conversely, Abraham Drassinower suggests that Canadian copyright law is truly a "dual-objective" system, in which the creator and the public play complementary and equally important roles in a balance between authors and users.[30] Fair dealing is not an *exception* to copyright on this view, but rather an integral *part* of copyright. Strictly speaking, "copyright" does not describe the author's rights, but the *system as a whole*. The author-cog and the user-cog do not spin independently but together, and the cogs must be in balance for the machine to work at all.

As Drassinower notes, many have argued that the same balance is in fact at the heart of American copyright (we noted this much in earlier chapters), and that users' rights are fundamental to this system. L. Ray Patterson and Stanley W. Lindberg contend:

> [U]sers have rights that are just as important as those of authors and publishers—and these rights are grounded in the law of copyright. To employ the fair-use provisions of the copyright act is not to abuse the rights of the authors or copyright owner; indeed, the very purpose of copyright is to advance knowledge and thus benefit the public welfare, which is exactly what fair use—properly employed—does.[31]

The fair use exception would seem to exist in US law to further the constitutional directive to advance knowledge. Where a copyright owner's strict control over copying would run *counter* to this end, and actually retard the advancement of knowledge, fair use provides a means of correction. Like Drassinower and the Canadian Supreme Court, Patterson and Lindberg argue that the rights of users are thus complement to those of authors within the system: where copyright owners have the right to restrict access to and copying of their works except in circumstances *a*, *b*, and *c*, users have the right to access and copy those works in circumstances *a*, *b*, and *c*. In particular, Patterson and Lindberg contend, "The constitutional purpose of copyright—the promotion of learning—requires the right-of-access principle."[32]

The particular worry here is about one of the provisions mentioned at the beginning this chapter, the "anti-circumvention" provision afforded by the Digital Millennium Copyright Act, which makes it illegal to circumvent access-control technology on digital information—to break digital "locks." According to Patterson and Lindberg, "individuals have a right to use copyrighted materials. Such use is necessary to learning."[33] That is, as the instrumental purpose of copyright is to promote learning, for an author to act in such a way that restricts users from doing so is to infringe the *users' rights*.

The supposition of users' rights by the Supreme Court, and by Patterson and Lindberg, then, would seem to presuppose an argument like this:

(1) Where copyright owners have rights to restrict copying of work W under all circumstances except *a, b,* and *c,* users have the right to access and copy work W in circumstances *a, b,* and *c*.

(2) By restricting the ability of users to access and/or copy work W in circumstances *a, b,* or *c,* copyright owners thus infringe the rights of users.

(3) Therefore, copy-protection, which so restricts the ability of users to access and/or copy work W, infringes the rights of others.[34]

Certainly, this is a valid argument: (2) follows from (1), and (3) follows from (2). However, this is not the only conclusion that follows from (2); consider:

(4) By not publishing work W, the copyright owner restricts the ability of users to access and/or copy work W, and therefore infringes the rights of (potential) users.

However, do we really want to say that I have done something *wrong* if, in writing a poem, taking a photograph, or scribbling a doodle, I hide that work away in a drawer, thus restricting your access to the work—that I have *infringed your rights?* Clearly (4) is an absurd conclusion, and even advocates of a "right of access" would not presumably go this far. Since (2), (3), and (4) all follow from (1), if there is a problem, it would seem to be with this first premise.

The central worry with (1) is: why should limitations to one person's rights thus give rise to complementary *rights* claims in others? This seems a conceptual misstep. Intuitively, following Wesley Newcomb Hohfeld's familiar conceptual scheme, the limitation on the right of copyright would seem to give rise to a *liberty* or *privilege* for others, but not thus a *right*.[35] Here is the difference: rights entail duties on the part of others; liberties do not. Where (in our situation) author A has the exclusive right to authorize copying of

work W except in circumstances a, b, and c, user B is at *liberty* (relative to A) with respect to W in circumstances a, b, and c—he may copy or not copy W. But B's liberty does not thus entail any duty on A's part (or that of anyone else) not to *interfere* with B's actions with respect to W in circumstances a, b, or c. Frances Kamm nicely sums things up: "I may be at liberty to look at you, but you have no duty to let me look at you if you may permissibly put up a screen in front of you."[36] Might the defender of users' rights, then, suggest that such a screen—in our case, say, a digital lock—would *not* be permissible? For that to be the case, some independent argument will need to be made for a right on the part of users, for while a limitation to an exclusive right may give rise to *privileges* or *liberties*, this is a far cry from giving rise to *rights*.

In 2012, in the wake of a 2007 overhaul to the Israeli Copyright Act, the Israeli Supreme Court reached a similar conclusion:

> [T]here are those who reckon that the permitted uses pursuant to the new law should be categorized as rights, per se, of the users, in the sense that the uses might serve as affirmative claims, as oppose[d] to claims of defense. I am unable to accept that argument. The language of the Law does not contain a clear indication that the legislature sought to alter the existing balance and to turn the defenses into rights. Even if a use is permitted, in that it allows users "freedom," that is not indicative of the existence of a right.[37]

The Israel Supreme Court raises a challenge that the Canadian Supreme Court has so far refused to answer: why think that users have a *right* to their uses, rather than a mere *privilege*?

Based on a view offered by Edwin Hettinger,[38] Adam D. Moore considers this argument:

> (1) If a tangible or intangible work can be used and consumed by many individuals concurrently (nonrivalrous), then access and use should be permitted.
> (2) Intellectual works falling under the domains of copyright, patent, and trade secret protection are nonrivalrous.
> (3) So it follows that here is an immediate prima facie case against intellectual property rights or for allowing access to intellectual works.[39]

The thinking here is that the very nature of authored works—that they can be enjoyed by many without taking anything away from the author—precludes any argument against limiting what others can do with those works. If you take my car out for a joyride, then I can't get to work. My car is a rivalrous good, and so I have been harmed in this instance. However, your accessing

or copying the book I have written in no way limits what I can do with my property. My book—the abstract object, not the physical one—is a nonrivalrous good, and so I have not been harmed. Given the nature of such abstract objects as authored works, there is no good argument for excluding the user from accessing or copying the work, and so such uses should be permitted.[40]

As Moore notes, (2) seems unproblematic. I am not concerned here with patent or trade secret protection, but on my view, authored works—the objects of copyright—are certainly nonrivalrous: it is in their nature as types to be multiply tokenable. Moore's complaint, then, is with (1), and the underlying assumption that harm is not done in the unauthorized consumption of another's nonrivalrous good. In any general sense, Moore suggests, harm and the nature of nonrivalrous goods have no such conceptual relationship. "Intangible works of all sorts are nonrivalrous," Moore suggests,

> including sensitive personal information, financial records, and information related to national security. It may even be the case that our bodies could be nonrivalrously used by others. Nevertheless, this feature of most intangible goods and some tangible goods does not obviously justify such use.[41]

Simply put, the sharing of nonrivalrous materials may cause *all manner* of harm. To this, of course, one might respond that it is not the *copying* of such materials that is in itself a harm-causing wrong, but rather what one *does* with those materials, so (1) would stand, as would the argument as a whole.

Now, if my argument for copyright ownership rested on a mere claim that the author deserves such ownership because her possession harms no one, then it would be fair game to use such a nonharm argument against her in return: so long as no one harms *her*, then any such unauthorized access or copying would be unproblematic. However, I do *not* make this argument—indeed, I explicitly rejected it last chapter. Rather, I would suggest, infringement of the author's natural exclusive right to exploit (or to authorize exploitation) of her works *is* a harm to her. It's not a violation of her rights because it's a harm; it's a harm because it's a violation of her rights. Moore writes: "[A] Peeping Tom may engage in immoral activity without harming his victims—perhaps there will be no consequences to the victims and they will never know of the peeping."[42] Moore's suggestion is that one might do *wrong* without causing one's victim any *harm*. However, where the victim of the peeping tom has a legitimate interest in not being peeped upon (a privacy interest), it is clear that said peeping represents a setback to her interests. This, as many have considered it, just *is* the definition of harm: *a setback to one's interests*.[43] And, of course, the same will hold true for our copyright

owner: insofar as the author has the exclusive right to copy (or authorize copying of) her works, she has a legitimate interest in that right; and, insofar as another infringes that right, the author has experienced a setback to her interests—a harm—and this will hold equally true even if she is unaware that such an infringement has occurred. So (1) fails: where one has an exclusive right to one's nonrivalous good, it does not follow that (unauthorized) access and use should be permitted.

Conflicting Rights

So far, we have not yet found a workable argument for users' rights—indeed, most who suggest such rights make no argument at all, and rather only assert their existence[44]—but this does not mean that such an argument *could* not be made, and I do not want to foreclose on the possibility.

So, let's suppose there *are* such things as users' rights—rights to access or copy another's copyrighted works. Being a right, and not a mere liberty or privilege, this would put a duty on others (and, in particular, the copyright owner) to allow such activities. And, insofar as the copyright owner worked to *prevent* such activities, this would be a wrong against the user. This is where things become complicated, because now we have to ask when one right defeats another, and on what grounds. Quite often, rights are treated as moral trump cards, but how can one trump defeat another?

Some rights theorists—dubbed "specificationists"—suggest that rights never actually conflict.[45] Recall, for instance, premise (1) from our first considered argument for users' rights, above:

> Where copyright owners have rights to restrict copying of work *W* under all circumstances except *a*, *b*, and *c*, users have the right to access and copy work *W* in circumstances *a*, *b*, and *c*.

There is no conflict here, the specificationist would argue: the author's right does not actually *conflict* with the user's right. Rather, we have a nicely (if, in this case, abstracted) delineated boundary between rights. Our problem, however, is this: we have on hand from last chapter a natural rights argument for copyright ownership that is wide-sweeping—that, on its face, precludes against all unauthorized copying of one's work. There is no apparent reason *internal* to this argument that the right should be limited, so it is not clear how another apparently conflicting rights claim (a claim to access or copy that work by another, without permission) could limit the boundaries of this right as the specificationist suggests. And so, if there *is* such an opposing

rights claim, it remains unclear how it would serve to defeat copyright in any circumstances. At the very least, this would require unpacking exactly what these rights are.

Any right is a right insofar as it burdens others with a duty. If I have a right not to be raped, for instance, then you (and everyone else) would have a duty not to rape me. On this formulation, the right not to be raped is a "negative" right: it *restricts* what others can do. Now, I might also have a right to be protected against being raped. If this is the case, then you (and all others) would have a duty to *prevent* (where possible) my being raped. This would be a "positive" right that burdens you with a *provision*. (And, not unreasonably, if you have the duty not to rape me, then you also have the duty to *prevent* yourself from raping me.) The right of copyright, as laid out last chapter, would be a *negative* right, restricting others from copying one's work without authorization.

There are at least a couple of possible ways that a user's right might be understood: either as a right to access another's work or as a right to copy from another's work in order to express one's own ideas. In each case, we seem to have another negative right: a right not to be interfered with. And so this is our apparent clash: author *A*'s copyright imposes a duty on user *B* not to copy her work, and *B*'s user's right imposes a duty on *A* not to interfere with his copying of her work. In the case of access, we would presumably be talking about a work that is not already publicly available, and so this access (depending on the kind of work involved) may or may not itself require unauthorized copying. Our conflict, then, is between negative rights (and their corresponding duties), in what Frances Kamm would call an "agent-neutral perspective" (the conflict lies *between* agents, not as conflicting duties *within* a given agent).[46]

Kamm suggests that the key to determining the outcome in such cases rests in determining what interests the respective rights protect. In the case of copyright, at a first pass, the interest would seem to be the interest to freely express one's ideas, an extension of the creator's autonomy. As for the user's right, there seem to be two possibilities: that such a right is based in an interest had in accessing ideas (a different interest from the copyright owner's), or that such a right is itself based in the interest of freely expressing one's ideas (being the same interest as that had by the copyright owner). Let's consider these in turn.

(a) Where the user's right is based in an interest had in accessing ideas:

In a case in which conflicting rights are based on distinct interests, Kamm suggests, we must ask which interest is more *important*. Unfortunately, Kamm

offers no algorithm for determining degrees of importance. One way to go about this would be to ask, which interest is more *fundamental*. We have on hand an argument for the right of copyright, but not one for users' rights. Insofar as (I suspect) the grounding for a *natural* right will always be more fundamental than one for an instrumental right, let's consider the hard case and suppose a natural rights grounding for users' right of access: say, that accessing ideas is necessary for one's advancement as a human being. At a first pass, this seems reasonable enough. Certainly, it may be true that without access to ideas, one cannot advance as a human being, and I think we all have an interest in so advancing (whether we recognize it or not). First, however, there seems no reason to suggest that such advancement requires access to any *given* idea—certainly not the ideas contained in the average novel, movie, or computer program. And so, there seems no basis (on this grounding, anyway) to suggest that one should be given access to the ideas expressed in any *given* work (and so no basis on this grounding to a claim that the copyright owner would have a duty to provide access to her works). Second, there seems good reason to think that ideas are things *discovered*, and that one will *always* (at least in principle) have access to the ideas expressed in a given work, even *without* access to that work. Granted, access to that work would make for *easier* access to the ideas expressed therein, but few would argue that we have a natural right to having things easy.

(b) Where the user's right is based in the interest of freely expressing one's ideas:

If one is looking to appropriate from another's work, then presumably one's interest in access is only instrumental. We might suppose (perhaps generously) that one is centrally appropriating for the sake of expressing *one's own* ideas, and that *this* interest is what grounds one's claim to a user's right. Again, this seems reasonable enough. If one is looking to parody another's work, for instance, one is likely to have to do some copying (and, unless one is Weird Al Yankovic, one is unlikely to get permission to do so).[47] Or, if one is looking to straightforwardly criticize the work of another, one is likely to have to quote from that work (and, again, one may be unlikely to get permission to do so). Here, we cannot reasonably ask which interest—the copyright owner's or the user's—is more important, or more fundamental; they are, after all, the very same interest.

We may note, however, an interesting asymmetry. Speaking in very general terms, one *can* freely express one's ideas without having copyright protection (it isn't as if people were unable to express their ideas prior to 1710,

after all), and one *can* freely express oneself without copying another's work (that is, one's being barred from copying another's work does not tie one's hands against all such expression). However, for any given work, *W*, while it seems an author can freely express her ideas in that work without having copyright in that work, at least for *some* works (as in the cases of parody or straightforward criticism), there is an argument to be had that one *cannot* freely express some given idea *without* copying another's work. If I can't re- produce part of Christy Mag Uidhir's latest book, I can't show you what's wrong with it. When it comes to show-and-tell, sometimes telling (express- ing) requires showing (copying). Of course, sometimes it doesn't.

Recall our distinction from way back in chapter 1 between the *mere* taker (who simply makes a copy of another's work) and the *maker*-taker (who copies and incorporates part or all of another's work into some new work). Insofar as the *mere* taker's interest is in accessing ideas, and even if we think of this as grounding a natural right to such ideas, this would not apparently defeat the author's copyright. However, insofar as the *maker*-taker's interest is in expressing his own ideas, this *may* defeat copyright. This would, it seems, be restricted to those cases where such expression *requires* such borrowing. Quoting from another's work because it is *easier* than paraphrasing (where this would serve just as well) would not seem to qualify, nor would quoting beyond what is required to make one's point, or to make it well. In some cases, complete reproduction of a work may be necessary to express one's ideas, as in the case where one is looking to analyze or criticize a photograph. Other cases of complete copying, however, would certainly be forbidden. The mere taker who illicitly downloads a song or movie, either because he can't afford to purchase it legally, would prefer not to spend the money, or because the work is not available otherwise, would not be justified in his actions on this argument. Nor would the plagiarist who appropriates another's work because he lacks ideas of his own. It may be that any justified appropriation would *also* require proper attribution, but this would require an argument for such a duty—and corresponding right on the author's part—which is beyond the core of the right of copyright.

Notice that, at this point, we have not *actually* provided an argument for users' rights, and only suggested a possible grounding. Nevertheless, it seems a grounding that would provide an argument for cases of presump- tive fair use. Rather than saying, however, that the boundaries of the author's right have been truncated, I think we simply want to say that her right in copyright may be trumped in such cases. Here, I adopt a conceptual schema provided by Judith Jarvis Thomson in "Some Ruminations on Rights":

Suppose that someone has a right that such and such shall not be the case. I shall say that we *infringe* a right of his if and only if we bring about that it is the case. I shall say that we *violate* a right of his if and only if *both* we bring about that it is the case *and* we act wrongly in doing so.[48]

Insofar as she has a copyright in her work, the author *always* has the exclusive right to restrict copying, and insofar as another copies her work without authorization, this person has *infringed* her right. But in cases where such copying was necessary for expressing the copyist's own ideas, the infringement is not also a wrongful *violation* of that right.

At this point, the most we have been able to do is provide a schema for how fair uses might be considered vis-à-vis our natural right of copyright. That copyright is a natural right does not suggest that it is an *absolute* right—that it cannot be overridden. Indeed, I would not be surprised if all manner of rights outweighed copyright. However, in a case of users' rights, whether any *given* use is presumptively fair would depend on the details of the case, specifically on what idea was being expressed and whether the degree of copying was necessary (or, we might suppose, reasonably required) for that expression. However, unlike the current fair use system in the United States, we have a principled schema that would offer predictive value to potential copyists without requiring the detailed inventory of exclusions required of a workable fair-dealing system.

By way of example, then, let's briefly revisit Stephanie Lenz and "Let's Go Crazy #1." Where facts qualify as ideas (as is standard in copyright laws), at a first pass, the video is an expression of the fact that baby Holden danced to Prince's "Let's Go Crazy." Versions of Prince's song run from 3'46" to 7'35," and it isn't clear from Lenz's video which version Holden is bopping along to. But, whichever version, as a capturing of that fact (an expression of the idea), twenty-nine seconds' worth of the song does not seem *excessive*. Certainly, Lenz would have to copy *some* of the song, and certainly *not all* of the song. This requires, admittedly, a judgment call regarding the bounds of what is reasonable, and perhaps it would be impossible to draw a precise line in the sand. However, I think that Lenz could *reasonably* hold that while her video is, strictly, an infringement of Prince's rights, it is not a violation of the same.

Perhaps most importantly, I think, this analysis represents a shift in consideration for users, from "do I *want* to copy (from) this work" or "can I *get away with* copying (from) this work," to "do I *need* to copy (from) this work?" Although there are undoubtedly details to be worked out—and many more if this were to form a basis to the law—I think this analysis points us in a direction that we—creators and users alike—want to be moving.

Now, with this in mind, let us return to something that has come up again and again throughout this book: appropriation art. This particular movement represents an acute and extreme case of artistic borrowing, as artists of this sort are engaged in a project that, by definition, involves the use of another's art. Quite often this source art is copyright-protected, and quite often permission would be unlikely or would defeat the purpose of the project (because the purpose often *is* to undermine the original author's authority). As we noted in chapter 5, on the face of it, a work of straightforward appropriation art is simply (formally speaking) a duplicate—a *copy*—of a preexisting work. Everything about the work—every word, every line, every note—is the way it is because its source is the way *it* is. If there was ever a straightforward case of copyright infringement—indeed, violation—this would seem to be it.

Appropriation and Transformation

Appropriation Art

In a little, largely overlooked paperback anthology published in 1973, there is an essay on New England artist Hank Herron.[1] Herron, the article tells us, for his one-man show had reproduced the entire oeuvre of minimalist painter and printmaker Frank Stella. In so doing, Herron was judged to have created something *more* than Stella: "in their real meanings, these objects are Stellas *plus*."[2] The crucial difference between an original Stella and a visually indistinguishable Herron, we are told, comes on further consideration of the artists' respective projects: "one begins to be more profoundly conscious of and receptive to a radically new and philosophical element in the work of Mr. Herron that is precluded in the work of Mr. Stella, i.e., the denial of originality."[3]

With his method and apparent philosophical approach, Herron would be characterized today as an appropriation artist—if he existed, which he didn't. Nor did the attributed author of the article, Cheryl Bernstein. Both Herron and Bernstein were inventions of art historian Carol Duncan, a hoax that went undetected for more than a decade.[4] On this realization, one might think that Duncan's game was a clever *reductio ad absurdum*, taking the direction of postmodern art to its hypothetical end to illustrate the inanity of the whole project. And this may have been the case. But, perhaps unknown to Duncan, the fictional Herron's project largely parallels the work of real-life artist Elaine Sturtevant, active at the time of Duncan's writing, and probably the earliest artist to be labeled an appropriation artist.[5] Although she did not attempt to reproduce any single artist's body of work, Sturtevant (as she prefers to be called) reproduced works by the likes of Roy Lichtenstein, Jasper Johns, Andy Warhol, and yes, Frank Stella. Typically, Sturtevant would re-paint another artist's painting from memory, usually inserting some hidden

"error" in her version.[6] However, in one famous case, Sturtevant obtained from Warhol the silk screens he used to create his series of "Flowers" prints and used these to create indistinguishable duplicates. When her 1967 reproduction of Claes Oldenburg's *Store* incited hostility from the art community (and particularly from Oldenburg himself),[7] Sturtevant disappeared from the art world for more than a decade, during which time a number of young artists took up the task of art appropriation.

Appropriation art traces its conceptual origins back to an artistic movement and to a philosophical paradigm shift. The artistic movement in question began with the "ready-mades" of Marcel Duchamp, works consisting entirely of ordinary objects found or purchased by the artist, and presented largely unchanged as art. Duchamp's most famous readymade, *Fountain*, consists of a common porcelain urinal, upended, and signed with the pseudonym, "R. Mutt 1917." Duchamp's work presented a conceptual breakthrough in modern art, opening the doors for artists to *select* objects from the world around them, rather than *fabricating* paint, clay, and bronze into new art objects.

The philosophical origin of appropriation art came half a century later, in Roland Barthes's 1967 essay, "The Death of the Author." In the famous essay, Barthes rails against the age-old notion that the author or artist is the arbiter of a work's meaning.[8] So far as meaning is concerned, Barthes suggests, the author "dies" when the work is released to the public and becomes just another reader. Michel Foucault, following the same line of thought, suggests that *imposing* an author on a work limits the meaning of the work.[9] On this basis, authors and artists began to question the nature of authorship, and attempted to distance themselves from it. One might have difficulty labeling Duchamp's ready-mades "art,"[10] or question the validity of Barthes's and Foucault's claims,[11] but the influence of Duchamp and Barthes is, in a word, inestimable.

While Sturtevant was on hiatus, a number of New York artists began experimenting with art appropriation. Sherrie Levine, perhaps best known for her series After Walker Evans, famously rephotographs others' photographs—in this case, the Depression-era portraits taken by Evans. Richard Prince became famous rephotographing advertisements—especially Marlboro ads depicting the "Marlboro Man"—cropping out visual and textual indications that these *were* advertisements. Jeff Koons, meanwhile, turned to what he took to be objects of everyday commercial banality, his most famous work being a 1986 stainless-steel replica of an inflatable toy rabbit, *Rabbit*. For those familiar with copyright law, it will perhaps seem ironic that the legal

troubles for appropriation artists began in earnest when they *strayed* from such straightforward appropriation.[12]

Legal Troubles

Koons's exhibition, the Banality Show, opened at New York's Sonnabend Gallery in 1988. For the show, Koons had commissioned a number of three-dimensional sculptures in wood and porcelain from artisans around the world. The sculptures are based on images of popular culture Koons had culled from postcards, cartoon strips, and elsewhere. The Banality Show immediately garnered no fewer than three copyright infringement suits against Koons and the gallery. The first of these centered on Koons's sculpture, *String of Puppies*, a life-sized painted wooden sculpture (in four editions) depicting, from the knees up, a couple sitting on a bench holding a litter of eight blue puppies with comically large noses.[13] The couple is dressed in brightly colored clothes, with daisies in their hair.

String of Puppies was based on a black-and-white photograph by Art Rogers, "Puppies," which had originally been commissioned by an acquaintance of Rogers's and later licensed by Museum Graphics for a notecard. Koons purchased a copy of the card at a commercial card shop, believing it "typical, commonplace and familiar"—a paradigm of popular commercial culture.[14] Koons tore the copyright notice from the card and sent it along with an enlarged photocopy and a chart to the Demetz Studio in Ortessi, Italy, with instructions to craft a sculpture of the couple and puppies depicted in the photograph. Koons oversaw the sculpting and painting of *String of Puppies*, providing written instructions specifying that, aside from the color, the puppies' scene depicted in the photograph was to be reproduced exactly.[15]

Rogers learned of Koons's sculpture in 1989 and filed suit against Koons and the Sonnabend Gallery, alleging copyright infringement and unfair competition. The district court found that *String of Puppies* did, indeed, infringe on Rogers's photograph, and did not qualify as a fair use. The court granted summary judgment and ordered Koons and the Sonnabend Gallery to turn over all infringing articles to Rogers, and enjoined the defendants from making, selling, lending, or displaying any copies of the sculpture, or any other derivative works based on "Puppies."[16] Koons appealed, and the court of appeals affirmed the district court's decision.[17]

Koons's central defense was made on the basis of fair use, centrally arguing that *String of Puppies* qualified as a parody,[18] specifically "a satire or parody of society at large."[19] To recall from last chapter, a defense of fair use

rests on § 107 of the Copyright Act of 1976, which lays out four nonexclusive, nonexhaustive factors on which consideration of "fair" use traditionally rests: (1) the purpose and character of the use, (2) the nature of the copyrighted work, (3) the amount and substantiality of the work used, and (4) the effect of the use on the market value of the original.[20]

Section 107, which encodes the fair use doctrine, explicitly cites "purposes such as criticism, comment, news reporting, teaching . . . scholarship, or research" as examples of presumptively fair uses.[21] As noted last chapter, parody became a special case in fair use decisions, beginning with *Campbell v. Acuff-Rose*, with parody taken to be a valuable form of criticism and central to the purposes of fair use.[22] Parody has come to be roughly defined, for legal purposes, as a work that, in imitating a preexisting work, ridicules that very work.[23] The first of the four factors—the purpose and character of the use—explicitly considers "whether such use is of a commercial nature."[24] Commercial uses have been established by the Supreme Court as presumptively unfair.[25] However, where a work is found to be parodic, its commerciality has generally been considered a nonissue.[26] The second factor is traditionally taken to distinguish between works of fact and works of fiction, such that the more "creative" the original, the more this factor tends to weigh against a finding of fair use. In cases of parody, however, the original is usually a creative work, and so, given the potential cultural value of parody, this factor tends to be disregarded in parody cases.[27] The third factor asks what, and how much, of the original has been taken in a secondary work.[28] Because parody, by its nature, typically requires substantial copying—and often copying the "heart" of the work—courts have generally given leeway in the amount copied for a parody such as would be required to conjure up the original work.[29] Finally, the fourth factor asks about the effect of the secondary use on the market value of the original. As noted last chapter, although the purpose of criticism—parody included—is often to devalue the original, the Supreme Court has found that parody that *suppresses* sales of the original is permissible, whereas works that, by copying, *usurp* the original are not.[30]

On these bases, once it is established that a secondary use is parodic in nature, much in the fair use doctrine is interpreted by the courts to align in favor of the use. In the case of *Rogers v. Koons*, however, the court found that *String of Puppies* did *not* qualify as parody under the law:

> It is the rule in this Circuit that satire need not be only of the copied work and may, as appellants urge of "String of Puppies," also be a parody of modern society, the copied work must be, at least in part, an object of the parody, otherwise there would be no need to conjure up the original work. . . . We think

this is a necessary rule, as were it otherwise there would be no real limitation on the copier's use of another's copyrighted work to make a statement on some aspect of society at large. If an infringement of copyrightable expression could be justified as fair use solely on the basis of the infringer's claim to a higher or different artistic use—without insuring public awareness of the original work—there would be no practicable boundary to the fair use defense. . . . The problem in the instant case is that even given that "String of Puppies" is a satirical critique of our materialistic society, it is difficult to discern any parody of the photograph "Puppies" itself.[31]

Without the label of "parody" to align them in favor of the secondary work, all four factors of fair use were found to weigh against *String of Puppies*, and Koons's use of the photograph was found to be unfair and infringing. The decision seemed to signal a death knell for appropriation art.[32] Art theorists reeled. Lynne A. Greenberg summarized the outlook: "[T]he effect of the case is to act as a powerful check on appropriation artists. Because the stakes under copyright law for appropriating imagery from a copyrighted work are now so high, it is likely that many artists will steer clear of using such techniques in their future work."[33]

With *Rogers v. Koons* decided, Koons's other pending cases fell much the same way. His porcelain sculpture, *Wild Boy and Puppy*, was found to have infringed on the character Odie from the *Garfield* comic strip,[34] and another work, *Ushering in Banality*—a wooden sculpture of two Putto-like figures helping a boy push an enormous pig—was found to infringe on a photograph by Barbara Campbell.[35] Perhaps surprisingly, then, the Koons decisions appear not to have dissuaded appropriation artists in their activities, though it did make them a little more savvy when it came to the law. Koons began licensing copyrighted materials including United Features Syndicate (which owns the copyright to Odie and which had successfully sued Koons for infringement on it).[36] But Koons's new copyright savvy did not keep him out of legal hot water.

In 2000, Koons was commissioned to create a new series of seven paintings for the Deutsche Guggenheim Museum in Berlin. Each work in the series dubbed "Easyfun-Ethereal" is essentially an oil-painted collage. Koons collected images from advertisements, scanned them into a computer, and digitally cut-and-pasted selected, disembodied elements together over a landscape background. The digital collages were then printed and used by Koons's assistants as templates for the final paintings. One painting in the series, *Niagara*, consists of images of women's lower legs and feet—two in shoes, two barefoot—dangling above a tray of donuts and another of Danishes. Behind

the feet is an image of an enormous brownie topped with ice cream, and behind that sits a landscape dominated by the image of Niagara Falls. According to Koons, the final painting was meant to "comment on the ways in which some of our most basic appetites—for food, play, and sex—are mediated by popular images."[37] One of the pairs of feet—the second pair from the left—was modeled on a photograph taken by Andrea Blanch, "Silk Sandals by Gucci." Blanch's original photograph showed the woman's feet resting on a man's lap in an airplane cabin. For her work, Blanch wanted to "show some sort of erotic sense[;] . . . to get . . . more of a sexuality to the photographs."[38] For *Niagara*, Koons reproduced only the legs, feet, and shoes from Blanch's photograph, adding a heel to one of the shoes, altering their orientation, and slightly modifying the coloring. Blanch discovered Koons's use and filed suit.

Although again claiming fair use, Koons did not attempt in this case to claim that his work was a parody. Rather, Koons argued that his work was *transformative*. In his seminal 1990 article on fair use, Judge Pierre Leval attempted to outline a permanent framework on which fair use cases might be adjudicated. Central to this framework is the notion of transformative use. Suggesting that transformation, which advances knowledge and the progress of the arts, can be distinguished from repackaged free riding, Leval argued:

> I believe the answer to the question of justification turns primarily on whether, and to what extent, the challenged use is *transformative*. The use must be productive and must employ the quoted matter in a different manner or for a different purpose from the original. . . . If . . . the secondary use adds value to the original—if the quoted matter is used as raw material, transformed in the creation of new information, new aesthetics, new insights and understandings— this is the very type of activity that the fair use doctrine intends to protect for the enrichment of society. . . . If a quotation of copyrighted material reveals no transformative purpose, fair use should perhaps be rejected without further inquiry into the other factors. Factor One is the soul of fair use.[39]

Judge Leval's analysis served as the philosophical basis to the landmark Supreme Court decision in *Campbell v. Acuff-Rose* four years later. Here, drawing on Leval's framework and the legal origin for fair use, *Folsom v. Marsh*, Justice Souter wrote:

> The central purpose of this investigation is to see, in Justice Story's words, whether the new work merely "supersede[s] the objects" of the original creation, ("supplanting" the original), or instead adds something new, with a further purpose or different character, altering the first with new expression, meaning,

or message; it asks, in other words, whether and to what extent the new work is "transformative." Although such transformative use is not absolutely necessary for a finding of fair use, the goal of copyright, to promote science and the arts, is generally furthered by the creation of transformative works. Such works thus lie at the heart of the fair use doctrine's guarantee of breathing space within the confines of copyright, and the more transformative the new work, the less will be the significance of other factors, like fair use.[40]

Campbell v. Acuff-Rose in many ways established the basis for parody claims under fair use, and as a result conceptually tied up issues of transformation with issues of parody. In *Blanch v. Koons*, however, the court returned to the core of Leval's theory and separated the issues of parody and transformation, focusing solely on the latter. The court noted, "The sharply different objectives that Koons had in using, and Blanch had in creating, 'Silk Sandals' confirms the transformative nature of the use."[41] Given the "distinct creative or communicative objectives"[42] of Koons and Blanch, respectively, the court decided Koons's use was transformative regardless of whether *Niagara* commented critically in any substantive way on Blanch's original photograph: "'Niagara' . . . may be better characterized for these purposes as satire—its message appears to target the genre of which 'Silk Sandals' is typical, rather than the individual photograph itself."[43] Although the work was not found to be parodic, the transformative nature of Koons's painting was found to weigh the first factor of fair use in its favor and trickled through the remaining factors in much the same way that they would in a parody case. On this basis, the court of appeals affirmed an earlier district court decision that Koons's use was fair.

The death knell of appropriation art, it seemed, had been rung prematurely. Where the cases surrounding Koons's Banality Show had seemed to put the kibosh on unauthorized appropriation art, the finding in *Blanch v. Koons* gave new hope to appropriation artists. And so, when Richard Prince was sued for copyright infringement only a couple of years later, he had reason to be optimistic.

Prince, discussed in chapter 5, had become known for photographing others' photographs—particularly images used in commercial advertising—and presenting the results as his own work. In 2005, one of Prince's "rephotographs" set an auction record, selling for more than $1 million. When Prince was sued, however, it was (as with Koons's *Niagara*) for a collage, and not for a straightforward rephotograph. The case in question centered on Prince's *Canal Zone* (2007), a collage consisting of thirty-five photographs from *Yes, Rasta*, a book of photographs by Patrick Cariou depicting Jamaican

Rastafarians. Prince had torn out the photographs and pasted them onto a wooden board. Prince used some of Cariou's photographs in their entirety, cropped others, and painted ovoid splotches over some of the faces depicted. The work was one of thirty created for the series Canal Zone, all but one of which employ images from Yes, Rasta. Motivated by a gallery's cancellation of a planned show of his work,[44] Cariou filed for summary judgment. Prince attempted to argue—as Koons had successfully—that his appropriation art was transformative and, on this basis, fair use. The district court, however, stated that it was "aware of no precedent holding that such use is fair absent transformative comment on the original."[45] Rather, it interpreted the finding of Koons's Niagara as transformative of Blanch's photograph because Koons "used it to comment on the role such advertisements play in our culture and on the attitudes the original and other advertisements like it promote."[46] Comparatively, the court found that Prince's appropriation was not in service of any commentary—either with regard to Cariou's works or to the broader culture of which they are a part. Where Koons and Blanch had clearly distinct artistic aims, the court in Cariou v. Prince found that Prince's purpose was essentially the same as Cariou's: "a desire to communicate to the viewer core truths about Rastafarians and their culture."[47] That is, while Prince intended that his work be something new, "his intent was not transformative within the meaning of Section 107."[48] And so the pendulum seemed to have swung back in the other direction for appropriation art.

The US Court of Appeals reversed the district court's decision in part, finding that twenty-five of Prince's offending works were in fact fair. The remaining five works were remanded to the district court to reconsider on the basis that the court of appeals set out. Citing the reasoning in Blanch, the court of appeals argues that, to be transformative, it is not necessary that a use comment on the original—or, indeed, on anything else.[49] Dismissing Prince's own stated intentions regarding his works as essentially irrelevant, the court contends, "Prince's works could be transformative even without commenting on Cariou's work or on culture, and even without Prince's stated intention to do so."[50] Instead, the court suggests, the central question is whether the new work is transformative in the sense of adding "something new, with a further purpose or different character, altering the first with new expression, meaning, or message."[51] And transformation in this sense, the court argues, hangs on "how the artworks may 'reasonably be perceived.'"[52] The assumption here is that whether a work is a new expression, has a new message, or is invested with new meaning, is something that the work will wear on its face: "Here, looking at the artworks and the photographs side-by-side, we conclude that Prince's images . . . have a different character, give Cariou's photographs a

new expression, and employ new aesthetics with creative and communicative results distinct from Cariou's."[53]

And so the pendulum swings once again.

Some Strategies

A number of strategies have been suggested for how copyright law—and, in particular, fair use—might accommodate appropriation art. Perhaps the first such theorist, Patricia Krieg, suggests that appropriation art constitutes a special form of political discourse—acting as a "political symbol"[54]—and, "[b]ecause political discourse lies at the very core of First Amendment concerns, these images deserve the status of protected speech."[55] Krieg elaborates:

> Courts should extend First Amendment protection to visual works which use appropriated images to convey original expression, as this is consistent with First Amendment guarantees of free artistic expression. If the art work has significantly altered or transformed the copyrighted material so that the work as a whole adds meaning beyond that conveyed by the context of the copyrighted image alone, First Amendment protection is warranted.[56]

Krieg was writing several years before the finding of *Rogers v. Koons*, and indeed several years before Judge Leval's oft-quoted paper, but her focus on transformation clearly predicts Leval's framework. Unfortunately, Krieg wraps up transformation in the issue of free speech. Only a year after Krieg's essay was published, the Supreme Court determined that the limits of copyright—including the confines of fair use—are consistent with First Amendment protections.[57] In other words, the First Amendment cannot serve as a viable defense against complaints of infringement.

Also writing before the Koons cases, but at a time when appropriation art seemed to be circling closer and closer to the courts, John Carlin suggested modifying existing fair use standards to better allow for appropriation art. Rejecting the standard four-factor model, Carlin focuses on the purpose of the copying and the nature of the work copied. Carlin suggests, first, that an appropriation artist's commercial interests should not determine a finding of fair use, but rather that the question hangs on "whether or not there is willful interference with another's commercial interests."[58] Second, Carlin looks to whether the image copied is a part of a shared cultural vocabulary—whether the particular image appropriated is recognizable to the average viewer.[59] Third, Carlin would require that, for an appropriation to be deemed fair, the artist behind the original work be no longer living, or at least no longer

actively exhibiting his work.[60] Finally, Carlin suggests that singular works of appropriation be deemed presumptively fair, while works of appropriation in multiple copies be subject to further investigation.[61]

Carlin's approach, while extremely interesting, runs into some problems. In general, Carlin's suggested framework seems jerrybuilt to handle the particular cases of appropriation that he has in mind, leaving little room for other forms of art appropriation.[62] As E. Kenly Ames notes, Koons's *String of Puppies*, though not a willful interference with Rogers's commercial interests, would likely not have fared well under Carlin's system: first, the image probably would not have been immediately recognizable to an average viewer; second, Rogers was at the time of Koons's appropriation still a working artist; and third, Koons created four editions of his sculpture.[63] Koons's other works, as well as Prince's *Canal Zone*, would seem to encounter similar problems under Carlin's framework.[64] Granted, Carlin did not have the advantage of such legal hindsight, but with these cases in mind, it seems his system offers no greater advantage to appropriation artists, and is no less convoluted, than the existing system.[65]

Like Carlin, Ames seeks a specialized approach to fair use for cases of artistic appropriation. Writing after *Rogers* but before *Blanch*, Ames seeks to distinguish appropriation art from parody, noting a particular disparity between what she sees as their respective functions, but establishing an approach that parallels the traditional approach to parody under fair use and in many ways predicting the outcome in *Blanch*.[66] First, looking to the purpose and character of use, Ames suggests that for a work of appropriation art to be presumptively fair, it should be a work of visual art, as defined under the Visual Artists' Rights Act of 1990.[67] Second, Ames suggests that, to be fair, "an artist's use of an appropriated image in a work of visual art should create a presumption that the work is created for the purpose of social criticism or commentary."[68] Regarding the nature of the work copied, Ames, unlike Carlin, does not limit the sources for appropriation to well-known images. Rather, Ames allows for appropriation of "existing images that are representative of a particular type of genre of popular expression," where "the reasonable observer would recognize the image as being of a particular type or genre of images."[69] Noting that the secondary artist may need to appropriate an entire visual work in order to convey her critical message, Ames suggests no limit to the amount of the original copied, and further suggests that the secondary artist not be required to directly criticize the work copied: "The ability to criticize and comment on the values and practices of society on a sweeping scale is the special attribute of appropriation."[70] Finally, regarding the effect on the potential market for the original work, Ames suggests that such appropriation should be deemed

fair so long as the secondary work cannot reasonably function as a market substitute for the original.[71]

Roxana Badin offers an approach that is largely in line with Ames's, particularly as regards the issue of social commentary, which both take to be central to the project of appropriation art. In general, Badin suggests that appropriation art performs a communicative function, leading to the public benefit of a "more direct relationship between the creative arts and popular culture, inevitably increasing the public's exposure to the arts."[72] Focusing on cases in which artists appropriate common, recognizable objects and imagery of popular culture ("soup cans, flags, cigarette packages, money, movie stars, comic strips and even shopping bags"[73]), Badin recommends a notion of "transformative use" expanded to recognize the "allegorical strategy" of appropriation art and so to allow for their fair use.[74] By "allegorical strategy," Badin refers to the recontextualization of recognizable images by artists so as to invest those images with new meaning. In the case of appropriation art, Badin suggests this new meaning takes the form of social commentary. The image gains new meaning, Badin argues, by forcing the viewer to reevaluate her understanding of the image. It is this reorientation of our evaluative practices, she suggests, that makes all art—and not merely appropriation art— valuable.[75] Badin further contends that "[p]ostmodern artists deliberately abstain from altering the appropriated symbol or adding stylistic marks that would identify the artist's authorship in the piece because, by principle, the symbol's own vocabulary is the means by which the artist conveys the allegorical message,"[76] treating images of popular culture as "parables of conspicuous consumption."[77]

Both Ames and Badin provide interesting analyses and offer interesting strategies, but both err in applying a universal philosophy to appropriation art, using this as the foundation on which to accommodate appropriation art within copyright law.

The Aims of Appropriation Art

Appropriation—the taking from artistic and other sources—for a new work is, as many will tell you, nearly as old as art itself. Some artists have employed such takings to build on previous works, many to study those works, others to comment on them, and some simply to steal. But Shakespeare, though he took many of his plots from other sources, cannot reasonably be called an "appropriation artist" in the sense that Koons and Prince are so called. Nor does it seem reasonable to label Vincent van Gogh an appropriation artist in the relevant sense, though he copied and adapted nearly two dozen works by

Jean-Francois Millet into paintings in his own inimitable style. Pablo Picasso reinterpreted (and, in a sense, recreated) Velasquez' *Las Meninas* (1656) in a series of fifty-eight paintings, but it would be similarly difficult to call Picasso an appropriation artist. Although each of these artists has *appropriated* in one sense or another, if we are to talk about the contemporary art-historical category of appropriation art, we cannot simply reduce it to appropriation—taking—as an artistic method.

Neither, however, can we describe the contemporary category of appropriation art on the basis that it is essentially a form of social commentary. Ames contends that "[w]hile societal criticism is usually incidental to traditional parody, it is the avowed purpose of appropriationist visual art."[78] Badin's view is even narrower: "Appropriation in contemporary art has been defined as an allegorical process through which the artist uses symbols of popular culture as parables of conspicuous consumption."[79] Certainly, this seems true of much of Koons's work, but it does not describe Koons's appropriationist work in its entirety, and it certainly does not describe the contemporary category of appropriation art as a whole. Probably the most celebrated of the appropriation artists is Sherrie Levine, who only very rarely appropriates from popular culture sources. Instead, Levine appropriates from other artists, such as Walker Evans, Alfred Stieglitz, and Kasimir Malevich. Sturtevant, who set the contemporary movement in motion, appropriated from her artistic contemporaries. Neither Levine nor Sturtevant seems centrally interested in popular culture, "conspicuous consumption," or the sort of societal criticism Ames discusses. And, in the case of *Canal Zone* at least, Prince "did not intend to comment on any aspects of the original works or on the broader culture."[80]

If we were to attempt to describe the contemporary movement of appropriation art in broad strokes, I would suggest that what links these artists is the employment of appropriation in pursuit of artistic projects focused on the art *object*—the nature of the *thing* (in both the original and secondary works)—and the nature of authorship. In many ways, appropriation art is *about* appropriation: the viewer is meant to know that the objects and images presented *are* appropriated, and this is meant to say something about the objects and the authorship of the original and new works. Lynne A. Greenberg suggests, "These artists likewise strive to erase all authorship from their work, replacing individual signature with the trademarks of mass-produced commodities. In so doing, they radically deny the notion of 'creative authorship' as a principle and as a definitional codification for works of art."[81] While this is true of, say, Levine,[82] Sturtevant considered her works "original Sturtevants" while openly acknowledging their sources.[83] Prince's general strategy is, if anything, the opposite of Levine's. Where Levine makes her sources

explicit in the titles of her works, Prince treats his *sources* as authorless and himself as the author. Speaking of his rephotographs of magazine advertisements, Prince says:

> I like to think about making it again instead of making it new. . . . Advertising images aren't really associated with an author—more with a product/company and for the most part put out or "art directed." They kind of end up having a life of their own. It's not like you're taking them from anyone. Pages in a magazine are more often thought of as "collage." When I re-photographed these pages they became "real" photographs.[84]

In another interview, Prince elaborates:

> They were like these authorless pictures, too good to be true, art-directed and over-determined and pretty-much like film stills, psychologically hyped-up and having nothing to do with the way art pictures were traditionally "put" together. I mean they were so off the map, so hard to look at, and rather than tear them out of the magazines and paste them up on a board, I thought why not rephotograph them with a camera and then put them in a real frame with a mat board around the picture just like a real photograph and call them mine.[85]

Prince revels in his authorship while denying it to the art from which he appropriates.

It is at best difficult to attempt to draw lines to clearly distinguish one artistic movement from all others, and it would be equally difficult to fully and clearly explain any given artistic project or artist's body of work. Nevertheless, Sturtevant, Levine, Koons, and Prince—despite differences in their respective goals and views—are involved in substantially similar projects, projects unlike those of Shakespeare, Van Gogh, and Picasso. However, the lines that separate appropriation art from other movements are certainly blurry. Does Duchamp's *L.H.O.O.Q.* (1919)—a postcard of the *Mona Lisa* on which Duchamp penciled a moustache and goatee—qualify as appropriation art? Roy Lichtenstein's enormous Pop-Art reproductions of comic book panels certainly seem to come close. And what of Walter Benjamin's *The Arcades Project* (1940)—a 1,000-page literary collage—or Kenneth Goldsmith's *Day* (2003), a word-for-word retyping of the September 1, 2000, issue of the *New York Times*? Ames restricts her analysis—and, indeed, membership in the category of appropriation art—to the visual arts, but there seems to be a clear fraternity with these "conceptual writers," as they have been dubbed. Like Koons and Prince, they trace their conceptual origins to Duchamp and

Barthes, and focus on the art object and the nature of authorship.[86] Their projects are very much *about* appropriation.

Appropriation and Transformation

As noted above, the court in *Rogers v. Koons* states, "If an infringer of copyrightable expression could be justified as fair use solely on the basis of the infringer's claim to a higher or different artistic use—without insuring public awareness of the original work—there would be no practicable boundary to the fair use defense."[87] This is, on its face, a compelling slippery-slope argument: without any such boundary, what *wouldn't* be allowable as fair use? Impressed by this argument, the district court in *Cariou* sought a principled break to keep copyright from sliding into oblivion.

The court states that Prince's "intent was not transformative within the meaning of Section 107."[88] This was an odd choice of words, however, given that transformation is not once mentioned in § 107 of the Copyright Act (the section devoted to the fair use doctrine). Indeed, the notion of transformation is raised only once in the whole of the Act: in § 101, in the definition of "derivative work."[89] And so it is perhaps even odder still that the court drew this particular line in the sand: "Prince's Paintings are transformative only to the extent that they comment on [Cariou's] Photos; to the extent they merely recast, transform, or adapt the Photos, Prince's Paintings are instead infringing derivative works."[90] The court as such appears to be making a distinction between "mere transformation" (with regard to derivative works) and a special sort of transformation-as-commentary (in the domain of fair use). Although this does draw a principled break on the slippery slope, the distinction employs a rather strange use of "transformative." While it is at the courts' discretion to introduce terms of law with specialized meanings in the legal domain, this is certainly not how "transformative" is used by Leval nor by the court in *Blanch v. Koons*, nor does it seem an intuitive use of the term. Rather, it appears to be an ad hoc definition solely invented by the court in *Cariou* to stop the slide toward copyright anarchy.

The appeals court, too, found this reasoning flawed, and introduced instead a stance on transformation disconnected from matters of intent. The court suggests, "What is critical is how the work in question appears to the reasonable observer, not simply what an artist might say about a particular piece or body of work."[91] However, the suggestion that transformativeness lies in "how the artworks may 'reasonably be perceived'"[92] is more complicated than it may at first appear. As the court notes, the audience for Prince's

work is very different from that of Cariou's.[93] And when the court reduces the question of transformation to how the work would appear to a "reasonable observer," it fails to ask whether this observer is a member of Prince's audience, or of Cariou's, both, or neither. Even where the original and the secondary work appear visually indistinguishable, the audience familiar with the aims and practices of appropriation art will treat them very differently, and in many cases, they are likely to find something new—a new meaning, a fundamentally different aesthetic. And much of this will turn *precisely* on what the artist says about his work.

In the end, the court leaves open what qualifies as a "new expression" or the employment of "new aesthetics," instead passing that burden on to an abstract "reasonable observer," and so, rather than providing a solution to the problem, only pushes the problem back a level.

Exactly what constitutes "transformation" in the law remains an open question. On the understanding that appearance alone cannot do the job, Ames and Badin attempt to ground transformation in context. Ames asserts, "What makes an image unique—what a reproduction cannot capture—is the context of the image. Meaning is dependent on context."[94] Badin elaborates:

> By placing a universal object such as Duchamp's Ready-made in the context of a gallery, the artist simultaneously appropriates a sign's already laden popular significance and reinvests new meaning in the object as testament to the vices or virtues of modern society. Shifting the context of the image in this way transforms the meaning of the original image by forcing the viewer to reevaluate his or her former, most often unconscious, understanding of the image.[95]

Change in context, on this view, brings about a change in meaning—a transformation in the work. Context alone, however, does not change a work, though a change in context might alter its *significance* to us. Taking a tribal African mask and placing it in an art gallery alongside primitivist works by Matisse and Picasso might alter how we *look at* or *think about* the mask, but it does not change *the work* (nor does it change those by Matisse and Picasso). Whatever was intrinsically true of the mask before its change in context remains true after, and whatever was false remains false.[96] We might be more aware of the work's subtle lines or of the relation it bears to contemporary Western art, but if these are properties of the mask, they were properties of the mask before we discovered them. If it were true that context alone changed a work, then moving a sculpture from one room to another would result in a new or altered sculpture, and this surely isn't the case.

That being said, *something* happens when Duchamp selects a urinal and makes it art, when a collagist combines preexisting images together, or when Levine rephotographs an image created by Walker Evans and presents it as a new work. This is not simply a matter of context, however. Rather, the artist (Duchamp, the collagist, or Levine) employs the preexisting object as a means of expressing some new and distinct idea.

Copyright protects expressions, and not the ideas expressed.[97] However, expressions and ideas are not so neatly divisible as the law would sometimes like to pretend. If we take an idea to be, roughly, the content of a thought, feeling, emotion, desire, and/or other cognitive state or event, and an expression to be the manifestation or embodiment of such an idea or ideas in a perceptible form, then "expression" will always be an ellipsis for "expression-of-an-idea" or "expression-of-ideas."[98] There are no bare expressions—expressions that do not express ideas; such a thing simply is not an expression, whatever it may be. And so, any expression will be indexical to its idea, though a given idea might be expressed in multiple ways.[99] Likewise, the same image, textual string, or series of notes may be used to express entirely disparate ideas.[100] As such, if two expressions, however indistinguishable, express two distinct ideas, they are (perhaps all appearances to the contrary) two distinct expressions, strictly speaking. And, just as I might imbue an ordinary urinal with an idea by transforming it into art (through perhaps little more than intending it to be treated as art),[101] so too can I use another's image, textual string, or series of notes to express some new idea of mine, thereby shedding or adding to the ideas expressed in the image, text, or notes by the original author. Strictly speaking, these will be distinct expressions, even if visually, textually, or sonically indistinguishable.[102]

Of course, if the original image, text, or musical work is copyrighted, and I use that image, text, or other work without permission, the result will be a case of prima facie copyright infringement. That is, although my creation will be a distinct expression from that work from which I have appropriated—even if it is visually, textually, or sonically indistinguishable from it—this alone will not shield me from a claim of infringement, nor will it guarantee that my creation is copyrightable. In the relatively simple case in which I have, for instance, photographed someone else's photograph (as Levine and Prince have done on numerous occasions), then everything in my resulting work owes its origin to the original photographer. Since nothing in the expression is original to me, the work will not pass the minimum bar of originality required for copyrightability.[103] As noted in chapter 5, as far as the law is concerned, my photograph will simply be an instance of the original work. Nevertheless, if I am employing the image in service of expressing

some distinct idea, it will be, strictly speaking, a distinct expression. Without formally altering the original, I will nevertheless have *transformed* it. Of course, I might also express some new idea by borrowing from a preexisting work and formally modifying it in the process. Where my creation would constitute a new work, insofar as it involves a recasting, transformation, or adaptation of an existing copyrighted work, it will also be a derivative work and so (if created without permission of the original copyright holder) a prima facie violation of the derivative works right.[104] To recall:

> A "derivative work" is a work based upon one or more preexisting works, such as a translation, musical arrangement, dramatization, fictionalization, motion picture version, sound recording, art reproduction, abridgment, condensation, or any other form in which a work may be *recast, transformed, or adapted.* A work consisting of editorial revisions, annotations, elaborations, or other modifications, which, as a whole, represent an original work of authorship, is a "derivative work."[105]

This returns us, then, to the central clash between transformative derivative works and transformation as the basis of fair use claims. It is certainly odd that one aspect of copyright law (the derivative works right) takes transformation to be sufficient for a finding of infringement, while another aspect of the law (the fair use doctrine) takes transformation as a core ingredient in nullifying such a charge. What does transformation mean in the context of derivative works? Not surprisingly, there is disagreement here as well.

The court of appeals in *Cariou* states, "A secondary work may modify the original without being transformative. For instance, a derivative work that merely presents the same material but in a new form, such as a book of synopses of [television] shows, is not transformative."[106] On this view, the issue seems to be whether the work is transformative *enough,* or *in the right way*—that *merely* derivative works do not have a "new expression" or "employ new aesthetics." Whether this is meant to be a difference merely in degree, or a difference in kind, is not clear. Either way, however, it seems very odd to suggest that the difference between a work and a written summary of that work does not so qualify. Although all too many students will happily read synopses, say, of Shakespeare's plays, rather than the originals, I think we can all agree that *Hamlet* and the CliffsNotes summary of the same differ wildly in their aesthetic character. And although *Seinfeld* might not rise to the level of Shakespeare, the same principle would seem to hold here.

The court in *Castle Rock v. Carol Publishing* stated that "derivative works that are subject to the author's copyright transform an original work into a

new mode of presentation."[107] The court in *Warner Bros. v. RDR Books* states, "The statutory language seeks to protect works that are 'recast, transformed, or adapted' into another medium, mode, language, or revised version, while still representing the 'original work of authorship.'"[108] These are still fairly high-order analyses, however, that would require substantial unpacking of their own. What is a "mode of presentation"? What constitutes a "revised version"? Paul Goldstein argues that a derivative work is created through transformation whenever it creates a "new work for a different market."[109] But what constitutes this creation of a "new work"? In the case of *Mirage v. Albuquerque A.R.T. Co.*, the court of appeals found that affixing copyrighted photographs, cut from a book, to ceramic tiles creates a violating derivative work:

> By removing the individual images from the book and placing them on the tiles, perhaps the appellant has not accomplished reproduction. We conclude, though, that appellant has certainly recast or transformed the individual images by incorporating them into its tile-preparing process.[110]

However, less than a decade later, in a case nearly identical in substance, the court in *Lee v. A.R.T. Co.* argued that simply mounting a note card on a tile backing does *not* result in a derivative work:

> [T]he copyrighted note cards and lithographs were not "transformed" in the slightest. The art was bonded to a slab of ceramic, but it was not changed in the process. It still depicts exactly what it depicted when it left Lee's studio. If mounting works is a "transformation," then changing a painting's frame or a photograph's mat equally produces a derivative work.[111]

That is, since we do not want to say that the mere reframing of a work constitutes the creation of a new, derivative work, transformation cannot consist in this. But, to dig a little further into the issue, let us consider another series of works by Jeff Koons.

For his 1985 "Equilibrium" exhibition, Koons purchased Nike posters from the manufacturer—two of each—framed them, and presented them as his own works. The original posters created by brothers Tock and John Costacos depict 1980s sports icons in quasi-mythic poses. The Costacos Brothers' poster of basketball legend Moses Malone, for instance, shows the player holding a staff and parting a sea of basketballs over a legend reading "MOSES." Koons's work, *Moses*, consists of a copy of the original poster in a

simple wooden frame. The frame was not incidental to the work, however. Koons notes: "The framing was very important. I spent a lot of time choosing the material and the color."[112] The frame is a *part* of Koons's work, and not merely a means of displaying the Costacos Brothers' poster—it was selected and arranged with the poster as essential *to* the work.

Certainly, there is *something* interesting going on here. At the very least, Koons thinks he has created a new work. Offering an interpretation of *Moses*, he says:

> Equilibrium is unattainable, it can be sustained only for a moment. And here are these people in the role of saying, "Come on! I've done it! I'm a star! I'm Moses!" It's about artists using art for social mobility. Moses [Malone] is a symbol of the middle-class artist of our time who does the same act of deception, a front man: "I've done it! I'm a star!"[113]

"People were shocked," Koons reports, "that I was asking 1000 dollars for a framed Nike poster."[114] But Koons was not merely selling a copy of the Costacos Brothers' poster; he was selling an edition of his work, *Moses*. And Koons isn't the only one who sees it this way. The original Nike poster of Moses Malone occasionally shows up for sale on eBay for about $40. One of the two editions of Koons's *Moses* sold at auction in 2004 for $78,000.[115] To buy a copy of the original poster is certainly not to purchase an edition of Koons's work.[116] *Moses* is in part *composed* of the original poster, but Koons's work is something distinct from it, in the same way that Duchamp's *Fountain* is distinct from the porcelain urinal of which it is composed.[117] Put simply, while the Nike poster is about Moses Malone, Koons's work is about (among other things) the Nike poster itself (and, importantly, this could be true even if Koons had not selected a frame, but had simply appropriated the poster itself). Insofar as what the work is *about* is, at least in part, determined by the idea expressed in that work, Koons's work expresses an idea distinct from that of the original, and so, as an expression is indexical to its idea, Koons's expression is, strictly speaking, distinct from that of the Costacos Brothers. And so, in this sense, Koons has *transformed* the original work.

A Proposal

Whether some work is independently copyrightable depends centrally on whether it constitutes an original work of authorship, and this is established within the law on formal and causal grounds. That is, a work constitutes

an original work of authorship if it is formally distinct from all preexisting works, or includes material not copied from any preexisting work, assuming that what sets the new work apart from others meets a fairly minimal bar of originality.[118] If an item is formally indistinguishable from, and is entirely copied from, some work, then that item simply counts as an instance of that preexisting work. As such, although I argue that two works will constitute different expressions, strictly speaking, so long as they are employed as expressions of distinct ideas (even if the resulting expressions are visually, textually, or sonically indistinguishable), where one is entirely and completely copied from the other, the newer of the works would not qualify as "original" within the law, and so would not be independently copyrightable. However, to whatever degree the new work appropriates from the preexisting work, where the new work is used to express some distinct idea, I would suggest that such a use be recognized as transformative and so presumptively fair.

As a finding of fair use does not in itself recognize a copyright in the new expression, the appropriation artist who entirely and accurately copies her work from some preexisting work will obtain no right to make further copies of the work, nor to license further derivative works based on it. Rather, she will gain *only* a finding of fair use in her copy. Where the new expression is not *entirely* copied from preexisting works, the appropriation artist would gain copyright ownership in what was not copied, where this new material itself meets the law's minimum bar of originality (there is, after all, a back side to *String of Puppies*), with all of the associated rights thereof.[119] However, as with cases of complete appropriation, the use here should be found to be fair where it is employed in the expression of an idea distinct from that of the original.

On this understanding, there is no essential difference between the notion of transformation employed in the definition of "derivative work" and that employed in fair use evaluation. Where a new work is based on a transformation of some preexisting work, it will constitute a derivative work (on the condition that it constitutes a new work at all under the law). But where this transformation is in service of expressing some distinct idea, this use will be presumptively fair.

Now, what of the slippery slope worry raised in *Rogers v. Koons*—that, if a use could be judged fair solely on the basis that the secondary user claims a higher or different artistic purpose, there would be no practicable boundary to the fair use defense? So long as we are discussing US law, where the author's artistic purpose constitutes the expression of a new idea, however, isn't the promotion of this the avowed *purpose* of copyright law? The constitutional foundation to copyright states, "The Congress shall have power . . .

to Promote the Progress of Science and useful Arts, by securing for limited Times to Authors and Inventors the exclusive Right to their respective Writings and Discoveries."[120] As standardly interpreted, the right of copyright exists to promote the progress of mankind's body of knowledge, or, as Donald Diefenbach puts it, "to expand the marketplace of ideas."[121] Isn't this precisely what Koons and the other appropriation artists are attempting to do? While copyrightability rests centrally on an author's expression, and not on her ideas expressed, I would suggest that, given the intended function of US copyright law in general and the fair use doctrine in particular, it is worth considering a secondary author's ideas in determining whether her use is fair. And while it would perhaps be ideal on this understanding to require for a finding of fair use that the secondary work express some *new* idea, such a requirement would undoubtedly place an enormous burden on the law. Instead, I suggest only for such a use to be presumptively fair that the secondary use be in service of expressing some idea *distinct* from that of the original. However, my proposal still requires a fairly high degree of sensitivity on the part of the courts.

In the case of *Cariou v. Prince*, the district court found that Prince's purpose in creating *Canal Zone* was the same as that of Cariou's in the original photographs: to "communicate to the viewer core truths about Rastafarians and their culture."[122] What the court failed to consider important was whether Cariou and Prince sought to communicate the *same* core truths, and this seems a critical matter. Both purposes and ideas can be described in varying degrees of specificity, and at an abstract enough level all authored works perform the same function: expression. However, it is very often the more detailed, nuanced levels that interest us, that expand the marketplace of ideas. Are the ideas expressed in *Canal Zone* importantly distinct from those expressed in *Yes, Rasta*? Here, the court notes:

> In creating the Paintings, Prince did not intend to comment on any aspects of the original works or on the broader culture. Prince's intent in creating the Canal Zone paintings was to pay homage or tribute to other painters, including Picasso, Cezanne, Warhol, and de Kooning, and to create beautiful artworks which related to musical themes and to a post-apocalyptic screenplay he was writing which featured a reggae band. Prince intended to emphasize themes of equality of the sexes; highlight "the three relationships in the world, which are men and women, men and men, and women and women"; and portray a contemporary take on the music scene.[123]

How the court could reduce this to a purpose to "communicate to the viewer core truths about Rastafarians and their culture" boggles the mind,

and clearly for my proposal to operate, works would have to be considered at a reasonable enough degree of specificity to distinguish the ideas genuinely expressed in the works in question. In taking up the *Cariou* case, the appeals court makes note of substantial differences between Prince's works and Cariou's:

> These twenty-five of Prince's artworks manifest an entirely different aesthetic from Cariou's photographs. Where Cariou's serene and deliberately composed portraits and landscape photographs depict the natural beauty of Rastafarians and their surrounding environs, Prince's crude and jarring works, on the other hand, are hectic and provocative. Cariou's black-and- white photographs were printed in a 9 1/2" x 12" book. Prince has created collages on canvas that incorporates color, feature distorted human and other forms and settings, and measure between ten and nearly a hundred times the size of the photographs. Prince's composition, presentation, scale, color palette, and media are fundamentally different and new compared to the photographs, as is the expressive nature of Prince's work.[124]

Notably, all of these differences are, or arise from, differences that the court *sees* in the *form* of the respective works. Judge Wallace, in his partial dissent to the court's opinion, notes that, according to the majority, "all the Court needs to do here to determine transformativeness is view the original work and the secondary work and, apparently, employ its own artistic judgment."[125] Wallace is rightly incredulous of this position: transformation need not be apparent on a work's surface. The courts, I take it, would very much like it if cases could be decided simply by looking at the works before them. Unfortunately for the courts, neither art nor copyright works that way, and nor should they. So, certainly, there is work to be done.

One of the great assets of the present US Copyright Act is that it was designed to accommodate future forms of art and technology not predicted by its authors at the time of its framing. Although Sturtevant was active when the Act was written, she was far from well known—and it seems safe to assume that none of the Act's authors were familiar with the fictional Hank Herron. However, appropriation art has since grown to become one of the most fascinating—and most influential—movements in contemporary art. As such, given the instrumental purpose of copyright law as encoded in the Constitution, it seems incumbent on the law to seek to find a way of accommodating appropriation art within its boundaries. What I suggest here is a conceptual framework for understanding how the law might do just

this by recognizing how the appropriation artist *transforms* what she takes. Herron's imagined art, appropriated from Frank Stella, transformed Stella's work. A painting by Herron expressed an idea distinct from that of a visually indiscernible Stella, even if Herron's idea was simply a denial of his own originality.

Afterword

New Portraits

Richard Prince just won't go away. In 2015, fresh from his victory over Cariou, Prince made headlines again when he began exhibiting and selling (for upwards of $100,000 apiece) large-scale unaltered prints of others' Instagram images at a Gagosian Gallery show, New Portraits.[1] The prints—mostly images of the users themselves—appear as they would on a computer or mobile device, with the Instagram user's username and personalized icon above the image and a tally of "likes" below, followed by comments by Instagram users. In each case, Prince himself has left the most recent comment, and so Prince's comment on the photo makes up part of the work—like a spray-painted tag.[2]

One of the Prince works in this case—a black-and-white depiction of a dreadlocked Rastafarian—like the others in the show, carries the byline of the Instagram user from whom Prince appropriated it: @rastajay92. But the image did not originate with @rastajay92. Rather, @rastajay92 had reposted the image from Instagram user @indigoochild, who isn't its creator either. The photograph—*Rastafarian Smoking a Joint* (1997)—was originally taken by Donald Graham. When @indigoochild posted the image, it was without attribution, and there is no way to tell where *he* got it. In many ways, Prince is just reflecting this Internet zeitgeist. "What's yours is mine," Prince writes in the seven-page stream-of-consciousness press release for the show:

Everyone is fair.

Game.

An even playing field.[3]

Graham sent Prince a cease-and-desist letter.[4] Other targets of Prince had other ideas. Several of Prince's New Portraits appropriate the Instagram images of the SuicideGirls, a collective of models and burlesque performers. One of the SuicideGirls, Selena Mooney—better known as Missy Suicide—lamented:

> SuicideGirls is about celebrating how the model feels sexiest about herself, how she wants to be presented to the world and how she curates her own image, so to have a guy [Prince] grab the images and claim them as his own, especially to such hefty profits, is such a violation.[5]

The SuicideGirls exacted their revenge by teaming up with a printer and selling their own blown-up versions of their Instagram images at a fraction of the price of Prince's (adding a new comment below Prince's in each case).[6] Of course, this in no way hurts Prince, whose customers are looking for *Richard Prince works* and would not buy cheaper alternatives, however indistinguishable, however authorized by the original photographers. The SuicideGirls sold 250 copies of their new prints. Prince sold out his show.

The New Portraits press release closes with an ironic boilerplate line from the Gagosian Gallery: "All images are subject to copyright. Gallery approval must be granted prior to reproduction." Asked if she is worried about Prince suing, Missy Suicide laughs, "That would be fucking awesome. He can go right ahead."[7]

Answers and Questions

At the end of chapter 2, I suggested that determining whether one artist does anything wrong in copying the work of another depends on understanding (1) the nature of the works in question, (2) the relationship of the author to the work, (3) the rights of the author and how they arise from this relationship, (4) the relationship holding between the original work and the potentially infringing work, and (5) the rights of nonauthors—if any—with regard to a given work.

My central view, in quick summary, is that

(1) an author of a work is one who has and exercises the power of selecting and arranging elements as constitutive of that work;

(2) this creative activity determines the nature of that work (in general, an authored work is a type instantiable in multiple tokens);

(3) this creative activity and the nature of the work give rise to the author's

ownership of the authored work—a natural right to determine the conditions under which that work can be copied;

(4) copying another author's work (where the properties of the new item are shared with and depend on those of the preexisting work) without permission constitutes prima facie infringement; and

(5) though copyright is a natural right, it is not thus an absolute right, and what qualifies as a nonviolating use (copying) of an author's copyrighted work depends on some interest or right of the user outweighing the natural right of copyright.

Not surprisingly, however, my view leaves some open questions. One worth taking a look at is the duration of copyright. The passing of the Sonny Bono Copyright Term Extension Act—and its extension of the term of copyright in the United States to life of the author plus seventy years—incited uproar among copyright reformers, culminating in the 2002 Supreme Court case of *Eldred v. Ashcroft*. At the heart of the case was the complaint that, by retroactively extending the term of copyright, Congress had opened the door to a never-ending series of such extensions, effectively violating the clause in the US Constitution that gave Congress the power to "promote the Progress of Science and useful Arts, by securing *for limited Times* to Authors and Inventors the exclusive Right to their respective Writings and Discoveries." Lawrence Lessig—who cofounded Creative Commons, and whose views we discussed in chapters 1 and 2—was lead counsel for the plaintiffs. In the end, the Supreme Court found that the act did not violate the constitutional requirement that copyright be of a limited term, though Justice Breyer, in his dissent, contends that the effect of the act is to produce a copyright term that is "virtually perpetual."[8] Constitutional particulars aside, why would this be a problem?

On May 20, 2007, author Mark Helprin penned an op-ed for the *New York Times*, arguing for just such a perpetual copyright:

> What if, after you had paid the taxes on earnings with which you built a house, sales taxes on the materials, real estate taxes during your life, and inheritance taxes at your death, the government would eventually commandeer it entirely? This does not happen in our society . . . to houses. Or to businesses.[9]

But it does happen to our copyrights. Helprin asks, if copyright is a form of property—*intellectual* property—why, unlike every *other* form of property, does its ownership expire? Seventy years after I die, my descendants will still freely

monopolize the tattered remains of my comic book collection, but any copyrights I have similarly passed down will (as things currently stand) vanish in a puff of law.[10]

Helprin's op-ed stirred a hornet's nest. The next twenty-four hours were a big day for copyright bloggers: Public Knowledge, a DC-based public interest group, posted an immediate response. *Techdirt* founder Mike Masnick wrote one too.[11] Lawrence Lessig, meanwhile, called in the troops, entreating his community of blog followers to "[p]lease write an argument that puts this argument in its proper place," linking to a page on his eponymous wiki website.[12] The vitriolic wiki article, "Against Perpetual Copyright"—written by several hundred contributors—is currently eight times the length of Helprin's op-ed, and growing.[13]

Arguments brought against Helprin—and generally posed for the limited term of copyright—come in a few main varieties. One position, already touched on in chapter 7, holds that intellectual property is property *by analogy only*: authored works are intangible, nonrivalrous things, while personal property is tangible and rivalrous in nature. As such, there is no good reason to think the two things should be treated alike. However, as I argue in chapter 6, the fact that material and abstract objects differ in their nature does not imply that the former can be owned and the latter not. Rather, as ownership generally consists in the exclusive right to exploit (or authorize exploitation of) one's property, what it *means* to own a thing will depend on what it means to exploit a thing of that kind. There is, however, no conceptual problem with the notion of owning an abstract object such as an authored work.

A second argument levied by many against Helprin—and generally against the notion of perpetual copyright—is that the author's interest in copyright must eventually give way to the public's interest in free expression. The renowned copyright scholar Melville Nimmer once asked:

If I may own Blackacre in perpetuity, why not also *Black Beauty?* The answer lies in the first amendment. There is no countervailing speech interest which must be balanced against perpetual ownership of tangible real and personal property. There is such a speech interest with respect to literary property, or copyright. I have suggested that the speech interest in so far as it relates to expression rather than idea should be given less weight than the copyright interest in encouraging creativity. But when we consider copyright protection beyond the life expectancy of the author's children and grandchildren the balance between speech and copyright must shift. The real, if relatively slight, speech interest in expression remains constant, while the copyright interest in encouraging creativity largely vanishes.[14]

The public's interest in free expression, Nimmer suggests, presses against copyright ownership in a way that it does not press against the ownership of material goods. A perpetual copyright would not encourage more creativity than a copyright that lasted for the author's life plus fifty or seventy years. Where the value in maintaining copyright in a work dwindles away and ultimately vanishes over time, the general public maintains its undiminished interest in free expression.

Nimmer's position (and that generally held by Helprin's opponents) rests on the notion that copyright is grounded in the public interest in building the marketplace of ideas—in promoting the creation of authored works. At a certain point, the argument suggests, that end is better achieved by putting that work in the public domain. So, if one holds to an instrumentalist view of copyright as enshrined in the US Constitution, this argument makes perfect sense. However, if one holds—as I do—that copyright is a *natural right*, then we must ask why (or when) the public's interests would outweigh the author's natural right. As discussed last chapter, I believe there may be conditions under which they would, but not conditions of the sort that would thus justify any across-the-board limitation to the *duration* of copyright.

The United States is not the only country with a life-plus-seventy-year copyright term. The European Parliament likewise directs its members to set the duration of copyright at life-plus-seventy,[15] exceeding the minimum life-plus-fifty-year requirement of the Berne Convention.[16] Copyright in Mexico lasts for the life of the author plus a century![17] While reformers in other countries have argued that the elongation of the term of copyright upsets the balance between authors and users (see chapter 2, for example), the United States is the only country whose copyright term limit is a constitutional matter.[18]

If (as I contend) copyright is a natural right, I see two nonarbitrary possibilities for the duration of copyright. The first is, indeed, a perpetual copyright. If the object of copyright *is* property—property justified by the natural right of copyright—then (as Helprin argues) there seems no good reason to treat it differently from other property in terms of the duration and transferability of ownership. The second possibility, however, is a copyright that expires when the author expires, as is the case for the "moral rights" of the author, briefly touched on in chapter 6. After all, it is at least a little strange to think that your natural rights will extend beyond your death. This, however, would suggest that copyright is prima facie nontransferable, which may seem even more unpalatable. So, our central question is, does our natural right give rise to ownership that may be *transferred* at or before the author's death? Answering this question would require more argument than I can devote to it here, but I am in principle open to either possibility.

Practical Hurdles

Throughout this book, my arguments have largely been happily free of practical worries. But copyright is a legal and thus a practical arena, so it is certainly worth asking, could my philosophical position recommend a workable structure for the law?

Since my ontological view largely grows out of metaphysical assumptions already built into existing copyright laws, my core theory would not itself require any major overhaul to most existing legal systems, though tweaks here and there are to be expected, and certainly either recommended adjustment to the duration of copyright would need to be addressed.[19] Where the law *does* clearly need some work is in the area of fair use or fair dealing.

In chapter 7, I made room for the argument that an unauthorized copying of another's work should be considered presumptively fair if such copying is *necessary* for the sake of expressing one's own ideas (though this depends on an argument—hypothesized, but not yet provided—for natural users' rights)—that a use is fair if there is no way to express one's idea without copying that work. In chapter 8, I suggested that even straightforward appropriation art—the direct and exact copying of another's work *as* a new work—should be considered presumptively fair if such copying is in service of expressing an idea *distinct* from that of the original author. My model suggests, then, that we treat some use as presumptively fair if (a) the use was required for the second author's expression (ordinary fair use case), or (b) the use expresses a different idea from that of the original author (appropriation art cases). These two should provide, I think, a principled grounding for the vast majority of uses we would think fair, including uses in review, criticism, education, and parody, and one that tracks contemporary art practice. However, giving a principled grounding and providing a structure to implement this in the law are distinct things.

The fair use doctrine is often touted for its flexible nature, but its flexibility is such that it offers effectively no predictive value (for authors *or* users). Despite claims by many that transformation is the key to fair use, as we saw last chapter the matter is hardly so simple. As things stand, David Nimmer (son of Melville Nimmer) contends, "transformative use" has essentially become a mere synonym for "fair use," with the label being added only after a finding of fairness has already been reached. Nimmer suggests that courts

> appear to label a case "not transformative" as a shorthand for "not fair," and correlatively "transformative" for "fair." Such a strategy empties the term of

meaning—for the "transformative" moniker to guide, rather than follow, the fair use analysis, it must amount to more than a conclusory label.[20]

It was for reasons like this that Matthew Sag called fair use the "god in the copyright machine," offering an unsatisfyingly opaque divine answer to a seemingly insoluble problem. In recent years, however, Sag has adopted a cheerier outlook, suggesting that things may not be so gloomy for fair use predictability after all. In a 2012 empirical study of some 280 fair use cases decided in US district courts between 1978 and 2011, Sag suggests we *can* find some predictive trends. Recognizing the conceptual ambiguity of "transformation" in fair use, Sag focuses on cases involving one specific sort of transformation: where the offending work represents a change *in kind* from the work copied—specifically where the work copied is creative and the copying work informational, or vice versa—what he calls a "creativity shift."[21] So, here, we might be talking about my use of another's photograph in an essay on my website or (in the reverse) a clip from a news broadcast in a student film. Sag notes that the probability of a use being found fair where there is such a "creativity shift" is 62 percent, and that where there is no such shift, the probability of such a finding drops to 33 percent.[22] If the use is noncommercial in nature, things improve even more for the user. Sag reports that noncommercial use of another's creative work in an informational context (or vice versa) has a 72 percent chance of being found fair.[23] Statistically, this is certainly noteworthy. If you are a partner in a major law firm who can afford to lose 28 percent of your cases, these *are* useful data: you certainly might want to play these odds in choosing your cases. If you are a scholar or an artist, however, these data are cold comfort. First, as Sag himself notes, his methodology allows us to conclude nothing about cases where one *creative* artist uses the *creative* work of another, as in most of the cases discussed in this book[24]—so the data are of limited help here. Second (and more critically) the *best* these data offer are odds. As it stands, there is no way to *assure*—prior to a judge's decision—that some use I make of another's work is fair—that it is *legal*. Determining whether some action is legal should not be a matter of playing the odds; it should not be a gamble.

Fair dealing attempts to solve the predictability problem by setting up rules rather than guidelines, and so sacrificing flexibility. And, where the rules are not specific enough—or are not designed to accommodate unforeseen uses—fair dealing must revert to a case-by-case analysis and/or an ongoing series of legislative patches. And so fair users of others' works find themselves pulled into court (and the copyright owners find themselves compelled to do

the pulling), with all of the expense, trouble, and time that implies for both parties. My proposal for presumptive fair uses should go a long way toward solving the predictability problem without sacrificing flexibility. Still, authors and users are certain to disagree on occasion about whether some use is necessary, or expresses some idea distinct from that expressed in the original, and so some mechanism is warranted for making this determination.

A first possibility would be the creation of a preliminary Fair Use Board, charged with assessment of fair use claims before anyone has to go to court. Conveniently, I am far from the first to suggest such an idea, and we can look to other models that have been offered over the years. In 2006, David Nimmer offered "A Modest Proposal" for the formation of a panel of Fair Use Arbiters to issue nonbinding opinions regarding proposed uses of copyrighted works.[25] On this proposal, those with intentions to make fair use of another's work could petition the US Register of Copyright, providing a copy of the petition to the copyright owner, who would in turn be invited to submit a response. Nimmer's proposed act includes a fee requirement of $1,000 for the petitioner and $1,000 for the copyright owner, should she choose to provide a response. If either party indicated that the case was a "complex matter," they could submit a supplementary fee of $9,000, and the register would assign three arbiters to the case rather than one. Within a month, the arbiter or arbiters would issue an opinion as to whether the use would be fair. The arbiter's report would not be legally binding on Nimmer's proposal, but would nevertheless carry weight in any legal action that may follow.

But wait, you might ask . . . back up . . . is Nimmer seriously suggesting that if I want some determination as to whether (say) my use of someone else's photograph on my website is fair, I pay a $1,000 (or $10,000) fee to a fair use panel? Wasn't the point of fair use that it was free? Surely $1,000 (never mind $10,000) is more than I would expect to have to *pay for permission* to use the photograph in the first place, making the issue of fair use rather moot. Indeed, there are a few clues suggesting that all of this *is* an elaborate joke. Nimmer's title is, after all, "A Modest Proposal to Streamline Fair Use Determinations." Since Jonathan Swift coined it, the phrase "A Modest Proposal" has become a sort of universal shorthand for straight-faced satire. Also, Nimmer's title for his proposed act is "The Fair Use Determination Given Expeditiously under the Statutory Indicia for Calibrating Liability and Enforcement Act." How is one supposed to take "The FUDGESICLE Act" seriously?

This evidence to the contrary, however, Nimmer's proposal *is* a serious one. The paper is part of a conference series sponsored by Cardozo Law School called "Modest Proposals," in which legal theorists are challenged to

turn their ideas for reform into legislative language.[26] That his paper is titled "A Modest Proposal" is just an artifact of the series title. That his proposed act is titled "The FUDGESICLE Act" is just because David Nimmer is funny. The money, though, is no joke. Beyond actual and statutory damages accrued for unlawful infringement (with the latter up to $150,000 per work infringed if the infringement was "committed willfully"[27]), § 505 of the US Copyright Act states that, in any civil case, the court may at its discretion "award a reasonable attorney's fee to the prevailing party as part of the costs"—that is, the court may decide that the winner gets her legal fees paid by the loser.[28] Not so long ago, the standard held that, while prevailing plaintiffs in copyright cases were awarded attorneys' fees as a matter of course, successful defendants were awarded legal fees only when the court felt that the suit had been brought frivolously or in bad faith.[29] The 1994 Supreme Court case of *Fogerty v. Fantasy Inc.* changed that: although still leaving the awarding or not of legal fees at the court's discretion, the Supreme Court determined that judges should take an "evenhanded" approach, making no distinction in principle between prevailing plaintiffs and prevailing defendants. Simply put, if you are successful in your copyright suit (whether as plaintiff or defendant), you may have your legal fees paid. And if you are unsuccessful (again, as plaintiff or defendant), you may be paying not only your own legal fees, but those of your opponent as well. So, what kind of legal fees are we talking about? In the *Fogerty* case (the Fogerty at hand being John Fogerty of Creedence Clearwater Revival), they amounted to $1,347,519.15.[30] And this was in 1994. Now, if you're sued for copyright infringement, hopefully your legal fees won't reach seven figures. But five figures is well within the realm of reason. Suddenly Nimmer's proposed $1,000 per party arbitration fee doesn't seem quite so extravagant. Still, most of us, I think, are not John Fogerty (or Richard Prince), and don't have a spare few thousand dollars in between the couch cushions.

In "Fixing Fair Use," Michael W. Carroll offers another proposal for a Fair Use Board, which, although similar in approach to Nimmer's, differs in some of the details. Under Carroll's proposal, the board's decision would be a legal ruling and not merely an arbiter's opinion, though it would be appealable to a higher court. Also, Carroll hand-waves the issue of fees, saying only:

> Close attention should be paid to the appropriate filing fee, which would serve as a measure of the option value of a fair use ruling. Ideally, this system would be self-funded, but it would also be critical to ensure equitable access for poorly-resourced petitioners.[31]

This language may make Carroll's proposal seem more appealing, but it should not thus make us complacent—after all, *someone* ultimately has to pay for this board, whether through fees or taxes. What is worse, though, neither Carroll nor Nimmer offers any recommendations for revising the fair use doctrine itself, and so both proposals would still rely on the traditional (and unreliable) four factors of fair use. As such, while Nimmer's proposal (and, presumably, Carroll's) would potentially lower the expense of fair use adjudication, neither offers any greater predictability for its outcome. Indeed, lowering the cost of fair use decisions only increases the likelihood that authors and users will be willing to pay for such decisions (and so increasing the likelihood that their opponents will be dragged into paying as well), but with no increased predictability of the outcome.

Unlike Nimmer's mock act, Carroll's article allows him the room to consider practical concerns for both copyright owners and for users. One worry raised by Carroll is that, in instituting a system of fair use petitions, copyright owners would have to expend precious resources responding to such petitions.[32] A second worry is that such a model of fair use adjudication would create the expectation that users will in fact use such adjudication, thus instilling in courts a prejudice against those who choose to rely on their own judgment.[33] Of course, if a Fair Use Board is still adjudicating according to the four fair use factors, these *are* real worries. If a Fair Use Board is to be of much use, it will need to operate according to rules and not merely the vague guidelines of the four factors.[34]

In "Fair Use Harbors," Gideon Parchomovsky and Kevin A. Goldman offer a set of bright-line rules for fair use. For example:

> [F]or any literary work consisting of at least one hundred words, the lesser of
> fifteen percent or three hundred words may be copied without the permission
> of the copyright holder. The words need not appear consecutively (either in
> the original or in the copy), so long as the total number of duplicated words
> does not exceed the threshold.[35]

For sound recordings, Parchomovsky and Goldman propose fair use in the copying of the lesser of 10 percent or 10 seconds of the original.[36] Similar rules are offered for other work-kinds. For those who find the proposed rules unpalatably arbitrary, Parchomovsky and Goldman state: "One can quibble, of course, with where the threshold is drawn, but the more important point here is simply to be precise and predictable."[37] On its face, this is a baffling statement. An arbitrary 2 percent or 98 percent copying threshold offers just as much precision and predictability as Parchomovsky and Goldman's

proposal. As any darts player can tell you, precision and predictability are worthless without hitting the target. As it happens, Parchomovsky and Goldman are aiming at a target of balance between the interests of authors and users, grounded in an instrumentalist conception of copyright. But, as we have dispatched with this model of justification and replaced it with a natural rights model, we have a different target. Indeed, we are playing a different game.

Nimmer, Carroll, Parchomovsky, and Goldman are all proposing revisions to existing US copyright law, changing only what they think necessary to make the system work. But this patchwork approach is insufficient for a problem that requires structural revision. Our revised justification of the right of copyright recommends an understanding of fair use that does not rest on quantitative analysis. But this does not mean we must sacrifice predictability. Although perhaps not as mechanical a matter as determining whether one has copied 300 words from a novel (or 10 seconds from a sound recording), it seems an intuitively straightforward matter whether it was possible to express one's idea without copying (or copying as much) from one's source material, or (in the case of appropriation art) whether one is expressing an idea distinct from that of one's source. At the same time, it is certainly easy enough for a user to convince herself that her use was necessary when it in fact was not. So, where the matter is contested, it could be settled by petition to our Fair Use Board, which would be charged with answering these questions. Unfortunately, adjudication does cost money, and somebody has to pay (whether directly through fees or indirectly through taxes). So, while we should be aiming to limit the cost of such decision making—and certainly, fair use adjudication would cost all parties substantially less than a trial—we should also seek to reduce the number of people (both authors and users) who feel the need to make use of such adjudication. Introducing presumptive fair uses that offer reasonable predictability would seem ideal in this regard; the establishment of such uses as presumptively fair makes it much more likely that an author or a user could reasonably determine fairness of use on her own.

Now, in this section, we have mostly been looking at recommendations from theorists for the American system, and indeed I have adopted the term "fair use" for my view. As with my larger theory, however, this is not in deference to US law, but is rather a matter of convenience. Indeed, as my recommendation for a Fair Use Board is not a recommendation for US law in particular, but for any jurisdiction, I can only go so far without examining the administrative or legislative details that would be required to implement it. Still, even in this sketch, we can add some detail.

As I imagine it, an author who thinks his work has been used unfairly would be able to petition the board for a ruling, but so too would a user who wants a preemptory ruling on her use. And, like Carroll, I would imagine that any judgment made by the Fair Use Board should be appealable to a higher court. Importantly, though, any user petitioning the board would, in effect, be admitting to having in fact copied the original. At least in the United States, this is one of the central facts that must be established in any copyright infringement suit. As such, any user who has petitioned the board and whose use has been found unfair should not be able to claim in a later trial on the use that the resemblance between her work and its source is mere coincidence.

As well, I have left open the possibility of other nonviolating infringements of copyright. Perhaps cases of incidental copying (as discussed in chapter 7) or de minimus uses would qualify, though it would need to be shown why (and under what conditions) such uses would defeat the author's natural right. And likewise for exceptions for libraries and educational uses. If conditions of any such uses *were* to be laid out, however, these could be added to the list of presumptively fair uses to be considered by the board.

One may worry that my treatment of appropriation art as presumptively fair would open the door to widespread piracy. Although in chapter 8 I recommended limiting such uses to single instances—not permitting further copies of the new work—we might introduce a further rule for limiting such activities, such that half the selling cost of any work of appropriation art be given to the copyright holder of the work so appropriated (and, in a case in which there are multiple sources, divided evenly among them), and that, in any event, the work of appropriation art not be sold for less than twice the standard price of the original (or combined price of the originals where there are multiple sources). This would ensure that a work of appropriation art could not serve as a market-undercutting substitute for the original, and that the author of the original be fully compensated. I could imagine this operating in a manner similar to the mechanical licensing fee currently employed for cover versions of musical recordings, as discussed in chapter 2. Whether this would satisfy the SuicideGirls and other authors of works targeted by Prince and his ilk, I can't say (but, then, I can't imagine that every recording artist is pleased that permission is not required for covers).

As a final concern, in *Art and Authority*, Karen Gover argues that my proposal—at least as regards appropriation art—places too much of a burden on the courts to make nuanced interpretations of artworks.[38] However, courts are already required to be able to distinguish in any given case the expression making up the work, and the idea being expressed, the former being

in-principle copyrightable and the latter not. And, at least in the United States, courts are also required to be able to determine when a given expression is necessary to express some particular idea (this being at the heart of the "merger doctrine" discussed in chapter 3). So my proposal for *ordinary* fair use cases—that we treat a use as presumptively fair when that use was necessary for the expression of some idea—requires making no distinctions not already required of the courts. Cases of appropriation art require only a determination of whether the appropriation artist is using some borrowed expression to express some idea distinct from that expressed by the original artist. I cannot see that determination of this fact for the purposes of a fair use verdict would prove more difficult than establishing that some copying was required for the expression of one's idea. Of course, as we saw in the *Cariou* cases, this is hardly foolproof.

Perhaps the single most famous work of appropriation art is Sherrie Levine's *After Walker Evans: 4* (1981), a rephotograph of Evans's photograph *Alabama Tenant Farmer Wife* (1936). Evans took the photograph of Allie Mae Burroughs while on assignment for the US federal government in a project documenting the effects of the Great Depression. Nearly half a century later, Levine rephotographed the image from one of Evans's published collections as a part of her After Walker Evans series. Today, both works are in the collection of the Metropolitan Museum of Art. Jeff Rosenheim, Curator in Charge of the Met's Department of Photographs, describes Evans's work as the portrait of "a closed and irritated Allie Mae, a troubled victim of both the Depression and the camera's burrowing eye."[39] Meanwhile, the Met describes Levine's After Walker Evans series as "a critique of the commodification of art, and an elegy on the death of modernism. Far from a high-concept cheap shot, Levine's works from this series tell the story of our perpetually dashed hopes to create meaning, the inability to recapture the past, and our own lost illusions."[40] Perhaps we might quibble over these descriptions, but even taken as a rough sketch, it seems untroubling that Evans and Levine were expressing distinct ideas, despite the latter copying the expression of the former. For an even simpler distinction here, we might say that Evans's work is essentially a portrait—a pictorial representation of a person—while Levine's essentially is not.

Granted, artistic practice is messy, and any Fair Use Board is likely to demand a more useful set of guidelines than this. While devising such a set of guidelines outstretches the scope of my current project, we can at least get an idea of the right direction. Certainly, my view would require rejecting any contention that the idea expressed in the work should be identified with the idea the work produces in the *audience's* mind—and this is an outcome that I

am perfectly comfortable with. My view would also require rejecting the contention that the idea expressed in the work can be unambiguously read off the formal properties of the work. If this were the case, it simply would not be possible for two authors—even by sheer coincidence—to make formally indistinguishable arrangements of shapes, words, or sounds and reasonably express different ideas in them. Beyond these disqualified candidates, however, a great many possibilities remain. Although what idea is expressed in a work may be a distinct matter from that work's *meaning*, the latter has long been a topic of inquiry by philosophers. And, I think the prevailing views are close enough together that a practical test is within reach. Perhaps all we need is the right reason to close the gap.

NOTES

INTRODUCTION

1. Mick Haggerty, personal correspondence by e-mail, July 21, 2015.
2. Perebinossoff, Gross, and Gross, *Programming for TV*, 210; Davids, "Eldred v. Ashcroft." Disney, of course, wasn't alone in this endeavor, but its efforts uniquely captured the public attention.
3. Copyright Act of March 4, 1909, ch. 320, §§ 23–24, 35 Stat. 1075, 1080–81.
4. There is actually some debate on this. Some argue that, under the law, *Steamboat Willie* has *always* been in the public domain, due to an error in the copyright notice in the film. See Hedenkamp, "Free Mickey Mouse."
5. Copyright Act of October 19, 1976, Pub. L. No. 94-553, tit. I, 101, 90 Stat. 2541, 2572–73 (codified as amended at 17 U.S.C. § 302(c)).
6. Ibid., 2572 (codified as amended at 17 U.S.C. § 302(a)). Different rules pertain to works created as work-for-hire, for example.
7. 17 U.S.C. § 302(a). Hereafter, unless referring to an earlier iteration of the US Copyright Act, I will use the citation format here.
8. In the case of paintings, public display in a gallery qualifies as "publication." See Pierce & Bushnell Mfg. v. Werckmeister, 72 F. 54, 58–59 (1st Cir. 1896).
9. Borrelli, "Connecting the Dots."
10. Attempts to confirm this with the Haring Foundation have been unsuccessful.
11. L. Gilbert, "No Longer Appropriate?" In *Cutting Across Media*, Kembrew McLeod and Rudolf Kuenzli assert that Lichtenstein, Warhol, and Haring *all* obtained licenses from Disney for their representations of Mickey (14). In this case of Warhol, this seems to be true. However, McLeod and Kuenzli offer no evidence to support their claims about Lichtenstein or Haring. All evidence suggests that Lichtenstein, at least, did not seek permission from Disney before painting *Look Mickey*. The artist says, "The idea of doing [a painting of cartoon characters] without apparent alteration just occurred to me. I first discussed it and thought about it for a little bit, and I did one really half seriously to get an idea of what it might look like" (quoted in Sylvester, "Roy Lichtenstein BBC Interview"). At least in select cases, Disney seems to have invited reimaginings of its flagship character. In 2009, Disney invited Damien Hirst to create a Mickey-inspired work—*Mickey* (2012)—for a charity event.
12. Price Budget for Boys, *Pac-Mondrian*.
13. Garfield Sales, "Garfield Q-Score"; Maglio, "Most and Least Liked."

14. See Mondrian, *Plastic Art.*
15. Codified in 17 U.S.C. § 107.
16. What justifies the right of copyright, what follows from it, and what limits it may not carry over to other areas of intellectual property, like trademark, patent, or the database right. A trademark is a word, symbol, or design that serves to distinguish the source of a product or service, and so trademark ownership provides the owner with the exclusive right to use that mark on a certain domain of product (say, cars or pet food). A patent is ownership over a useful invention (a utility patent), industrial design (design patent), or new variety of plant (plant patent), and provides the owner with the exclusive commercial right to make, use, import, or distribute the thing protected. A database is a collection and arrangement of data, works, or materials accessible by electronic or other means, and the database right provides the owner with the exclusive right to use that database. Trademarks are relatively easy to get and easy to lose, and apply exclusively in commercial domains. Patents are quite difficult to get and expire quite quickly, compared with copyright. Database rights expire even more quickly. Since intellectual property laws differ by territory, not all of these rights are recognized in all countries (the United States, for example, does not recognize database rights). Even where they are, they may be understood or operate quite differently. For the sake of this book, we will largely be talking about copyright, which provides enough difficulties of its own.

CHAPTER ONE
1. Zakarin, "Shia LaBeouf Apologizes."
2. Duke, "Shia LaBeouf Offers."
3. Zakarin, "Shia LaBeouf Apologizes."
4. Johnston, "Authorship is Censorship" (formatting as in original).
5. Quoted in Tomkins, *Off the Wall,* 117.
6. Betts, "Poets Against Authorship."
7. Goldsmith, "It's Not Plagiarism."
8. *Huffington Post,* "Shia LaBeouf Receives."
9. Silvie, "Daniel Clowes Interview," 66.
10. Dickens, "'Super Mario Busters.'"
11. Dickens, "7 Classical Masterpieces."
12. Manjoo, "How to Make."
13. Madrigal, "Cute Animal Pictures."
14. B. Smith, "Editor's Note."
15. Chen, "Remix Everything."
16. *BBC News,* "Sweden Recognizes."
17. Ibid.
18. Lessig, *Remix,* 28.
19. Lessig, *Free Culture,* 37.
20. Followed the same year by Arthur Seal's "Baby Seal's Blues" and W. C. Handy's "Memphis Blues." In fact, "Dallas Blues" was originally published as an instrumental and would not be published with lyrics—added by Lloyd Garrett—until 1918.
21. Govenar, *Texas Blues,* 22; Govenar and Brakefield, *Deep Ellum,* 87–89.
22. Schuller, *Early Jazz,* 226.
23. Govenar and Brakefield, *Deep Ellum,* 92; Carnes, *Invisible Giants,* 167.
24. Carnes, *Invisible Giants,* 167.
25. Evans, *Big Road Blues,* 5–6.

26. Ibid., 48.
27. Ibid., 77.
28. Ibid., 72–74.
29. Ibid., 74.
30. Evans, "An Interview with H. C. Speir," 120.
31. Evans, *Big Road Blues*, 74.
32. 17 U.S.C. § 102(a).
33. 17 U.S.C. § 101.
34. White-Smith Publishing Co. v. Apollo College, 209 U.S. 1, 17 (1908). The history of musical copyright in the United States is notoriously—indeed, ridiculously—complicated. Prior to the implementation of the Copyright Act of 1976, two regimes of copyright law held sway—one at the federal level, and one at the state level. The 1976 Act was the fifth substantial overhaul of US federal copyright, with prior iterations occurring in 1790, 1831, 1870, and 1909. Prior to the effective date of the 1976 Act, if a work failed to meet the conditions for federal protection—if, for instance, it had not been published—it may have been afforded state protection either by statute or common law. Although federal protection for musical compositions fixed in sheet music stretches back as far as 1831, sound recordings did not garner independent protection until the enactment of the Sound Recording Amendment of 1971, which allowed for copyright in recordings created on or after February 15, 1972. Musical recordings created prior to this date could qualify for protection only at the state level. In the 1908 case of *White-Smith Music Publishing Co. v. Apollo Co.*, the Supreme Court held that a manufactured piano roll—a perforated roll of paper used in player pianos—was not, legally speaking, a "copy" of a musical composition, and so such an item would not infringe the copyright in a work encoded in its perforations. The implementation of the 1909 Act the following year changed things, extending the protection of musical compositions to include "mechanical reproductions" of such a work. Under this Act, once the owner of a musical copyright had encoded—or licensed the encoding of—the work in a phonorecord, others were free to reproduce the work under a statutory licensing fee. Federal copyright today effectively preempts any conflicting state-level common law, and so federal law has largely eclipsed state common law, though there are certainly surviving vestiges of the latter.
35. U.S. Const. art. 1, § 8, cl. 8.
36. Burrow-Giles Lithographic Co. v. Sarony, 111 U.S. 53, 58 (1883).
37. Complications arise in cases of "useful articles"—artifacts with utilitarian function. See Hick, "Conceptual Problems."
38. Quoted in Evans, *Big Road Blues*, 75 (formatting removed).
39. M. Jones, "On Blues," 82.
40. Arewa, "Blues Lives," 580.
41. Harrington, "Celebration of Home-Grown Soul."
42. I'm in the debt of Maria Balcells, who introduced me to this little musical wonder.
43. Harrison, "Reflections"; Nuttall, "Seven Seconds of Fire."
44. The original release of "Amen Brother" was on a 7-inch, 45-rpm record; for the *Ultimate Breaks and Beats* bootleg, the break was slowed to 33⅓ rpm.
45. Artist Nate Harrison provides an interesting insight into the Amen Break in his installation, *Can I Get an Amen?*, 2004, http://nkhstudio.com/pages/popup_amen.html.
46. Whelan, "'Amen' Breakbeat as Fratriarchal Totem," 114. Michael S. Schneider suggests that the popularity of the Amen Break is due in part to its adherence to the golden ratio, though the claim is dubious. See Schneider, "Amen Break."

47. See, e.g., submissions prepared by Digital Rights Ireland (https://www.djei.ie/en /Consultations/Consultations-files/Murphy-Donnelly-McGarr-DRI.pdf), 22–23; and the Open Rights Group (http://www.ipo.gov.uk/ipreview-c4e-sub-org.pdf), 9.

48. Whelan, "'Amen' Breakbeat as Fratriarchal Totem," 125 (internal citations omitted).

49. Kutski, "Amen Break."

50. Ibid. Spencer suggests, "I think towards the end, Greg did realize [the Amen Break's] popularity, but who's benefiting? Certainly not Greg. Who's gonna pay his children? Greg's family ain't gonna get shit." (Quoted in Williams, "Can I Get an Amen, Brother?") In 2015, Martyn Webster, a British DJ, ran a campaign through the GoFundMe crowd-sourcing website to raise funds for Spencer, stating: "If you have ever written or sold any music with the amen break, or even just enjoyed one of the countless hundreds and hundreds of tunes that contain it over various genres and styles of music, please donate towards the good cause of the worldwide music community giving some-thing back to the man behind the legendary breakbeat." (https://www.gofundme.com /amenbrother) The campaign raised an impressive £24,000 (about US$32,000), which was sent to a very grateful Richard Spencer. However, first, though he is the copyright holder, it is problematic to call Spencer the "man behind the legendary breakbeat," which was drummed by Coleman. Second, as none of the funds appear to have come from the music publishers who benefited most directly from the unlicensed sampling of the Amen Break, it would be a stretch to call this compensation. Finally, let's consider: had the Winstons been compensated a literal nickel for each copy sold of N.W.A.'s *Straight Outta Compton*, that check would have exceeded $150,000. Another nickel for each copy of Oasis's "D'You Know What I Mean" (on their album *Be Here Now*) would add more than $400,000 to that check. At the same rate, sales of Public Enemy's "Bring the Noise" (on *It Takes a Nation of Millions to Hold Us Back*) would add at least another $50,000. So far, I have counted sales from three songs (of the hundreds or thousands that same the Amen Break)—and only their sales on albums (not as singles)—and we have topped $600,000. Even if I am off on what would be a reasonable royalty by an or-der of magnitude, that £24,000 is a drop in the bucket of what Spencer should be owed.

51. The amazing story of Lacks and her cells is told in Skloot, *Immortal Life*.

52. Brown and Henderson, "Mass Production and Distribution."

53. Skloot, *Immortal Life*, 2.

54. Moore v. Regents of University of Cal., 51 Cal. 3d 120 (1990).

55. Bridgeport Music, Inc. v. Dimension Films, 410 F.3d 792 (6th Cir. 2005).

56. This particular turn of phrase is used by Allison Samuels in "How Henrietta Lacks Changed Medical History."

57. European Molecular Biology Laboratory, "Genome."

58. Callaway, "Deal Done," 132–33.

59. Kutski, "Amen Break."

60. Franzen and McLeod, *Copyright Criminals*. The Beastie Boys' second album, *Paul's Boutique* (1989), employs so many samples that a third-party website is devoted to cataloguing them (paulsboutique.info), and the band's members have been defen-dants in a number of copyright cases. Indeed, Diamond and his bandmates were the defendants in a pivotal case decided only nine weeks before *Bridgeport Music v. Dimension Films*. When a sound recording also represents a musical composition, sampling without permission may infringe *two* copyrights—that on the sound re-cording itself, and a separate copyright on the underlying composition. In this case, the Beastie Boys had cleared permission for a six-second, three-note snippet of sound

recording (from ECM Records), but not the musical composition (held by jazz flutist James W. Newton). In the case of *Newton v. Diamond* (388 F.3d 1189 (9th Cir. 2004)), the US Court of Appeals for the Ninth Circuit established that there *is* a de minimus rule for infringement from musical compositions in sampling.

61. Schloss, *Making Beats*, 175.
62. Nuttall, "Seven Seconds of Fire."
63. Bridgeport Music, Inc. v. Dimension Films, 410 F.3d 792, 801 (6th Cir. 2005).
64. Lessig, *Remix*, 56.
65. Gleason, "Can the White Man" 28–29, quoted in Rudinow, "Race," 127.
66. Taylor, ". . . So Black and Blue."
67. See Rudinow, "Race," and Rudinow, "Reply to Taylor."
68. Schloss, *Making Beats*, 105.
69. Ibid., 114 (quoting King Otto).
70. Schur, *Parodies of Ownership*, 48.
71. Mallon, *Stolen Words*, 242.
72. Posner, *Little Book of Plagiarism*, 19–20.
73. Ibid., 33.
74. Ibid., 18.
75. White, *Letters of E. B. White*, 344–45. White also suggests "the total recall guy, who can read something or hear something and later regurgitate it, practically word for word, not knowing he is doing it." (Ibid.)
76. Shaw et al., "Children Apply Principles." The authors often fail to make important distinctions between ideas and expression, stating, for example: "Although not exactly parallel to the right to exclude in physical ownership, copyright laws in the United States allow individuals to exclude others from using or expanding upon their intellectual property. Therefore, the law seems to conclude that the right to exclude applies to both objects and ideas." (1391, internal citation omitted) Notably, copyright explicitly excludes idea ownership. Although the authors generally refer to those things recognized by children as owned as "ideas," most of their examples would more likely qualify under the law as "expressions."
77. Olson and Shaw, "'No Fair, Copycat!'"
78. Brandes, *Academic Honesty*.
79. McCabe, "Academic Dishonesty."
80. *New York Times*, "Plagiarism is Rampant," 36.
81. McCabe et al., *Cheating in College*, 70.
82. Ibid., 57–59.
83. Jeffrey Young, "Cat-and-Mouse Game."
84. Lieberman, "Plagiarize, Plagiarize, Plagiarize," 24.
85. Straw, "Plagiarism of Generation 'Why Not?'"
86. Stahl, "Ethics and the No-Fear Generation."
87. Blum, *My Word!*, 41.
88. Ibid., 61.
89. Ibid., 89–90.
90. Ibid., 125–47; McCabe et al., *Cheating in College*, 118–21.
91. Bowden, "Coming to Terms," 82–84.
92. Fritz, "Redefining Research, Plagiarism."
93. See Sinnreich et al., "Ethics Reconfigured"; Latonero and Sinnreich, "Hidden Demography"; Sinnerich and Latonero, "Tracking Configurable Culture."

94. Karaganis, "Copy Culture Survey."
95. Jenkins et al., *Confronting the Challenges.*
96. Sinnreich et al., "Ethics Reconfigured," 1247.
97. Latonero and Sinnreich, "Hidden Demography," 527; Sinnerich and Latonero, "Tracking Configurable Culture," 799.
98. Sinnreich et al., "Ethics Reconfigured," 1243–44.
99. Z. Smith, Introduction, vii.

CHAPTER TWO

1. Eberhard Ortland, personal correspondence by e-mail, January 16, 2009.
2. Hick, "Aesthetics and Copyright," 1.
3. Ibid., 2–3.
4. The US Copyright Act of 1976, for example, states only: "In no case does copyright protection for an original work of authorship extend to any idea, procedure, process, system, method of operation, concept, principle, or discovery, regardless of the form in which it is described, explained, illustrated, or embodied in such work." (17 U.S.C. § 102(b)) However, the Act offers no definitions of these terms. Similarly, the international WIPO (World Intellectual Property Organization) Copyright Treaty states that "[c]opyright protection extends to expressions and not to ideas, procedures, methods of operation or mathematical concepts as such," but does not define its terms (WIPO Copyright Treaty (20 December 1996), art. 2.)
5. Hick, "Making Sense," 402. Clearly, there is a lot more to be said about the idea/ expression distinction, and I point the reader to this article as a starting point.
6. Shiner, "Ideas, Expressions, and Plots," 402.
7. Ibid., 403.
8. Ibid., 404.
9. Hick, "Expressing Ideas," 407.
10. Ortland, "Aesthetics of Copyright," 227; see also Ortland and Schmücker, "Copyright and Art."
11. Being how fifteenth-century alchemist Paracelsus discovered hydrogen.
12. Thomasson, "Ontology of Art and Knowledge," 227; see also Thomasson, "Ontology of Art."
13. See also Davies, *Art as Performance*; and Davies, "Primacy of Practice."
14. Grand Upright Music Ltd. v. Warner Brothers Records, Inc., 780 F. Supp. 182 (S.D.N.Y. 1991).
15. Ibid., 183.
16. Judge Duffy concludes his decision by referring the case to the US district attorney to consider prosecuting Markie for *criminal* copyright infringement, a charge with the potential for several years' imprisonment for a guilty offender.
17. McAdams, "Clearing House," 85.
18. McLeod and DiCola, *Creative License*, 27.
19. McLeod, "Oral History of Sampling," 91.
20. Marzorati, "Art in the (Re)Making," 97.
21. Aufderheide et al., "Copyright, Permissions, and Fair Use," 5.
22. Ibid., 9.
23. Even more broadly, Aram Sinnreich and Patricia Aufderheide report that some 64 percent of communication scholars "would do something different in their scholarly or teaching practices—sharing, quoting, remixing, archiving—if copyright were not

a concern." (Sinnreich and Aufderheide, "Communication Scholars and Fair Use," 821.) Tellingly, the editors of *The Routledge Companion to Remix Studies* (2015)—a volume devoted to the study of the very subject of artistic appropriation—note that several contributors left the volume because they were unable to negotiate more flexible contracts regarding copyright. (Navas et al., *Routledge Companion to Remix Studies*, 2.)

24. Cowley, Notes.
25. See Monge, "See That My Grave," 869.
26. US Copyright Office, "Mechanical License Royalty Rates." This rate is subject to change; at the time of Jefferson's recording, the rate was 2¢ per copy. All of this assumes that the first recording was done with the copyright owner's permission. You are welcome to negotiate another deal with the copyright owner or the owner's representatives, but you aren't required to seek permission.
27. See Cohen, "When Does a Work," 627–28.
28. 17 U.S.C. § 101.
29. 17 U.S.C. § 115(a)(2).
30. Goodman, *Languages of Art*, 113.
31. Ibid., 119.
32. Ibid.
33. The same would be true if one tried to sell the artist's or printer's proofs as authentic prints.
34. See Chatelain, "Original in Sculpture," 281.
35. Edemariam, "I Think," 12.
36. Decree No. 81–255, 3 March 1981, art. 9.
37. Milroy, "Rodin: Truly, a Bust."
38. Edemariam, "I Think," 12.
39. Adams, "Rodin Thinkers," R3.
40. This may not be the case, for instance, if you created the work in the course of duties as an employee, though work-for-hire conditions vary between countries. The US Copyright Act specifies that the US federal government cannot generate copyrights of its own (thought it may, for instance, be bequeathed such copyrights). Notice, however, that the lack of copyright on an American president's speech is not because such a work of authorship falls outside the domain of copyright, but is excluded from such protection by *fiat* of copyright law (see 17 U.S.C. § 105).
41. There may, however, be certain *advantages* to registration (see, e.g., 17 U.S.C. § 412). The sort of "extremely rare" exception here includes, for example, the requirement of registration for copyright in cinematic works and phonograms in Turkey (UNESCO World Anti-Piracy Observatory, "Turkey," 8–9). Two international copyright treaties—the Berne Convention for the Protection of Literary and Artistic Rights and the Agreement on Trade-Related Aspects of Intellectual Property Rights (TRIPS)—outlaw such formalities and require their signatories to recognize the copyrights of authors from other treaty nations. Almost every country in the world is a signatory to one, or both, of these two treaties.
42. As discussed last chapter, the point when copyright adheres is when the work is "fixed in a tangible medium of expression" (17 U.S.C. § 102(a)), which excludes certain ephemeral kinds of works from protection. This is not, however, a universal standard.
43. US Congress, "Intellectual Property Rights."
44. The preamble to another international treaty—the World Intellectual Property Organization (WIPO) Copyright Treaty—states the treaty is founded on "the need to

maintain a balance between the rights of authors and the larger public interest, particularly education, research, and access to information." (WIPO Copyright Treaty (20 December 1996), preamble.)

45. Arcangel, *Clouds*.
46. Ziv, "New York Public Library." See New York Public Library, "Public Domain Collections: Free to Share & Reuse," accessed July 15, 2016, http://www.nypl.org/research /collections/digital-collections/public-domain.
47. Lessig, *Remix*, 109.
48. Ibid., xix.
49. Open Source Initiative FAQ, "What about the Creative Commons."
50. Creative Commons, "Size of the Commons."
51. Digital Copyright Canada, "Changes to Copyright."
52. Appropriation Art Coalition, "Open Letter."
53. Australian Law Reform Commission, "Copyright and the Digital Economy," 20, 62 (citations removed).
54. Ibid., 65.
55. Ibid., 212.
56. Litman, *Digital Copyright*, 112.
57. Ibid.
58. Agence France-Presse, "India Gang-Rape Victim."
59. Ibid.
60. Lessig, *Remix*, xix.
61. Ibid., xix–xx.
62. Ibid., 114.

CHAPTER THREE

1. "Ein Kugelblitz in Prosaform und Prosasprache." (März, "Literarischer Kugelblitz.")
2. Delius, "Mir zerfallen die Worte im Mund wie schlechte Pillen."
3. Pirmasens, "Axolotl Roadkill."
4. Derbyshire, "On Translating Axolotl Roadkill."
5. This quotation is from the 2012 English translation. The original German reads: "Berlin is here to mix everything with everything, Alter! . . . Ich bediene mich überall, wo ich Inspiration finde und beflügelt werde . . . Filme, Musik, Bücher, Gemälde, Wurstlyrik, Fotos, Gespräche, Träume . . . Straßenschilder, Wolken . . . Licht und Schatten, genau, weil meine Arbeit und mein Diebstahl authentisch warden, sobald etwas meine Seele berührt. Es ist egal, woher ich die Dinge nehme, wichtig ist, wohin ich sie trage." (Hegemann, *Axolotl Roadkill* (German edition), 15.)
6. Airen, "Berlin Is Here."
7. Jarmusch, "Jim Jarmusch's 5 Golden Rules."
8. What Jarmusch says is, "In any case, always remember what Jean-Luc Godard said: 'It's not where you take things from—it's where you take them to." (Ibid.) The origin of the quote (or some near-variant of it) is usually presented as said by Godard offhandedly to another filmmaker—sometimes Paul Schrader, sometimes Martin Scorsese—who admits to borrowing a scene from one of Godard's films.
9. *Local*, "Young Literary Star."
10. "[E]ntschuldige ich mich dafür, nicht von vornherein alle Menschen entsprechend erwähnt zu haben, deren Gedanken und Texte mir geholfen haben." *BuchMarkt*, "'Axolotl Roadkill.'"
11. Connolly, "There's No Such Thing."

12. "Nothing is original. . . . Authenticity is invaluable; originality is nonexistent." (Jarmusch, "Jim Jarmusch's 5 Golden Rules.") As we might note, even Shia LaBeouf's act of plagiarizing his apologia is not novel.
13. Boswell, *Boswell's Life of Johnson*, 4:236.
14. Polti, *Les Trente-Six Situations Dramatiques*.
15. See, e.g., Friedman, *Roadkill*, 167; White-Parks, "Beyond the Stereotypes," 266.
16. Barthes, "Death of the Author," 146.
17. Aquin, "Occupation: Writer," 51.
18. Fish, "Plagiarism."
19. Foucault, "What Is an Author?," 148.
20. A number of excellent histories of copyright have been written, including Deazley et al., *Privilege and Property*; P. Goldstein, *Copyright's Highway*; and Rose, *Authors and Owners*.
21. 17 U.S.C. § 102(a).
22. Copyright Act R.S.C., 1985, c. C-42, s.5(1).
23. Directive 2006/116/EC of the European Parliament and of the Council of 12 December 2006 on the term of protection of copyright and certain related rights, Recital 16.
24. Judge and Gervais, "Of Silos and Constellations," 376.
25. Woodmansee and Jaszi, *Construction of Authorship*, 2–3.
26. See, e.g., Kaplan, *Unhurried View of Copyright*, 23–24; McFarland, "Originality Paradox," 451–52; Lunsford and Ede, *Singular Texts/Plural Authors*, 82; Attridge, *Singularity of Literature*, 152; Pope, *Creativity*, 57; MacFarlane, *Original Copy*, 18–19. Young's is treated as the culmination of half a century's worth of rumination on genius and originality. Patricia Phillips provides an excellent study of the background leading to Young's *Conjectures* in *Adventurous Muse*.
27. MacFarlane, *Original Copy*, 19.
28. Young, *Conjectures on Original Composition*, 34.
29. Ibid., 10.
30. Ibid., 12.
31. Ibid., 75.
32. Ibid., 19–20.
33. Ibid., 21.
34. Ibid., 78.
35. Ibid., 24–25.
36. Ibid., 81.
37. Ibid., 36.
38. Ibid., 34.
39. Mazzeo, *Plagiarism and Literary Property*, 10.
40. Ibid., 179.
41. Schlapp, *Kants Lehre vom Genie und die Entstehung*, 61.
42. Kant, *Critique of Judgment*, § 46. Herder quotes the German original, naturally.
43. "Allerdings arbeitet das Genie nach Regeln, erstand nach Regeln, und ist sich selbst Regel, gesetzt, daß jeder Dritte ihm diese auch nicht vorzählen könnte. Seine 'Originalität,' (ein sehr mißbrauchtes Wort,) kann bloß bedeuten, daß der Genius ein Werk seiner Kräfte darstellt, nicht nachgeahmt, nirgend erborget." (Herder, *Sämmtilche Werke*, 197–98.) I borrow and amend John Louis Kind's translation from *Edward Young in Germany*, 54.
44. According to John Louis Kind, Herder's views are "identical with Kant's, only expressed in different words." (Kind, *Edward Young in Germany*, 54.)

45. Kant, *Critique of Judgment*, § 49.
46. For a more full explanation, see Guyer, "Exemplary Originality."
47. MacFarlane, *Original Copy*, 33.
48. Lang, "Literary Plagiarism," 835.
49. Goethe, *Conversations of Goethe*, 263.
50. De Quincey, *Collected Writings*, 138.
51. Ibid., 146. Thomas Mallon points out several layers of irony here, including De Quincey's stated aversion to plagiarism hunters, and the fact that De Quincey was himself a plagiarist on par with Coleridge. See Mallon, *Stolen Words*, 31.
52. Coleridge, *Biographia Literaria*, 1:150.
53. Ibid. Tilar J. Mazzeo argues that Coleridge's use of "coincidence" here should not be taken to mean mere accidental happenstance, but rather that of "two texts [that] *inhabit the same space . . . that literally coincide.*" (Mazzeo, *Plagiarism and Literary Property*, 39.) Given the lengths to which Coleridge goes to explain the coincident overlap in views, however, this seems to perhaps outstretch his own thinking on the matter.
54. Coleridge, *Complete Works*, 2:104.
55. Guyer, *Values of Beauty*, 248.
56. MacFarlane, *Original Copy*, 2. Thomas McFarland commits the same error: "Wordsworth's poetry, says Coleridge, is of a kind 'perfectly unborrowed and his own.'" (McFarland, *Originality and Imagination*, 84.)
57. Coleridge, *Biographia Literaria*, 2:175–76.
58. Elizabethan author George Puttenham writes that, like God who "made all the world of nought . . . the very Poet makes and contriues out of his owne braine, both the verse and matter of his poeme, and not by any foreine copy or example, as doth the translator, who therefore may well be sayd a versifier but not a Poet." (Puttenham, *Arte of English Poesie*, 19.) Puttenham continues the analogy: "It is therefore of Poets thus to be conceiued, that if they be able to deuise and make all these things of them selues, without any subiect of veritie, that they be (by maner of speech) as creating gods." (Ibid., 20.) Centuries before, the analogy was more popular in the reverse: that God was a poet and the world his poem. See, e.g., Augustine, *City of God*, XI.18.
59. Collingwood, *Principles of Art*, 325.
60. Kant, *Critique of Judgment*, § 49.
61. Young, *Conjectures on Original Composition*, 71.
62. Kant, *Critique of Judgment*, § 46.
63. Julie Van Camp suggests that attribution of originality to a work should depend on a certain sort of merit—that the original work *advances* the artistic project: "We value originality because it demonstrates the ability of the artist to advance the potential of an art form." (Van Camp, "Originality," 250.) Van Camp's proposal is interesting, but would require overhauling the foundational notion of originality underlying copyright, and (presumably) distributing copyright on a case-by-case basis according to the artistic merit of any given artist's project, two things I would prefer to avoid if possible.
64. Young, *Conjectures on Original Composition*, 12.
65. Stinson, "Netflix."
66. Ecclesiastes 1:9 (New International Version).
67. Read, "Originality."
68. Ibid., 551.
69. Young, *Conjectures on Original Composition*, 9.

70. Ibid., 14–15.
71. Case C-145/10, Painer v. Standard VerlagsGmbH [2011], §§ 88–89, http://curia.europa
 .eu/juris/liste.jsf?&num=C-145/10.
72. Ibid., §§ 91–92.
73. Shortly after the CJEU case, a Belgian Supreme Court decision held that, to enjoy
 copyright protection, it is not necessary that a work carry "the stamp of the author's
 personality," but only that it be the "intellectual creation of its author." (http://jure
 .juridat.just.fgov.be/pdfapp/download_blob?idpdf=N-20120126-1.) Since the Direc-
 tive harmonizing EU copyright specifically discusses photographs, there remains some
 question as to whether the principle generalizes to other kinds of works.
74. Burrow-Giles Lithographic Co. v. Sarony, 111 U.S. 53, 55 (1884).
75. Ibid., 58 (internal quotations omitted).
76. *Sheldon v. Metro-Goldwyn Pictures Corp.*, 81 F.2d 49, 54 (2d Cir. 1936).
77. H.R. Rep. No. 94–1476, 94th Cong., 2d Sess. 51 (1976), *reprinted in* 1976 U.S.C.C.A.N.
 5659, 5665–66.
78. The exclusion of artistic merit as a basis for copyrightability was established in the
 finding of *Bleistein v. Donaldson Lithographing Co.*, 188 U.S. 239, 251 (1903), in which
 Justice Holmes states, "It would be a dangerous undertaking for persons trained only
 to the law to constitute themselves final judges of the worth of pictorial illustrations,
 outside of the narrowest and most obvious limits."
79. Inge, *Assessments and Anticipations*, 277.
80. Danto, "Artworks and Real Things," 14.
81. Feist Publications, Inc. v. Rural Telephone Service Co., 499 U.S. 340 (1991).
82. Ibid., 345.
83. Ibid., 341.
84. A similar issue has arisen in US patent law. Prior to 1952, to be granted a patent,
 an invention had to show a "spark of genius," although this condition was found
 in no statute and was nebulous in meaning. The Patent Act of 1952 dispensed with
 this traditional requirement, replacing it with the condition of "non-obviousness,"
 which is at least a little less murky (see generally Applegate, "Patenting Improve-
 ments"). In 2014, Justice Clarence Thomas resurrected the spark of genius under
 a different name, requiring that an invention have "something more" than mere
 non-obviousness to warrant a patent (see Alice Corp. v. CLS Bank International,
 573 U.S. ___, 134 S. Ct. 2347 (2014)). I owe this example to Lawrence A. Husick.
85. Atari Games Corp. v. Oman, 979 F.2d 242, 246 (D.C. Cir. 1992).
86. Assessment Technologies v. Wiredata, 350 F.3d 640, 643 (7th Cir. 2003).
87. 17 U.S.C. § 102(b).
88. See Baker v. Selden, 101 U.S. 99 (1879); Nichols v. Universal Pictures Corp., 45 F.2d
 119 (2d Cir. 1930); Morrissey v. Procter & Gamble Co., 379 F.2d 675 (1st Cir. 1967).
89. As stated in *Whelan Associates v. Jaslow Dental Laboratories*:

 [T]he line between idea and expression may be drawn with reference to the end
 sought to be achieved by the work in question. In other words, *the purpose or func-
 tion of a utilitarian work would be the work's idea, and everything that is not necessary
 to that purpose or function would be part of the expression of the idea* Where there
 are various means of achieving the desired purpose, then the particular means
 chosen is not necessary to the purpose; hence, there is expression, not idea.

 797 F.2d 1222, 1236 (3d Cir 1986) (emphasis added).

CHAPTER FOUR

1. Grossman, "Critique of *Abraham Lincoln*"; Fischer, "'Pride and Prejudice." Grahame-Smith would go on to write both the novel and film of *Abraham Lincoln: Vampire Hunter*.
2. Harvison, "Seth Grahame-Smith Interview."
3. Ibid.
4. Halford, "Jane Austen."
5. Wagner, "Pride and Prejudice."
6. Stillinger, *Multiple Authorship*.
7. Jaszi, "On the Author Effect," 40.
8. Love, *Attributing Authorship*, 39.
9. Ibid., 40.
10. Ibid., 41.
11. Stillinger, *Multiple Authorship*, 154–55.
12. Ibid., 154.
13. Love, *Attributing Authorship*, 37.
14. Stillinger, *Multiple Authorship*, 183.
15. Lunsford and Ede, *Singular Texts/Plural Authors*, 14.
16. Ibid., 76.
17. Ibid., 60.
18. Mag Uidhir, *Art and Art-Attempts*, 49.
19. Ibid., 68n.
20. Ibid., 67.
21. Ibid., 60.
22. There are two noteworthy differences between the cases of *Pride and Prejudice and Zombies* and *The Mystery of Edwin Drood*, though neither of these, I would suggest, makes any difference regarding whether any of the writers involved is an author of a given work. The first difference is that Jane Austen left behind a finished novel, while Dickens left behind an unfinished work. The second difference is that Grahame-Smith made alterations to what Austen penned, while James and Garfield made no alterations to the words left by Dickens.
23. Barthes, "Death of the Author," 147.
24. Foucault, "What Is an Author?," 159.
25. Nehamas, "What an Author Is," 688.
26. Ibid., 686.
27. Nathan, "Irony," 199.
28. Robinson, "Style and Personality," 234.
29. See, e.g., Pinar et al. (1995), *Understanding Curriculum*, 8.
30. M. Perloff, "'Creative Writing,'" 3.
31. Oddly enough, this position is perhaps best summarized in the view of the fictional Robyn Penrose, temporary lecturer at the University of Rummidge, in David Lodge's comic novel, *Nice Work*: "[T]here is no such thing as an author, that is to say, one who originates a work of fiction *ab nihilo*. Every text is a product of intertextuality, a tissue of allusions to and citations of other texts" (22).
32. Jaszi, "Toward a Theory of Copyright," 459.
33. Woodmansee, "Genius and the Copyright," 426.
34. Fish, "Professor Sokal's Bad Joke," A23. Ian Hacking argues that Fish takes the matter too far by suggesting that like strikes in baseball, quarks in science, too, are socially constructed but nevertheless real. (Hacking, *Social Construction of What?*, 29–31.)

35. See Rose, *Authors and Owners*.
36. See, e.g., West, "Invention of Homer."
37. Foucault, "What Is an Author?," 160.
38. Marzorati, "Art in the (Re)making," 96.
39. Levine, "Statement."
40. Owens, "Discourse of Others," 73.
41. Singerman, *Art History*, 186.
42. Irvin, "Appropriation and Authorship," 134.
43. Sellors, "Collective Authorship in Film," 263.
44. See Searle, "Collective Intentions and Actions."
45. Ibid., 407.
46. Ibid., 408.
47. Bratman, *Faces of Intention*.
48. Livingston, *Art and Intention*, 83–84. Livingston's conditions parallel those of Bratman in *Faces of Intention*, 100–102.
49. It is worth noting, however, that on Livingston's view, Charles Dickens isn't an author of *The Mystery of Edwin Drood* either, as a necessary condition for authorship is a "completion decision"—the judgment by the author that the artwork is complete and that no further contributions by the author are necessary. (Livingston and Archer, "Artistic Collaboration," 454.) Since Dickens died while *Drood* was only half-written, we can reasonably assume that no such decision was made, and so the unfinished work is unauthored.
50. Rizzo, "Worth Fighting For."
51. According to Cameron, only he, his wife, and perhaps one other member of the cast were Christians (Cameron, *Still Growing*, 253).
52. Berys Gaut argues that, "if there are others who make a significant artistic difference to the work, then it is only fair to acknowledge them as artistic collaborators." (Gaut, "Film Authorship and Collaboration," 157.) This, for Gaut, will include a film's actors (158). As Aaron Meskin notes, however, this reasoning would suggest that the subject of a portrait photographer, too, is a co-author of any resulting photograph. (Meskin, "Authorship," 23.)
53. Holden, "Left Behind the Movie."
54. Livingston, *Art and Intention*, 85.
55. Specifically, from Gilbert, *Theory of Political Obligation*.
56. Bacharach and Tollefsen, "*We* Did It," 29.
57. Ibid., 30.
58. Bacharach and Tollefsen explicitly do not extend the coauthorship role to the caterer on the film set as it is "implausible that she is party to a joint commitment regarding the creation of the film per se" (ibid.), and so we might generally exclude those who are listed among the credits but who play only incidental or support roles, and who are not directing their activities to the work itself. As such, we might reasonably exclude the transportation coordinator, animal wrangler, and perhaps the production accountant. However, we would still seem to have to include every actor—including every extra—as well as every camera and sound equipment operator, every set decorator, the editing department's color timer, and countless others as coauthors.
59. See Hick, "Authorship."
60. Donner himself was hired to replace Guy Hamilton, who dropped out of the project before filming began. (Delson and Morrisroe, "Interview with Richard Donner," 11.)
61. Ibid., 16.

62. Mankiewicz and Crane, *My Life as a Mankiewicz*, 212.
63. Livingston, *Art and Intention*, 80.

CHAPTER FIVE

1. *Calf Rescue* (1998).
2. This would likely be dependent on issues of "fair use" or "fair dealing"—more on this below.
3. See, e.g., 17 U.S.C. § 106.
4. In both the Copyright Act and case law, American copyright tends to drift into speaking of works of art. However, in the defining language of US law, copyright protects "works of authorship" or "authored works."
5. Although first introduced in Britain's 1735 Engravers' Copyright Act, the distinction between the authored work and the physical object is perhaps most explicitly stated in § 202 of the US Copyright Act of 1976: "Ownership of a copyright, or of any of the exclusive rights under a copyright, is distinct from ownership of any material object in which the work is embodied." (17 U.S.C. § 202.) It might be contended that a painting, for instance, just is a physical object, and that even an exact copy of the work is not itself the work, because it is materially distinct from the original. However, this is a contentious matter of the ontology of art, something I wish to distinguish from the ontology of authored works. If a painting as an artwork is an essentially singular and physical object, this most likely arises as a result of artistic practice. As discussed in chapter 2, however, the nature of authored works is established on the basis of legal practice and doctrine. So while a painting qua artwork may be essentially singular, the same need not be true for a painting qua authored work.
6. The idea/expression dichotomy originally arises from the US case of *Baker v. Selden* (101 U.S. 99 (1879)), and is encoded in article 9(2) of the TRIPS (Trade Related Aspects of Intellectual Property Rights) Agreement and in article 2 of the WCT (World Intellectual Property Organization Copyright Treaty).
7. For a more problematic case of distinguishing idea from expression, see my "Making Sense of the Copyrightability of Plots."
8. Peirce, "Prolegomena," 492.
9. This issue and others are described more fully in Wetzel, "Types and Tokens."
10. Is it simply letter order that matters? Is it letter order plus meaning? Is a spoken word a token of the same type as a printed word?
11. In aesthetics, the type/token ontology is perhaps most fully explored first by Richard Wollheim in *Art and Its Objects*, and further expanded in particular by Joseph Margolis (in "Ontological Peculiarity of Works of Art" and *Art and Philosophy*). See also, e.g., Levinson, "What a Musical Work Is"; Currie, *Ontology of Art*; and N. Carroll, *Philosophy of Mass Art*. Both James Wilson and Michael Wreen present arguments for type/token ontologies of intellectual property, though each, I think, runs into problems. (See Wreen, "Ontology of Intellectual Property"; Wilson, "Ontology and Regulation.")
12. Jerrold Levinson, for one, has argued that in composing a musical work, one standardly selects a specific instrumental means of production (see Levinson, "What a Musical Work Is"). However, while this is standard to most Western music, it is by no means always *required* that a composer specify the instruments to be used.
13. As an extreme example, consider Mark Z. Danielewski's novel, *House of Leaves* (2000), which includes certain words printed in blue, red, and purple, and other passages composed entirely in Braille.

14. Still, unusual choices in composite elements may have some strong and undesirable effects (see Walton, "Categories of Art.").

15. Levinson contends that the notion that composers simply discover their works flies in the face of our deeply embedded intuitions. With regard to authored works in general, I suggest that the notion is precluded by the assumptions inherent to their nature.

16. Wolterstorff, *Works and Worlds of Art*, 86. It is worth noting that, on Wolterstorff's view, as "incorrect instances" are a category of instances, not all instances of a work will be tokens of that work, where tokening requires strict adherence. On my view, an "incorrect instance" is a *non*-instance, strictly speaking.

17. Currie, *Ontology of Art*, 56.

18. In principle, copyright infringement requires a form of actual *copying* to have taken place. Although tests for similarity may ground complaints of infringement, in such cases similarity is employed as *evidence* of copying. Judge Frank in the case of *Alfred Bell & Co. v. Catalda Fine Arts, Inc.*, notes, "The 'author' is entitled to a copyright if he independently contrived a work completely identical with what went before; similarly, although he obtains a valid copyright, he has no right to prevent another from publishing a work identical with his, if not copied from his." (191 F.2d 99, 103 (2d Cir. 1951).)

19. Although grounded on principles other than my own, for a discussion of the consequences of identifying two textually identical works with entirely distinct origins, see Currie, "Work and Text."

20. I will use the term "atomic" to include not only the work's essential formal structure, but also, where applicable, its material components (as in painting and sculpture), instrumentation (as in musical works) and the like.

21. Levinson, "What a Musical Work Is," 10–13.

22. Although the notion of one's work being influenced by other works will be discussed below.

23. Indeed, Levinson makes a move in this direction, though in a limited regard. See Levinson, "What a Musical Work Is," 24–25.

24. Notably, the context of creation of some work will differ in its properties from the context of creation of its composite elements, where such elements indeed were created. While a sound or a shape might not be said to have a context of creation in virtue of being itself a universal, the urinal used by Duchamp in *Fountain* will have its own context of creation, which will differ from that of Duchamp's work.

25. I introduce the notion of $<a, t, p>$ properties primarily to further articulate what a context of creation amounts to. While defending this concept at length would require more space than this chapter allows, as a starting place, I point to section II of Levinson, "What a Musical Work Is."

26. In this way, my theory of the ontology of authored works diverges from Wolterstorff's notion of artworks as norm-kinds, discussed above. Wolterstorff allows for flawed instances of works. On my view, a flawed instance of an authored work is not an instance of that work at all, though it may certainly be an instance of another, critically related work.

27. In our earlier example of Tchaikovsky's Fourth Symphony being Beethoven-influenced, we would say that the there is a weak historical link between the Fourth Symphony and works of Beethoven's oeuvre.

28. Given this, might a given work possess weak historical links to every preexisting work its author has ever encountered? Although *possible*, this seems very unlikely, as not every work that author has encountered is likely to play an influencing role in a given new work.

29. Similarly, as Tchaikovsky's Fourth Symphony incorporates into the fourth movement the Russian folk song, "In the Field Stood a Birch Tree," it will bear strong historical links to this work, such that had the folk song been different, so too would be the symphony. Imagine this case, someone might say: the author of some work X sees something she likes in some earlier work W (say, a depiction of a dog), and so incorporates it into X. It might be reasonable to say that there is both atomic similarity between the works and strong historical links operating over these points of similarity. However, it might further be imagined, had the author of W depicted the dog differently, the author of X would have still depicted the dog the way that she did in fact. Here, it could be argued, there *is no* strong historical link. And I would have to agree. Although strong historical links do not rely on an author's conscious deliberation, establishing the existence of strong historical links without knowing the author's intentions may at times be a very difficult matter, as is establishing most any metaphysical relation. As the challenge here is essentially an epistemic one and does not injure my metaphysical claim, I put the matter to the side.

30. Because a weak historical link between some new work, z, and some body of preexisting works, Y, allows for the exclusion of any given work within that body, even if some one work in that body, y_1, bears a weak historical link to some even earlier body of works, X, work z will not bear a weak historical link to *that* body.

31. Note that in this example, it may easily be the case that the author of Y, while aware of the strong historical link to X, is unaware of the continued chain of links to W.

32. The Berne Convention requires that its member nations grant copyright without the further prerequisite of such formalities as copyright registration and notice. In the United States, federal copyright adheres to the authored work when it is first "fixed in a tangible medium of expression," and similarly in the copyright laws of Japan, Britain, and many other nations. Swiss, Swedish, and Brazilian copyrights, for example, require no fixation, but instead recognize copyright protection from the moment of creation, whether the work is "fixed" or not.

33. As a complicating factor, however, the properties at issue in the respective works are those that are *essential* to each—that is, those that were selected and arranged *as constituting* the work. As such, inessential or variable properties (such as the font associated with a standard literary work) are outside this consideration.

34. I say "prima facie" copyright infringement here because various doctrines within the law may deem some otherwise infringing act permissible. Doctrines of "fair use" or "fair dealing" exist in the copyright laws of many countries to limit the power of copyright, such that if some case of copying is deemed "fair," it constitutes a noninfringing act. Specifics of these doctrines vary wildly by country, as do other exceptions to infringement including expiration of copyright. As we will be looking at fair use in detail in chapters 7 and 8, I shall for the time being deal only with cases of prima facie infringement.

35. Notably, atomic similarity alone *has* been used as the basis of many copyright suits. In the United States, tests are used in the law for "substantial similarity," such that where a certain high degree of similarity is found between works, copying is *assumed* to have taken place. As such, "substantial similarity" is used as *evidence* of what I call strong historical links.

36. I am indebted to sculptor Benjamin Jones for our many discussions on this topic.

37. Kennedy, "What's the Original?"

38. An argument may be made that Prince's photograph is of a different scale than Krantz's, and insofar as each chose a different scale, and scale is among those atomic elements

selected and arranged by an author, these are in fact distinct works. Given that Krantz created his photograph to be used in advertising, it is likely that Krantz's photograph is open as regards scale (just as typeface is usually left open for literary works). As Prince's project was different, it is possible that scale was among those atomic properties selected by him. However, as scale tends to be a variable property for photographs, for the sake of argument here, I shall assume that Prince made no such specification. Another argument could be made that Krantz's photograph and Prince's are differentiable on the basis of their titles. Although arguments have been made that titles may be inherent parts of their respective artworks, such arguments tend to be founded on matters of artistic interpretation (see, e.g., Levinson, "Titles."). Given my specifications for the ontology of authored works here, it is not entirely clear that titles will count as distinguishing elements for authored works. As discussion on the matter would require more space than I can afford it here, I leave the matter to the side for the moment.

39. Christy's, *Richard Prince (b. 1949): Untitled (Cowboy)*, accessed July 17, 2016, http://www.christies.com/LotFinder/lot_details.aspx?intObjectID=4189322.

40. Hegel, *Introductory Lectures on Aesthetics*, 23.

41. Danto, "Art and Meaning," xix.

CHAPTER SIX

1. Fichte, "Proof."

2. In fact, most countries represent a blend of common and civil law systems.

3. Details of the moral rights requirement are laid out in article 6*bis* of the Berne Convention; those of the economic rights are spread out over articles 8 (right of translation), 9 (right of reproduction), 11 (performance rights in dramatic and musical works), 11*bis* (broadcast and recording rights), 11*ter* (performance rights in literary works), 12 (adaptation rights), and 14 (certain rights in films).

4. Another reason for holding out was that the Berne Convention requires members to eliminate any formalities such as copyright registration, deposit, and mandatory copyright notice.

5. On this topic, I strongly recommend Gover's *Art and Authority*.

6. U.S. Const. art. I, § 8, cl. 8.

7. Jefferson, *Writings*, 1291.

8. I borrow the phrase "the marketplace of ideas" from Diefenbach, "Constitutional and Moral Justifications."

9. US Patent Act of 1790, ch. 7, § 2, 1 Stat. 109, 110.

10. US Copyright Act of 1790, ch. 15, § 3, 1 Stat. 124, 125.

11. Today, patents last for twenty years from date of filing (35 U.S.C. § 154(a)(2)) and still require the submission of a description (35 U.S.C. § 112(a)); ordinary US copyrights now last seventy years past the death of the author and require no registration or submission of the work.

12. Although discussing a "value-added" interpretation of Locke's view, Justin Hughes summarizes this notion: "A very high percentage of protected works could be worthless so long as the system of property protection results in a net increase in social value beyond what would be produced without the system." (Hughes, "Philosophy of Intellectual Property," 310.)

13. Homer (if he existed at all), Chaucer, Shakespeare, Cervantes, Plato, and Machiavelli well predate any copyright in their respective countries. Shakespeare lived during the time of the Stationers' Company printing monopoly—the precursor to copyright— begun in 1557, but this grant protected only publishers, not authors, and only published

works, not performed ones. (See Blagden, *Stationer's Company*, 33; and Patterson and Lindberg, *Nature of Copyright*, 27–28.) Kant's Third Critique was published in 1790, just four years before the enactment of the first, real copyright-like protection in Prussia, the 1794 Prussian Statute Book (*Allgemeines Landrecht für die Preußischen Staaten*). New translations of these works, however, will generally receive copyrights of their own.

14. It was not until the Prussian Act (1837) for the Protection of Property in Works of Scholarship and the Arts from Reprint and Reproduction that German composers' copyright in their works was officially recognized. See Kretschmer and Kawohl, "History and Philosophy of Copyright," 35–37.

15. It might be pointed out that at least *some* of these artists found support for their work in the patronage system. Although this would be some evidence for the unsurprising claim that authors may be incentivized, it is thus actually evidence *against* a claim that copyright is a necessary incentive for authors to author.

16. Schijndel and Smiers, "Imagining a World without Copyright," 156–57.

17. See, e.g., Schijndel and Smiers, "Imagining a World without Copyright," 157; Posner, "Intellectual Property," 66; Hettinger, "Justifying Intellectual Property," 49.

18. See, e.g., Koff and Schildgen, *Decameron and the Canterbury Tales*.

19. Aylward, *Cervantes*.

20. See Shavin, "Continuing the American Revolution," 54–58.

21. Hettinger, "Justifying Intellectual Property," 48.

22. See, e.g., Landes and Posner, "Economic Analysis of Copyright Law"; Larvick, "Questioning the Necessity"; Bauer, "Refusals to Deal with Competitors," 1225; Cooter, "Separation and Fertility."

23. An earlier argument—indeed, earlier than Fichte's—is provided by Immanuel Kant in his 1785 essay, "On the Injustice of Counterfeiting Books." However, Kant's argument is specifically for the ownership of literary works, and specifically *against* ownership of works of visual art, and so is much more rarely appealed to.

24. Hegel, *Philosophy of Right*, § 39.

25. Ibid., § 45.

26. Ibid., §§ 51–52, 59–62.

27. Ibid., § 68.

28. Ibid.

29. Ibid.

30. Justin Hughes suggests that, given the technology of his time, Hegel may simply not have considered the possibility of mechanically reproducible visual art. See Hughes, "Philosophy of Intellectual Property," 338n209.

31. Sherrill, *International Comparative Legal Guide*, 35.

32. Judge and Gervais, "Of Silos and Constellations," 378–79n15.

33. Ibid., citing Lucas and Lucas, *Traité de la Propriété Littéraire et Artistique*, 84–85.

34. Arp, *Collected French Writings*, 232.

35. Tate Gallery, *Tate Gallery*, 260.

36. Another example might be Simon Morris's *Re-Writing Freud* (2005), in which the author employed a computer program to randomly shuffle the 223,704 words in Sigmund Freud's opus, *The Interpretation of Dreams*.

37. See, e.g., Hughes, "Philosophy of Intellectual Property"; Hettinger, "Justifying Intellectual Property"; Gordon, "Property Right in Self-Expression"; Drahoss, *Philosophy of Intellectual Property*; Damstedt, "Limiting Locke"; Spinello, "Future of Intellectual Property"; Craig, "Locke, Labour and Limiting"; Moore, "Lockean Theory."

38. Locke, *Two Treatises*, II.27.
39. Another limitation is the "waste proviso," which requires that the value of one's acquisition not be lost through spoilage as a matter of neglect. (Locke, *Two Treatises*, II.31) Since, I think, the waste proviso does not weigh too heavily on copyright, I shall put it to the side. See, however, Hull, "Clearing the Rubbish."
40. Locke, *Two Treatises*, II.26; see also I.86.
41. Shiffrin, "Lockean Arguments," 146–47.
42. Ibid., 147.
43. Ibid., 156.
44. In an essay penned before the *Second Treatise*—"Liberty of the Press"—Locke writes:

 [N]obody should have any peculiar right in any book which has been in print fifty years, but any one as well as another might have the liberty to print it, for by such titles as these which lie dormant and hinder others many good books come quite to be lost. . . . [N]or can there be any reason in nature why I might not print [classic books] as well as the Company of Stationers, if I thought fit. (Locke, "Liberty of the Press," 333.)

 Notably, Locke is specifically discussing the perpetual monopoly held by the Stationers' Company in England, the grant to publishers (not authors) that was eliminated in the 1710 Statute of Anne. He is, thus, arguing against any natural right to be held by publishers (and not explicitly against any such right held by authors).
45. Singer, *One World*, 29.
46. Kershnar, "Private Property Rights," 239.
47. Epstein, "Liberty versus Property?," 5.
48. Nozick, *Anarchy, State, and Utopia*, 174.
49. Narveson, *Respecting Persons*, 127.
50. Moore, "Lockean Theory," 1071.
51. Thomas L. Pangle and Timothy W. Burns treat it, ambiguously, both ways. See Pangle and Burns, *Key Texts of Political Philosophy*, 288–93.
52. Nozick, *Anarchy, State, and Utopia*, 175.
53. Kinsella, "Objectivists on the PRO-IP Act."
54. Some might question whether "ownership" of labor is even an appropriate term here. However, if we take "private ownership" as being—at a first pass—the exclusive right to exploit a thing, then I think it seems not incoherent to talk of owning one's labor.
55. Shiffrin, "Lockean Arguments," 148.
56. See Kim, "Events and Their Descriptions"; and Kim, "Events and Property Exemplifications."
57. Other, competing theories of event ontology will, I think, generally provide an equivalent outcome: where the particular event is one of laboring, the laborer will be a constituent element.
58. All of this assumes there is only one laborer. If there is more than one laborer, then the labor owes its existence to all of the laborers, and likewise the product of that labor.
59. Wheaton v. Peters, 33 U.S. (8 Pet.) 591, 669–70 (1834).
60. Quoted in Spies, "Trigger Happy."
61. Levinson, *Pleasures of Aesthetics*, 141.
62. While nineteenth-century American treaties on copyright regularly appealed to principles of natural law, the House Report on the 1909 revision of the US Copyright Act formally disavowed claims that copyright was grounded in any natural right had by the author. (See H.R. Rep. No. 60-2222, at 7 (1909).) However, the law at least

implicitly recognized ownership arising from "sweat of the brow"—the laborious collection of facts—until the 1991 *Feist* case, discussed at the end of chapter 3. Canada similarly did away with any lingering sweat-of-the-brow doctrine in the 2004 Supreme Court case of *CCH Canadian Ltd. v. Law Society of Upper Canada* ([2004] 1 SCR 339, 2004 SCC 13, 236 DLR (4th) 395, 30 CPR (4th) 1, 247 FTR 318). More on this important case next chapter.

63. As such, there is a principled distinction to be made between those unowned things in the intellectual common (which are undeveloped), and those unowned works existing in the public domain (which have been developed). See Damstedt, "Limiting Locke," 1192–93.

64. Conversely, Adam D. Moore contends, "Intangible property is generally characterized as non-physical property where owner's rights surround control of physical manifestations or tokens of some abstract idea or type. . . . Intangible property rights surround control of physical tokens, and this control protects rights to types or abstract ideas." (Moore, "Intangible Property," 174.) Moore's view, however gets the matter backwards: what the author centrally *owns* is the abstract object, and only derivatively (if at all) the physical object that embodies it.

65. Honoré, "Ownership," 166 (emphasis added).

66. Ibid., 183.

67. Waldron, "From Authors to Copiers," 854.

68. Palmer, "Are Patents and Copyrights Morally Justified?," 77.

69. We shall put aside Palmer's erroneous assertion that copyright involves any claim to ownership of ideas.

70. Adam D. Moore makes a similar point with a different example, arguing: "prior to my act of creation, the recipe did not exist, so there was no way for others to be worsened because of lack of access. After my creation, others are still without access, so there has been no lessening or flourishing of well-being." (Moore, "Lockean Theory," 1082.) Moore's concern is centrally with challenging claims that intellectual property ownership *harms* others, where mine is with concerns that copyright restricts others' freedoms.

CHAPTER SEVEN

1. Lenz won the case on appeal.

2. H.R. Rep. No. 94-1476, at 65 (1976), *reprinted in* 1976 U.S.C.C.A.N. 5659, 5678.

3. Dellar v. Samuel Goldwyn, Inc., 104 F.2d 661, 662 (2d Cir. 1939).

4. 17 U.S.C. § 107.

5. H.R. Rep. No. 94-1476, at 65 (1976), *reprinted in* 1976 U.S.C.C.A.N. 5659, 5679.

6. Sag, "God in the Machine."

7. Leval, "Fair Use or Foul?," 167–68.

8. Walker, "Fair Use," 754–55.

9. D. Nimmer, "'Fairest of Them All,'" 280.

10. MCA, Inc. v. Wilson, 425 F. Supp. 443 (S.D.N.Y. 1976), *aff'd and modified*, 677 F.2d 180 (2d Cir. 1981).

11. Ibid., 677 F.2d at 185.

12. Campbell v. Acuff-Rose Music, 510 U.S. 569 (1994).

13. Van Camp, "Judging Aesthetic Value."

14. D. Nimmer, "Fairest of Them All," 280.

15. Sag, "God in the Machine," 434.

16. Guyana Copyright Act of 1956, §§ 6, 9. Certain uses under this exception require sufficient acknowledgment.
17. Indian Copyright Act of 1957, § 52(1).
18. British Copyright Act of 1956, § 6.
19. Copyright, Designs and Patents Act of 1988, § 31(3) (revised 2003).
20. Football Association Premier League Ltd. v. Panini UK Ltd. [2004] FSR 1, 15.
21. Bently and Sherman, *Intellectual Property Law*, 247.
22. The British Act was most recently revised in 2015, with new exceptions added under the heading of "fair dealing," including important, broadened provisions for the disabled, but the provisions for "incidental inclusion" remain unchanged and unclear.
23. Copyright Act of Antigua and Barbuda, §§ 15, 36, 53–54, 116.
24. Canadian Copyright Act, § 29; Australian Copyright Act of 1968, §§ 40–43, 103; New Zealand Copyright Act of 1994, §§ 42–43, 176.
25. CCH Canadian Ltd. v. Law Society of Upper Canada, 2004 SCC 13 [2004] 1 S.C.R. 339, ¶ 48 (emphasis added).
26. 17 U.S.C. § 108(f)(4) (emphasis added).
27. 321 Studios v. MGM Studios, Inc., 307 F. Supp. 2d 1085, 1101 (N.D. Cal. 2004).
28. Alberta (Education) v. Canadian Copyright Licensing Agency ("Access Copyright") (September 30, 2011), SCC 33888 (Factum of the Respondent, Access Copyright, at ¶ 130).
29. Society of Composers, Authors & Music Publishers of Canada v. Bell Canada, 2012 SCC 36 [2012] 2 S.C.R. 326, ¶ 13.
30. Drassinower, "Taking User Rights Seriously," 478–79. Drassinower's article provides a fascinating in-depth analysis and discussion of the *CCH* case, discussed above. See also Geist, *Copyright Pentalogy*.
31. Patterson and Lindberg, *Nature of Copyright*, 11.
32. Ibid., 69.
33. Ibid., 52.
34. I consider this argument, and responses to it, in Hick, "Mystery and Misdirection."
35. Hohfeld, *Fundamental Legal Conceptions*.
36. Kamm, "Rights," 479.
37. Cited in Nair, "Fairness of Use," 252.
38. Hettinger, "Justifying Intellectual Property."
39. Moore, "Lockean Theory," 1092.
40. We might, here, look back to Shiffrin's argument from last chapter.
41. Moore, "Lockean Theory," 1093.
42. Ibid., 1092.
43. Feinberg, *Harm to Others*, chap. 1; see also, e.g., Archard, "Wrong of Rape," 378; James Young, *Cultural Appropriation*, 130.
44. See, e.g., Lipton, "Solving the Digital Piracy Puzzle"; Okediji, "Givers, Takers."
45. See, e.g., Steiner, *Essay on Rights*.
46. Kamm, *Intricate Rights*, chap. 9.
47. See Sanders and Gordon, "Strangers in Parodies," 36–39.
48. Thomson, "Some Ruminations on Rights," 47 (emphasis added).

CHAPTER EIGHT
1. Bernstein, "Fake as More," 41.
2. Ibid., 42.

3. Ibid., 44–45.
4. Duncan's hoax was ultimately uncovered by another art historian, Thomas Crow. See Crow, "Return of Hank Herron." Duncan has caught many in her web. See, e.g., Tormey, "Transfiguring the Commonplace," 214 (quoting "critic Cheryl Bernstein"); Ulmer, "Borges and Conceptual Art," 847 (same); Cohen, "Copyright Law," 231n231 (citing Bernstein).
5. Sturtevant herself has resisted this label.
6. Arning, "Sturtevant," 46.
7. Cameron, "Conversation," 76.
8. Barthes, "Death of the Author," 142.
9. Foucault, "What Is An Author?"
10. However, a 2004 survey of British art experts named Fountain the most influential work in the history of modern art. See BBC News, "Duchamp's Urinal Tops Art Survey."
11. Many have. See Hirsch, "Validity in Interpretation."
12. It should be noted that some appropriation artists have drawn legal attention that has not made it to court. Levine, for instance, reportedly ceased rephotographing images by photographer Edward Weston when Weston's estate threatened to sue. See Carlin, "Culture Vultures," 108.
13. See Rogers v. Koons, 960 F.2d 301 (2d Cir. 1992).
14. Ibid., 305.
15. Ibid., 305.
16. Ibid., 306.
17. Ibid.
18. Koons also argued that what he copied from "Puppies" did not meet the definition of an original work of authorship under the law. Ibid., 309. On the long-established basis of Burrow-Giles Lithograph Co. v. Sarony (11 U.S. 53 (1884)), however, the district court found the contents of "Puppies" protected by copyright, and the court of appeals confirmed. Ibid., 306–8.
19. Ibid., 309.
20. 17 U.S.C. § 107.
21. Ibid.
22. See, e.g., Campbell v. Acuff-Rose Music, 510 U.S. 569, 569 (1994); MCA, Inc. v. Wilson, 677 F.2d 180, 185 (2d Cir. 1981).
23. See MCA, 677 F.2d at 184–85.
24. 17 U.S.C. § 107.
25. See Sony Corp. v. Universal City Studios, Inc., 464 U.S. 417, 451 (1984).
26. See Campbell, 510 U.S. at 584–85; see also Badin, "Appropriate(d) Place," 1653.
27. See Campbell, 510 U.S. at 586.
28. See 17 U.S.C. § 107.
29. See Campbell, 510 U.S. at 588.
30. Ibid., 591–92.
31. Rogers v. Koons, 960 F.2d 301, 305 (2d Cir. 1992).
32. See, e.g., Buskirk, "Commodification as Censor," 102; Sullivan, "Appeals Court."
33. Greenberg, "Art of Appropriation," 32–33.
34. See United Features Syndicate, Inc. v. Koons, 817 F. Supp. 370 (S.D.N.Y. 1993). Here, Koons attempted an argument that such characters as Odie, due to their cultural pervasiveness, had become "public figures" and had "a factual existence as such" that entitled them to more limited copyright protection (ibid., 380), despite Koons's own claim that he was not familiar with the character (ibid., 384).

35. See Campbell v. Koons, No. 91 Civ. 6055, 1993 WL 97381, at *2-3 (S.D.N.Y. Apr. 1, 1993).
36. L. Gilbert, "No Longer Appropriate?"
37. Blanch v. Koons, 467 F.3d 244, 247 (2d Cir. 2006) (quoting Koons's affidavit).
38. Ibid., 248-49 (quoting Blanch's deposition).
39. Leval, "Toward a Fair Use Standard," 1111, 1116. Here, Leval contrasts the first factor of fair use with the Supreme Court's earlier claim that the fourth factor was "the single most important element of fair use." Harper & Row, Publishers, Inc. v. Nation Enters., 471 U.S. 539, 566 (1985).
40. 510 U.S. 569, 579 (1994) (internal citations omitted).
41. Blanch v. Koons, 467 F.3d 244, 252 (2d Cir. 2006). The court also draws on *Bill Graham Archives v. Dorling Kindersley Ltd.*, 448 F.3d 605 (2d Cir. 2006), in which reproduced images of Grateful Dead concert posters and tickets were found sufficiently transformative and ultimately fair when used in a biography of the rock band.
42. *Blanch*, 467 F.3d at 253.
43. Ibid., 254.
44. Cancelled by the gallery owner due to fears that she would seem to be capitalizing on Prince's success and notoriety, and worries about exhibiting work that had been "done already." Cariou v. Prince, 784 F. Supp. 2d 337, 344 (S.D.N.Y. 2011).
45. Ibid., 348.
46. Ibid.
47. Ibid., 349.
48. Ibid.
49. Cariou v. Prince, No. 11-1197-cv (2d Cir. Apr. 25, 2013).
50. Ibid.
51. Ibid.
52. Ibid.
53. Ibid.
54. Krieg, "Copyright," 1578.
55. Ibid.
56. Ibid., 1584.
57. Harper & Row, Publishers, Inc. v. Nation Enters., 471 U.S. 539, 560, 582 (1985); see also Eldred v. Ashcroft, 537 U.S. 186, 218-21 (2003).
58. Carlin, "Culture Vultures," 139.
59. Ibid.
60. Ibid.
61. Ibid., 129-30, 135-36.
62. Ames, "Beyond Rogers v. Koons," 1514.
63. Ibid., 1513. Ames further suggests that Carlin's system "arbitrarily privileges the work of established artists over that of fledgling artists." Ibid. This, however, seems questionable.
64. Though *Wild Boy and Puppy* would have had the advantage of including a recognizable character of popular culture, and *Niagara* and *Canal Zone* exist in only single copies.
65. Ames, "Beyond Rogers v. Koons," 1519.
66. Ibid.
67. Ibid., 1518-19. This restriction is suggested by Ames for two reasons: (1) to "ensure that a copyright holder's image will not turn up on mass-produced and massmarketed consumer goods, about whose critical purpose one would be quite skeptical; and

(2) to avoid any need to decide whether it is 'good art,' or even 'art' at all, or whether it is successful in getting its critical message across to the viewer." Ibid.

68. Ibid., 1519.
69. Ibid., 1521.
70. Ibid., 1522.
71. Ibid., 1524–25.
72. Badin, "Appropriate(d) Place," 1655.
73. Ibid., 1656.
74. Ibid., 1684.
75. Ibid., 1660.
76. Ibid., 1661.
77. Ibid., 1660.
78. Ames, "Beyond Rogers v. Koons," 1500.
79. Badin, "Appropriate(d) Place," 1660. Here, Badin cites Buchloh, "Allegorical Procedures," 46, though it is worth noting that Buchloh does not actually give this as a definition.
80. Cariou v. Prince, 784 F. Supp. 2d 337, 349 (S.D.N.Y. 2011).
81. Greenberg, "Art of Appropriation," 6; see also Carlin, "Culture Vultures," 129n106. ("Appropriation transcends parody because it is a well-grounded and conscious attack on traditional notions of originality and authorship in art. Appropriation is one of the most important conceptual strategies in late twentieth-century art because it underscores the role of the artist as the manipulator or modifier of existing material, rather than as the inventor or creator of new forms.").
82. See Irvin, "Appropriation and Authorship."
83. Schaar, "Spinoza in Vegas," 890.
84. Appel, "Richard Prince."
85. Rian, "In the Picture," 12.
86. See M. Perloff, Unoriginal Genius; Goldsmith, Uncreative Writing.
87. Rogers v. Koons, 960 F.2d 301, 310 (2d Cir. 1992).
88. Cariou v. Prince, 784 F. Supp. 2d 337, 349 (S.D.N.Y. 2011).
89. See 17 U.S.C. § 101 ("A 'derivative work' is a work based upon one or more preexisting works, such as a translation, musical arrangement, dramatization, fictionalization, motion picture version, sound recording, art reproduction, abridgment, condensation, or any other form in which a work may be recast, transformed, or adapted. A work consisting of editorial revisions, annotations, elaborations, or other modifications, which, as a whole, represent an original work of authorship, is a 'derivative work.' ").
90. Cariou, 784 F. Supp. 2d at 349.
91. Cariou v. Prince, No. 11-1197-cv (2d Cir. Apr. 25, 2013).
92. Ibid.
93. Ibid.
94. Ames, "Beyond Rogers v. Koons," 1481.
95. Badin, "Appropriate(d) Place," 1660.
96. Of course, its relational properties may be so altered. It is now true of the mask that it sits beside a Picasso sculpture, where this was false of it before.
97. See 17 U.S.C. § 102(b) ("In no case does copyright protection for an original work of authorship extend to any idea, procedure, process, system, method of operation, concept, principle, or discovery, regardless of the form in which it is described, explained, illustrated, or embodied in such work"); see also Baker v. Selden, 101 U.S. 99 (1879).
98. See Hick, "Making Sense," 402. Under "ideas," here, I would include ideas about facts.
99. See R. Jones, "Myth of the Idea/Expression Dichotomy," 553.

100. This, allowing for possible exceptions where an idea is expressible in only one way. In the parlance of copyright law, this idea and its expression will have "merged." See *Baker*, 101 U.S. at 106; Morrissey v. Procter & Gamble Co., 379 F.2d 675, 679 (1st Cir. 1967); Nichols v. Universal Pictures Corp., 45 F.2d 119 (2d Cir. 1930).
101. See, e.g., Levinson, "Defining Art Historically"; Dickie, *Art Circle.*
102. As the law recognizes that two authors might independently and coincidentally string together the same words in the same order, and so treats these as two distinct and copyrightable expressions under the law—each being "original" to its author—my theory here is less strange than it may initially appear. See Alfred Bell & Co. v. Catalda Fine Arts, Inc., 191 F.2d 99, 103 (2d Cir. 1951).
103. See Burrow-Giles Lithographic Co. v. Sarony, 111 U.S. 53, 58 (1884).
104. See 17 U.S.C. § 106 (among the six exclusive rights recognized in the copyright owner is the right "to prepare derivative works based upon the copyrighted work").
105. 17 U.S.C. § 101 (emphasis added).
106. Cariou v. Prince, No. 11-1197-cv (2d Cir. Apr. 25, 2013).
107. Castle Rock Entertainment, Inc. v. Carol Publishing Group, 150 F.3d 132, 143n9 (2d Cir. 1998).
108. Warner Bros. Entertainment Inc. v. RDR Books, 575 F. Supp. 2d 513, 538 (S.D.N.Y. 2008).
109. Goldstein, *Copyright*, § 5.3.1.
110. Mirage v. Albuquerque A.R.T. Co., 856 F.2d 1341, 1344 (9th Cir. 1988).
111. Lee v. A.R.T. Co., 125 F.3d 580, 582 (7th Cir. 1997).
112. Koons, *Jeff Koons*, 19.
113. Ottman, "Jeff Koons"; see also Siegel, "Jeff Koons," 253.
114. Koons, *Jeff Koons*, 19.
115. S. Perloff, "Lambert Sale."
116. Although I am centrally restricting my discussion in this article to the issue of transformation, this matter also bears on the fourth factor of fair use: the effect of the secondary use on the market value of the original. On the interpretation that uses that suppress sales of the original are allowable while those that usurp the sales of the original are not, no reasonable person simply seeking to obtain a copy of the Nike poster would purchase a copy of Koons's work at several thousand times the original poster's price.
117. See Danto, "Artworld."
118. As discussed at the end of chapter 5.
119. This would do little for Prince in the case of *Canal Zone*, however, as nearly every part of the work is copied from *some* work of Cariou's, leaving him little to further copy or license.
120. U.S. Const. art. I, § 8, cl. 8.
121. Diefenbach, "Constitutional and Moral Justifications," 226.
122. Cariou v. Prince, 784 F. Supp. 2d 337, 349 (S.D.N.Y. 2011).
123. Ibid. (internal citations omitted).
124. Cariou v. Prince, No. 11-1197-cv (2d Cir. Apr. 25, 2013).
125. Ibid.

AFTERWORD
1. The Gagosian also hosted Prince's Canal Zone show.
2. Zhang, "Richard Prince."
3. Gagosian Gallery, "Richard Prince: *New Portraits*."

4. Vartanian, "Photographer."
5. Parkinson, "Instagram."
6. Needham, "Richard Prince v Suicide Girls."
7. Rosenthal, "We Talked to the Suicide Girls."
8. Eldred v. Ashcroft, 537 U.S. 186, 243 (2003).
9. Helprin, "Great Idea Lives Forever."
10. Helprin's op-ed echoes one of the most wonderful speeches ever made before Congress, in which Samuel Clemens made an impassioned and at times hilarious argument for a perpetual copyright:

 > I understand. I am aware, that copyright must have a term, must have a limit, because that is required by the Constitution of the United States, which sets aside the earlier constitution, which we call the Decalogue. The Decalogue says that you shall not take away from any man his property. I do not like to use the harsher term, "Thou shalt not steal." But the laws of England and America do take away property from the owner. They select out the people who create the literature of the land. (Clemens, "Statement," 116.)

 Although arguing for perpetual copyright, Clemens's speech was in support of a bill that would have extended the term of copyright to life-plus-fifty-years. The bill did not pass. This was 1906, and it would be another seventy years before US copyright would get its life-plus-fifty-years term (Clemens's published works would already be in the public domain).
11. Masnick, "Arguing for Infinite Copyright."
12. Lessig, "Helprin on Perpetual Copyright."
13. See *Lessig Wiki*, "Against Perpetual Copyright."
14. M. Nimmer, "First Amendment Guarantees," 1193.
15. Directive 2006/116/EC of the European Parliament and of the council of 12 December 2006 on the Term of Protection of Copyright and Certain Related Rights, art. 1(1).
16. Berne Convention for the Protection of Literary and Artistic Works, Sept. 9, 1886, as revised July 24, 1971, 828 U.N.T.S. 221, art. 7(1).
17. Mexican Federal Law on Copyright (as consolidated up to July 14, 2014), art. 29.
18. Though I know of no country that currently recognizes a perpetual copyright term.
19. No small matter in the United States, where making copyright a perpetual right would require passing a constitutional amendment superseding the language of the copyright clause.
20. Nimmer and Nimmer, *Nimmer on Copyright* § 13.05[A][1][b].
21. Sag, "Predicting Fair Use," 58.
22. Ibid., 76.
23. Ibid.
24. Ibid., 77.
25. D. Nimmer, "Modest Proposal."
26. Hughes, "Introduction."
27. 17 U.S.C. § 504.
28. Ibid., § 505.
29. Fogerty v. Fantasy, Inc., 510 U.S. 517, 520–521 (1994).
30. Fantasy Inc. v. Fogerty, 19 F.3d 553, 555 (9th Cir. 1996).
31. Carroll, "Fixing Fair Use," 1125–26.
32. Ibid., 1136–37.
33. Ibid., 1137–38. Carroll's attempts to discharge these worries for his own view are not altogether satisfying.

34. In "Administering Fair Use," Jason Mazzone offers two models for fair use adminis-tration, each predicated on a rule- rather than standards-based adjudication, noting: "Agency regulation can shift fair use from standards to rules and from litigation to administration" (415). A move from administration to litigation would undoubtedly lower costs for all parties (the only losers here would be the lawyers), and a move from fair use standards to rules should increase predictability. Unfortunately, Maz-zone offers no advice on the formulation of these rules. But, certainly, any chance at improving fair use will require making it more predictable for both authors and users alike. See also Simon, "Teaching without Infringement."
35. Parchomovsky and Goldman, "Fair Use Harbors," 1511.
36. Ibid., 1512.
37. Ibid.
38. Gover, *Art and Authority* chap. 6.
39. Rosenheim, "Cruel Radiance of What Is," 90.
40. Metropolitan Museum of Art, "After Walker Evans: 4."

BIBLIOGRAPHY

Adams, James. "Rodin Thinkers to the ROM: We Think Not, Thank You." *Globe & Mail*, October 20, 2001, R3.

Agence France-Presse. "India Gang-Rape Victim 'Partly to Blame,' Says Attacker." *Daily Mail*, March 3, 2015. http://www.dailymail.co.uk/wires/afp/article-2977068/Delhi-rapist -blames-victim-night.html.

Airen. "Berlin Is Here to Mix Everything with Everything." June 5, 2008. http://airen.word press.com/2008/06/05/berlin-is-here-to-mix-everything-with-everything.

Ames, Kenly. "Beyond Rogers v. Koons: A Fair Use Standard for Appropriation." *Columbia Law Review* 93, no. 6 (1993): 1473–1526.

Appel, Brian. "Richard Prince." *Rove TV*, 2007. Archived at http://www.americansuburbx. com/2013/03/interview-richard-prince-2007.html.

Applegate, Douglas A. "Patenting Improvements: The Cost of Making Patents Easily Available." *Santa Clara High Technology Law Journal* 8, no. 2 (1992): 429–46.

Appropriation Art Coalition. "Open Letter." Archived at http://archive-ca.com/ca/a /ap propriationart.ca/2014-01-14_3528472/.

Aquin, Hubert. "Occupation: Writer." In *Writing Quebec: Selected Essays by Hubert Aquin*, edited by Anthony Purdy, 49–58. Edmonton: University of Alberta Press, 1988.

Arcangel, Cory. *Clouds*. July 30, 2012. http://www.youtube.com/watch?v=fCmAD0TwG cQ#t=71.

Archard, David. "The Wrong of Rape." *Philosophical Quarterly* 57, no. 228 (2007): 374–93.

Arewa, Olufunmilayo B. "Blues Lives: Promise and Perils of Musical Copyright." *Cardozo Arts & Entertainment Law Journal* 27 (2010): 573–619.

Arning, Bill. "Sturtevant." *Contemporary Art* 2, no. 2 (1989): 39–50.

Arp, Jean. *Collected French Writings: Poems, Essays, Memories*. Edited by M. Jean. Translated by J. Neugroschel. London: Calder & Boyars, 1974.

Attridge, Derek. *The Singularity of Literature*. London: Routledge, 2004.

Aufderheide, Patricia, Peter Jaszi, Bryan Bello, and Tijana Milosevic. "Copyright, Permissions, and Fair Use among Visual Artists and the Academic and Museum Visual Arts Communities: An Issues Report." College Art Association, 2014. http://www.college art.org/pdf/FairUseIssuesReport.pdf.

Augustine. *City of God*. In *The Works of Aurelius Augustine*, translated by Marcus Dods. Edinburgh: T. & T. Clark, 1913.

Australian Law Reform Commission, "Copyright and the Digital Economy" (ALRC Report 122). November 30, 2013. http://www.alrc.gov.au/sites/default/files/pdfs/publications /final_report_alrc_122_2nd_december_2013_.pdf.

Aylward, E. T. *Cervantes: Pioneer and Plagiarist*. Suffolk, UK: Tamesis, 1982.

Bacharach, Sondra, and Deborah Tollefsen. "*We* Did It: From Mere Contributors to Coauthors." *Journal of Aesthetics & Art Criticism* 68, no. 1 (2010): 23–32.

Badin, Roxana. "An Appropriate(d) Place in Transformative Value: Appropriation Art's Exclusion from *Campbell v. Acuff-Rose Music, Inc.*" *Brooklyn Law Review* 60, no. 4 (1995): 1653–92.

Barthes, Roland. "The Death of the Author." In *Image Music Text*, edited and translated by Stephen Heath, 142–48. London: Fontana Press, 1977.

Bauer, Joseph P. "Refusals to Deal with Competitors by Owners of Patents and Copyrights: Reflections on the *Image Technical* and *Xerox* Decisions." *DePaul Law Review* 55, no. 4 (2006): 1211–46.

BBC News. "Duchamp's Urinal Tops Art Survey." December 1, 2004. http://news.bbc.co.uk /2/hi/entertainment/4059997.stm.

———. "Sweden Recognizes New File-Sharing Religion Kopimism." March 8, 2012. http:// www.bbc.com/news/technology-16424659.

Bently, Lionel, and Brad Sherman. *Intellectual Property Law*. 4th ed. Oxford: Oxford University Press, 2014.

Bernstein, Cheryl. "The Fake as More." In *Idea Art: A Critical Anthology*, edited by Gregory Battcock, 41–45. New York: Dutton, 1973.

Betts, Gregory. "Poets Against Authorship: A 5 Minute Manifesto in 20 Parts, 15 Seconds Each." Accessed July 23, 2016. http://gregorybetts.files.wordpress.com/2012/10/poets againstauthorship1.pdf.

Blagden, Cyprian. *The Stationer's Company: A History 1403–1959*. Stanford, CA: Stanford University Press, 1977.

Blum, Susan D. *My Word! Plagiarism and College Culture*. Ithaca, NY: Cornell University Press, 2009.

Borrelli, Christopher. "Connecting the Dots on Roy Lichtenstein Retrospective at Art Institute." *Chicago Tribune*, May 11, 2012. http://articles.chicagotribune.com/2012-05-11 /entertainment/ct-ae-0513-roy-lichtenstein-20120511_1_roy-lichtenstein-comic-art -lichtenstein-show/2.

Boswell, James. *Boswell's Life of Johnson*. 6 vols. Edited by George Birkbeck Hill, revised by L. F. Powell. Oxford: Clarendon Press, 1934.

Bowden, Darsie. "Coming to Terms: Plagiarism." *English Journal* 85, no. 4 (1996): 82–84.

Brandes, Barbara. *Academic Honesty: A Special Study of California Students*. Sacramento: California State Department of Education, Bureau of Publications, 1986.

Bratman, Michael E. *Faces of Intention*. Cambridge: Cambridge University Press, 1999.

Brown, Russell W., and James H. M. Henderson. "The Mass Production and Distribution of HeLa Cells at Tuskegee Institute." *Journal of the History of Medicine & Allied Sciences* 38, no. 4 (1983): 415–31.

Buchloh, Benjamin H. D. "Allegorical Procedures: Appropriation and Montage in Contemporary Art." *Artforum* 21, no. 1 (1982): 43–56.

BuchMarkt. "'Axolotl Roadkill': Helene Hegemann und Ullstein Verlegerin Dr. Siv Bublitz antworten auf Plagiatsvorwuft." February 7, 2010. http://www.buchmarkt .de/content/41393-axolotl-roadkill-helene-hegemann-und-ullstein-verlegerin-dr-siv -bublitz-antworten-auf-plagiatsvorwurf.htm.

Buskirk, Martha. "Commodification as Censor: Copyrights and Fair Use." *October* 60 (1992): 82–109.

Callaway, Ewen. "Deal Done over HeLa Cell Line." *Nature* 500 (2013): 132–33.

Cameron, Dan. "A Conversation: A Salon History of Appropriation with Leo Castelli and Elaine Sturtevant." *Flash Art* 143 (1988): 76–77.

Cameron, Kirk. *Still Growing: An Autobiography.* Ventura, CA: Regal, 2008.

Carlin, John. "Culture Vultures: Artistic Appropriation and Intellectual Property Law." *Columbia-VLA Journal of Law & the Arts* 3, no. 1 (1988): 103–43.

Carnes, Mark C., ed. *Invisible Giants: Fifty Americans Who Shaped the Nation but Missed the History Books.* Oxford: Oxford University Press, 2002.

Carroll, Michael W. "Fixing Fair Use." *North Carolina Law Review* 85, no. 4 (2007): 1087–1154.

Carroll, Noël. *A Philosophy of Mass Art.* Oxford: Oxford University Press, 1998.

Chatelain, Jean. "An Original in Sculpture." In *Rodin Rediscovered,* edited by Albert E. Elsen, 275–82. Washington, DC: National Gallery of Art, 1981.

Chen, Adrian. "Remix Everything: BuzzFeed and the Plagiarism Problem." Gawker, June 28, 2012. http://gawker.com/5922038/remix-everything-buzzfeed-and-the-plagiarism -problem.

Clemens, Samuel L. "Statement of Mr. Samuel L. Clemens." In *Copyright Hearings, December 7 to 11, 1906. Arguments Before the Committees on Patents of the Senate and House of Representatives, Conjointly, on the Bills S. 6330 and H.R. 19853 to Amend and Consolidate the Acts Respecting Copyright,* 59th Congress, 1st Session, 116–21. Washington, DC: Government Printing Office, 1906.

Cohen, Amy B. "Copyright Law and the Myth of Objectivity: The Idea-Expression Dichotomy and the Inevitability of Artistic Value Judgments." *Indiana Law Journal* 66, no. 1 (1990): 175–232.

———. "When Does a Work Infringe the Derivative Works Right of a Copyright Owner?" *Cardozo Arts & Entertainment Law Journal* 17, no. 3 (1999): 623–58.

Coleridge, Samuel Taylor. *Biographia Literaria.* Vol. 1. London: Rest Fenner, 1817.

———. *Biographia Literaria.* Vol. 2. London: William Pickering, 1847.

———. *Complete Works.* Vol. 2, edited by W. G. T. Shedd. New York: Harper and Brothers, 1864.

Collingwood, R. G. *Principles of Art.* Oxford: Clarendon Press, 1938.

Connolly, Kate. "There's No Such Thing as Originality." *Gulf News,* July 9, 2012. http://gulf news.com/arts-entertainment/books/there-s-no-such-thing-as-originality-1.1046488.

Cooter, Robert. "Separation and Fertility in Intellectual Property Law." In *The Falcon's Gyre: Legal Foundations of Economic Innovation and Growth,* Version 1.4, Berkeley Law Books, 2014. http://scholarship.law.berkeley.edu/books/1/.

Cowley, John H. Notes to "Two White Horses Standin' in a Line." Flyright-Matchbox Library of Congress, vol. 5, SDM 264, 1976, L.P.

Craig, Carys J. "Locke, Labour and Limiting the Author's Rights: A Warning against a Lockean Approach to Copyright Law." *Queens Law Journal* 28, no. 1 (2007): 1–60.

Creative Commons. "The Size of the Commons." Accessed July 23, 2016. https://stateof .creativecommons.org/report/.

Crow, Thomas. "The Return of Hank Herron." In *Endgame: Reference and Simulation in Recent Paintings and Sculpture,* edited by Yve-Alain Bois, Thomas Crow, Hal Foster, David Joselit, Elisabeth Sussman, and Bob Riley, 11–27. Cambridge, MA: MIT Press, 1986.

Currie, Gregory. *An Ontology of Art.* London: Macmillan, 1989.

———. "Work and Text." *Mind* 100, no. 3 (1991): 325–40.

Damstedt, Benjamin G. "Limiting Locke: A Natural Law Justification for the Fair Use Doctrine." *Yale Law Journal* 112, no. 5 (2003): 1179–1221.

Danto, Arthur C. "Art and Meaning." In *The Madonna of the Future: Essays in a Pluralistic Art World*, xvii–xxx. Berkeley: University of California Press, 2001.

———. "Artworks and Real Things." *Theoria* 39, no. 1 (1973): 1–17.

———. "The Artworld." *Journal of Philosophy* 61, no. 19 (1964): 571–84.

Davids, Jaime. "*Eldred v. Ashcroft*: A Critical Analysis of the Supreme Court Decision." *DePaul University Journal of Art & Entertainment Law* 13 (2003): 173–202.

Davies, David. *Art as Performance*. London: Blackwell, 2004.

———. "The Primacy of Practice in the Ontology of Art." *Journal of Aesthetics & Art Criticism* 67, no. 2 (2009): 159–71.

Deazley, Ronan, Martin Kretschmer, and Lionel Bently, eds. *Privilege and Property: Essays on the History of Copyright*. Cambridge: OpenBook, 2010.

Delius, Mara. "Mir zerfallen die Worte im Mund wie schlechte Pillen." *Frankfurter Allgemeine Zeitung* (Frankfurt), January 22, 2010. http://www.faz.net/aktuell/feuilleton /buecher/rezensionen/belletristik/helene-hegemann-axolotl-roadkill-mir-zerfallen -die-worte-im-mund-wie-schlechte-pillen-1913572.html.

Delson, James, and Patricia Morrisroe. "Interview with Richard Donner." *Fantastic Films*, June 1979, 8–17.

De Quincey, Thomas. *The Collected Writings of Thomas De Quincey*. Vol. 2, edited by David Masson. London: A. & C. Black, 1896.

Derbyshire, Katy. "On Translating Axolotl Roadkill." *New Books in German*, 2013. http://www .new-books-in-german.com/english/1078/337/337/129002/design1.html.

Dickens, Donna. "7 Classical Masterpieces Surreally Infused with Pop Culture." Buzz-Feed, February 21, 2013. http://www.buzzfeed.com/donnad/classical-masterpieces -surreal-pop-culture.

———. "'Super Mario Busters' Is the Mario/Ghostbusters Mash-Up You've Been Waiting For." BuzzFeed, February 7, 2013. http://www.buzzfeed.com/donnad/super-mario -busters-mario-ghostbusters-mash-up.

Dickie, George. *The Art Circle: A Theory of Art*. New York: Haven, 1984.

Diefenbach, Donald L. "The Constitutional and Moral Justifications for Copyright." *Public Affairs Quarterly* 8, no. 3 (1994): 225–35.

Digital Copyright Canada. "Over 1800 Canadians Rejected Changes to Copyright, Even before Bill Was Introduced." June 22, 2005. http://www.digital-copyright.ca/petition /press20050622.shtml.

Drahoss, Peter. *A Philosophy of Intellectual Property*. Aldershott: Dartmouth, 1996.

Drassinower, Abraham. "Taking User Rights Seriously." In *In the Public Interest: The Future of Canadian Copyright Law*, edited by Michael Geist, 462–79. Toronto: Irwin Law, 2005.

Duke, Alan. "Shia LaBeouf Offers Cloudy Plagiarism Apology." CNN, January 3, 2014. http://www.cnn.com/2014/01/02/showbiz/shia-labeouf-plagiarism-apology/.

Edemariam, Aida. "I Think, but I'm Not Quite Sure Who I Am." *Guardian*, October 2, 2001, 12.

Epstein, Richard A. "Liberty versus Property? Cracks in the Foundation of Copyright Law." *San Diego Law Review* 42, no. 1 (2005): 1–28.

European Molecular Biology Laboratory. "Genome of Most Used Human Cell Line Available to Scientists Following Agreement between NIH and Lacks Family." August 7, 2013. http://www.embl.de/aboutus/communication_outreach/news/2013/130807 _Heidelberg/.

Evans, David. *Big Road Blues: Tradition and Creativity in the Folk Blues*. Oakland: University of California Press, 1982.

———. "An Interview with H. C. Speir." *John Edwards Memorial Foundation Quarterly* 8, no. 3 (1972): 117–21.

Feinberg, Joel. *Harm to Others: The Moral Limits of the Criminal Law*. Oxford: Oxford University Press, 1984.

Fichte, Johann Gottlieb. "Proof of the Illegality of Reprinting: A Rationale and a Parable," translated by Martha Woodmansee. In *Primary Sources on Copyright (1450–1900)*, edited by L. Bently and M. Kretschmer. http://www.copyrighthistory.org.

Fischer, Russ. " 'Pride and Prejudice and Zombies' Rises from the Grave." *Slashfilm*, March 1, 2013. http://www.slashfilm.com/pride-and-prejudice-and-zombies-rises-from-the-grave/.

Fish, Stanley. "Plagiarism Is Not a Big Moral Deal." *New York Times*, August 9, 2010. http://opinionator.blogs.nytimes.com/2010/08/09/plagiarism-is-not-a-big-moral-deal/.

———. "Professor Sokal's Bad Joke." *New York Times*, May 21, 1996, A23.

Foucault, Michel. "What Is an Author?" In *Textual Strategies: Perspectives in Post-Structuralist Criticism*, edited by Josue V. Harari, 141–60. Ithaca, NY: Cornell University Press, 1980.

Franzen, Benjamin, and Kembrew McLeod. *Copyright Criminals*. Astoria, NY: IndiePix Films, 2009. DVD.

Friedman, Kinky. *Roadkill*. New York: Ballantine, 1997.

Fritz, Mark. "Redefining Research, Plagiarism." *Los Angeles Times*, February 25, 1999. http://articles.latimes.com/1999/feb/25/news/mn-11647.

Gagosian Gallery. "Richard Prince: *New Portraits*." Updated June 9, 2015. http://www.gagosian.com/exhibitions/richard-prince--june-12-2015.

Garfield Sales. "Garfield Q-Score." Paws, Inc. Accessed September 21, 2015. http://sales.garfield.com/qscore.pdf.

Gaut, Berys. "Film Authorship and Collaboration." In *Film Theory and Philosophy*, edited by R. Allen and M. Smith, 148–72. Oxford: Oxford University Press, 1997.

Geist, Michael, ed. *The Copyright Pentalogy: How the Supreme Court of Canada Shook the Foundations of Canadian Copyright Law*. Ottawa: University of Ottawa Press, 2013.

Gilbert, Laura. "No Longer Appropriate?" *Art Newspaper*, May 9, 2012. Archived at http://old.theartnewspaper.com/articles/No-longer-appropriate/26378.

Gilbert, Margaret. *A Theory of Political Obligation: Membership, Commitment, and the Bonds of Society*. Oxford: Clarendon Press, 2006.

Gleason, Ralph J. "Can the White Man Sing the Blues?" *Jazz & Pop* 7/8 (1968): 28–29.

Goethe, Johann Wolfgang von. *Conversations of Goethe with Eckermann and Soret*. Vol. 1, translated by John Oxenford. London: Smith, Elder, 1850.

Goldsmith, Kenneth. "It's Not Plagiarism in the Digital Age, It's Repurposing." *Chronicle of Higher Education*, September 11, 2011. http://chronicle.com/article/Uncreative-Writing/128908/.

———. *Uncreative Writing*. New York: Columbia University Press, 2011.

Goldstein, Paul. *Copyright: Principles, Law and Practice*. 2nd ed. Boston: Little, Brown, 1996.

———. *Copyright's Highway: From Gutenberg to the Celestial Jukebox*. Rev. ed. Stanford, CA: Stanford Law and Politics, 2003.

Goodman, Nelson. *Languages of Art: An Approach to a Theory of Symbols*. 2nd ed. Indianapolis: Hackett, 1976.

Gordon, Wendy J. "A Property Right in Self-Expression: Equality and Individualism in the Natural Law of Intellectual Property," *Yale Law Journal* 102, no. 7 (1993): 1533–1609.

Govenar, Alan. *Texas Blues: The Rise of a Contemporary Sound*. College Station: Texas A&M University Press, 2008.

Govenar, Alan, and Jay Brakefield. *Deep Ellum: The Other Side of Dallas*. College Station: Texas A&M University Press, 2013.

Gover, K. E. *Art and Authority: Moral Rights and Meaning in Contemporary Art*. Oxford: Oxford University Press, forthcoming.

Greenberg, Lynne A. "The Art of Appropriation: Puppies, Piracy, and Post-Modernism." *Cardozo Arts & Entertainment Law Journal* 11, no. 1 (1992): 1–34.

Grossman, Lev. "Critique of *Abraham Lincoln: Vampire Hunter*." *Time*, March 8, 2010. http://www.time.com/time/magazine/article/0,9171,1968104,00.html.

Guyer, Paul. "Exemplary Originality: Genius, Universality, and Individuality." In *Values of Beauty: Historical Essays in Aesthetics*, 242–62. Cambridge: Cambridge University Press, 2005.

———. *Values of Beauty: Historical Essays in Aesthetics*. Cambridge: Cambridge University Press, 2005.

Hacking, Ian. *The Social Construction of What?* Cambridge, MA: Harvard University Press, 1999.

Halford, Macy. "Jane Austen Does the Monster Mash." *New Yorker*, April 8, 2009. http://www.newyorker.com/online/blogs/books/2009/04/jane-austen-doe.html.

Harrington, Richard. "A Celebration of Home-Grown Soul." *Washington Post*, June 30, 2006. http://www.washingtonpost.com/wp-dyn/content/article/2006/06/29/AR2006062 900855.html.

Harrison, Nate. "Reflections on the Amen Break: A Continued History, an Unsettled Ethics." In *The Routledge Companion to Remix Studies*, edited by Eduardo Navas, Owen Gallagher, and xtine burroughs, 444–52. London: Routledge, 2015.

Harvison, Anthony. "Pride and Prejudice and Zombies Review and Seth Grahame-Smith Interview." *Den of Geek!*, June 11, 2009. http://www.denofgeek.us/books-comics/5872 /pride-and-prejudice-and-zombies-review-and-seth-grahame-smith-interview.

Hedenkamp, Douglas A. "Free Mickey Mouse: Copyright Notice, Derivative Works, and the Copyright Act of 1909," *Virginia Sports & Entertainment Law Journal* 2 (2003): 254–79.

Hegel, G. W. F. *Introductory Lectures on Aesthetics*. Translated by Bernard Bosanquet. Harmondsworth: Penguin, 1994.

———. *Philosophy of Right*. Translated by T. M. Knox. Oxford: Clarendon Press, 1952.

Hegemann, Helene. *Axolotl Roadkill*. Berlin: Ullstein, 2010.

———. *Axolotl Roadkill*. London: Constable & Robinson, 2012.

Helprin, Mark. "A Great Idea Lives Forever. Shouldn't Its Copyright?" *New York Times*, May 20, 2007. http://www.nytimes.com/2007/05/20/opinion/20helprin.html.

Herder, Johann Gottfried. *Sämmtliche Werke*. Vol. 22. Stuttgart and Tübingen: J. G. Cotta, 1853.

Hettinger, Edwin C. "Justifying Intellectual Property." *Philosophy & Public Affairs* 18, no. 1 (1989): 31–52.

Hick, Darren Hudson. "Aesthetics and Copyright." *American Society for Aesthetics Newsletter* 30, no. 1 (2010): 1–3.

———. "Authorship, Co-Authorship, and Multiple Authorship." *Journal of Aesthetics & Art Criticism* 72, no. 2 (2014): 147–56.

———. "Conceptual Problems of Conceptual Separability and the Non-Usefulness of the Useful Articles Distinction." *Journal of the Copyright Society of the USA* 57, no. 1–2 (2010): 37–57.

———. "Expressing Ideas: A Reply to Roger A. Shiner." *Journal of Aesthetics & Art Criticism* 68, no. 4 (2010): 405–8.

———. "Making Sense of the Copyrightability of Plots: A Case Study in the Ontology of Art." *Journal of Aesthetics & Art Criticism* 67, no. 4 (2009), 399–407.

———. "Mystery and Misdirection: Some Problems of Fair Use and User's Rights." *Journal of the Copyright Society of the USA* 56, nos. 2–3 (2009): 401–20.

Hirsch, E. D., Jr. *Validity in Interpretation.* New Haven, CT: Yale University Press, 1967.

Hohfeld, Wesley Newcomb. *Fundamental Legal Conceptions as Applied in Judicial Reasoning.* New Haven, CT: Yale University Press, 1923.

Holden, Stephen. "Left Behind the Movie: Film Review; A Biblically Inspired Tale About Dying and Surviving." *New York Times*, February 2, 2008. http://www.nytimes.com/movie /review?res=9D05EEDD143EF931A35751C0A9679C8B63.

Honoré, Tony. "Ownership." In *Making Laws Bind: Essays Legal and Philosophical*, 161–92. Oxford: Oxford University Press, 2002.

Huffington Post. "Shia LaBeouf Receives Cease and Desist Letter from Daniel Clowes' Lawyer." January 23, 2014. http://www.huffingtonpost.com/2014/01/08/shia-labeouf-cease -and-desist-letter_n_4561298.html.

Hughes, Justin. "Introduction to David Nimmer's Modest Proposal." *Cardozo Arts & Entertainment Law Journal* 24, no. 1 (2006): 1–9.

———. "The Philosophy of Intellectual Property." *Georgetown Law Journal* 77, no. 2 (1988): 287–366.

Hull, Gordon. "Clearing the Rubbish: Locke, the Waste Proviso, and the Moral Justification of Intellectual Property." *Public Affairs Quarterly* 23, no. 1 (2009): 67–93.

Inge, William Ralph. *Assessments and Anticipations.* London: Cassell, 1929.

Irvin, Sherri. "Appropriation and Authorship in Contemporary Art." *British Journal of Aesthetics* 45, no. 2 (2005): 123–37.

Jarmusch, Jim. "Things I've Learned." *MovieMaker*, June 5, 2013. http://www.moviemaker .com/articles-directing/jim-jarmusch-5-golden-rules-of-moviemaking/.

Jaszi, Peter. "On the Author Effect: Contemporary Copyright and Collective Creativity." In *The Construction of Authorship: Textual Appropriation in Law and Literature*, edited by Martha Woodmansee and Peter Jaszi, 29–56. Durham, NC: Duke University Press, 1994.

———. "Toward a Theory of Copyright." *Duke Law Journal* 40, no. 2 (1991): 455–502.

Jefferson, Thomas. *Writings*, edited by Merrill D. Peterson. New York: Library of America, 1984.

Jenkins, Henry, Ravi Purushotma, Margaret Weigel, Katie Clinton, and Alice J. Robison. *Confronting the Challenges of Participatory Culture: Media Education for the 21st Century.* Cambridge, MA: MIT Press, 2009.

Johnston, Rick. "'Authorship Is Censorship'—Bleeding Cool in Conversation with Shia LaBeouf." *Bleeding Cool*, January 2, 2014. http://www.bleedingcool.com/2014/01/02 /authorship-is-censorship-bleeding-cool-in-conversation-with-shia-labeouf/.

Jones, Max. "On Blues." In *The PL Yearbook of Jazz 1946*, edited by Albert McCarthy, 72–107. London: Nicholson & Watson, 1946.

Jones, Richard H. "The Myth of the Idea/Expression Dichotomy in Copyright Law." *Pace Law Review* 10, no. 3 (1990): 551–607.

Judge, Elizabeth F., and Daniel Gervais. "Of Silos and Constellations: Comparing Notions of Originality in Copyright Law." *Cardozo Arts & Entertainment Law Journal* 27, no. 2 (2009): 375–408.

Kamm, Frances. *Intricate Rights: Rights, Responsibilities, and Permissible Harm.* Oxford: Oxford University Press, 2006.

———. "Rights." In *The Oxford Handbook of Jurisprudence & Philosophy of Law*, edited by Jules Coleman and Scott Shapiro, 476–513. Oxford: Oxford University Press, 2002.

Kant, Immanuel. *Critique of Judgment*. Translated by Werner S. Pluhar. Indianapolis: Hackett, 1987.

———. "On the Injustice of Counterfeiting Books." Translated by Luis Sundkvist. In *Primary Sources on Copyright (1450–1900)*, edited by L. Bently and M. Kretschmer. www.copyrighthistory.org.

Kaplan, Benjamin. *An Unhurried View of Copyright*. New York: Columbia University Press, 1967.

Karaganis, Joe. "The Copy Culture Survey: Infringement and Enforcement in the US." American Assembly, November 2011. http://piracy.americanassembly.org/wp-content/uploads/2011/11/AA-Research-Note-Infringement-and-Enforcement-November-2011.pdf.

Kennedy, Randy. "If the Copy Is an Artwork, Then What's the Original?" *New York Times*, December 6, 2007. http://www.nytimes.com/2007/12/06/arts/design/06prin.html.

Kershnar, Stephen. "Private Property Rights and Autonomy." *Public Affairs Quarterly* 16, no. 3 (2002): 231–58.

Kim, Jaegwon. "Events and Property Exemplifications." In *Action Theory*, edited by M. Brand and D. Walton, 159–77. Dordrecht: Reidel, 1976.

———. "Events and Their Descriptions." In *Essays in Honor of Carl G. Hempel*, edited by N. Rescher, 198–215. Dordrecht: Reidel, 1969.

Kind, John Louis. *Edward Young in Germany*. New York: AMS Press, 1966.

Kinsella, Stephan. "Objectivists on the PRO-IP Act." *Against Monopoly* (blog), November 21, 2008. http://www.againstmonopoly.org/index.php?perm=593056000000000190.

Koff, Leonard Michael, and Brenda Deen Schildgen, eds. *The Decameron and the Canterbury Tales: New Essays on an Old Question*. Plainsboro, NJ: Associated University Presses, 2000.

Koons, Jeff. *Jeff Koons: Pictures 1980–2002*. Edited by Thomas Kellein. New York: Distributed Art, 2002.

Kretschmer, Martin, and Friedemann Kawohl. "The History and Philosophy of Copyright." In *Music and Copyright*, 2nd ed., edited by S. Frith and L. Marshall, 21–53. Edinburgh: Edinburgh University Press, 2004.

Krieg, Patricia. "Copyright, Free Speech, and the Visual Arts." *Yale Law Journal* 93, no. 8 (1984): 1565–85.

Kutski, "The Amen Break." *BBC Radio 1's Stories*, June 6, 2011. http://www.bbc.co.uk/programmes/b011nyd1.

Landes, William M., and Richard A. Posner. "An Economic Analysis of Copyright Law." *Journal of Legal Studies* 18, no. 2 (1989): 325–63.

Lang, Andrew. "Literary Plagiarism." *Contemporary Review* 51 (June 1887): 831–40.

Larvick, Matthew P. "Questioning the Necessity of Copyright Protection for Software Interfaces." *University of Illinois Law Review* 1994 (1994): 187–216.

Latonero, Mark, and Aram Sinnreich. "The Hidden Demography of New Media Ethics." *Information, Communication & Society* 17, no. 5 (2013): 572–93.

Lessig, Lawrence. *Free Culture: The Nature and Future of Creativity*. London: Penguin, 2004.

———. "Helprin on Perpetual Copyright: Write the Reply?" *Lessig*, May 20, 2007. http://www.lessig.org/2007/05/helprin-on-perpetual-copyright/.

———. *Remix: Making Art and Commerce Thrive in the Hybrid Economy*. London: Penguin, 2008.

Lessig Wiki. "Against Perpetual Copyright." Created May 20, 2007 (last visited September 15, 2015). http://wiki.lessig.org/Against_perpetual_copyright.

Leval, Pierre N. "Fair Use or Foul?" *Journal of the Copyright Society of the USA* 36, no. 1 (1989): 167–81.

———. "Toward a Fair Use Standard." *Harvard Law Review* 103, no. 5 (1990): 1105–36.

Levine, Sherrie. "Statement." In *Mannersm: A Theory of Culture,* edited by John Shearman, 48. Vancouver: Vancouver Art Gallery, 1982. (Reprinted in Charles Harrison and Paul Wood, eds., *Art in Theory 1900–2000* [Oxford: Oxford University Press, 2002], 1067.)

Levinson, Jerrold. "Defining Art Historically." *British Journal of Aesthetics* 19, no. 3 (1979): 232–50.

———. *The Pleasures of Aesthetics.* Ithaca, NY: Cornell University Press, 1996.

———. "Titles." *Journal of Aesthetics & Art Criticism* 44, no. 1 (1985): 29–39.

———. "What a Musical Work Is." *Journal of Philosophy* 77, no. 1 (1980), 5–28.

Lieberman, Trudy. "Plagiarize, Plagiarize, Plagiarize . . . Only Be Sure to Always Call It Research." *Columbia Journalism Review* 34, no. 2 (1995): 21–25.

Lipton, Jacqueline D. "Solving the Digital Piracy Puzzle: Disaggregating Fair Use from the DMCA's Anti-Device Provisions." *Harvard Journal of Law & Technology* 19, no. 1 (2005): 111–60.

Litman, Jessica. *Digital Copyright.* Amherst, NY: Prometheus, 2001.

Livingston, Paisley. *Art and Intention.* Oxford: Oxford University Press, 2005.

Livingston, Paisley, and Carol Archer. "Artistic Collaboration and the Completion of Works of Art." *British Journal of Aesthetics* 50, no. 4 (2010): 439–55.

Local. "Young Literary Star Hegemann Counters Plagiarism Claim." February 9, 2010. http://www.thelocal.de/20100209/25143.

Locke, John. "Liberty of the Press." In *Political Essays,* 329–39. Cambridge: Cambridge University Press, 2001.

———. *Two Treatises of Government.* Edited by Peter Laslett. Cambridge: Cambridge University Press, 1988.

Lodge, David. *Nice Work.* London: Penguin, 1990.

Love, Harold. *Attributing Authorship: An Introduction.* Cambridge: Cambridge University Press, 2002.

Lucas, André, and H. J. Lucas. *Traité de la Propriété Littéraire et Artistique.* 3rd ed. Paris: Litec, 2006.

Lunsford, Andrea, and Lisa Ede. *Singular Texts/Plural Authors: Perspectives on Collaborative Writing.* Carbondale: Southern Illinois University Press, 1990.

MacFarlane, Robert. *Original Copy: Plagiarism and Originality in Nineteenth-Century Literature.* Oxford: Oxford University Press, 2007.

Madrigal, Alexis C. "Where Do All Those BuzzFeed Cute Animal Pictures Come From?" *Atlantic,* April 30, 2012. http://www.theatlantic.com/technology/archive/2012/04/where-do-all-those-buzzfeed-cute-animal-pictures-come-from/256547/.

Maglio, Tony. "The Most and Least Liked Summer Movie Actors—Tom Cruise, Vin Diesel, Morgan Freeman, Channing Tatum." *Wrap,* May 28, 2014: http://www.thewrap.com/most-least-liked-summer-movie-actors-morgan-freeman-zac-efron-adam-sandler-seth-macfarlane-vin-diesel/.

Mag Uidhir, Christy. *Art and Art-Attempts.* Oxford: Oxford University Press, 2013.

Mallon, Thomas. *Stolen Words.* San Diego: Harcourt, 2001.

Manjoo, Farhad. "How to Make a Viral Hit in Four Easy Steps." *Slate,* June 26, 2012. http://www.slate.com/articles/technology/technology/2012/06/_21_pictures_that_will

_restore_your_faith_in_humanity_how_buzzfeed_makes_viral_hits_in_four_easy
steps.html.

Mankiewicz, Tom, and Robert Crane. *My Life as a Mankiewicz: An Insider's Journey Through Hollywood*. Lexington: University Press of Kentucky, 2012.

Margolis, Joseph. *Art and Philosophy*. Brighton, UK: Harvester Press, 1980.

———. "The Ontological Peculiarity of Works of Art." *Journal of Aesthetics & Art Criticism* 36, no. 1 (1977): 45–50.

März, Ursula. "Literarischer Kugelblitz." *Die Zeit* (Hamburg), January 21, 2010. http://www.zeit.de/2010/04/L-B-Hegemann.

Marzorati, Gerald. "Art in the (Re)Making." *ARTnews* 85, no. 5 (1985): 95–99.

Masnick, Mike. "Arguing for Infinite Copyright . . . Using Copied Ideas and a Near Total Misunderstanding Of Property." *Techdirt*, May 21, 2007. https://www.techdirt.com/articles/20070521/015928.shtml.

Mazzeo, Tilar J. *Plagiarism and Literary Property in the Romantic Period*. Philadelphia: University of Pennsylvania Press, 2007.

Mazzone, Jason. "Administering Fair Use." *William & Mary Law Review* 51, no. 2 (2009): 395–437.

McAdams, Janine. "Clearing House: EMI Music Uses Sampling Committee." *Billboard*, January 30, 1993, 1, 85.

McCabe, Donald L. "Academic Dishonesty Among High School Students." *Adolescence* 34, no. 136 (1999): 681–87.

McCabe, Donald L., Kenneth D. Butterfield, and Linda K. Treviño. *Cheating in College: Why Students Do It and What Educators Can Do about It*. Baltimore: Johns Hopkins University Press, 2012.

McFarland, Thomas. *Originality and Imagination*. Baltimore: Johns Hopkins University Press, 1985.

———. "The Originality Paradox." *New Literary History* 5, no. 3 (1974): 447–76.

McLeod, Kembrew. "An Oral History of Sampling: From Turntables to Mashups." In *The Routledge Companion to Remix Studies*, edited by Eduardo Navas, Owen Gallagher, and xtine burroughs, 83–95. London: Routledge, 2015.

McLeod, Kembrew, and Peter DiCola. *Creative License: The Law and Culture of Digital Sampling*. Durham, NC: Duke University Press, 2011.

McLeod, Kembrew, and Rudolf Kuenzli. *Cutting Across Media: Appropriation Art, Interventionist Collage, and Copyright Law*. Durham, NC: Duke University Press, 2011.

Meskin, Aaron. "Authorship." In *The Routledge Companion to Philosophy and Film*, edited by P. Livingston and C. Plantinga, 12–28. London: Routledge, 2009.

Metropolitan Museum of Art. "After Walker Evans: 4." *The Collection Online*. Accessed September 21, 2015. http://www.metmuseum.org/collection/the-collection-online/search/267214.

Milroy, Sarah. "Rodin: Truly, a Bust." *Globe & Mail*, September 22, 2001, R15.

Mondrian, Piet. *Plastic Art and Pure Plastic Art, 1937, and Other Essays 1941–1943*. New York: Wittenborn, 1945.

Monge, Luigi. "See That My Grave Is Kept Clean." In *Encyclopedia of the Blues*, edited by Edward Komara, 869–70. London: Routledge, 2006.

Moore, Adam D. "Intangible Property: Privacy, Power, and Information Control." In *Information Ethics: Privacy, Property, and Power*, 172–90. Seattle: University of Washington Press, 2005.

———. "A Lockean Theory of Intellectual Property Revisited." *San Diego Law Review* 49, no. 4 (2012): 1069–1103.

Nair, Meera. "Fairness of Use: Different Journeys." In *The Copyright Pentalogy: How the Supreme Court of Canada Shook the Foundations of Canadian Copyright Law*, edited by Michael Geist, 235–69. Ottawa: University of Ottawa Press, 2013.

Narveson, Jan. *Respecting Persons in Theory and Practice: Essays on Moral and Political Philosophy*. Lanham, MD: Rowman & Littlefield, 2002.

Nathan, Daniel. "Irony, Metaphor, and the Problem of Intention." In *Intention and Interpretation*, edited by Gary Iseminger, 183–202. Philadelphia: Temple University Press, 1992.

Navas, Eduardo, Owen Gallagher, and xtine burroughs, eds. *The Routledge Companion to Remix Studies*. New York: Routledge, 2015.

Needham, Alex. "Richard Prince v Suicide Girls in an Instagram Price War." *Guardian*, May 27, 2015. http://www.theguardian.com/artanddesign/2015/may/27/suicide-girls -richard-prince-copying-instagram.

Nehamas, Alexander. "What an Author Is." *Journal of Philosophy* 83, no. 11 (1986): 685–91.

New York Times. "Plagiarism Is Rampant, A Survey Finds." April 1, 1990, 36–37.

Nimmer, David. "'Fairest of Them All' and Other Fairytales of Fair Use." *Law & Contemporary Problems* 66, no. 1 (2003): 263–88.

———. "A Modest Proposal to Streamline Fair Use Determinations." *Cardozo Arts & Entertainment Law Journal* 24, no. 1 (2006): 11–22.

Nimmer, Melville. "Does Copyright Abridge the First Amendment Guarantees of Free Speech and Press?" *UCLA Law Review* 17, no. 6 (1970): 1180–1204.

Nimmer, Melville, and David Nimmer. *Nimmer on Copyright*. New Providence, NJ: Lexis-Nexis, 2011.

Nozick, Robert. *Anarchy, State, and Utopia*. New York: Basic, 1974.

Nuttall, Tom. "Seven Seconds of Fire: How a Short Burst of Drumming Changed the Face of Music." *Economist*, December 17, 2011. http://www.economist.com/node/21541707.

Okediji, Ruth. "Givers, Takers, and Other Kinds of Users: A Fair Use Doctrine for Cyberspace." *Florida Law Review* 53, no. 1 (2001): 107–81.

Olson, Kristina R., and Alex Shaw. "'No Fair, Copycat!' What Children's Response to Plagiarism Tells Us About Their Understanding of Ideas." *Developmental Science* 14, no. 2 (2011): 431–39.

Open Source Initiative FAQ. "What about the Creative Commons 'CC0' ('CC Zero') Public Domain Dedication? Is That Open Source?" Accessed July 26, 2016. http://opensource .org/faq#cc-zero.

Ortland, Eberhard. "The Aesthetics of Copyright." *World Congress of Philosophy 2008 Proceedings* 23 (2008): 227–32.

Ortland, Eberhard, and Reinold Schmücker. "Copyright and Art." *German Law Journal* 6, no. 12 (2005): 1762–76.

Ottman, Klaus. "Jeff Koons." *Journal of Contemporary Art* 1, no. 1 (1988). http://www.jca -online.com/koons.html.

Owens, Craig. "The Discourse of Others: Feminists and Postmodernism." In *The Anti-Aesthetic: Essays on Postmodern Culture*, edited by Hal Foster, 57–82. Port Townsend, WA: Bay Press, 1983.

Palmer, Tom G. "Are Patents and Copyrights Morally Justified? The Philosophy of Property Rights and Ideal Objects." In *Copy Fights: The Future of Intellectual Property in the Information Age*, edited by A. Thierer and C. W. Crews Jr., 43–93. Washington, DC: Cato Institute, 2002.

Pangle, Thomas L., and Timothy W. Burns. *The Key Texts of Political Philosophy: An Introduction*. Cambridge: Cambridge University Press, 2015.

Parchomovsky, Gideon, and Kevin A. Goldman. "Fair Use Harbors." *Virginia Law Review* 93, no. 6 (2007): 1483–1532.

Parkinson, Hannah Jane. "Instagram, An Artist and the $100,000 Selfies—Appropriation in the Digital Age." *Guardian*, July 18, 2015. http://www.theguardian.com/technology /2015/jul/18/instagram-artist-richard-prince-selfies.

Patterson, Lyman Ray, and Stanley W. Lindberg. *The Nature of Copyright: A Law of User's Rights*. Athens: University of Georgia Press, 1991.

Peirce, C. S. "Prolegomena to an Apology for Pragmaticism," *Monist* 16, no. 4 (1906): 492–546.

Perebinossoff, Philippe, Brian Gross, and Lynne S. Gross. *Programming for TV, Radio & the Internet*, 2nd ed. Burlington, MA: Focal Press, 2005.

Perloff, Marjorie. "'Creative Writing' Among the Disciplines." *MLA Newsletter* 38, no. 1 (2006): 3–4.

———. *Unoriginal Genius: Poetry by Other Means in the New Century*. Chicago: University of Chicago Press, 2010.

Perloff, Stephen. "Lambert Sale a Smashing Success as Records Fall for Contemp Work." *E-Photo Newsletter*, December 10, 2004. http://www.iphotocentral.com/news/article _view.php/88/82/441.

Phillips, Patricia. *The Adventurous Muse: Theories of Originality in English Poetics 1650–1760*. Uppsala: Studia Anglistica Upsaliensia, 1984.

Pinar, William F., William M. Reynolds, Patrick Slattery, and Peter M. Taubman. *Understanding Curriculum: An Introduction to the Study of Historical and Contemporary Curriculum Discourses*. Bern: Peter Lang, 1995.

Pirmasens, Deef. "Axolotl Roadkill: Alles nur geklaut?" *Die Gefühlskonserve* (blog). February 5, 2010. http://www.gefuehlskonserve.de/axolotl-roadkill-alles-nur-geklaut-05022010 .html.

Polti, Georges. *Les Trente-Six Situations Dramatiques*. Paris: Mercure de France, 1912.

Pope, Rob. *Creativity: Theory, History, Practice*. London: Routledge, 2005.

Posner, Richard A. "Intellectual Property: The Law and Economics Approach." *Journal of Economic Perspectives* 19, no. 1 (2005): 57–73.

———. *The Little Book of Plagiarism*. New York: Random House, 2007.

Puttenham, George. *The Arte of English Poesie*. Edited by Edward Arber. London: Alex Murray & Son, 1869.

Read, Herbert. "Originality." *Sewanee Review* 61, no. 4 (1953): 533–56.

Rian, Jeff. "In the Picture: Jeff Rian in Conversation with Richard Prince." In *Richard Prince*, edited by Rosetta Brooks and Jeff Rian, 8–24. New York: Phaidon, 2003.

Rizzo, Marian. "Worth Fighting For: Actor Kirk Cameron Brings Love Seminar to Ocala Church," 2011. http://www.ocala.com/article/20110723/ARTICLES/110729917.

Robinson, Jenefer. "Style and Personality in the Literary Work." *Philosophical Review* 94, no. 2 (1985): 227–47.

Rose, Mark. *Authors and Owners: The Invention of Copyright*. Cambridge, MA: Harvard University Press, 1993.

Rosenheim, Jeff L. "'The Cruel Radiance of What Is': Walker Evans and the South." In *Walker Evans*, edited by John P. O'Neill, 54–105. New York: Metropolitan Museum of Art, 2000.

Rosenthal, Emerson. "We Talked to the Suicide Girls About Richard Prince's 'Appropriation Art.'" *The Creators Project*, May 28, 2015. http://thecreatorsproject.vice.com/blog /we-talked-to-the-suicide-girls-about-richard-princes-appropriation-art.

Rudinow, Joel. "Race, Ethnicity, Expressive Authenticity: Can White People Sing the Blues?" *Journal of Aesthetics & Art Criticism* 52, no. 1 (1994): 127–37.

———. "Reply to Taylor." *Journal of Aesthetics & Art Criticism* 53, no. 3 (1995): 316–18.

Sag, Matthew. "God in the Machine: A New Structural Analysis of Copyright's Fair Use Doctrine." *Michigan Telecommunications & Technology Law Review* 11, no. 2 (2005): 381–435.

———. "Predicting Fair Use." *Ohio State Law Journal* 73, no. 1 (2012): 47–91.

Samuels, Allison. "How Henrietta Lacks Changed Medical History." *Newsweek*, February 15, 2010. http://www.newsweek.com/how-henrietta-lacks-changed-medical-history -74949.

Sanders, Charles J., and Steven R. Gordon. "Strangers in Parodies: Weird Al and the Law of Musical Satire." *Fordham Intellectual Property, Media & Entertainment Law Journal* 1, no. 1 (1990): 11–46.

Schaar, Elisa. "Spinoza in Vegas, Sturtevant Everywhere: A Case of Critical (Re-)Discoveries and Artistic Self-Reinventions." *Art History* 33, no. 5 (2010): 886–909.

Schijndel, Marieke van, and Joost Smiers. "Imagining a World without Copyright: The Market and Temporary Protection, a Better Alternative for Artists and the Public Domain." In *Copyright and Other Fairy Tales: Hans Christian Andersen and the Commodification of Creativity*, edited by H. Porsdam, 147–64. Northampton, MA: Edward Elgar, 2006.

Schlapp, Otto. *Kants Lehre vom Genie und die Entstehung der 'Kritik der Urteilskraft.'* Göttingen: Vandenhoeck & Ruprecht, 1901.

Schloss, Joseph G. *Making Beats: The Art of Sample-Based Hip-Hop.* Middletown, CT: Wesleyan University Press, 2004.

Schofield, Jack. "Pac-Mondrian." *Guardian*, December 30, 2004. https://www.theguardian .com/technology/blog/2004/dec/30/pacmondrian.

Schuller, Gunther. *Early Jazz: Its Roots and Musical Development.* Oxford: Oxford University Press, 1968.

Schur, Richard L. *Parodies of Ownership: Hip-hop Aesthetics and Intellectual Property Law.* Ann Arbor: University of Michigan Press, 2009.

Searle, John. "Collective Intentions and Actions." In *Intentions in Communication*, edited by Philip R. Cohen, Jerry Morgan, and Martha E. Pollock, 401–16. Cambridge, MA: MIT Press, 1990.

Sellors, C. Paul. "Collective Authorship in Film." *Journal of Aesthetics & Art Criticism* 65, no. 3 (2007): 263–71.

Shavin, David M. "Continuing the American Revolution in the Operas of Mozart and His Allies." *Executive Intelligence Review* 29, no. 16 (2002): 54–58.

Shaw, Alex, Vivian Li, and Kristina R. Olson. "Children Apply Principles of Physical Ownership to Ideas." *Cognitive Science* 36, no. 8 (2012): 1383–1403.

Sherrill, Phil. *The International Comparative Legal Guide to Copyright 2015.* London: Global Legal Group, 2014.

Shiffrin, Seana Valentine. "Lockean Arguments for Private Intellectual Property." In *New Essays in the Legal and Political Theory of Property*, edited by Stephen R. Munzer, 138–67. Cambridge: Cambridge University Press, 2001.

Shiner, Roger A. "Ideas, Expressions, and Plots." *Journal of Aesthetics & Art Criticism* 68, no. 4 (2012): 401–5.

Siegel, Katy. "Jeff Koons Talks to Katy Siegel." *Artforum* 41, no. 7 (2003): 252–53, 283.

Silvie, Matt. "Daniel Clowes Interview." *Comics Journal*, May 2001, 52–77.

Simon, David A. "Teaching without Infringement: A New Model for Educational Fair Use." *Fordham Intellectual Property, Media & Entertainment Law Journal* 20, no. 2 (2009) 453–561.

Singer, Peter. *One World: The Ethics of Globalization.* New Haven, CT: Yale University Press, 2002.

Singerman, Howard. *Art History, after Sherrie Levine.* Oakland: University of California Press, 2012.

Sinnreich, Aram, and Patricia Aufderheide. "Communication Scholars and Fair Use: The Case for Discipline-Wide Education and Institutional Reform." *International Journal of Communication* 9 (2015): 818–28.

Sinnerich, Aram, and Mark Latonero. "Tracking Configurable Culture from the Margins to the Mainstream." *Journal of Computer-Mediated Communication* 19, no. 4 (2014): 798–823.

Sinnreich, Aram, Mark Latonero, and Marissa Gluck. "Ethics Reconfigured: How Today's Media Consumers Evaluate the Role of Creative Reappropriation." *Information, Communication & Society* 12, no. 8 (2009): 1242–60.

Skloot, Rebecca. *The Immortal Life of Henrietta Lacks.* New York: Random House, 2010.

Smith, Ben. "Editor's Note: An Apology to Our Readers." *BuzzFeed,* July 25, 2014. http://www.buzzfeed.com/bensmith/editors-note-an-apology-to-our-readers.

Smith, Zadie. Introduction to *The Book of Other People,* vii–xi. London: Penguin, 2007.

Spies, Michael. "Trigger Happy." *Village Voice,* February 13, 2007. http://www.villagevoice.com/arts/trigger-happy-7157588.

Spinello, Richard A. "The Future of Intellectual Property." *Ethics & Information Technology* 5, no. 1 (2003): 1–16.

Stahl, Stephanie. "Ethics and the No-Fear Generation." *Information Week,* March 18, 2002, 8.

Steiner, Hillel. *An Essay on Rights.* Oxford: Blackwell, 1994.

Stillinger, Jack. *Multiple Authorship and the Myth of Solitary Genius.* Oxford: Oxford University Press, 1991.

Stinson, Scott. "Netflix Has Its First Truly Original Series with Orange Is the New Black." *National Post,* July 13, 2013. http://arts.nationalpost.com/2013/07/25/stinson-netflix has-its-first-truly-original-series-with-orange-is-the-new-black/.

Straw, Deborah. "The Plagiarism of Generation 'Why Not?'" *Community College Week* 14, no. 24 (2002): 4–7.

Sullivan, Ronald. "Appeals Court Rules Artist Pirated Pictures of Puppies." *New York Times,* April 3, 1992, B3.

Sylvester, David. *Interviews with American Artists.* New Haven, CT: Yale University Press, 2001.

Tate Gallery. *Tate Gallery: Illustrated Catalogue of Acquisitions 1986–88.* London: Tate, 1996.

Taylor, Paul C. ". . . So Black and Blue: Response to Rudinow." *Journal of Aesthetics & Art Criticism* 53, no. 3 (1995): 313–16.

Thomasson, Amie. "The Ontology of Art." In *The Blackwell Guide to Aesthetics,* edited by Peter Kivy, 78–92. London: Blackwell, 2004.

———. "The Ontology of Art and Knowledge in Aesthetics." *Journal of Aesthetics & Art Criticism* 63, no. 3 (2005): 221–29.

Thomson, Judith Jarvis. "Some Ruminations on Rights." *Arizona Law Review* 19, no. 1 (1977): 45–60.

Tomkins, Calvin. *Off the Wall: A Portrait of Robert Rauschenberg.* London: Picador, 2005.

Tormey, Alan. "Transfiguring the Commonplace." *Journal of Aesthetics & Art Criticism* 33, no. 2 (1974): 213–15.

Ulmer, Gregory L. "Borges and Conceptual Art." *Boundary 2* 5, no. 3 (1977): 845–62.

UNESCO World Anti-Piracy Observatory. "Turkey." Unesco.org, 2009. http://www.unesco.org/culture/pdf/turkey_cp_en.

US Congress, Office of Technology Assessment. "Intellectual Property Rights in an Age of Electronics and Information." Washington, DC: US Government Printing Office, 1986.

US Copyright Office. "Mechanical License Royalty Rates." Revised January 2010. http://www.copyright.gov/licensing/m200a.pdf.

Van Camp, Julie. "Judging Aesthetic Value: 2 Live Crew, Pretty Woman, and the Supreme Court." In *1995–96 Entertainment, Publishing and the Arts Handbook,* edited by Stephen F. Breimer, Robert Thorne, and John David Viera, 125–35. New York: Clark, Boardman & Callaghan, 1995.

———. "Originality in Postmodern Appropriation Art." *Journal of Art Management, Law & Society* 36, no. 4 (2007): 247–58.

Vartanian, Hrag. "Photographer Sends Cease and Desist Letters to Richard Prince and Gagosian." *Hyperallergenic,* February 15, 2015. http://hyperallergic.com/183036/photographer-sends-cease-and-desist-letters-to-richard-prince-and-gagosian/.

Wagner, Vit. "Pride and Prejudice Adds Zombies." *Toronto Star,* April 12, 2009. https://www.thestar.com/entertainment/2009/04/12/pride_and_prejudice_adds_zombies.html.

Waldron, Jeremy. "From Authors to Copiers: Individual Rights and Social Values in Intellectual Property." *Chicago-Kent Law Review* 68, no. 2 (1993): 842–87.

Walker, William C. "Fair Use: The Adjustable Tool for Maintaining Copyright Equilibrium." *Louisiana Law Review* 43, no. 3 (1983): 735–57.

Walton, K. L. "Categories of Art." *Philosophical Review* 79, no. 3 (1970): 334–67.

West, M. L. "The Invention of Homer." *Classical Quarterly* 49, no. 2 (1999): 364–82.

Wetzel, Linda. "Types and Tokens." *Stanford Encyclopedia of Philosophy,* April 28, 2006. http://plato.stanford.edu/entries/types-tokens.

Whelan, Andrew. "The 'Amen' Breakbeat as Fratriarchal Totem." In *Dichotonies, Gender and Music,* edited by Beate Neumeier, 111–33. Heidelberg: Universitätsverlag Winter, 2009.

White, E. B. *Letters of E. B. White.* Edited by Dorothy Lobrano Guth. New York: Harper & Row, 1976.

White-Parks, Annette. "Beyond the Stereotypes: Chinese Pioneer Women in the American West." In *Writing the Range: Race, Class, and Culture in the Women's West,* edited by Elizabeth Jameson & Susan Armitage, 258–73. Norman: Oklahoma University Press, 1997.

Williams, Desmond. "Can I Get an Amen, Brother?" *Verbicide,* June 20, 2008. http://www.verbicidemagazine.com/2008/06/20/can-i-get-an-amen-brother/.

Wilson, James. "Ontology and the Regulation of Intellectual Property." *Monist* 93, no. 3 (2010): 450–63.

Wollheim, Richard. *Art and Its Objects.* New York: Harper & Row, 1968.

Wolterstorff, Nicholas. *Works and Worlds of Art.* Oxford: Clarendon Press, 1980.

Woodmansee, Martha. "The Genius and the Copyright: Economic and Legal Conditions of the Emergence of the 'Author.'" *Eighteenth-Century Studies* 17, no. 4 (1984): 425–48.

Woodmansee, Martha, and Peter Jaszi. *The Construction of Authorship: Textual Appropriation in Law and Literature.* Durham, NC: Duke University Press, 1994.

Wreen, Michael. "The Ontology of Intellectual Property." *Monist* 93, no. 3 (2010): 433–49.

Young, Edward. *Conjectures on Original Composition.* London: A. Miller, 1759.

Young, James O. *Cultural Appropriation and the Arts*. Malden, MA: Blackwell, 2008.
Young, Jeffrey R. "The Cat-and-Mouse Game of Plagiarism Detection." *Chronicle of Higher Education* 47, no. 43 (2001): A26–A28.
Zakarin, Jordan. "Shia LaBeouf Apologizes after Plagiarizing Artist Daniel Clowes for His New Short Film." BuzzFeed, December 16, 2013. http://www.buzzfeed.com/jordan zakarin/shia-labeouf-rip-off-daniel-clowes-howard-cantour.
Zhang, Michael. "Richard Prince Selling Other People's Instagram Shots without Permission for $100K." PetaPixel, May 21, 2015. http://petapixel.com/2015/05/21/richard -prince-selling-other-peoples-instagram-shots-without-permission-for-100k.
Ziv, Stav. "The New York Public Library Encourages Readers to 'Remix' Its Public Domain Collections." *Newsweek*, January 7, 2016. http://www.newsweek.com/new-york -public-library-encourages-readers-remix-its-public-domain-collections-412912.

INDEX

Cézanne, Paul, 159
Chasnik, Ilya, 78
Chaucer, Geoffrey, 104–5, 193
 Canterbury Tales, 105
Chen, Adrian, 11
Chuck D, 36
CJEU. *See* Court of Justice of the European
 Union (CJEU)
Clancy, Tom, 81
Clemens, Samuel, 202. *See also* Twain, Mark
CliffsNotes, 155
Clowes, Daniel, 9–10, 28
 David Boring, 10
 "Justin M. Damiano," 9, 28
coauthorship. *See under* authorship
Coleman, Gregory C., 18–20, 180
Coleridge, Samuel Taylor, 57–58, 186
collaboration. *See* authorship
collage, 36, 43, 109, 143, 145, 151, 154, 160
College Art Association, 36
Collingwood, R. G., 59
common, the, 110–13, 114, 116–17, 119,
 196. *See also* public domain
configurable culture, 27. *See also* Read/
 Write (RW) culture
Congress. *See* US Congress
constructivism, 33
context of creation, 92, 95–96, 191
contract, 85
copy culture, 27. *See also* Read/Write (RW)
 culture
copyright: as an economic right, 101–2,
 193; of fictional characters, 1; fixation
 requirement, 14–15, 183, 192; infringe-
 ment, 3, 6, 9, 10, 15, 19, 24, 29, 35, 36,
 38, 45–48, 52, 59, 63, 96–98, 100, 108,
 111, 117–18, 121, 122, 124, 125–26, 127,
 128, 129, 130, 132–33, 137, 138, 141,
 143, 145, 147, 152, 154–55, 164–65,
 171, 174, 179, 180–81, 182, 191, 192; as
 a moral right, 101–2, 106, 167, 193; reg-
 istration, 3, 41, 183, 192, 193; substantial
 similarity, 192; term duration, 2, 104,
 106, 165–68, 193, 202
copyright clause. *See* intellectual property
 clause
Costacos, John, 156–57
Costacos, Tock, 156–57
counterfeiting. *See* forgery
Court of Justice of the European Union
 (CJEU), 61, 108, 187

cover versions, 37, 38, 174. *See also* me-
 chanical licenses
creation ex nihilo. *See under* originality
creative choices test, 109–10
Creative Commons, 44, 165
creative spark, 64–65
criteria for correctness, 91, 92
Crow, Thomas, 198
cultural practice. *See* artistic practice
"Cunnilingus Champion of Company C,"
 124
Currie, Gregory, 91, 191

Danielewski, Mark Z.
 House of Leaves, 190
Danto, Arthur, 63, 99
database right, 178
Davies, David, 34
Da Vinci, Leonardo
 Mona Lisa, 151
death of the author, 50, 77, 140, 193. *See
 also* Barthes, Roland
De Kooning, Willem, 159
Demetz Studio, 141
de minimus uses, 174
De Quincey, Thomas, 57, 186
derivative works, 38, 44, 102, 118, 141, 152,
 155–56, 158, 200, 201
Derome, Philippe, 78
Deutsche Guggenheim Museum (Berlin),
 143
Diamond, Michael "Mike D," 19, 180
Dickens, Charles, 23–24, 71–75, 80–81, 83,
 188, 189
 Mystery of Edwin Drood, The, 71–75, 80–
 81, 188, 189
 Tale of Two Cities, A, 23–24
Diefenbach, Donald L., 159, 193
Digital Millennium Copyright Act of 1998
 (DMCA), 121, 130
Directors Guild of America, 85
DMCA. *See* Digital Millennium Copyright
 Act of 1998 (DMCA)
DnB (music genre). *See* drum and bass
 (music genre)
Donald Duck (character), 1, 3
Donkey Kong, 5
Donner, Richard, 84–85, 189
 Superman: The Movie, 85
Drassinower, Abraham, 129, 197
droit d'auteur. *See* copyright: as a moral right

Printed and bound by CPI Group (UK) Ltd, Croydon, CR0 4YY

09/06/2025

14685712-0002